Cesare Ripa
BAROQUE AND ROCOCO
PICTORIAL IMAGERY

Cesare Ripa
BAROQUE AND ROCOCO
PICTORIAL IMAGERY

THE 1758–60 HERTEL EDITION OF RIPA'S 'ICONOLOGIA'

WITH 200 ENGRAVED ILLUSTRATIONS

Introduction, translations and 200 commentaries

by EDWARD A. MASER, Professor of Art, The University of Chicago

DOVER PUBLICATIONS, INC.

NEW YORK

Published in Canada by General Publishing Company, Ltd., 30 Lesmill Road, Don Mills, Toronto, Ontario.

Published in the United Kingdom by Constable and Company, Ltd., 10 Orange Street, London WC2.

This Dover edition, first published in 1971, is an unabridged republication of the work in ten parts originally published by Johann Georg Hertel, Augsburg, n.d. [probably 1758-60], with the title *Historiae et Allegoriae . . . (. . . Caesaris Ripae . . . Sinnbildern, und Gedancken . . .)*; further bibliographical details are given in the Introduction. Edward A. Maser has prepared specially for this edition a new Introduction, translations of the Latin and German captions and of the Index, and descriptions of each plate based on various Italian editions of Ripa's *Iconologia* and on other sources.

DOVER *Pictorial Archive* SERIES

Baroque and Rococo Pictorial Imagery belongs to the Dover Pictorial Archive Series. Up to ten illustrations from this book may be reproduced on any one project or in any single publication free and without special permission. Wherever possible include a credit line indicating the title of this book, author, and publisher. Please address the publisher for permission to make more extensive use of illustrations in this book than that authorized above.

The republication of this book in whole is prohibited.

International Standard Book Number: 0-486-22748-0
Library of Congress Catalog Card Number: 78-100544

Manufactured in the United States of America
Dover Publications, Inc.
180 Varick Street
New York, N. Y. 10014

TO

GERTRUDE AND HANS

LYDIA AND GIULIO

LILLY AND ERICH

GEMMA AND MARCELLO

BLANCHE AND HERBERT

AND INGE

INTRODUCTION

THIS first modern English-language edition of the *Iconologia* of Cesare Ripa is a republication, much amplified with notes and thus rendered more useful for the contemporary reader, of the finest illustrated edition of one of the most famous handbooks of allegories, personifications, and symbols in the history of art. Ripa's book is the product of a time when there was, unlike today, a fairly common agreement on the way in which ideas, often very abstract ones, could be intelligibly and effectively represented visually. This compendium of suggestions for depicting such things as the virtues and vices, the emotions, the seasons, the parts of the globe, etc., was the result of a great deal of study and a great deal of assimilation of all that had been written on such matters before. Based on writings both ancient and medieval, it attributed religious meanings, or at any rate philosophical ones, to all aspects of the visible world and even to pagan symbols and deities. It was intended largely for poets, orators, and preachers, providing them with suitable metaphors and similes. It soon became clear, however, that the book was most useful to the other part of its readership—artists and others concerned with the visual representation of such things—and it became, in short, a handbook of iconography, of subject-matter, for them. (Ripa had in mind not only painters and sculptors, but also theatrical designers and the builders of elaborate wedding and funeral decorations.)

The study of the subject-matter of the artists of the past is of fairly recent date—that is, when done on a more or less scientific basis—and is largely the result of the research and teaching of the late great Erwin Panofsky, who came to this country some thirty-odd years ago. It is fitting that Panofsky's own words be used to explain just what "iconology" and "iconography" are, although his precise definition and differentiation of the two terms was not that of Ripa, who actually meant by *"iconologia"* what Panofsky defined as purest "iconography." Panofsky says, "Iconography is that branch of the history of art which concerns itself with the subject matter or meaning of works of art, as opposed

to their form." He points out that "Iconography is, therefore, a description and classification of images much as ethnography is a description and classification of human races."[1] This brings the exact meaning of the word, of Greek origin, into focus, for *icon* (*eikón*) means "picture" in Greek, and *graphy* (*graphé, graphía*) means "writing" or "description," so that the literal translation is "description of pictures" or "picture-writing," and the term suggests a subject easily rendered in writing which is, instead, being communicated through an image. This relationship of pictures with writing resulted in one of the great questions which fascinated men of the past—whether poetry, "written imagery," or painting, "depicted poetry," came first. The problem of *"ut pictura poesis"* is one which has received much treatment by scholars, for it was a much-discussed question during the Renaissance and after, and was certainly one of the many reasons why Cesare Ripa compiled his handbook.

Cesare Ripa and His ICONOLOGIA

Relatively little is known about the life and personality of Cesare Ripa, the author of this remarkable and influential book. Even the editor of the last Italian edition of his work (1764-67), Abbate Cesare Orlandi, whose aim was to honor his great compatriot and to present his work in the finest and most scholarly manner possible, was able to do little more than establish the date of his death more precisely.[2] Orlandi considered Ripa one of Perugia's greatest sons, and his book one of the literary monuments of Italy. While this estimate of the literary worth of the *Iconologia* has not been upheld, it is true that it had a profound influence on literary and artistic thinking for over two centuries, losing ground only as the eighteenth century drew to a close.

Cesare Ripa was born of humble parentage in Perugia about 1560.[3] The exact date has never been established. His real name seems to have been Giovanni Campani, Ripa being a pseudonym which was later given him when he became a member of the Accademia degli Intronati in Siena, and which he used in his publications. While still very young he went to Rome to work at the court of Cardinal Antonio Maria Salviati, in what capacity is not known, although it would seem that he went as a cook. He eventually became majordomo or chief butler of the cardinal's household. He also seems to have been famous as a chef, however, for he was permitted to give instruction in the preparation and

serving of food. He also sometimes worked for other cardinals and princes as a majordomo, probably being lent to them for special occasions by the Salviatis. After the death of the cardinal, Ripa continued to work for his heir, Marchese Lorenzo Salviati, to whom he dedicated the second edition of his book. But it was while working for the cardinal, who maintained one of the more cultivated courts of the day, that Ripa began, in his free time, to compile his great book, the *Iconologia*, through which he immediately became famous, and on which he continued to work for the rest of his life.

The first edition of the *Iconologia* (not illustrated), published in Rome in 1593 by the heirs of Giovanni Gigliotti, was received with great enthusiasm; it apparently filled a long-standing need. Duke Charles Emmanuel of Savoy was so taken with it that he presented the author with the Order of Sts. Mauritius and Lazarus, after which Ripa was always referred to as "Cavaliere," or knight.

The title page of this first edition reads:

> Iconologia overo Descrittione dell'Imagini universali cavate dall'antichità et da altri luoghi Da Cesare Ripa Perugino. Opera non meno utile, che necessaria à Poeti, Pittori, & Scultori, per rappresentare le virtù, vitij, affetti, & passioni humane. In Roma, Per gli Heredi di Gio. Gigliotti. 1593.

The concepts were arranged in alphabetical order by their Italian names. For each there was a verbal description of the allegorical figure proposed by Ripa to embody the concept, giving the type and color of its clothing and its varied symbolic paraphernalia, along with the reasons why these were chosen, reasons often supported by references to literature (largely classical). Authors' names are given for allegories not by Ripa himself, such as that for Eternity, designed by Francesco Barberini, or that of Philosophy as described by Boethius.

Another edition, also without illustrations, was published in Milan in 1602. Ripa himself produced an enlarged edition in Rome in 1603, to which he added over four hundred items, and for which woodcut illustrations were made, allegedly on the designs of Giuseppe Cesari, Cavaliere d'Arpino, one of the most popular and fashionable painters of the day. From this time on, all editions of the work were illustrated, the next appearing in 1607.

After an interval of working elsewhere, Ripa returned to the service of the Salviati family about 1613. Now, however, he had a house of his own, one with a garden, which he occupied for the rest of his life. The exact date of his death is also unknown, al-

though the available evidence points to a date around 1623.

Ripa's death did not diminish the popularity of his book, as is evident from the many other editions which followed in France, Germany, and the Netherlands, as well as in Italy. The *Iconologia* became the standard reference work for the representation of allegories, providing examples of how to represent abstract ideas in visual terms.

Ripa had gone to the great classical writers for his ideas, to men like Aristotle, Ovid, Homer, and Pliny, as he indicates time and time again in his text. He also made full use of the herbals, bestiaries, and encyclopedias of the Middle Ages, in which all manner of natural phenomena had been given symbolic meanings related to the Christian faith. But there was also already extant at the end of the sixteenth century a large body of iconological literature, which he found very useful. Such works as the *Emblemata* of Alciatus, first published in 1531 and of which one hundred and fifty editions are known, and Boccaccio's *Genealogia degli Dei* (Genealogy of the Gods), were certainly used. Probably even more important for Ripa, if the number of times he refers to them in his text is significant, were books dealing with the pictorial writing of the ancient Egyptians, known to Renaissance Italians through the many obelisks and works of art brought to Italy by the Romans. Such a book as the *Hieroglyphica* of Piero Valeriano, first published in Basel in 1556, provided him with much material. Even more valuable was the book of the so-called Horapollo, which also dealt with the hieroglyphics of the Egyptians.[4] In reality Horapollo simply offered his readers a sort of pictorial writing with specific symbols being used arbitrarily to represent a specific concept or subject. His work had absolutely nothing to do with actually deciphering Egyptian hieroglyphics—that had to wait for the discovery of the Rosetta Stone—but his inventions inspired and served the learned artists of the Renaissance. It was on the basis of these writings and of his own poetic imagination that Ripa developed the verbal representations of the virtues, vices, passions, and temperaments which make up his *Iconologia*—a blend of antique mythology, Egyptian pictorial writing arbitrarily interpreted, Biblical motives, and medieval Christian allegory, with all sorts of recondite meanings being assigned to human expressions and actions, to the animals, plants, prescribed colors, and all objects natural and artificial which were their symbolic attributes.

During Ripa's lifetime four more editions of the *Iconologia*

were published, those of 1618 and 1620 adding three hundred new
allegorical subjects. After his death (around 1623) the book con-
tinued to flourish. The 1625 Padua edition was further "enriched"
by Giovanni Zaratino Castellini with several hundred new per-
sonifications of his own invention, which were retained in all
subsequent editions in Italy—in the editions of 1630, 1645, and
1669, and in Orlandi's great Perugia edition of 1764-67, by which
time the number of allegories had increased to over a thousand.

There were several French-language editions, notably those of
1644, 1677, 1681, and 1698. German editions under various titles
preceded the Hertel one (the basis of the present volume), that of
1669-70 in Frankfurt am Main and that of 1704 in Augsburg. An
English translation of Ripa first appeared in London in 1709 with
the title *Moral Emblems*; George Richardson's two-volume edition
of 1777–79 and 1785 was the fourth and last to appear in England
in the eighteenth century. Dutch editions, of which there were at
least five, range in date from 1644 to 1750. A Spanish edition was
even published in Mexico as late as 1866 (the only one, apparently,
to appear in the Western Hemisphere to date).[5]

All these editions except the Hertel were alike in that they
consisted primarily of written descriptions of the various allegor-
ies with varying numbers of illustrations serving only as amplifi-
cations of the text. The Hertel edition, then, remains unique in the
whole history of the publication of Ripa's *Iconologia*, for it alone
consists almost exclusively of visual material, applying, one might
say, the principle which motivated the work in the first place—the
representation of abstract ideas through visual means—to the
book itself.

The Hertel Edition of Ripa's ICONOLOGIA

One of the finest editions of the *Iconologia*, produced in
Augsburg in Southern Germany in the eighteenth century, is that
published by Johann Georg Hertel. Unlike most editions of this
late sixteenth-century compendium of iconographic material, the
Hertel edition, as mentioned above, is almost without text and
depends chiefly on its full-page illustrations to provide its two
hundred allegories and personifications of virtues, vices, charac-
ters, and emotions. The illustrations, designed by the painter,
Gottfried Eichler the Younger, and engraved by a group of im-
portant reproductive engravers of Augsburg, are among the best
examples of their kind. With even the title pages and the indices

engraved throughout, this edition is a prime example of the ornamental engraving for which Augsburg was justly famous in this period, and is certainly the most beautiful edition of Ripa's book. While the subjects for the two hundred examples of allegories and personifications were almost entirely standard ones chosen from the many hundreds in earlier Ripa editions, the Augsburg editor decided to enrich his presentation with the addition in pictorial form of historical or literary exegeses of the main allegories, in order to provide an example in each case of how the allegory might be used. The so-called *fatto*, or event, usually taken from sacred writings or ancient literature and history, offered, in the background, an example of the main allegory in action in some famous episode or personality. Since the *fatti* were original contributions to the allegories by the German publisher-author, they were explained by him through the addition of short Latin and German titles and subtitles, in both prose and poetic form. The term *fatto* does not occur in the Hertel edition, but is used in the 1764 Orlandi edition, which supplies verbally three types: the *fatto storico sagro* (event from sacred history), the *fatto storico profano* (event from secular history), and the *fatto favoloso* (event from mythology). Editions of the *Iconologia* published in Ripa's lifetime did not contain *fatti*.

The free Imperial city of Augsburg, the ancient Augusta Vindelicorum, was one of the most important artistic centers of Germany. This was not due, as it was elsewhere in Germany, to the patronage of an aristocratic court or to the great efforts made by the rejuvenated Catholic Church of the Counter-Reformation, but to the production and export of works of art, notably objects in silver, one of the main industries of this commercial center. The many artist-craftsmen—silversmiths, engravers, and ornament designers—active in this industry made up a large part of the city's population.[6] The fostering of the arts as a commercial enterprise and the resultant need for a steady supply of artist-designers with a sound and fairly "standardized" kind of training led the city to be the first in Southern Germany to establish an art academy. For a time there were even two art schools in the city, which as one of the centers of the Reformation had a large Protestant population as well as an active Catholic one. Both sects founded their own schools, the Protestants first, and the Catholics in competition with them. In the course of the century, however, the two schools merged, and the Academy became more or less interdenominational. It was from the Academy that most of the

leading artists of the city came, and its influence was paramount in a large part of Central Europe.

Among the artistic products for which Augsburg became famous were ornament prints. These were etchings and engravings of ornamental designs made to serve as patterns in the design and decoration of objects in the crafts—silver vessels, furniture, or even stucco decorations for wall surfaces, a specialty of Southern Germany. They were not made for purely local use, moreover; as single sheets or bound into booklets, they were sold to craftsmen far and wide, and were thus signally important in the spread of artistic styles throughout Europe, and even far beyond. The production of these ornament prints became a specialty of Augsburg,[7] for, although the city maintained a number of printers and publishing houses, it never became a center for book publishing or book illustration, as Nuremberg did.[8] Instead, the printers of Augsburg seemed to concentrate almost exclusively on the production of independent decorative prints or series of them with some sort of common subject, such as the representation of the seasons of the year, the ages of man, or the allegories of the months. These pictorial designs were usually framed in an ornamental cartouche, which was often considered the most important part of the whole design: it was the ornamental surround which often most interested the craftsmen who bought these prints, since they could use it as a model for anything they wanted to decorate.

One of the leading publishers of prints of this sort was Johann Georg Hertel, who, after buying up a large part of the stock of the art publisher Jeremias Wolf, had established himself by mid-century as one of the most active and enterprising publishers of the city. He was born in 1700, for the burial records of the city note that he was buried in the Unterer Friedhof of Augsburg on July 7, 1775 at the age of seventy-five.[9] With his sons, he ran a very flourishing art publishing house, employing, at one time or another, most of the leading designers and engravers of the city.

Sometime during the late 1750's, with the collaboration of Gottfried Eichler the Younger, who designed the allegories for him, Hertel began the publication of an edition of Ripa's famous manual of iconography, the *Iconologia*. As the title pages of his edition indicate, the selection of the subjects was Hertel's, with Eichler given the task of providing these often very abstract subjects with new visual form. The edition was a typically Augsburg one, for Hertel eliminated almost completely the long explanatory text which had always accompanied Ripa illustrations, and thus made

of the very elaborate plates—now the sole vehicle for the Ripa allegories—more ornament prints than book illustrations. For each *fatto* (historical allusion or application of the allegory) Hertel provided a Latin inscription and a German couplet explaining the story or personage used and nothing more. He announced in the Introduction of the first part to be issued (Plate 2) that he intended to publish the work gradually, over an indefinite period of time, until the final number of plates had been reached. Ten parts, each with nineteen prints and an illustrated title page, were eventually published, so that there were, in all, two hundred plates in the book. The majority of the plates were engraved by Jeremias Wachsmuth (1711–1771), considered to have been one of the best engravers and inventors of ornament in Augsburg. The other engravers of the plates were Emmanuel Eichel, Jakob Wangner, and Christian Halbaur, all, though less important than Wachsmuth, among the leading printmakers of the city.[10]

Most important in the enterprise was, of course, Gottfried Eichler, whose task it was to design the plates, in other words, to find the means of expressing Ripa's allegories in visual terms. He was the son, namesake, and pupil of the esteemed painter Gottfried Eichler the Elder, who, known chiefly as a portraitist, was Court Painter in the Palatinate and, from 1742 until his death, director of the art academy, the Städtische Kunstakademie, in Augsburg.[11] The younger Eichler was born in Augsburg in 1715 and, after studying with his father, traveled about Europe for a while. Having spent some time in Vienna and Nuremberg, he finally accepted the post of Drawing Master at the University of Erlangen in 1743, and settled there.[12] His son, Matthias Gottfried, was born there on February 4, 1748.[13] Some time after his second marriage, in 1752, to Sabina Margaret Held from Bayreuth, Gottfried Eichler the Younger moved back to Augsburg, where he remained until his death on October 21, 1770.[14] Although he did a great deal of ornament designing for print publishers, he was chiefly famous as a mezzotint engraver. In his design for the allegory of Painting (Plate 197) in the Hertel Ripa, he included his own self-portrait. Although very different in spirit from the self-portrait in the Städtische Kunstsammlungen in Augsburg, which shows him in a very relaxed mood with his new wife from Franconia (it is dated 1752), the physiognomy is unmistakably the same.[15]

The actual date of Eichler's collaboration with Hertel on the Ripa edition is not recorded, for the book was published without

a date and, as the introduction to the first part tells us, was published over a long period of time, part by part. All later references to the Hertel Ripa have put the date of publication anywhere between 1732 and 1760.[16] A close scrutiny of the book does, however, provide a clue to the exact date. On the title pages of the first eight parts of the book, Eichler is always listed as Gottfried Eichler Junior, presumably to distinguish him from his more famous father, the Academy Director. Yet the last two parts of the book, Parts IX and X, list him simply as Gottfried Eichler, which must mean that his father had died between the publication of Part VIII and Part IX. With the senior Eichler gone, and with a son named Matthias, there was no longer any need for Gottfried Eichler the Younger to indicate that he was the junior of the two names. Since the elder Gottfried Eichler had indeed been buried on May 11, 1759, the last two parts of the Hertel Ripa must have been published after that date, and what is even more certain, the first eight parts must have been published previous to it. After having made such a point of indicating that he was the junior Gottfried Eichler, leaving off the designation in the last two parts cannot have been an oversight, but was clearly an indication of his changed condition. There is also no reason to believe that Hertel departed from his original plan of putting out the ten parts gradually, or that the last two parts did not appear last, as they would normally. Thus, the more exact date of publication should be 1758–60. It is possible that the last two parts of the work were printed and issued well before the end of 1759, but, what with the time involved in engraving Eichler's designs, printing them, binding the separate booklets, and so forth, it is possible that the last fascicles did not appear until the following year. Actually, six or so of the ten parts originally appeared with many errors in the Latin, and had to be redone, so in that respect the Hertel reproduced here is the second, corrected, edition.

With Hertel supervising the edition, and apparently being the one to decide which of the hundreds of subjects in the earlier editions of Ripa were to be used in this one, Eichler's task was to design each one as a full-page engraving, with the main allegory or personification in the foreground and the *fatto*, the specific allusion, shown as a small scene in the background. He took as his point of departure traditional representations from past editions of the work, but dealt with them fairly freely, sometimes combining several alternative allegories into a single figure (as Ripa himself, even in the earliest editions, had suggested could be done).

Sometimes symbolic objects held in the hand in earlier illustrations are heaped on the floor, sometimes a second personification is added to give a further nuance or shade of meaning to the main subject. It is often difficult to distinguish any sort of division between the allegory and its application. In short, although Eichler held to the traditional representations of these virtues, vices, temperaments, etc., he gave them a highly personal treatment.

While the figures are certainly well drawn, as are the attributes, the animals, and the *fatti*, they seem fairly standardized and unimaginative when compared to the fantastic ornamental forms which frame the plates. The edges of the scenes are often dissolved into *rocaille* motifs of such variety and richness that it is sometimes they, rather than the allegories themselves, which give the illustrations for Hertel's Ripa their elegance and their interest. Important here is the participation of Wachsmuth, who was justly famous for the ornamental surrounds with which he embellished figural scenes.[17] Since he and Eichler collaborated on a large number of engraved series and single prints of an ornamental nature, his influence on this aspect of the Ripa plates seems certain.

The almost total absence of text is one of the chief characteristics (and disadvantages) of the Hertel edition. Other editions have very lengthy descriptive texts and only a limited number of illustrations, usually of such meager artistic quality that their secondary importance is made fully evident. To make the best use of the Hertel version, the contemporary purchaser would have had to read some other edition of the book for the explanation of the figures and for such things as the meaning of the attributes, the prescribed colors, and animals. (Hertel himself probably consulted one of the other German editions, such as that of Lorenz Strauss, the *Erneuerte Iconologia oder Bilder-Sprach* . . ., which had been published in Frankfurt am Main in two volumes in 1669-70, or *Der Kunst-Göttin Minerva Liebreiche Entdeckung*, published in Augsburg in 1704,[18] although any of the many Ripa editions in Italian, French, or Dutch might have served as well, for they all had the explanatory texts his own did not.) As a result the Hertel Ripa does not seem to be a unified book at all, one in which printed text and pictorial material form a whole, but really is a large collection of the single prints or series of prints of the type for which the Augsburg printmakers were famous. In these series the number of prints could be decided upon quite arbitrarily, and increased or decreased as one wished.[19] Although Hertel's publi-

cation appears to be complete with its two hundred prints, there
was no reason why he could not have continued to produce them
in almost any number he chose, for there were hundreds of other
allegories in even the first, and smallest, of the Ripa editions.
Thus the Eichler designs are as much individual ornament prints
as they are visual versions of the literary subjects dealt with by
the Italian Cavaliere. Yet the Hertel book does adhere to the
representations as Ripa suggested them, with only occasional vari-
ations or new inventions. Perhaps no text was necessary for the
public for which the book was intended. The symbolic language
devised by the Italian had become so much the common property
of even the partially educated during this time that it might have
been felt that explanatory texts were superfluous.

The Dover Edition of the Hertel Ripa

Certainly the most beautiful of all the illustrated editions of
Ripa's *Iconologia*, the Hertel edition of 1758–60 also offers a
number of problems, especially when used to present Ripa's work
in a modern English edition for the first time. It assumes, among
other things, a much greater knowledge of the symbolism of the
post-Renaissance period than is possessed today by even the most
literate of audiences. The authors of the Augsburg edition did not
feel it necessary to explain each of the main personifications in
each plate, but only to provide a written key to the secondary
scenes, or *futti*, all of them the choice of Hertel and Eichler them-
selves (they indicate that these were their own selection and were
not simply taken from some earlier edition). This key was pro-
vided in the Latin inscriptions (some in prose, some in elegiac
couplets) above, and the rhymed German couplets below the pic-
tures, all engraved on the plate. In this way the visual importance
of the print was not minimized by a great deal of writing, which
would tend to relegate the representation to being a mere illustra-
tion for the text.

It seemed, however, that for the present edition a translation
of the Latin and German inscriptions on the plates was really not
enough to make the Hertel-Eichler plates understandable, let alone
useful, and that some further explanation and description of the
plates would add to, rather than diminish, the enjoyment of the
artistic quality of these rococo versions of Ripa's allegories. Each
plate of this edition is accompanied, therefore, by a short com-
mentary which outlines in brief the often lengthy discussions of all

aspects of the main allegories to be found in the many other editions of the work.

Though a few plates called for special treatment, in most cases the new English-language material facing each engraving is arranged as follows:

(1) At the head of each page there is a literal prose translation of the classical Latin couplet or prose statement that appears, along with the Latin title, above the picture.

(2) Next, in paragraph form, there is a description of the main foreground personification and its attributes, as well as an interpretation of the symbolism following closely that given in the texts of Ripa and later iconologists in two editions of the *Iconologia*, the first illustrated edition of 1603 and the last important Italian edition, the five-volume Perugia edition by Orlandi of 1764-67, which incorporates all later additions to Ripa's original group of allegories, such as those of Castellini of 1625. It will be noted that occasionally the descriptions derived from these editions of Ripa do not match the Hertel illustration in every detail; these deviations can only be attributed to the invention or the artistic license of Hertel or Eichler. This descriptive section generally closes with an edition and page reference, in square brackets, to the source passage in Ripa (or elsewhere).

(3) The above is followed by a description of the *fatto*, usually deriving from the Bible or from classical writers, and in a few cases from contemporary sources (such as Aegidius Tschudi's sixteenth-century *Chronicon Helveticum*, Johann Ludwig Gottfried's *Historische Chronica* [2nd ed., 1657] and Benjamin Heidrich's *Gründliches Mythologisches Lexicon* of 1724), sometimes even Italian or Swabian proverbs. Here too, a reference to the source, in square brackets, is given whenever possible. Incidentally, the Hertel Ripa was the first Ripa edition to include *fatti*.

(4) The last element on the page is a translation of the German title and a free translation, in verse, of the German couplet that appears below the picture. Without being literally exact about it, it was felt that something of the humor and the folksy quality of the German doggerel verses might be maintained.

When the explanation of a plate cannot be found in Ripa's own edition of 1603, it is given as it appears in the eighteenth-century Perugia edition, which, although later in date than the Hertel edition, has been used for the reasons mentioned above.

When Ripa felt it necessary or desirable to provide literary sources for his symbols, they have been given, but without going into details of current editions of the sources, or later scholarship regarding them. The same is true for the sources of the *fatti*, some of which, however, are either so obscure—or so commonplace—that no plausible or probable source was found.

This first modern English version of Ripa's *Iconologia*,[20] then, not only reproduces the edition with the finest illustrations, but also incorporates textual material from the first and from the most scholarly illustrated Italian editions, drawing on the whole development of iconography during the century and a half between 1603 and 1767, and presenting a generalized version of all the interpretations. The scholar searching for specific matters depending on a particular edition must refer to it, for the only specific material given here is that related to the Hertel edition. Special care has been taken in the clear reproduction of the plates, yet some of the details in the originals are so small that a magnifying glass is needed to see them, and the same will be true here. For this reason, full descriptions of the plates have been given throughout, even though they may seem superfluous in some instances. The Latin and German subject indices of the Hertel edition, completely engraved and not in letterpress, have also been included, but a single unified English index has also been added. Thus this edition becomes more or less what Hertel and Eichler intended theirs to be, a handbook of visual imagery for both the artist and his public, a sourcebook for visual ideas for the use of the one, and an explanation of them for the edification of the other.

1971 EDWARD A. MASER

Notes

[1] Erwin Panofsky, *Meaning in the Visual Arts.* New York, Doubleday and Co., 1955, pp. 26–32. Panofsky uses "iconology" for the study and interpretation of the principles and attitudes underlying the content of a work of art.

[2] *Iconologia del Cavaliere Cesare Ripa Perugino Notabilmente accresciuta d'Immagini, di Annotazioni, e di Fatti dall'Abate Cesare Orlandi patrizio di Città della Pieve, etc. etc. Tomo Primo. In Perugia. MDCCLXIV,* pp. xix–xx. Here Orlandi, on the basis of statements in earlier editions of the *Iconologia,* presents evidence that Ripa must have died in 1623 or shortly after.

[3] The biographical information about Ripa given here is derived from: Erna Mandowsky, *Untersuchungen zur Iconologie des Cesare Ripa* (Hamburg dissertation, 1934), also published as "Ricerche intorno all'-Iconologia di Cesare Ripa," *La Bibliofilia,* Anno XLI (1939), Vol. XLI, Florence, 1940, pp. 7–27, 111–124, 204–235, 279–326.

[4] Horapollo's book was apparently written in Alexandria in the second half of the fifth century A.D. A Greek copy was brought to Italy in 1419, and a Latin edition was available by 1517. See: George Boas, *The Hieroglyphics of Horapollo,* Bollingen Series XXIII, New York, 1950.

[5] Mario Praz, *Studies in Seventeenth-Century Imagery,* Sussidi Eruditi XVI, 2nd ed., Rome, 1964, pp. 472–475.

[6] Paul von Stetten, *Kunst-, Gewerb-, und Handelsgeschichte der Reichsstadt Augsburg,* Augsburg, 1779, I, p. 429.

[7] Maria Lanckoronska, "Die Augsburger Druckgraphik des 17. und 18. Jahrhunderts," *Augusta 955–1955,* Munich, 1955, p. 350.

[8] M. Lanckoronska and R. Oehler, *Die Buchillustration des XVIII. Jahrhunderts in Deutschland, Österreich und der Schweiz,* Frankfurt am Main, 1932, I, pp. 36 ff.

[9] Albert Hämmerle, *Evangelisches Totenregister zur Kunst- und Handwerksgeschichte Augsburgs,* Augsburg, 1928, p. 36.

[10] Lanckoronska-Oehler, *op. cit.,* p. 27.

[11] Thieme-Becker, *Allgemeines Lexikon der bildenden Künstler,* Leipzig, 1907–50, X, p. 407. Born in Lippstadt near Meissen in 1676, he died in Augsburg on May 11, 1759 (A. Hämmerle, *op cit., loc. cit.*). He had been a pupil of Johann Heiss in Augsburg and then studied with Carlo Maratta in Rome for five years. Beginning in 1706 he worked under Jan Kupetsky in Vienna for an equal length of time. By 1713 he had returned to Augsburg, where he married.

[12] Paul von Stetten, *op. cit., loc. cit.*

[13] Johann Georg Meusel, *Teutsches Künstlerlexicon oder Verzeichnis*

der jetzt lebenden Teutschen Künstler, Lemgo, 1778–89, Pt. II (1789), p. 36.

[14] Albert Hämmerle, *op. cit., loc. cit.*

[15] There is also a self-portrait by his father, Gottfried Eichler the Elder, in the Augsburg collections. A comparison between these two and the portrait shown in the allegory of Painting makes clear the reason for considering the portrait in the print a self-portrait by the younger Eichler.

[16] *Reallexicon für Deutsche Kunstgeschichte*, Stuttgart, 1937–67, III, col. 1187 gives 1732 as the date. Vol. IV, col. 27 gives the date as 1750, but in the same volume, col. 785, and in all subsequent references, the date is given as "around 1760."

[17] Maria Lanckoronska, *op. cit.*, p. 354.

[18] Mario Praz, *op. cit.*, pp. 473 f.

[19] Lanckoronska-Oehler, *op. cit.*, p. 29.

[20] Mario Praz, *op. cit.*, p. 474, and Erna Mandowsky, *op. cit.*, p. 326, list four English editions, the first of 1709 and the last of 1785.

Part I

of the

celebrated Italian knight
Cesare Ripa's
Allegories and Conceits,
useful
to all sorts of arts and sciences,
to each of which
is here added
an appropriate
history or allusion.
The present author and publisher
is Johann Georg Hertel
in Augsburg.

Pars I.

des
berühmten Italiänische: Ritters,
Cæsaris Ripæ,
allerley Künsten, und Wissenschafften,
dienlicher
Sinnbildern, und Gedancken,
Welchen,
jedesmahlen eine hierzu taugliche
Historia oder **Gleichnis,**
beygefüget.
dermahliger Autor, und Verleger,
Joh: Georg Hertel,
in Augspurg.

*The Cynic of Sinope is not disheartened because he is far from his homeland;
he delights in showing publicly all that lies hidden in darkness.*

Histories

and

Allegories

designed and drawn

by

Gottfried Eichler the Younger,

invented, however,

by the seller,

Johann Georg Hertel,

Augsburg

Part I

*Diogenes high the light doth hold,
That this book's contents may be told.*

Non doluit patria Cynicus procul esse Sinopeus
Quicquid in occultis hoc manifestat ovans.

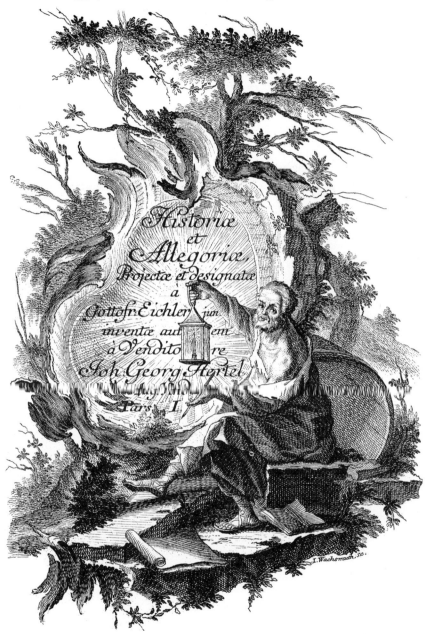

Historiæ
et
Allegoriæ,
Projectæ et designatæ
a
Gottfr. Eichler jun.
inventæ autem
a Venditore
Joh. Georg Hertel
Pars I.

J. Wachsmuth. sc.

Diogenes, ertheilt den Schein
Von dem, waß soll der Inhalt seyn.

THE MESSENGER
The messenger races through the capital with great uproar,
going and coming by various roads.

The esteemed reader is herewith advised, with all respect, that on each page of this work, the primary or main figure appearing in the so-called foreground always indicates the general title of the subject at hand, whereas the somewhat more distant representations indicate the associated histories and allegories; and that a number of similar parts will follow in succession, with God's help, until the work is complete.

THE MESSAGE
I bring report and elucidate
What this work will communicate.

Nuncius Ingenti per regia tecta tumultu ,
Ecce ruit, varias itque reditque vias.

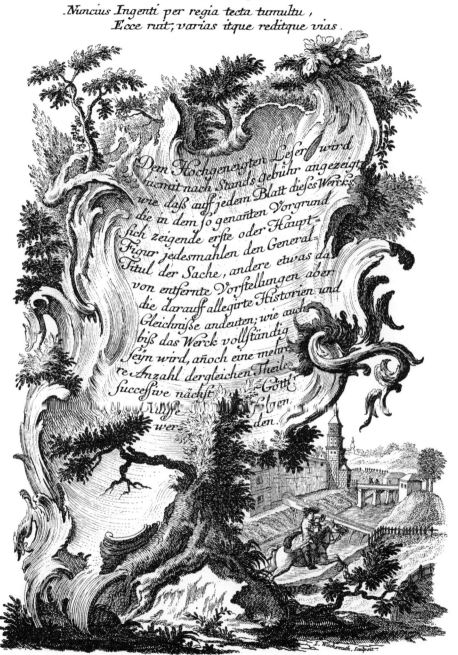

Den Hochgeneigten Leser, wird
hiemit nach Stands Gebühr angezeigt,
wie daß auff jedem Blatt dieses Wercks,
die in dem so genañten Vorgrund
sich zeigende erste oder Haupt-
Figur jedesmahlen den General-
Titul der Sache, andere etwas da
von entfernte Vorstellungen aber
die darauff allegirte Historien und
Gleichnisse andeuten; wie auch
biß das Werck vollständig
seyn wird, añoch eine mehre-
re Anzahl dergleichen Theile
successive nächst Gott folgen
wer= den.

Die Nachricht.
Ich bring Erklärung und Bericht,
von waß das Werck noch weiter spricht.

Eichler, del. J. Wachsmuth, Sculpsit. Hertel, excud.

THE DEITY
Never will Augustine be able to explore the divine mystery;
he searches fruitlessly for the things which man is incapable of understanding.

Inside a triangle with a flame at each corner (the Trinity) is seen the name of Jehovah written in Hebrew characters, all within a blazing round sun, below which burn seven flames. The whole representation is surrounded by clouds from which fiery trumpets and flashes of lightning emerge.

[Ripa, 1603, p. 109]

The *fatto storico sagro* (allusion from religious history) depicts the legend of St. Augustine known since the late Middle Ages. He is shown as a mitred bishop seated among his books on the shore, where he beholds the apparition of a child with a seashell with which it seems to be trying to empty the ocean. This vision showed Augustine that his attempts to plumb the mystery of the Trinity were equally hopeless. In the background a busy harbor and the rising sun appear.

THE DEITY
Augustine hoped to penetrate
A mystery which was too great.

Nunquam Augustinus Sacrum scrutaberit altum,
quærit inutiliter quæ fugiunt hominem .

Die Gottheit.

Augustinus wolt ergründet
waß niemand weiß außzufinden.

Eichler, del : E. Eichel, Sculps . Hertel, excud .

4

THE BEGINNING
God created from nothing the whole globe of the earth and the
stars, then man, the wonders of the deep, and its waters.

The personification of the Beginning is a female figure draped in white (the purity of the essence of God) standing in a deserted rocky landscape with fumes rising out of the ground. She holds out two blue globes in her hands (blue is the color of eternity, the globe is its symbol) from which flames rise; a flame also rises from her head (the three flames are the three equal aspects of God, the Trinity).

[Ripa, 1603, p. 109; the same as "The Deity" (see no. 3)]

There is no *fatto*, although the desolate, rocky, smoke-filled landscape can be taken as such, representing the chaos, the nothingness, out of which the world was created. In the Latin and German couplets, perhaps under the constraint of meter and rhyme, the authors have taken some liberties with the chronology of the Creation, whose correct order would be the deeps, water, earth, the stars, man.

[Genesis 1: 1–31]

THE BEGINNING
First God created the heavens and empty earth,
Then gave the light, beasts, men, and sea their birth.

PRINCIPIUM.

Procreat ex nihilo terræ totum Deus orbem
Sydera, tunc hominem, monstra marina et aquas.

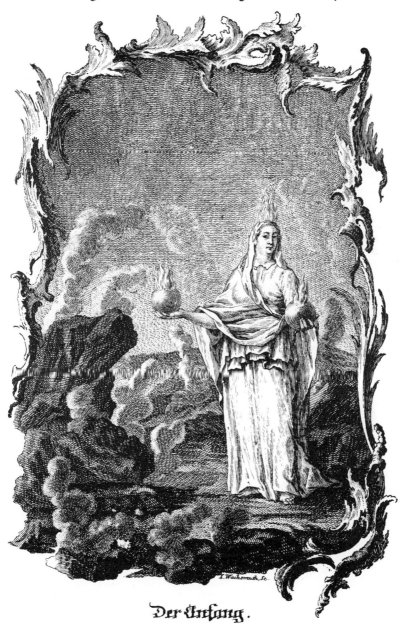

I.Wachsmuth, Sc.

Der Anfang.

Gott schuff Himel und Erden leer,
dann erst das Licht Thier Menschen Meer.

Eichler, del.

Hertel. excud:

5

THE RATIONAL SOUL
God, when He formed him, adorned man with a mind
shining with His own reason and sense.

The personification of the Soul is a female figure draped in white, the color of purity, the color which is supposedly not made up of any other colors, just as the soul is not composed of anything earthly. Her head is covered with a transparent veil, since the soul, according to St. Augustine, *De definitione animae*, is invisible to human eyes. Through the veil, the woman is seen to be beautiful, since God, the source of all beauty and perfection, created man in His own image. She has wings on her shoulders (the lightness, the fleeting swiftness of the soul; one wing could represent the intellect, the other the will, two other qualities of the soul) and a star above her head (according to Piero Valeriano, *Hieroglyphica*, Book 44, the star is a symbol for the immortality of the soul "according to the Egyptians"). Although the soul has no form or body, it must be represented thus to men, who can perceive things only through their senses.
[Ripa, 1603, p. 21]

The *fatto:* The main figure, the Soul, points into the background, where Adam and Eve are seen in the Garden of Eden.
[Genesis 2: 9–25]

THE RATIONAL SOUL
Man in God's image was created,
By sense and reason regulated.

Ornavit quemvis hominem, cum fingeret illum,
mente Deus, ratione sua sensuque corusca.

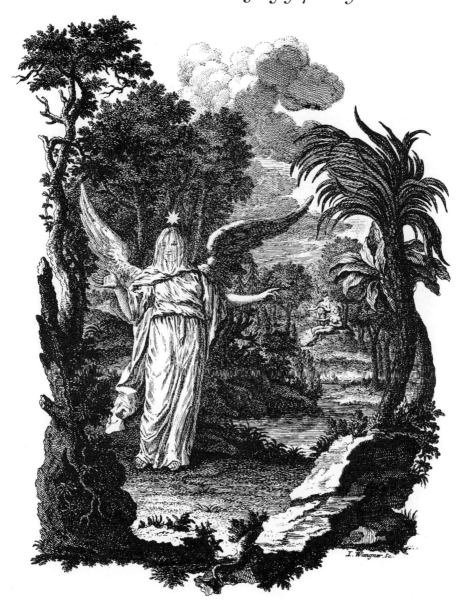

I. Wangner, Sc.

Die vernünftige Seele.
Der Mensch nach Gottes Bild gezieret,
wird durch Vernunfft, und Sinn regiert.

Eichler, del. *Hertel, excud.*

THE WORLD
All that you see everywhere—heaven, the sea, the clouds, the earth—
now all pass away; their transiency proves they existed.

In this case, the World is to be understood as the universe, as everything (the Greek word *pan*, meaning everything, or all), and is represented by the bearded and goat-footed god Pan. He looks upward, while dancing before a waterfall, wears a panther skin, and carries a shepherd's crook and a syrinx, or reed flute. His horns represent the sun and the moon. His red face symbolizes the pure celestial fire, superior to all other elements which make up the world. His pendent beard represents the two "upper" elements, air and fire, which are "masculine" and send *down* their power to the other two, earth and water, which are "feminine" in nature. The spotted panther hide symbolizes the eighth sphere of the universe, which is studded with bright stars, and which covers and encloses all that pertains to the world, according to Ptolemaic thinking. The shepherd's crook is the rule of nature's laws; a staff or rod usually signifies dominion or rule. (It could also symbolize the year, which, like the top of a shepherd's crook, turns back upon itself.) The syrinx, the "pipes of Pan," is this god's invention (Vergil, second Eclogue). His hairy goat legs can represent the earth, covered with shaggy growth: plants, bushes, grasses, etc.

[Ripa, 1603, p. 331; from Boccaccio's description in the first book of *The Genealogy of the Gods*; see also the illustration in Vincenzo Cartari, Venice, 1647, p. 72]

The *fatto*: The labyrinth seen in the background is the course of human life. At the entrance stands a child with flowers; in the first circle stands a youth with a sickle and grain; in the second, a mature woman with grapes; in the third, an old man crouching at a fire. These symbolize the four ages of man and the four seasons. In the center stands Death with hourglass and scythe, the goal, the end, of existence.

THE WORLD
Thus life's path does twist and bend
Until at last all things do end.

MUNDUS.

Quicquid ubique vides coelum, mare nubila tellus,
Omnia nunc pereunt, exitus acta probat.

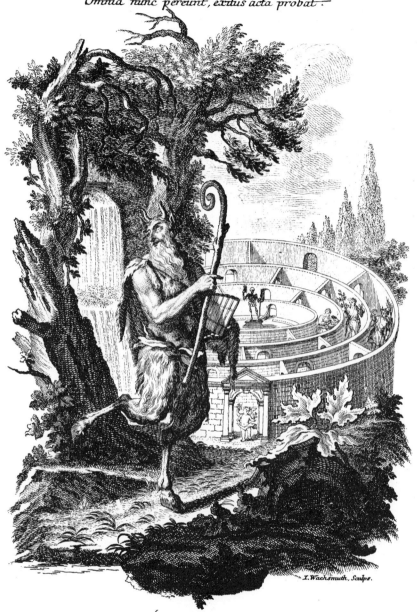

I. Wachsmuth, Sculps.

Die Welt.

So ändert sich der Lebens Lauf,
und endlich höret alles auf.

Eichler, del.

Hertel excud:

WATER
*Pharaoh passes through the great waters of the sea,
and because of God's anger, the whole band perishes.*

The personification of Water is a beautiful woman wearing transparent blue draperies which fall in wavelike folds, with pearls in her hair and on her wrists, and a necklace of shells and coral around her neck. She holds a sailing ship, her foot resting on an upturned anchor. Near her a stream filled with fish rushes by. More shells and branches of coral lie about on the ground. The woman's dress, the ship, the fish, the shells, and the corals are all references to the various aspects, products, and denizens of water.

[Ripa, 1603, p. 123]

The *fatto:* The Israelites stand on the shore of the Red Sea and watch Pharaoh's hosts being engulfed in the returning waters.

[Exodus 14: 26–28]

WATER
*Pharaoh's hosts all drownéd be
In crossing over the Red Sea.*

AQUA.

Tendit iter Pharao per magnas æquoris undas,
iratoque Deo tota caterva perit.

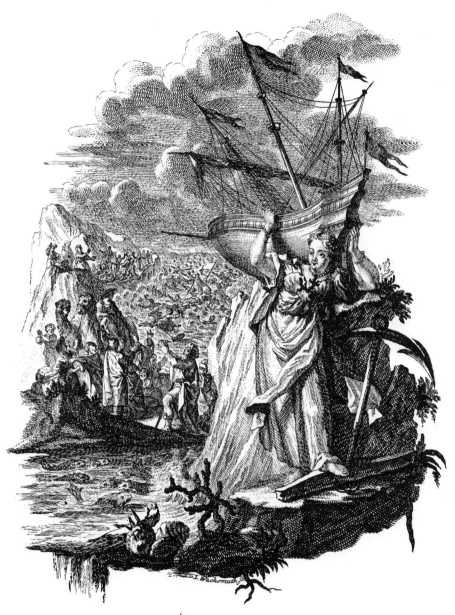

L. Wachsmuth, sc.

Das Waßer.

Pharaô mit seinem Heere,
wird ersäufft im Rothen Meere.

Eichler, del. Hertel, excud.

8

AIR
Elijah is carried aloft across the reaches of the sky;
no one excelled him in piety.

The personification of Air is a pretty young girl dressed in draperies of transparent white, with wings on her shoulders. She flies aloft, parting clouds as she goes. The draperies and wings symbolize her diaphanous, weightless nature; the clouds are one of the natural components of the air. Over her head is a sun, whose rays mix with her hair, signifying the beneficial aspect of the air, which transmits the sun's rays to man. The girl hovers over a stream whose banks are lined with rushes, among which the masts, sails, and rigging of a ship can be seen, stressing the function of air in providing the motive power for sea vessels, and thus its natural relationship to water. In the sky is a rainbow, a symbol of divine benevolence found in the air, and one of the beautiful phenomena peculiar to it.

[Ripa, 1603, p. 123, where he also suggests as a symbol the cameleopard, a legendary beast which was supposed to nourish itself exclusively on air]

The *fatto* is the transportation of Elijah in the fiery chariot up to Heaven. Elisha stands on the shore of a stream watching in wonderment, as do other people on the opposite side of the stream.

[II Kings 2: 1–12]

AIR
Elijah travels through the air
To Heaven, for God hath called him there.

AER.

Fertur in alta volans Elias per inania coeli,
Nullus ei major nec pietate fuit —

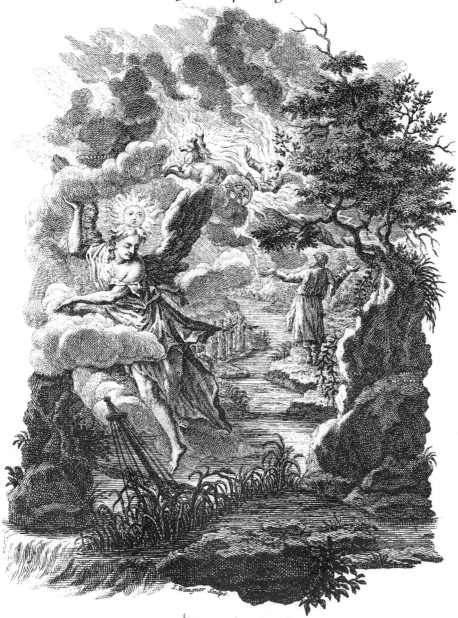

I.Wangner Sculps.

Die Lufft.

Elias führet aus der Welt,
in Himmel wie es Gott bestelt.

Eichler. del. Hertel. excud.

9

EARTH
*The earth opens her maw, and instantly perish the hordes of Korah,
the powerful rebel, who would not submit to being ruled.*

The personification of Earth is an elderly female dressed in earth color with a green drapery over her shoulder, standing before a waterfall which issues from a forest. She has one breast bared and wears a mural crown; a garland of leaves and flowers hangs over one shoulder. She carries a staff tipped with a star at each end and entwined by a grapevine.

Earth is often represented by the goddess Rhea, or Cybele, who wears a mural crown. She is shown as a matron, for she was also known as the Great Mother. The color of the draperies and the garland represent the earth's covering. The mural crown symbolizes the inhabited parts of the earth. The staff, which she holds across her middle, represents the axis of the earth, the two stars being the poles. Her naked breast symbolizes the fountains of the earth, from which all water comes, and hence all fruitfulness as well. The waterfall and the forest represent the parts of the earth covered with water and with woodland.

[Ripa, 1603, pp. 122–124]

The *fatto* represents the destruction of the followers of the rebel Korah, who, with Dathan and Abiram, rose in rebellion against Moses and Aaron. The earth opened, and his hosts fell into a flaming chasm and were swallowed up.

[Numbers 16: 1–35]

EARTH
*God doth Earth's yawning maw expand
To swallow up bold Korah's band.*

TERRA.

Os aperit tellus pereunt simul agmina Korah,
Seditione potens, indocilisque regi.

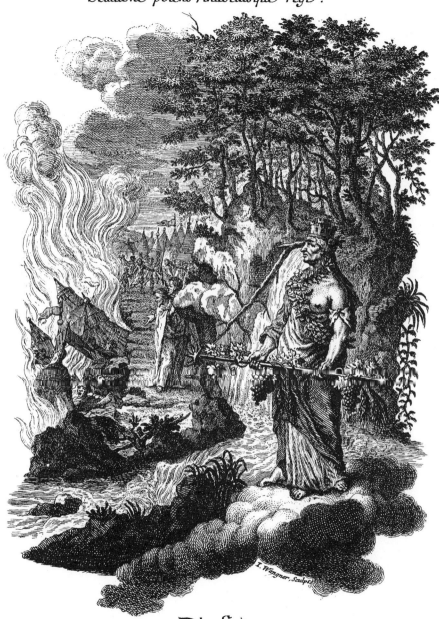

I. Wengner, Sculps.

Die Erde.

Gott öfnete der Erden Mund,
drum Korah Rott auch geht zu Grund.

Eichler, del : Hertel, excud.

FIRE

The brothers Nadab and Abihu die in the fire's flames;
their guilt was the main cause of their bad end.

The personification of Fire is a nude little boy of ruddy complexion wearing a red scarf which flutters, flamelike, behind him. He flies through the air, borne aloft by winds, seen in the form of cherub heads which blow at him. He is bald, save for one lock of hair in the center of his brow which looks like a flame. Over his head is a crescent moon, and he carries lightning bolts in his hand.

His color and the flamelike appearance of his hair are obvious allusions to the nature and appearance of fire. He is borne by the winds because fire is weightless and is fanned by the wind. The crescent moon symbolizes the celestial nature of fire, the highest of the elements. The lightning bolts are the sparks from heaven which create fire.

[Ripa, 1603, p. 123–124]

The *fatto:* In a temple, before the high altar, two sons of Aaron, Nadab and Abihu, are punished for their improper and therefore blasphemous sacrifice by being consumed by a shower of flame and lightning from heaven.

[Leviticus 10: 1–2]

FIRE

Nadab and Abihu by heaven's bolt are fated
For improper sacrifice to be incinerated.

Flamæ igni fratres Nadab pereunt et Abihu,
Propria culpa mali maxima causa sui.

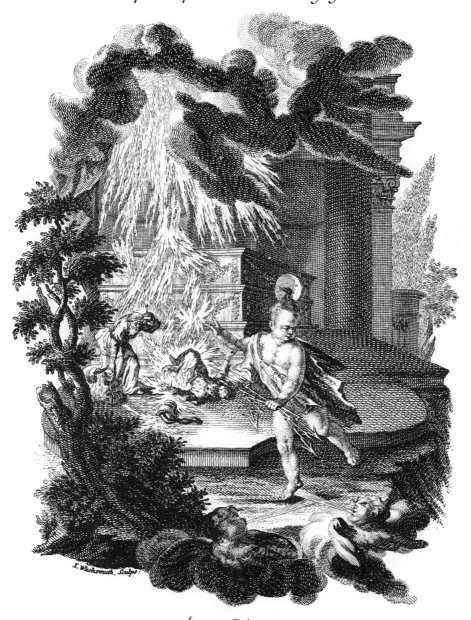

Das Feuer.

Nadab und Abihu sterben,
durch ihr Schuld in dem Verderben.

Eichler, del. Hertel, excud:

11

TIME

Meanwhile time races by, slipping away on fleet foot,
nor can past time return to you.

The personification of Time is an aged man, bearded and winged (for time flies), who wears a drapery of shifting, changing colors spangled with stars (the stars control all things subject to time, that is, all earthly things). He bears on his head a wreath of roses, ears of grain, fruit, and dry branches (the products and symbols of the four seasons of the year). In one hand he holds a mirror (only the present part of time is perceptible, and even that is as unreal as an image in a mirror) and in the other a snake biting its own tail (an ancient symbol of time, or eternity, or the year, which follows upon itself). He stands on a great circular band of the Zodiac (for time is measured through the movement of the heavenly bodies). The two putti or cherubs looking into a mirror are the past and the future, one of whom lives in the memory of man and the other in his hopes and dreams. Seated next to them are

two others, one with the sun (day) on his head and the other with the moon (night), the divisions of time during which human life goes on; they write down its events in a book (history). Lying before them are a set of scales (time equalizes all things). The ruined setting symbolizes time the destroyer. He also has iron teeth, which can gnaw away at anything.

[Ripa, 1603, p. 482]

The *fatto* seems to be an invention of the authors. Out of an open crack in a huge globe, probably the Ptolemaic sphere of the universe, winged Time, in the form of Charon the boatman, on his head an hourglass and in his hand a scythe, which he uses as an oar, guides a boat, in which a coffin can be seen, out into a stream, perhaps the Styx (or the stream of eternity?).

TIME

Though time speeds on eternally,
All men's ends established be.

TEMPUS.

Fluxere interea pede tempora lapsa fugaci,
Tempora nec possunt lapsa redire tibi.

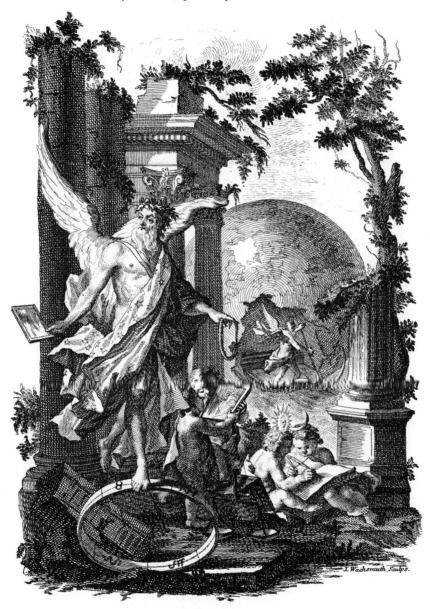

I. Wachsmuth, Sculps.

Die Zeit.

So streicht hindurch die Zeit der Welt,
weil jedem ist daß Zihl bestelt.

Eichler, del.

Hertel, excud.

THE HOUR
The times speed on and we grow old as the years pass unnoticed
and the days pass by with no restraining check.

A huge ring or wheel is marked off on its inside and outside surfaces with the numbers of the hours of the day and night from I to XII. A steering rod runs through and across it. The Hours are the guide of the sun chariot, according to Ovid. The wheel is held up by a winged, bearded head of a man, probably Father Time. Four winged putti fly about and hold on to the ring. The one at the top, blonde and dressed in red, represents the first hour of the day; he holds a symbol of the sun and a spray of freshly opened red and yellow flowers. The next putto, representing the twelfth hour of the day, has darker blonde hair and is dressed in violet; he holds a willow branch in one hand (the willow turns its leaves to follow the course of the sun) and the zodiacal symbol of Saturn in the other. The two lower putti are the hours of the night: the first hour has dark hair and a multicolored drapery, and holds the symbol of Jupiter and a bat (which appears in the evening), while the twelfth hour of the night, also with dark hair, is dressed in blue and white (with the approach of day the darkness of night diminishes), holds the symbol of Mercury, and has a star, probably the Morning Star, on his head. In the distant sky is the symbol of Eternity (Ripa, 1603, p. 140; based on a description by Francesco Barberini) seen as a constellation of stars.

[Ripa, 1603, pp. 203–214]

The *fatto*: Death, dressed as a night watchman with lantern and staff, or spear, is seen walking amid ruins through the night. He holds a worm (?) in one hand. In the distance a town sleeps beneath a crescent moon.

THE HOUR
O man, thou nearest life's last border;
Awake! Put soul and house in order.

HORA.

Tempora labuntur, tacitisque senescimus annis,
Et fugiunt fræno non remorante dies.

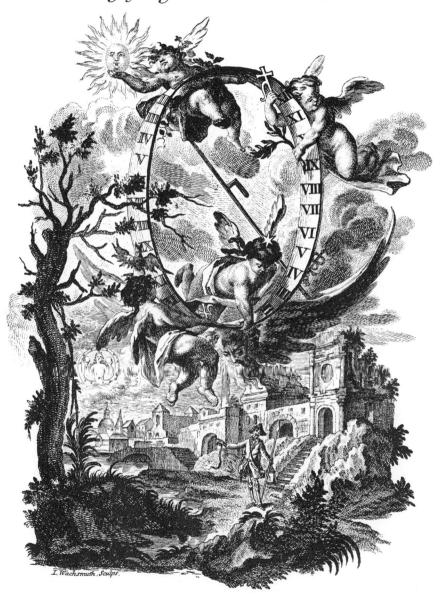

I. Wachsmuth, Sculps.

Die Stunde.

O Mensch die lebenszeit ist aus,
Wach auf bestelle Seel und Hauß.

Eichler, del.

Hertel, excud.

13

DAWN
Daybreak had already filled the whole world with its rays,
while Jacob and the angel still fought.

The personification of Dawn is a dark-complexioned nude youth, with dark wings and a wreath of flowers on his head, who flies above a pool of water. He is dark because daybreak is not yet a time of light. The flaming torch he holds downward symbolizes his role as herald of day, as Phosphor, the Morning Star, also called Lucifer, the Lightbearer. In the background is Mount Helicon with the Hippocrene spring at its rocky base and, on its summit, Pegasus rearing before the Muses' temple in its grove, looking toward the horizon where the sun is rising.
[Ripa, 1603, p. 95]

The *fatto storico sagro*, the allusion from sacred history, is the well-known story of Jacob at Penuel, who wrestled through the whole night with a heavenly apparition until, at daybreak, he finally won a blessing.
[Genesis 32: 24–30]

MORNING
Jacob and the angel wrestled through
The night, until the morning dew.

Aurora.

Orta dies totum radus impleverat orbem,
Cum luctantur adhuc Angelus atque Iacob.

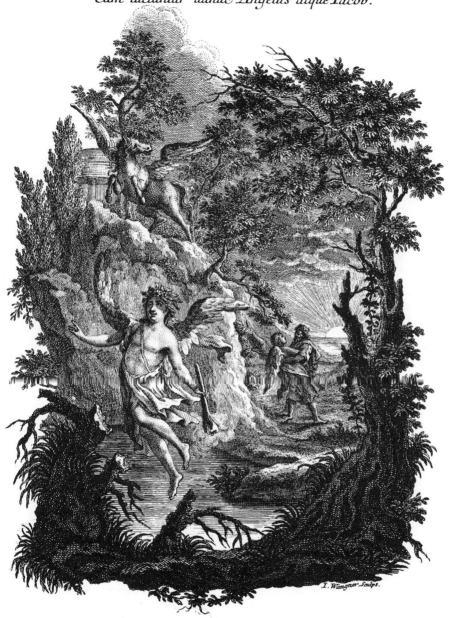

I. Wangner. Sculps.

Der Morgen.

Iacob mit dem Engel ringte,
eh der Morgen Thau sich schwingte.

Eichler, del.

Hertel, excud.

14

MIDDAY
Already Midday had dissipated the thin shadows,
when Sarah laughed on hearing the angel.

The personification of Midday is a blonde winged male child with flame-colored draperies, nude save for calf-high boots. He flies through the air, holding a lotus blossom in one hand and the zodiacal symbol for Jupiter in the other.

Midday is the sixth hour of the day, when the sun is at its zenith and its rays are most powerful. Hence the vigorous child wears the classical boots of the hunter or warrior. Pliny *(Natural History,* Book 13, chap. 17–18) supplies the explanation of the lotus: this plant, it was supposed, rises out of the water at dawn, reaches its full height and opens its flower at noon, and slowly closes as the sun descends, sinking back into the water as darkness falls.

[Ripa, 1603, p. 207]

The *fatto:* Seated under a drapery beneath a tree, through which the sun shines, are the three angelic visitors, dressed as travelers. Abraham serves them food, while Sarah stands behind a door, eavesdropping. The shortness of the shadows indicates that it is midday.

[Genesis 18: 1 ff.]

MIDDAY
God, as three angels, is Abraham's guest;
Old Sarah's laughter can't be suppressed.

MERIDIES.

Iamque dies medius tenues confraxerat umbras,
Ridet dum genium percipit aure Saræ.

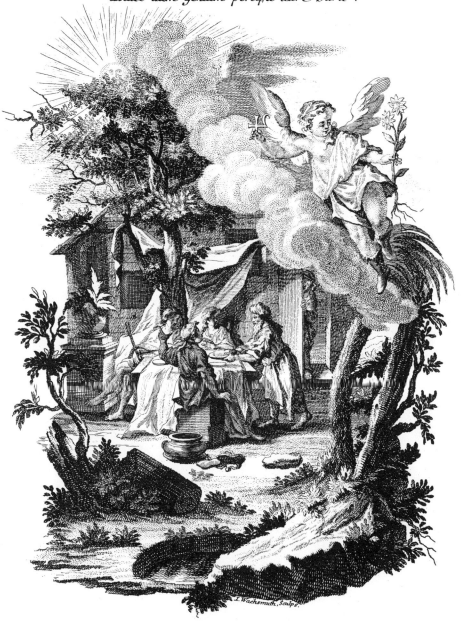

J. Wachsmuth, Sculps.

Der Mittag.

Gott und Engel seyn die Gäste,
Saræ lachen hält nicht feste.

Eichler del. Fertel. excud.

EVENING
*Finally Hesperus arrives, the sign of approaching night;
the sun hides his head and the nocturnal hours come.*

The personification of Evening is Hesperus, the Evening Star, depicted as a winged nude male child flying through the air. He has a large shining star on his head and holds an owl, a creature of the night, in one hand and an arrow in the other, having just cast other arrows to the ground. These symbolize the vapors of the earth, which, having risen during the day, return down to the ground at night. Hesperus flies toward the west, as does the sinking day.
[Ripa, 1603, p. 97]

The *fatto*: Christ, walking with two disciples who do not recognize Him, is urged by them to stop at Emmaus and enter a picturesque, semi-dilapidated inn. In the background is a peaceful landscape with the sun setting behind a hill, casting long shadows everywhere.
[Luke 24: 28–29]

EVENING
*Oh Lord, the sun toward earth draws near.
Abide, evening will soon be here.*

Vicinæ noctis tandem venit hesperus index,
Sol caput occultat, tempora noctis eunt.

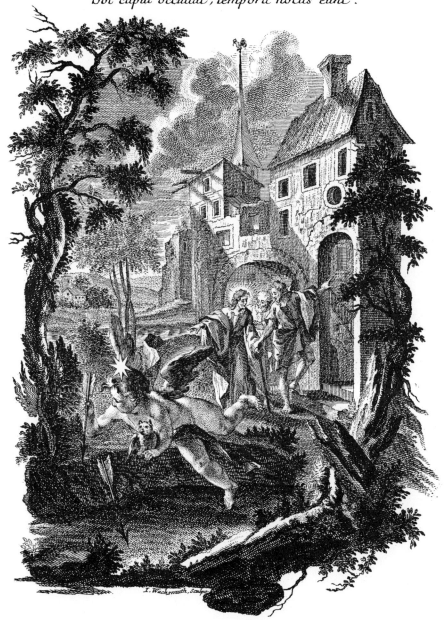

I. Wachsmuth, Sculps.

Der Abend.

Herr die Sonne naht zur Erden,
bleib dann es will Abend werden.

Eichler del: Hertel excud:

NIGHT

To learn the teachings of Christ, Nicodemus went to Him
by night, and partook of all His doctrines.

The personification of Night is a barefoot female, dressed in dark colors, who makes fire by striking a flint. A nude child holds a candle up to the flame to light it. The woman's dark dress is in the colors of night and, as Boccaccio says in the first book of *The Genealogy of the Gods*, night is the time to light candles to chase away its shadows.

[Ripa, 1603, p. 361, where Night is also provided with some stars in the sky and an owl flying about, which Eichler has placed in the background with the *fatto*]

The *fatto:* In a noble classical building, seen against a starry sky with a waning moon, Christ is seated in a circular room, lit by a lamp with seven lights, expounding His teachings to Nicodemus, a bearded old man. Outside, on the building, an owl is perched.

[John 3: 1–21]

NIGHT

Nicodemus sought Christ in the night
To hear His word and see the Light.

NOX.

Ut disciplinam Christi capiat Nicodemus,
Ipsi nocte adiens dogmata cuncta capit.

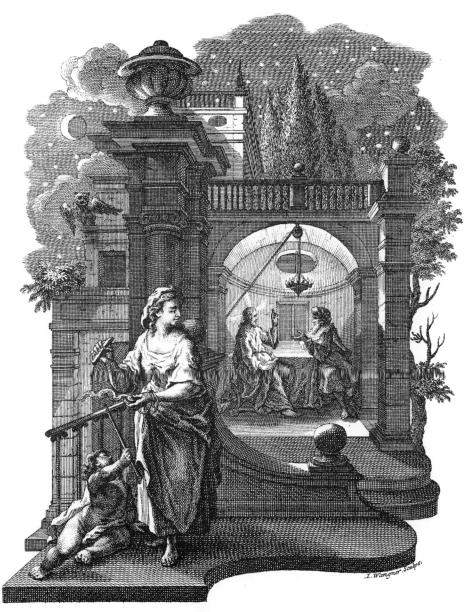

Die Nacht.

Nicodemus war beflißen,
Christi Lehre recht zu wißen.

Eichler, del.

I. Wangner, Sculps.

Hertel, excud.

THE YEAR
Today and every day passes; we hasten toward a single goal—
black Death, who awaits all men.

The personification of the Year is an aged bearded man with wings, nude save for a cloak lined with the signs of the Zodiac. He is draped with flowers (for spring), ears of grain (for summer), and grapes (for autumn). In one hand he holds the ancient symbol for the year, the snake biting its own tail. In his other hand he holds a nail, an allusion to the story that the ancient Romans began each year by pounding a nail into a temple wall, thus keeping track of the number of years. The season of winter, when the year begins, is represented by the dead tree on the right. The man rests his hand on a globe on a pedestal, symbol of the universe or of perfect continuity. [Ripa, 1603, pp. 20–21]

The *fatto*: The application of the allegory, which is concerned with the measurement of time, is shown by a man standing before a house looking up at a sundial attached to its wall. The German couplet is closely connected with this, and gives it a profounder meaning.

THE YEAR
He wishes to see by the sundial
How soon he must meet his final trial.

ANNUS.

Hic alterve dies transit properamus ad unam,
metam mors cunctis iminet atra viris.

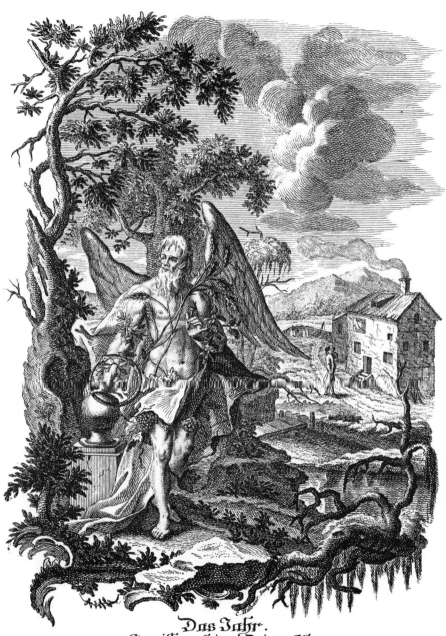

Eichler, del.

Das Jahr.
Er will nach dem Zeiger sehen,
Wie bald ist's um ihn geschehen.

Hertel, excud.

HUMAN LIFE
*Death, the ultimate goal of all, like smoke
destroys all life, after many grief-laden years.*

The personification of Human Life is a woman in classical draperies, holding in her hands the sun and the crescent moon, which symbolize the predestined events in life determined by the heavenly bodies. She stands on the hub of a wheel (the wheel of Fortune) laid horizontally, which determines the chance events in human existence. In the sky the symbol of God, the shining triangle with the eye of God in the center, sends down a beam of light to the sun, signifying that even the sun, source of light, receives its power from God.

[Ripa, 1603, p. 514]

The *fatto:* A man dressed as a pilgrim, with hat, staff, cloak, and bottle, leaves a rocky, tree-grown, mountainous landscape and steps onto a wooden bridge to cross a stream. On the other bank stands Moses (?) with shining rays of light on his head, holding the Decalogue and pointing with his staff to the entrance to a graveyard.

HUMAN LIFE
*We wander ever in fear and sorrow,
Only to meet death upon the morrow.*

VITA HUMANA.

Destruit ut fumus vitam mors ultima finis,
post multos annos anxietate graves.

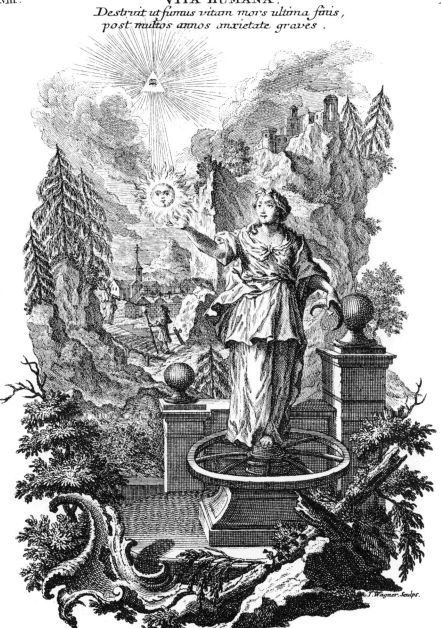

F. Wagner, Sculps.

Das Menschliche Leben.

Wir wandern fort in Angst und Noth,
und kommen näher zu dem Tod.

Eichler, del. Hertel, excud.

DEATH
*The same fate awaits all; we hasten toward a common goal,
black Death, who claims all under his power.*

The personification of Death, a skeleton, lies on a bier within an elaborate catafalque decorated with skulls and many lamps. He is wrapped in a rich robe (he takes away the rich man's wealth) and wears a laurel crown symbolizing his rule over all mortals. In one hand he holds a sword entwined with an olive branch, meaning that peace cannot endure if men do not run the risk of death in fighting for it. The motto above the catafalque reads: "Death makes all men equal." Four lighted tapers stand on either side of the bier.

In the lower foreground stand two putti, heavily veiled to signify their blindness, not their mourning, for they represent man's pleasure in the things of this world. The power and glory of the world are shown in the child wearing classical armor and carrying crowns, a mitre, a scepter, and medals on a cushion, while a sword, lances, and a marshal's baton lie at his feet. The other putto represents all human invention and art; the flail and shovel lying near him stand for agriculture, while the quill pens, scrolls, palette and brushes, and compass and triangle stand for the arts and sciences.

[Ripa, 1603, pp. 339–340; a free adaptation]

DEATH
*Not rank nor dignity can me withstand;
My power extends o'er every land.*

Fata manent omnes metam properamus ad unam,
Omnia sub leges mors vocat atra suas.

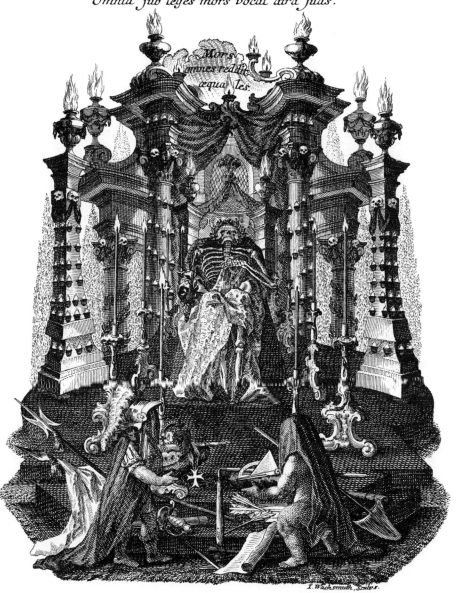

Der Tod.

Ich schone weder Würd, noch Stand,
mein Recht ist aller Welt bekant.

Eichler, del. Hertel, excud.

ETERNITY

Without end, I always was and always shall remain,
I, who have neither beginning nor end.

A scantily draped heroic male figure bearing a bow and arrow and a lyre approaches a cave or grotto whose entrance is encircled by a huge serpent holding its own tail in its mouth. Within the cave a heavily veiled matronly figure is seated. Beside her sits an old man, nude and bearded, who is writing on a stone tablet. They look up in greeting. In front of the cave four children or putti are seated on some steps. One holds a pinwheel and blows a flute at another, who points to something he is reading in a scroll he holds. A third holds a cluster of grapes and talks to a fourth, who holds a walking stick. On the right stands a flat slab of stone inscribed with the image of a female figure whose legs, which end as tails, join above her head, encircling her. Her body is strewn with stars and she holds two balls in her hands.

The Augsburg authors have here reversed their usual practice, and the main allegory taken from Ripa is simply the image of Eternity depicted on the stone slab in the foreground. This, the invention of Francesco Barberini, as Ripa tells us (1603, p. 140), suggests the circular nature of eternity, complete within itself and never ending. The two balls she holds are of gold, a symbol of her incorruptibility. Her body, blue and covered with stars, represents the heavens.

The *fatto* takes up most of the page and is not, in this case, a specific historical or mythological reference to the allegory, but actually another representation of Eternity taken from a totally different source, Cartari. The god Phoebus Apollo is approaching the cave of Demogorgon, the aged and bearded companion of the heavily veiled Eternity. The snake encircling the entrance symbolizes the year and its revolutions. Demogorgon, who is probably a symbol for destiny, is writing down the laws which govern the universe. Eternity is heavily veiled because one cannot see the past and the future which she encompasses, only the vague forms of the present. The four putti are the four ages of man, as well as the four seasons. Youth (Spring), with his joys and pleasures, distracts ambitious Maturity (Summer) from his profitable studies. Nearby, Full Maturity (Autumn) enjoys the fruits of his labors and talks to Age (Winter), who has a cane.

[Ripa, 1603, pp. 138–141, for the symbol of Eternity; Cartari, 1647, pp. 11–13, for the illustration of Apollo, Demogorgon, the snake, and Eternity]

ETERNITY

Forevermore my course doth run;
Without an end, 'tis never done.

ÆTERNITAS.

Fine carens semperque sui semperque manebo,
Cui neque principium, cui neque finis erit.

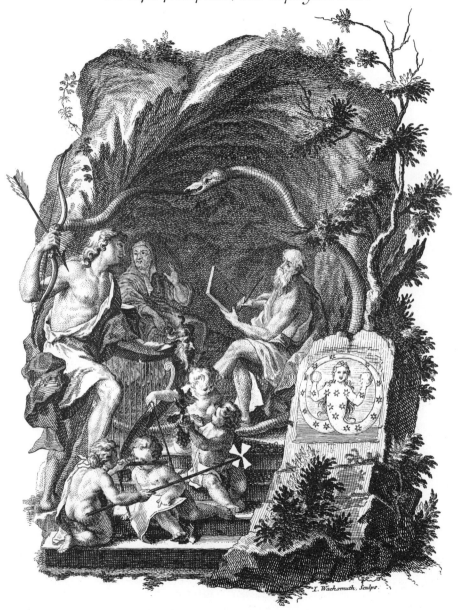

I. Wachsmuth, Sculps.

Die Ewigkeit.

Sans ohnauffhörlich ist mein lauf,
Dann es folgt gar kein Ende drauf.

Eichler, del: Hertel, excud:

Now follows a second part. May it sell as well as the other.
This part recommends itself by its usefulness.

Part II

Histories

and

Allegories

designed and drawn

by

Gottfried Eichler the Younger,

published

by the author,

Johann Georg Hertel,

Augsburg

To the left of the fantastic cartouche (apparently made of bark) for the title page information, a magnificent city street can be seen, somewhat reminiscent of the Maximilianstrasse in Augsburg, or a street in Rome. There a ragged ambulatory printseller is seen showing his wares to an elegant gentleman in eighteenth-century garb; a little dog prances about nearby.

This second part we show to you,
And hope that you will buy it too.

Altera nunc sequitur pars hæc vendatur et æque,
Seque sua pars hæc utilitate probat.

Pars IIda
Historiæ
et
Allegoriæ
Projectæ et designatæ
à
Gottfr. Eichler,
Excusa
ab Authore
Joh. Georg. Hertel
Aug. Vind.

I. C. Wachsmuth sculp.

Hier folget auch der zweyte Theil,
und bietet sich zu kauffen feil

INSTRUCTION

Antigonus, taught by the Muses, studies not only the causes
of things, but also that which Nature teaches.

The personification of Instruction is a man of venerable and grave aspect dressed in long, fur-trimmed academic robes: a scholar who teaches the wise things which lead to virtue. The mirror he holds means that a man should observe his own actions so that they are in accord with those of his fellows. The motto above reads: "Look in [the mirror] and you will be wise"—in other words: Know thyself.

[Ripa, 1603, p. 18]

The *fatto*: In a princely library, wearing crown and turban, Antigonus II Gonatas of Macedon is seated at a table, deep in discussion with two robed sages. The one crowned with laurel is undoubtedly the great Stoic philosopher Zeno of Citium.

[Diogenes Laertius, VII]

INSTRUCTION

Antigonus for wise Zeno sought
To learn from him all that he taught.

INSTRUCTIO.

Tam rerum causas quam quid natura docebat,
Instructus Musis percipit Antigonus.

Inspice
cautus eris.

I. Wachsmuth, Sculps.

Die Unterweißung.
Antigonus aus Lehr Begier,
Zenonis Unterricht sucht für.

Eichler. del. Hertel. excud.

23

THE ACADEMY
*Wise Plato was the first to teach the Muses' arts,
and molded wild passions with gentle art.*

The personification of the Academy is a young, richly dressed woman wearing a crown and seated on a throne raised on a dais; several books lie near her feet. Her multicolored robe represents the various sciences and branches of learning studied in an academy. In one hand she holds a file, which refers to the motto on the throne: "It removes and polishes." In her other hand is a wreath of laurel, ivy, and myrtle, the plants of Apollo, Bacchus, and Venus, and pomegranates, the symbol of a group brought together out of common interests. She points back and upward to Parnassus. Behind the throne is seated a bearded ape, or baboon, the symbol of letters, the animal consecrated to Mercury (Thoth of the Egyptians), the inventor of arts and letters. The ape is also a symbol for the equinox, a measurement of time (the academician must measure his hours carefully, spending most of them in study), and for imitation (the beginning of learning, according to Aristotle).

[Ripa, 1764, I, p. 15; an invention of Giovanni Zaratino Castellini]

The *fatto:* In the background, the Grove of Academe is seen, with philosophers strolling among its trees. Above and behind is Mount Parnassus with winged Pegasus standing on top.

THE ACADEMY
*In ancient times Plato prepared the way
By which on earth the Muses might hold sway.*

ACADEMIA.

Plato ſagax primus Musarum tradidit artes,
atque animos molli conſtruit arte feros.

Die Hohe Schul.
Plato ſchon zu alten Zeiten,
thut der Muſen Sitz bereiten.

Eichler. del. Hertel. excud.

ARCHITECTURE
Semiramis constructed Babylon, the city of the Persians;
commanded in war; and was always strong.

The personification of Architecture is a woman in the prime of life, crowned and dressed in classically draped robes of shifting colors, who holds drafting and measuring instruments and points to a ground plan lying at her feet. Other tools for construction and designing lie about, and two putti are present, one writing on a tablet and the other measuring a Corinthian column.

The woman is mature, at the age in which great projects are best realized. Her dress is of changing colors to symbolize the variety of elements and considerations which the architect must bring into beautiful accord. Her bare arms show that architecture is also a manual art requiring a great expenditure of strength and energy.

The *fatto*: In the middle ground, in a setting of classical buildings, is a statue of Minerva, the warrior-goddess of wisdom. This is an allusion to the abilities of Semiramis, who, in armor and helmet, is seated on a throne in the background, gesturing imperiously with her scepter. Behind her can be seen the walls and towers of Babylon, still under construction.

[Justin, *Historiae*, I, 2, 7]

ARCHITECTURE
Semiramis on the field of Mars was skilled,
And also could a world wonder build.

ARCHITECTURA.

Persarum struxit Babylona Semiramis urbem,
Imperat in bellis ferrea semper erat.

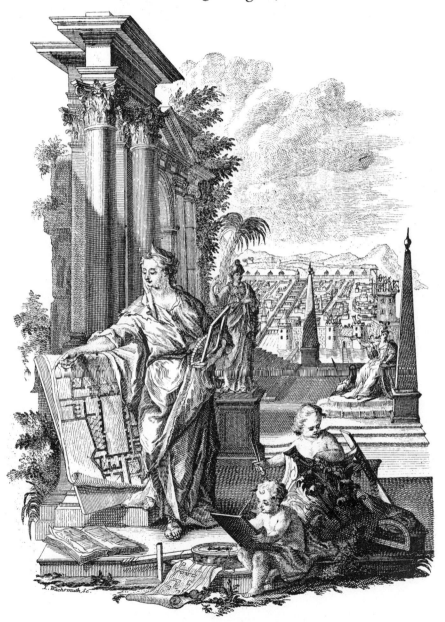

Die Bau Kunst.

Semiramis, liebt Martis Feldt,
ü: baut ein Wunderwerck der Welt.

Eichler. del. Hertel, excud.

25

PAIN

The gout-ridden man, worn by long and varied pain,
begs Hippocrates to relieve his terrible suffering.

The personification of Pain is an aged man whose garments and shoes are black (the color of pain, which is the absence of joy, well-being, and light). The smoke still rising from the extinguished candle he holds represents the pain which is the first symptom of death. The spent candle itself symbolizes man's spirit, which, like a flame, can gradually be put out by pain, grief, and adversity, still emitting a little heat for a while, but soon none at all.

[Ripa, 1603, p. 114; "based on a description of a lost work by the Greek painter Zeuxis"]

The *fatto:* A man with one foot bandaged, wearing a nightcap and holding a flywhisk, lies in a bed beside which stands a table with a handbell. He gestures in a dissatisfied or desperate manner at an Oriental, who bears a staff with a serpent winding around it (the symbol of Aesculapius, god of healing) and who is undoubtedly supposed to be Hippocrates the physician. He offers the sufferer a paper on which "Patience" is written.

PAIN

Podagricus, tormented by disease,
Calls Hippocrates to gain surcease.

Hippocratem Podager longo varioque dolore,
implorat fessus, quo mala dura levet.

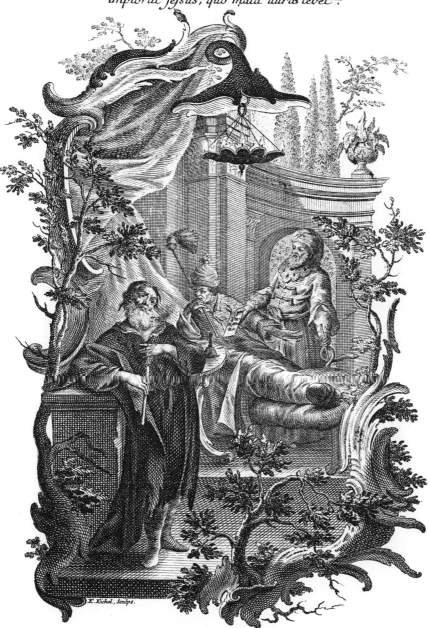

F. Eichel, Sculps.

Der Schmerzen.
Podagricus der plagte Mann,
Hypocratem, um Hülf ruft an.

Eichler. del. *Hertel, excud.*

26

PATRIOTISM
Camillus himself had sworn an inviolable oath;
breaking this oath, he was victorious over his enemies.

The personification of Patriotism is a vigorous, powerfully built man dressed in classical armor standing by a flaming and smoking brazier. He holds two wreaths, one of dog grass (*gramigna* in Italian) and the other of oak. He rests one foot on an axe, a spear, and a sword, and points to the fire. Behind him is a military trophy, and a precipice yawns at his feet.

The man is powerfully built because patriotism never weakens but actually grows stronger with age. He points to the brazier because, according to Homer in the *Odyssey*, the smoke of one's homeland is brighter than the fire of other countries. The two wreaths are awards for patriotic deeds: the one made of dog grass was given by the ancient Romans to those who

liberated their besieged homeland, the one made of oak leaves to those who saved a fellow citizen of Rome in battle. The precipice suggests that the true patriot fears nothing for the sake of the fatherland. The military trophy is a standard symbol of victory.

[Ripa, 1764, I, p. 110; based on the description by Giovanni Zaratino Castellini]

The *fatto*: Camillus, dictator of Rome, broke his treaty with the Gauls, prompting their king Brennus to attack the city (391–390 B.C.). The Romans emerged victorious, however, and Rome was saved.

[Livy, V, 19 *seq.*; Plutarch, *Life of Camillus*]

PATRIOTISM
For victory Camillus his oath did break;
He did it for his country's sake.

AMOR PATRIÆ.

Inviolabile votum voverat ipse Camillus,
hoc votum perimens victor ab hoste fuit.

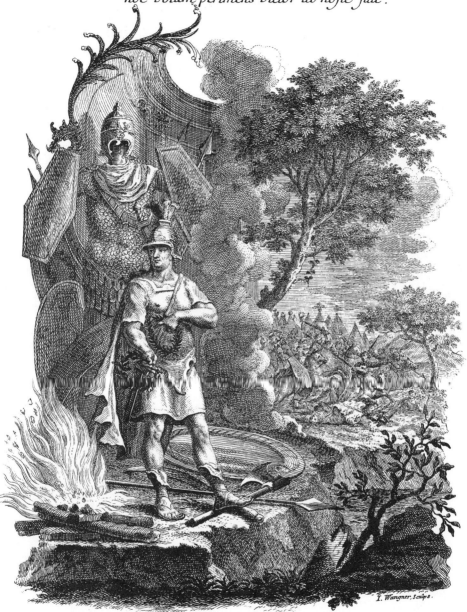

Die Liebe zum Vaterlandt.
Camillus hat der Götter Pflicht,
durch Sieg mit neuem Ruhm verricht.

Eichler. del:

Hertel excud:

I. Wangner, Sculps.

BITTERNESS
*When Sapor would ride upon his warhorse,
it was Valerian who served as his footstool.*

The personification of Bitterness is a woman dressed in black seated in an architectural setting. She holds in her lap and contemplates a round piece of honeycomb from which a wormwood plant (absinthe) grows. Ripa thus alludes to the idea that moments of great sweetness are made all the sweeter by a little bitterness. But it can also mean that the man who has not known bitterness or sorrow cannot appreciate true sweetness or joy. Ariosto said, too, that the man without experience of war cannot fully appreciate peace.
[Ripa, 1603, p. 12]

The *fatto:* In a castle yard, Sapor, King of the Persians (Shapur I of the Sassanian dynasty), mounts his horse. The Roman Emperor Valerian, his vanquished prisoner (battle of 260 A.D.), bends his back so that Sapor can mount more easily.
[Lactantius, *De morte persecutorum,* V, 4]

BITTERNESS
*Valerian, a slave, his back must bend
When Sapor will his mount ascend.*

AMARITUDO.

Rex Sapores dum martium equum calcaribus urget,
Scabellum plantæ Valerianus erit.

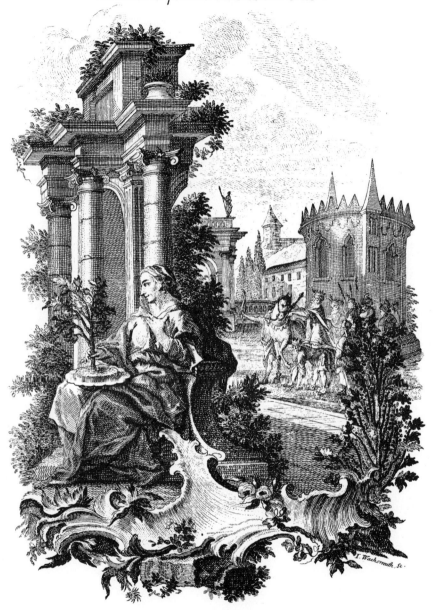

Die Bitterkeit.
Valerian als Sclav sich neigt,
wañ Sapores zu Pferde steigt.

Eichler. del

Hertel. excud!

28

JOY

*Unexpectedly death snatches Diagoras away; joy at the success
of his sons is the cause of the unhappy event.*

The personification of Joy is a pretty young girl in a white dress embroidered with red and yellow flowers and green leaves. A flower garland over one shoulder and another in her hair, she holds in one hand a crystal vessel filled with ruby-red wine, in the other a golden cup. She rests one foot on a cabbage, symbol of contentment with one's lot, and looks up at a female herm, around the shaft of which are tied borage flowers, a lyre, and a golden arrow. To the left of the girl, grapevines grow up the trunk of an elm tree, symbolizing the joys of wine; at the foot of the tree lies a cornucopia, symbol of plenty. In the foreground lie a thyrsus, a rose garland, and a songbook, all allusions to play and pleasure.

The girl's face wears a radiant expression; her flower-strewn garment is like pleasure-filled flowery meadows. The wine bottle and cup represent the joys of conviviality. The borage plant was often used in Italy as a symbol of great happiness.

[Ripa, 1603, pp. 11–12; Hertel has taken several alternative representations given and combined them into one]

The *fatto*: Diagoras of Rhodes falls back dead into the arms of his servants as his three sons, all crowned as victors in the Olympic games, appear before him, one carrying a racing baton. It was his great pride and joy at their victories that caused Diagoras to expire.

[Pindar, 7th Olympian Ode]

JOY

*His sons' three Olympic crowns did send
Happy Diagoras to his sad end.*

Damni principium puerorum gaudia læta,
Diagoram subito mors inopina rapit.

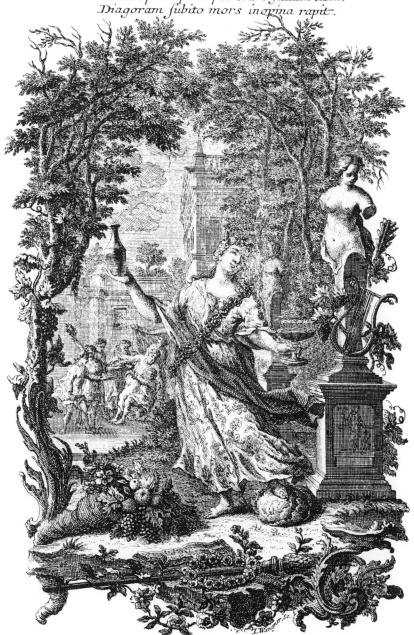

I. Wangner Sc.

Die Freude.
Diagoram der Söhne Freud,
beförderte zur Todtes Beut.

Eichler del. Hertel. excud.

FALSE SPLENDOR
The cowherd usurps the scepter and rules the kingdom.
He is headed for the abyss, all his glory ended.

The personification of False Splendor is a blindfolded young woman (she is blind to her own faults and to the light of God) with a proud expression on her face (the sin of pride). She wears a crown and is dressed in a richly decorated red robe, beneath which a torn and dirty ash-colored undergarment is visible (red is the color of pride and ambition, for the passionate young have much blood; the dirty ashen underclothes represent the ugly truth beneath a great deal of showy display). The woman holds a peacock, traditional symbol of pride, always showing off its plumage and believed to be too proud to associate with other birds. The large ball she stands on symbolizes the unstable and easily overturned foundation of unwarranted pride and ambition. Behind her is a throne on which is placed a crown.

[Ripa, 1764, I, p. 79]

The *fatto:* In a country scene with cows in the fields, a simply dressed man (a cowherd?) is carrying a staff and wearing a crown. One of the soldiers with him seems to be about to lay hands on him. The whole scene signifies pride coming before the fall. It is probably based on the play *Rusticus Imperator* by Jacobus Masenius (1606–1681).

FALSE SPLENDOR
If the cowherd takes the crown,
By other means he'll tumble down.

POMPA PAUPERTATIS.

Sceptifer usurpans dominatur regna bubulcus,
In præceps ruitur desinit omne decus.

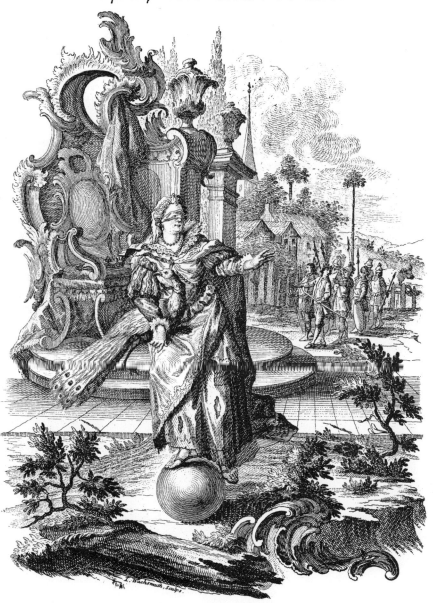

Armer Leut Pracht.
Nimt der Kuh-Hirt Cron und Tittel,
fürst man ihn durch andre Mittel.

Eichler, del.

Hertel, excud.

ATTERY

*Dionysius applies cruel and bloody tortures;
speaking treacherous words, he punishes the flatterer.*

The personification of Flattery is a young woman in drapery of shifting colors who stands playing a flute. At her feet are a stag and a dog. Behind her are a bust of a two-faced woman and a palm tree with a swarm of bees in a hollow in its trunk. Many bees are flying about.

The woman's pretty appearance and clothes represent the pleasing exterior of the flatterer which hides his real intention. The stag is supposed to be so attracted by the sound of the flute that he forgets himself and allows himself to be taken. The dog, on the other hand, is the flatterer grateful to whoever feeds him, without any distinction of persons. The bust with one fair and one ugly face symbolizes the hidden motives behind the flatterer's words. Bees are an old symbol for flattery: though they carry honey in their mouths, they sting with their tails.

[Ripa, 1603, pp. 6–7]

The *fatto*: Against a background of classical ruins Dionysius I, the Elder, crowned and robed tyrant of Syracuse, orders that the tongue of a courtier be pulled out or cut off.

[Diodorus Siculus, *Bibliotheca Historica*]

FLATTERY

*Dionysius ordered grim
Pains for those who flattered him.*

BLANDITIÆ.

Sanguine crudeli poenas Dionysius urget,
Plectit adulantem subdola verba loquens.

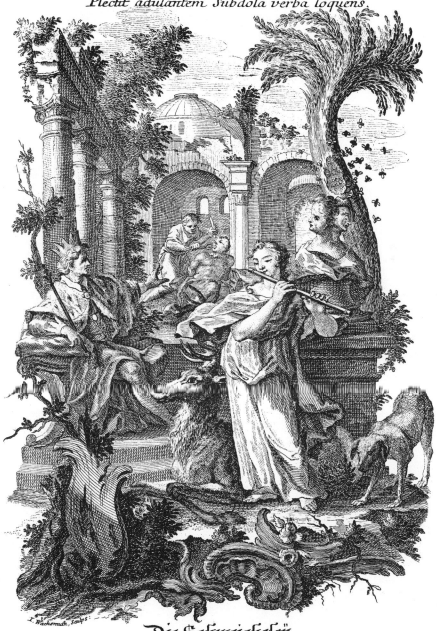

I. Wachsmuth, Sculps:

Die Schmeicheley.

Dionysius, nicht schonet,
Die Fuchsschwäntzer hart belohnet.

Eühler del. Hertel, excud.

AMBITION

*Manlius established an inviolable and just law; his son
transgressed it and atoned with his death as he deserved.*

The personification of Ambition is a young woman, winged, dressed in green, blindfolded, barefoot. She holds above her head a tray filled with crowns, tiaras, mitres, and scepters —symbols of worldly and churchly power. She confusedly tries to put the papal tiara (and all the others too, for that matter) on her head, though she has no right to it. Beside her is a lion with upraised head, watching her.

The woman is young (the green of her clothing also represents youth and freshness) because only the young are so eager for fame. She is barefoot because the ambitious are willing to suffer all sorts of discomforts and indignities to gain fame. She tries to put the crowns on her head because the ambitious may desire visible glory without really knowing if they are worthy of it. The great variety of crowns and the blindfold symbolize the indiscriminateness of ambition. The lion, king of beasts, is, of course, the symbol of worldly power.

[Ripa, 1603, pp. 12 ff.]

The *fatto*: Manlius Torquatus has his son beheaded, for although victorious, he had offended against the rules of battle established by his father.

[Livy, VIII, 7; Valerius Maximus, VI, 9]

AMBITION

*Titus Manlius, for his own law's sake,
Even punished his son, when he did it break.*

Sacratam legem componens Manlius æquam,
transit morte luit filius et merita.

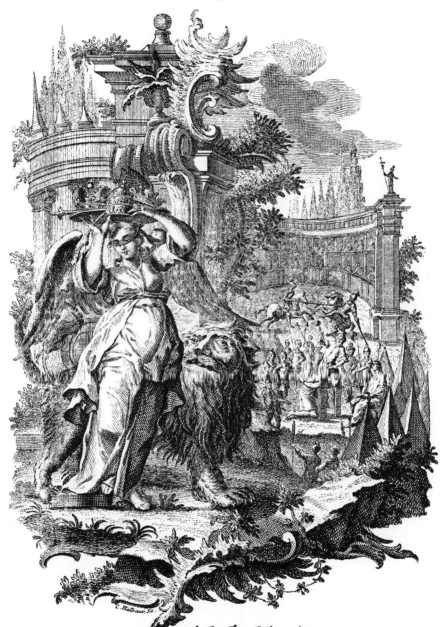

Die Ehrsucht Ehrgeiß
Manlius am Sohn gerochen
das Gebott, so er verkrochen.

Eichler. del. Hertel. exc.

CREDIT
He who departs this world in debt, abandoning everything,
dies a cheat, since he cannot pay.

The personification of Credit is a dignified-looking man of mature years, dressed in long, rich robes, with a golden chain around his neck. He is seated before an elaborate structure of rocaille forms. On his knee he holds a merchant's account book inscribed "Solutus omni foenere" (Free of all debt). He points to a griffin standing on a mound to the left. The rocaille structure behind him bears a cartouche inscribed "Mors peccati merces" (The wages of sin is death). A figure is seated on either side of the cartouche. On the left is Hope, with her anchor, weeping bitterly and pointing to the inscribed motto; on the right is a man in dark eighteenth-century garb, hung with little bags, who points to a large millstone behind him.

A man acquires credit only when he is established and mature; hence the age of the personifying figure and his long, rich robes "like those of the mature and dignified senators of ancient Rome." The golden chain he wears shows that credit is inspired by gold, upon which it is based. He is seated, for the man with good credit can rest with a tranquil mind. The inscription on the account book refers to the fact that the book has only a credit side in it and no debit side. The griffin is an ancient symbol for the custodian of treasures and valuable things. Its mound represents the mountains of gold and precious stones which, ac-cording to Pliny (*Natural History*, Book 7, chap. 2), are guarded by griffins. In the same way, the man who enjoys good credit should guard it as his most precious possession, and must ever be on the alert that none steal his wealth and thus also deprive him of his credit. The figure at the left of the cartouche represents disappointed hope, the result of loss of credit, through a man's own fault or that of his heirs; the figure at the right, perhaps an invention of Hertel, suggests that the man loaded with debts (the sacks of money) and without credit is like a single millstone without the other millstone needed for its proper functioning. This motif was taken from another Ripa allegory, that of Human Commerce, where it symbolizes the need for having the respect and trust of one's fellows if one is to be successful.

[Ripa, 1765, II, p. 93, "Credito di C. R."; Ripa, 1766, IV, p. 208, "Commercio nella Vita Humana"]

The *fatto*: An open coffin is seen beside a freshly dug grave. Apparently a debtor is being buried, for the weeping women and children surrounding the coffin all hold slips of paper covered with figures, presumably sums of money—the amounts of the man's debts and bills outstanding.

CREDIT
What still I owed when hence I went
Is graven on my monument.

BONA FIDES.

Exüt e mundo defraudans omne relinquit,
In debitis moritur solvere nulla potest.

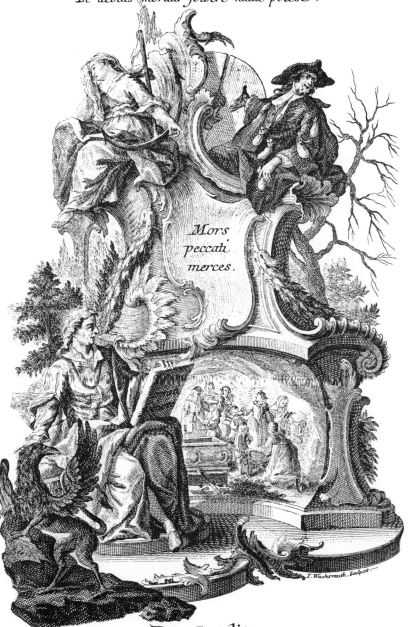

Mors
peccati
merces.

I. Wachsmuth, Sculpsit.

Der Credit.

Was ich schuldig bin verbliben,
steht am Grabmahl angeschriben.

Eichler del.　　　　　　　　　　　　　　　　Hertel, excud.

ILL-GOTTEN GAINS
*The great amount of usury so disturbed the just Publicola
that he crushed it and wiped out this crime.*

The personification of Ill-gotten Gains is a bearded man who looks with displeasure at his rich oriental robe, which catches on a thorn bush and is torn as he walks along. He carries in his arms a vomiting owl. The color of his dress is, as Ripa puts it, that "of leaves when they are about to fall"; thus things improperly gained can only lead to the same kind of luck enjoyed by autumn leaves—namely bad luck, for they die and fall to the ground. The unexpected damage caused by the thorn bush represents the trouble that can arise from ill-gotten gains when least expected. The vomiting owl, a symbol taken from Alciatus, is losing not only his own food, but also that of others which he has stolen from them—an obvious reference to usurers and those who gain through exploiting others.

[Ripa, 1603, p. 4]

The *fatto*: Publicola (Publius Valerius, Roman consul, died 503 B.C.) stands before a group of Roman soldiers who bear standards, and issues his commands. He had been so incensed at the corruption in Rome that he refused to accept any public office until he was given the mandate to wipe out all abuses.

[Plutarch, *Life of Publicola*]

ILL-GOTTEN GAINS
*Vexed Publicola doth high office refuse:
He found too much usury and its abuse.*

LUCRUM INJUSTUM.

Publicolam justum anxerat ingens tempore foenus
Usuras pellit destruit omne scelus.

Unrechtmäßiger Gewiñ.

Publicola viel Wucher fund,
schlägt aus Verdruß die Stell in Wind.

Eichler. del.

Hertel. excud.

34

ABUNDANCE
The patrimony of great Croesus finally fails;
what Solon foretold was true.

The personification of Abundance is a fair young woman dressed in a green gown embroidered with gold, the color of the fields and of ripening grain, and with a wreath of flowers, the harbingers of abundance and delight, in her hair. She holds a horn of plenty—the cornucopia filled with fruit—at her right side, and in her left arm she bears a sheaf of all sorts of grain. Many fallen ears of grain lie at her feet, and in the foreground are bags of money and containers of gold and jewels.

[Ripa, 1603, p. 1]

The *fatto:* Rich King Croesus of Lydia in Asia Minor has just shown the wise Athenian Solon his great treasure. Solon, unimpressed, warns him that it cannot save him from a bad end, should it come to that. He points to a funeral pyre in the background, where, indeed, condemned by the Persian conqueror Cyrus, Croesus did meet his end.

[Herodotus, I, 29 ff., 86; Plutarch, *Life of Solon*]

ABUNDANCE
Croesus' wealth may end, alas!
And Solon's prediction come to pass.

ABUNDANTIA.

Deficiunt tandem magni patrimonia Croesi,
Verum, quod Solon vaticinatur, erat.

Der Überfluß.

Croesi Reichthum kan sich enden
Und waß Solon sagt, einfinden.

Eichler, del.

Hertel, excud.

AUDACITY
See what ardor and love of fatherland are worth and to what
they lead: great Curtius throws himself into the chasm.

The personification of Audacity is a woman with a determined expression on her face, dressed in red and green, strong colors. She grasps at a column, symbol of stability. Pulling at it, she attempts to throw it down, although it supports a whole building.
[Ripa, 1603, p. 33]

The *fatto:* In this famous example of Roman virtue, Marcus Curtius, astride his horse, leaps into the fiery chasm which has opened in the Roman marketplace, and by his sacrifice saves his city.
[Livy, VII, 6]

AUDACITY
Into the chasm brave Curtius leaped.
Thus saving Rome, his death he reaped.

Adspice quid valeant, quo tendant ardor amorque,
Curtius in terram se mittit magnus apertam.

Die Kühnheit.

Curtius stürzt sich in den Schlund
geht aus verwegnem Muth zu Grund.

Eichler del. I. Wachsmuth, Sculp. Hertel, excud.

PERSPICACITY
In vain his neighbor steals the blind man's hidden gains,
for he recovers the lost things with his skill.

The allegorical figure representing Perspicacity is Pallas Athena, the goddess of wisdom. At her feet is the Sphinx. According to Piero Valeriano, the Sphinx is a symbol for acuteness of mind, since nothing in the world remains hidden from human (or, in her case, superhuman) ingenuity. Yet Alciatus, in Emblem 188 of his *Emblemata*, considers the Sphinx the symbol of Ignorance conquered by acuteness of mind, since Oedipus guessed her riddle. Her form, made up of three different creatures, represents the three main components of ignorance: her feathered wings stand for frivolity or light-mindedness, her beautiful woman's face and breasts for the lovely and voluptuous appear-

ance which misleads the foolish (the Sphinx was very dangerous), and the lion's feet and body for pride (which also leads to foolishness), the lion being the proudest of beasts.
[Ripa, I, 1764, p. 27]

The *fatto:* A man, presumably the blind man of the story, is seen burying a vessel full of gold, while being watched from behind a door by another man, apparently the neighbor who will steal it from him. But by means of his wit and his acute hearing, developed to compensate for his lack of sight, the blind man will trace his stolen property and simply take it back again.

PERSPICACITY
Robbed of his gold, by his sharp wit
The blind man doth recover it.

PERSPICACITAS.

Dona rapit cœco vicinus condita frustra,
perdita nam quævis arte sua recipit.

Die Scharfsinnigkeit.
Wird der Blinde schon bestohlen,
kan durch List ers wider höhlen.

Eichler del.

Hertel, excud:

CUNNING

Dido, full of trickery, when founding the Tyrian city,
cleverly measures the land with the skin of an ox.

The personification of Cunning is a woman wearing a wolfskin over one shoulder (according to Aesop, the wolf is the most astute of beasts). She holds a monkey in her arms and points to him (according to Aristotle, the ape or monkey is the most astute animal). The woman is distinguished by a ruddy complexion, for this, also according to Aristotle, reflects cunning or astuteness. The sanguine nature of such people makes them the ones who "set the world on fire," who are always in motion and who, like red fire, consume all they touch.

[Ripa, 1603, p. 29]

The *fatto*: Queen Dido of Tyre, wishing to build her new city on the coast of Africa, is given permission by the Nubian king to do so but only on as much land as can be covered by the hide of an ox. Clever Dido has the oxhide cut into thin strips, which are then strung together, and her horsemen race across a great stretch of land upon which she then builds Carthage.

[Virgil, *Aeneid*, I, 364–68]

CUNNING

To build Carthage, Dido used her woman's wile
And with an oxhide marked off mile on mile.

Plena doli Dido Tyriam cum condidit urbem,
metitur tellus, Callida, pelle bovis.

Die Arglistigkeit.
Dido durch List der Ochßenhaut,
Daß Land außmeßt, Carthago baut.

ADOPTION
*Trajan the clement invokes the great gods and adopts Hadrian,
giving him the title of great king.*

The personification of Adoption is a well-dressed elderly female who embraces a small boy in ragged clothing. In a fold of her skirt is a bird, the coot or water hen (*Fulica*), which, according to Pliny and Aristotle, receives maternally chickens frightened by an eagle—in other words, adopts strange birds in need. By thus imitating nature, man has devised a legal way to console those without children. The allegorical figure is that of a matron, for, as in nature, only the mature person can adopt a younger one. On a stone slab on the right is the inscription "Imp. Caes. Trajan. P. F. Aug." [Ripa, 1764, I, p. 31]

The *fatto:* While this is not exactly the same sort of adoption as the allegory is supposed to represent, Hertel could not have picked a grander historical application of it than the example of Emperor Trajan (reigned 98–117 A.D), who, following an established custom in Rome, adopted his distant relative, Hadrian (reigned 117–138 A.D.), and made him his successor to the throne.

ADOPTION
*Hadrian for his worth has won
The place of Trajan's heir and son.*

ADOPTIO.

Numina magna vocat clemens Trajanus adoptans,
et magna titulo regis donans Hadrianum

I. Wachsmuth, Sc.

Aufnehmung an Kindesstatt.
Trajanus Sohnes Stell und Cron,
dem Hadriano gibt zu Lohn.

Eichler. del. Hertel. excud.

39

IDLENESS
The vintner, when his turn comes to join in the task,
calls each man idle, even if he is working.

The personification of Idleness is an elderly woman dressed in ragged clothing, with her head wrapped in a black cloth, who sits in a stupor. She holds a large fish in one hand. Above her in a cartouche is the inscription "Torpet iners" (the idle person is inactive). The woman is old, for in senility strength diminishes. Her clothing is poor, for idleness produces poverty. The black cloth on her head signifies that the mind of the idle is filled with torpor, which makes man stupid. She is seated, since, as the motto indicates, lazy people are slothful and inert. Fish, it was believed, when touched by a net or by hands become so stupefied that they cannot escape. Idleness affects the idle in the same way; they cannot do anything.
[Ripa, 1603, p. 3]

The *fatto:* In a vineyard where many people are at work, a man of authority, the steward, calls on two idle men to join the others at work. This is a reference to the parable of the vintner (Matthew 20: 1 ff.).

IDLENESS
Out to the vineyard the foreman doth repair
To urge to work those idly lazing there.

Si vinitori rediit labor actus in orbem,
nomine quemque vocat tardum, quin ipse laborat.

Torpet mers.

Faulheit, Müßigang.
Der Schafner in den Weinberg geht,
Zur Arbeit ruft wer müßig steht.

Eichler del. Hertel excud:

40

SPEED

Behold, swift Polymnestor here challenges the winds;
by his running he gains praise and hares.

The personification of Speed is a slender nude female covered with only scant draperies so that nothing can slow her down. The wings on her shoulders help to increase her velocity, but are not large enough to permit flying. She balances with one foot on a rock, in the act of springing to another.

[Ripa, 1603, p. 8, "Agilità"]

The *fatto*: In a forest glade runs the goatherd Polymnestor of Milesia, reaching out before him to catch a large hare which is also running. When his swiftness became known, he was entered in the forty-sixth Olympic games by the owner of the herd, and won a victor's crown.

[Solinus, *Collectanea rerum mirabilium*, I, 97]

SPEED

Polymnestor fame has won
By catching hares while on the run.

Ecce Polymnestor velox hic provocat auras
Laudem currendo percipit et lepores.

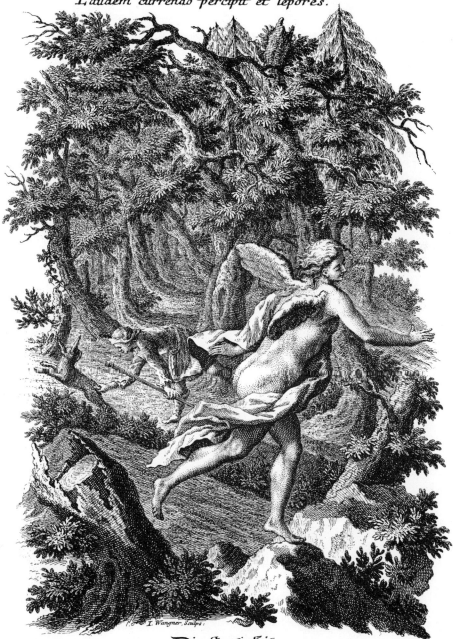

I. Wangner, Sculps.

Die Hurtigkeit.
Polymnestor Ruhm erlangte,
weil er laufend Hasen fangte.

Eichler, del Hertel, excud.

When the wind rises, it will fill the sails with breezes;
once the vessels leave the port, it will direct their course.

Part III

Histories and Allegories

designed and drawn

by Gottfried Eichler the Younger;

published by the author,

Johann Georg Hertel,

Augsburg

On a handsome quay in a seaport, elegant loungers and tourists, along with porters and seamen, look at the sights or watch several sailing ships move out to sea. There is a lighthouse in the distance, while in the foreground a statue of Mercury, god of commerce, extends the caduceus, seemingly giving his blessing to the maritime enterprises.

Also by sea, to near and far,
Wares often expedited are.

Cum dabit aura viam, præbebit carbasa ventis,
Portubus exierant, vela parabit iter.

Pars III.
Historiæ et Allegoriæ
figuratæ et designatæ
à Gottfr. Eichler, jun.
Pensæ ab Authore,
Joh. Georgio Hertel,
Aug. Vind.

I. Wachsmuth, Sc

So wird in nah und ferne Land
Zu Wasser auch die Waar versant.

42

INCREASING AGE
*Just as the palm tree raises its weighted branches toward the sky,
so should you, O Youth, seek virtue as your recompense.*

The personification of Increasing Age is a young woman in a multicolored dress, with flowers in her hair and at her wrists, who points to a palm tree weighted down with a large millstone on its leaves. In the background the rising sun can be seen.

This is undoubtedly poetic license on Hertel's part, for the young woman is actually Ripa's allegory of Youth, the third of the seven ages of man (there are seven planets and thus seven ages of man dominated by them). She is present at the rising of the sun, the planet which, according to Ptolemy, had the fourth position in the universe; being the most perfect and most important of the planets, the sun dominated the fourth age of man, also the most perfect, which produced lovers of honesty and virtue. The fourth age of man is Early Matur-

ity, and not Youth, so that Hertel shows the sun here as only rising and not yet dominant.
[Ripa, 1765, II, p. 376, "Età in generale"]

The *fatto:* The palm tree, though off to one side, is in this case actually essential to the allegory, and is often the emblem for it. The young woman points to the palm tree as an example to be followed, since it is a symbol for victory over great odds; it was said that no matter how great a weight was placed atop its leaves, it would not bend or break under the load, but would continue to grow in spite of it. The palm tree can also be the symbol of temperance in this context, for just as it does not give in to the weight on its top, so the temperate person does not give in to passions, however strong they may be.

INCREASING AGE
*Though burdened, the palm tree yet doth grow apace;
Thus Youth should to Virtue always give a place.*

CRESCENS ÆTAS.

Palmarum gravidos ut tendit ad æthera ramos,
Virtutem juvenes quærite pro pretio.

Das wachsende Alter.
Durch Last erwächst der Palmen Baum,
So Jugend laß der Tugend Raum

Eichler, del.

Hertel, excud.

43

LOVE OF GOD

Simeon praises just and eternal God with his songs;
no hour of the day is without his praises.

The personification of Love of God is a handsome mature man, dressed in noble classical robes, who looks up adoringly to the blazing sun, which represents Heaven. He points upward with one hand, and to his bared breast (his heart) with the other.

[Ripa, 1603, p. 18]

The *fatto storico sagro* (allusion to sacred history) is the presentation of Jesus to Simeon in the Temple.

[Luke 2: 22–38.]

LOVE OF GOD

Simeon, his Lord to praise,
His voice in thanks to Him doth raise.

AMOR IN DEUM.

Æternum Simeon Numen carminibus æquum,
Laudat, nulla caret laudibus hora suis.

C. Halbaut, Sculps:

Die Liebe zu Gott.
Simeon den Herrn Preißet,
Ihme Lob, und Danck erweißet.

Eichler, del:

Hertel excud:

44

LOVE OF FELLOW MAN
The wounded man's plight touches not the heart of the hard Levite;
it is the Samaritan who brings aid to the fallen.

The personification of Love of Fellow Man is a richly dressed man bending and embracing a ragged beggar, who, with begging bowl and staff, is seated on the ground. On the right is the base of a column, probably put there by Eichler to substitute for the "pelican in its piety," which, following Ripa's indications, is also supposed to be present, but which, to the Protestant Hertel, was probably too well-known a symbol for the Roman Church.
[Ripa, 1603, p. 18]

The *fatto:* The allusion is the obvious one to the story of the Good Samaritan.
[Luke 10: 30 ff.]

LOVE OF FELLOW MAN
Should Priest and Levite just pass on,
Be thou the Good Samaritan.

AMOR IN PROXIMUM.

Saucius immitis non tangit corda Levitæ,
auxilium lapso fert Samarita suum.

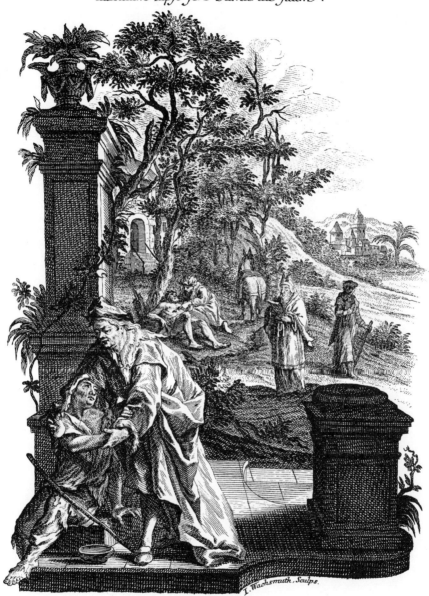

I. Wachsmuth. Sculps.

Die Liebe deß Nechsten.

Geht Priester und Levit vorbey,
drum du der Samariter sey.

Eichler. del.

Hertel. excud

ENFORCED LOVE
Restless Potiphar (sic) *blazes with the heat of love;*
flee, O chaste Joseph, leaving behind your mantle.

Before an elaborate rococo archway, Cupid sits blindfolded on a broken column, holding an hourglass in one hand and a small bird, a titmouse, in the other. An inverted burning torch leans beside him, and his bow and arrows lie underfoot.

Here Hertel has combined two different images for two different kinds of Love, that which is held in control ("Amore domato") and that which is impure ("Amore impudico") to try to make an image for a third kind, Enforced Love ("Amore coatto"). The hourglass (time is the best tamer of love) and the titmouse, a small and thin creature usually so weak from hunger that it cannot make its own nest, and itself a symbol of poverty (hunger overcomes

love, too), are used to represent the first kind of love. Cupid's blindfold, however, refers to impure love's blindness to reason, and the torch to blazing lust. And yet this allegory hardly seems to match the eruption of passion in the *fatto* or to suggest the reason for its rejection by Joseph.

[Ripa, 1764, I, p. 106, "Amore Domato"; I. p. 121, "Amore Impudico"]

The *fatto:* Potiphar's wife, reclining semi-nude on an elaborate canopied bed, makes improper advances to young Joseph, who, in fleeing her, leaves his mantle in her hand.

[Genesis 39: 1 ff.]

ENFORCED LOVE
Potiphar's wife with impure lust doth burn;
At cost of coat, chaste Joseph doth her spurn.

AMOR COACTUS.

Impatiens calido Potyphar scintillat amore,
Pallia destituens aufuge caste Ioseph.

E. Wachsmuth, Sc.

Die gezwungne Liebe.
Potiphar will Keuschheit spahren,
Ioseph läßt den Mantel fahren.

Eichler, del.

Hertel, excud;

ADULTERY
David, enamored, seduces Bathsheba;
God found a punishment to fit the crime.

The allegorical figure personifying Adultery is a rather fat young man, very richly dressed in clothing reminiscent of the sixteenth century, seated upon cushions and holding a broken ring in one hand and a snake entwined with an eel in the other. At his feet, next to an elaborately decorated ewer, is a wine bottle; grapes hang above his head.

He is young, for youth is the age most interested in matters sexual, and so most tempted to commit adultery. He is richly dressed, for such pleasures are reserved for those who can afford a great deal of leisure. He is fat because of his sins of sloth (indicated by his being seated), which generates libidinous thoughts, and greed for food, which also leads to lewd thinking.

Just as adultery is against the law, so is the copulation of a snake and an eel against nature, for they are of different species; entwined, they are a very old symbol for adultery, as is the broken marriage ring. Since passions are aroused and unleashed by drinking, the wine and grapes are also a clear symbol of license.
[Ripa, 1764, I, p. 42.]

The *fatto*: Bathsheba, wife of Uriah the Hittite, is seated, seminude, before her bath. King David watches her from the roof of his adjoining palace. His passion aroused, he coveted her although she was another man's wife.
[II Samuel 11: 2 ff.]

ADULTERY
God King David punishéd,
For Bathsheba he took to bed.

Bathsebam violat David correptus amore,
Par sceleri a Domino poena reperta fuit.

Der Ehebruch.
David muſte Gott beſtraffen
weil er Bathſebam beſchloſſen.

Eichler del. Hertel, excud.

The content:

RETRIBUTION
Adoni-bezek pays for his crime with well-earned death.
Thus does one suffer for past misdeeds;

The personification of Retribution is a tall, bearded, roughly dressed man who is cutting down a tree with an axe. In the tree is a grinning bear. Behind the man stands a lion with an outraged expression on its face. On the floor of the cave in the background are lying two dead lion cubs.

Obviously related to Plate 60, the allegory of Punishment, this one is basically composed of the same elements (man with axe, lion and bear), but the plot and action seem to be different. In the present allegory the man, by chopping down the tree into which the bear has fled for safety, is apparently assisting the lion in wreaking its vengeance on the bear for having murdered the lion's cubs. Indeed, the injured lion is the symbol used by Ripa for Vengeance, since "according to the Egyptians" the lion is supposed never to forget an injury.

[Ripa, 1767, V, p. 321, "Vendetta"; Ripa, 1764, I, p. 330, "Castigo"]

The *fatto:* In a military camp, soldiers are seen cutting off the thumbs and big toes of Adoni-bezek, king of Bezek in Canaan. He thus suffers the same punishment he had often inflicted on others.

[Judges 1: 5–7]

RETRIBUTION
Adoni-bezek suffers in the end
The same fate he did others send.

Ergo exercentur poenis veterumque malorum,
Crimen Adoni Beseck morte luit merita.

I. Wangner. Sc.

Die Wiedervergeltung.
Adoni Besek, wird zuletzt,
mit gleicher Straffe hingesetzt.

Eichler. del. Hertel. excud.

CHASTITY
*Let me be poor, provided I be not unmindful of modesty
and the tenor of my life be without blemish.*

The personification of Chastity is a young woman dressed in white, with a wreath and a diadem on her head, who leans on a parapet upon which lies a sieve. In one hand she holds a richly decorated cup full of rings and in the other a scepter and two sticks of cinnamon. She stands on a pile of coins spilling from an over-turned vessel; she has one foot on a serpent. Nearby stand another vessel full of jewels, and an ermine. On the left a putto holds a dove.

The prototype for the figure of Chastity is Tuccia, or Tuscia, a Vestal Virgin of Rome, who, accused of breaking her vow of chastity, carried water in a sieve as proof of her innocence (Pliny, *Natural History*, Book 28, chap. 12). The white of her robe represents the purity of the chaste. The parapet she leans on is the symbol of steadfastness. The cup of rings indicates the chastity of the matrimonial state, while the scepter stands for the chaste person's self-control and dominion over himself. Cinnamon, a most precious and delicious spice which grows among rocks and thorns, is like chastity, which develops out of self-mortification and is a

sweet and desirable possession. The coins trodden underfoot represent the avarice one must overcome to preserve chastity, while the serpent represents concupiscence, which must also be put down. Lastly, the dove and the ermine are also symbols of the chaste; the dove by its own example shows that one should always remain true to one's legal mate, while the white ermine, which takes such great care that its coat remain immaculate, demonstrates the necessity to keep one's honor and reputation unsullied and as pure as the snow. (On the other hand, Ripa, on page 289 of his edition of 1603, points out that the ermine, with its whiteness, also represents the man who seems pure, but is totally lascivious underneath, as is the beast.)

[Ripa, 1603, pp. 66–67]

The *fatto:* The application of the concept is the story of Susanna and the Elders, as related in the book of the Old Testament Apocrypha, *The History of Susanna* (an addition to the book of *Daniel*).

CHASTITY
*Susanna's good repute did suffer nought,
Though false witnesses to besmirch her sought.*

CASTITAS.

Sim sane pauper dum non oblita pudoris,
Dumque tenor vitæ sit sine labe meæ.

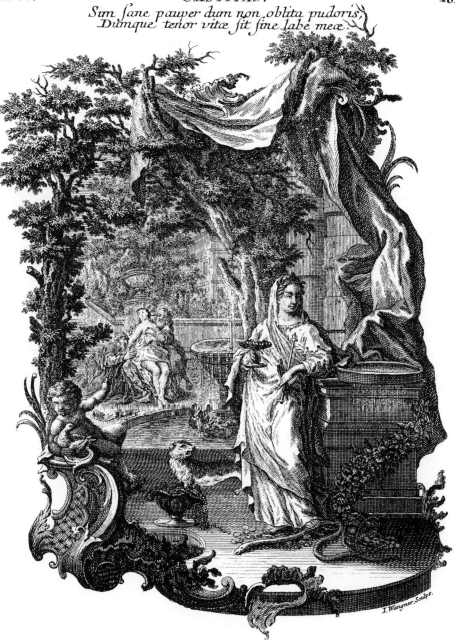

Die Keuschheit.
Susanna guten Ruhms behält,
daß falsche Zeugnis Sie nicht fält.

Eichler. del.

I. Wangner. Sculp.

Bodel. exud.

THE DISTINCTION BETWEEN GOOD AND EVIL
The fertility of the rich fields gives fruit in abundance;
the bad seeds sown are without fruit.

The allegorical figure in this case is a heavily draped mature woman who stands holding a sieve in one hand and a rake in the other. As simple as she looks, she represents very complicated ideas. She is of mature age, for only when one has passed youth is one really capable of making the distinction between good and evil. She is heavily dressed because older people tend to be so. The sieve is an obvious symbol for separating mixed things from one another. Here it is the harvester's sieve, with which he separates the useless seeds from the good grain. Valerius Maximus uses the sieve as the symbol of the man of perfect wisdom. The rake has the same meaning; it is used by farmers to free the fields of weeds and undesirable plants, leaving the good. It is also used during the harvest to gather the good grain into heaps, a harvest of the good.
[Ripa, 1765, II, p. 257]

The *fatto*: A farmer is seen sleeping in a shed among his fields, while the Devil is busy sowing. This is the parable of the sleeping farmer and the sowing "enemy."
[Matthew 13: 24–30]

THE DISTINCTION BETWEEN GOOD AND EVIL
Good fruits come only from good seeds;
The Devil hopes for crops of weeds.

DISTINCTIO BONI ET MALI.

Divitis uber agri fruges cum foenore reddit,
Frugibus et carent semina sparsa mala.

Unterscheidung deß Guten vom bößen.
Auf gute Saat folgt gleiche Frucht,
der Feind des Unkrauts Wachsthum sucht.

L. Wachsmuth, Sculps.

Eichler, del.

Hertel. excud:

TRUTH

Verily am I the honor of virtue, having no knowledge of deceit;
I am alone the true path to eternal life.

The personification of Truth is a nude female figure, modestly covered with a bit of drapery, who holds a sun in one hand, and an open book and a palm leaf in the other. She rests one foot on a globe of the world. Seated at her feet is a putto holding a mirror and a pair of scales. On the left stands a palm tree with a grapevine growing up it.

Truth's nudity indicates that truth is a natural state and, like a nude person, exists without need for any artificial embellishment. The sun, the source of all light, is also a symbol of truth, which is the friend of light; light chases away the shadows, as truth does in the mind. One arrives at truth by the study of science, of facts, hence Truth holds a book. The palm leaf and the palm tree on the left refer to the example of the tree's resistance to obstacles (compare Plate 42), which is also a characteristic of truth. Truth's foot is on the globe for she dominates it and is, indeed, superior to anything on earth. Truth is to be seen in a mirror, if we honestly see what is reflected. Truth is like a set of balancing scales, made up equally of things as they are and as they are perceived.

[Ripa, 1603, pp. 499–502]

The *fatto*: Christ is seen preaching to His disciples before a hillside topped with a round temple. He is undoubtedly saying, "I am the Way, the Truth, the Life" (John 14: 6).

TRUTH

The Way, the Truth, the Life, am I
Which leads to God for those who try.

VERITAS.

Verum, Sum virtutis honos et nescia fraudis,
Æternæ vitæ semita vera egomet.

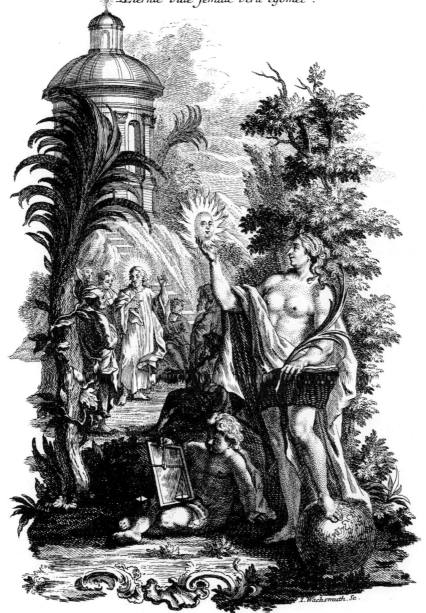

I. Wachsmuth. Sc.

Die Wahrheit.

Ich der Weeg, die Wahrheit, leben,
kan das liecht zum Vater geben.

Eichler. del:

Hertel. exc:

51

VIGILANCE
A cry rises to Heaven, a cry sounds everywhere:
"Watch now, O men, and see, the Bridegroom is at hand."

The personification of Vigilance is an elderly woman in classical draperies, who stands holding a large book in one hand and an oil lamp and a rod in the other. Next to her stands a large crane, holding a stone in one foot.

Her book signifies that vigilance of the mind and spirit is gained through study, in preparation. One needs to be most vigilant at night, hence the oil lamp. With a rod, one wakes the sleeping body, arousing it to vigilance. Both Pliny (*Natural History*, Book 10, chap. 23) and Horapollo (*Hieroglyphica*, II, 94) use the crane as a symbol of watchfulness, for the crane is supposed to sleep with a stone in its claws to use as a weapon if surprised. Even more telling symbolically is the idea that the crane, when

acting as a sentinel guarding a group of its fellows, holds a stone so that, if it falls out of his grasp because he has fallen asleep, the others will be alerted by the noise of its fall and can be on their guard. As long as it does not fall, they know they are protected.
[Ripa, 1603, p. 502]

The *fatto:* In a richly decorated room Christ meets the Wise Virgins, while outside the closed door, in the darkness, the Foolish Virgins seek entrance. On top of the building in which this is taking place stands a statue of Faith, with a flaming heart in her hand.
[Matthew 25: 1–13]

VIGILANCE
At midnight there arose a cry:
"Hark, for the Bridegroom doth come nigh."

Tollitur in coelum clamor, furit undique clamor,
Nunc vigilate viri, cernite sponsus adest.

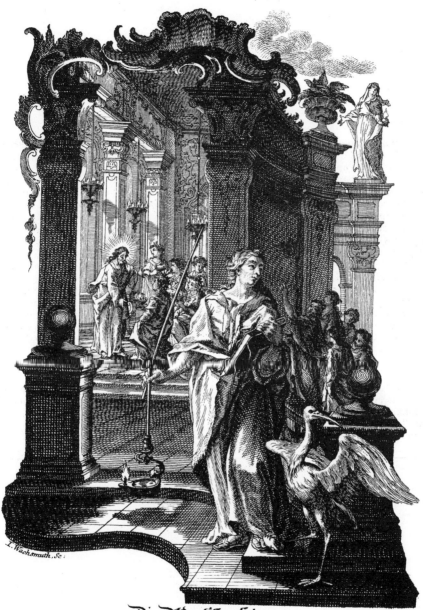

Die Wachsamkeit.
Zu Mitternacht war ein Geschrey
es kompt der Bräutigam herbey.

I. Wachsmuth. Sc.

Eichler. del.

Hertel, excud.

FRIENDSHIP
The brothers Jacob and Esau arm for battle,
but finally the warriors make peace.

The personification of Friendship is a fair young blonde woman, simply draped in the white color of truth, upon which friendship is based. She points to her bare bosom, the seat of the heart. The wreath she wears is of myrtle, which is, like true friendship, ever green, and of pomegranate flowers, which are the products of concord and internal union (of which the pomegranate is the symbol). She is barefoot, for friendship knows no inconvenience too great for it, and, being unshod, she is swift in the service of friendship. She trods on a skull, for friendship jeers at death. At her feet is a dog, the old symbol of fidelity, upon which friendship is based. She stands next to an elm tree up which a grapevine grows; this indicates that true friendship is based on mutual support and interdependence. (The elm tree is sometimes shown as being dead, and the image would then mean that one true friend does not abandon another in distress.) Her robe has inscribed on its hem "Mors et Vita" (Death and Life). On a ribbon hanging from her shoulder is the inscription "longe et prope" (far and near). She stands before a large cartouche inscribed "Hyems, Aestas" (Winter, Summer). All the inscriptions refer to the duration and extent of true friendship. On the cartouche is a swallows' nest, where the parents are caring for their young—a form of friendship. (Swallows can also have a negative meaning in this context, for they come in the spring but leave in the winter, and are thus "fair-weather friends.") In the foreground a putto holds and points to a relief sculpture of the three Graces, who represent the three aspects or kinds of friendship according to the ancients: giving, receiving, and reciprocating. On the far right a blind man is seen carrying a cripple, an example of the benefits to be had from friendship, for the one lends his sight and the other his legs to the problem of purposeful locomotion (actually an emblem taken from Alciatus).

[Ripa, 1603, pp. 15–17]

The *fatto*: Jacob and Esau embrace and forget their fraternal rivalry while their followers look on.

[Genesis 33]

FRIENDSHIP
Esau and Jacob end their enmity
And in fraternal love united be.

AMICITIA.

Iacob et Esavus se armant in prælia fratres
Sed tandem ponunt foedera belligeri.

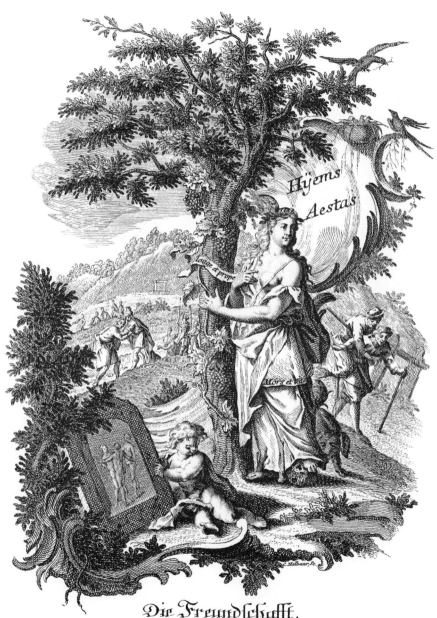

Die Freundschafft.
Iacob, Esau, waren Feinde,
Küßen Herzen Sie vereinte.

Eichler, del.

Hertel, excud.

ASSISTANCE
You, Rahab, were once in Jericho the only hope of survival;
you were for me a refuge, you were for me a haven.

The personification of Assistance is a man of mature age, richly dressed in white and purple, the colors of purity and charity. Around his neck is a chain from which hangs a heart; on his head is an olive wreath. His right hand is extended; in his left he holds a pole around which a grapevine is entwined. A stork stands next to him.

The man is no longer young, for only maturity is sensible enough to want to help others, youth being too intent on personal gain and pleasure, and old age on satisfying its greed. The olive wreath he wears is the symbol of the good and virtuous man. The heart which hangs from his chain is an emblem of good counsel, which is a form of aid to others. His outstretched hand implies the offer of aid to fellow men. The pole and vine are a symbol of conjugal assistance; they represent the husband and wife, who exist and have meaning only through their interdependence and mutual aid. The stork, usually a symbol of filial piety, for it was supposed to care for its parents with great tenderness, is also, through this action, a symbol of aid and care of others, for aid cannot exist without piety. It is also a symbol of silence, which, under certain circumstances, can be very helpful (Pliny, *Natural History*, Book 10, chap. 62).

[Ripa, 1764, I, p. 65]

The *fatto:* Through an archway the walls of Jericho are seen. Rahab lets Joshua's spies down the wall with a rope. For her aid, the Israelites spared her and hers when the city was taken.

[Joshua 2: 1–21]

ASSISTANCE
Rahab took Joshua's spies and hid them well,
And so was spared when Jericho fell.

Tu Rahab in Iericho vitæ spes unica quondam,
Tu mihi perfugium tu mihi portus eras.

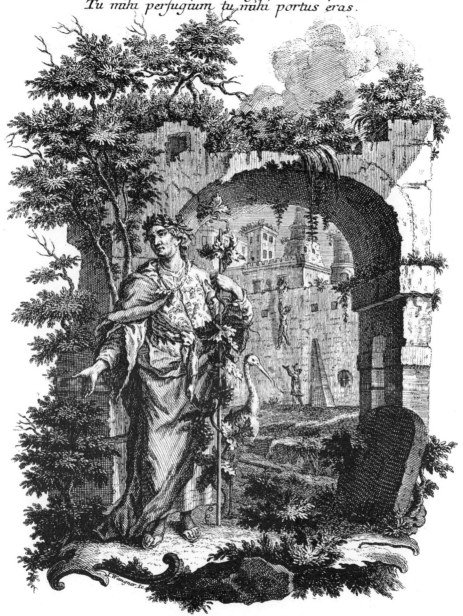

Hülffe, und Beystandt.
Rahab läßt die Kundschaffer ein,
daß Sie soll künfftig sicher seyn.

.Pichler. del. Hertel. excud.

AGRICULTURE
King Pharaoh, during the night, was frightened by his dream;
here is Joseph, prophesying and interpreting it.

The personification of Agriculture is a pretty young country girl, barefoot and dressed in green, with a wreath of grain ears in her hair. She holds the band of the Zodiac in one hand and with the other embraces a flowering young, newly planted tree, at which she stares fixedly. Beside her sits a lion, resting on a cornucopia overflowing with fruits of all kinds. A plow, mattock, and spade are on the ground near her. A grapevine grows up a pole nearby.

She is dressed in green, the color of hope, which is needed in agriculture. The wreath of grain in her hair symbolizes agriculture's chief purpose, the production of foodstuffs for man. She embraces the tree, for she is like a mother watching over her children, waiting for them to develop. She is also waiting for the fruits of which the flowers give promise. The lion draws the chariot of Cybele, who symbolizes the Earth. The Zodiac marks the times of the year and the seasons, on which all agriculture is based. The overflowing horn of plenty represents the rich gifts of the soil, of which the grape is one, second only to grain (in wine-drinking countries, that is). The plow and the other tools are self-explanatory.

[Ripa, 1603, pp. 8–10]

The *fatto:* In the background, Egypt is seen, with pyramids, a temple, and the Nile. There Joseph stands interpreting for Pharaoh his dream of the fat and the meager ears of grain, which can be seen represented in the sky above them.

[Genesis 41]

AGRICULTURE
His dream of seven ears of grain
Did Joseph to Pharaoh explain.

AGRICULTURA.

Rex Pharao noctu terretur imagine visu,
Præscius ecce Ioseph vaticinatur eam.

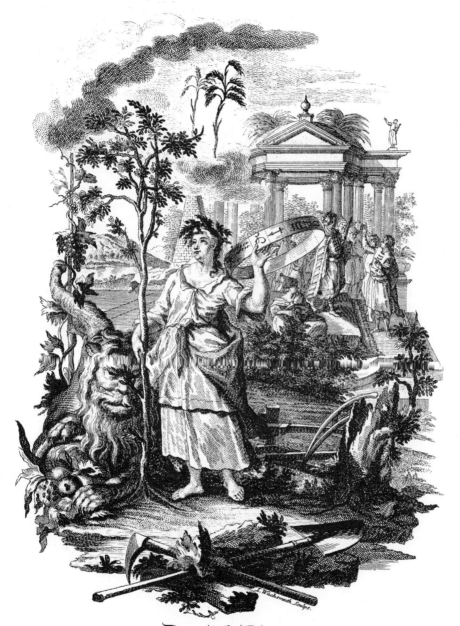

Der Acker Bau.

Pharo Traum der Sieben Lehren,
Iosephs Deutung thut belehren.

Eichler. del.

Hertel. excud.

DREAMS

'Twas night, and Jacob dreamed he saw the halls of Heaven,
while his eyes were overcome by sweet slumber.

The personification of Dreams is a phantasmagoric sleeping figure reclining on a bed of clouds. Half man and half skeleton, he is draped in a robe of black and white. In one hand, he holds a cornucopia from which fumes rise, and in the other the caduceus. A vine laden with grapes grows nearby.

Sleep is often referred to as being like death, or like dying a little every night. Seneca called it death's brother, and said that through sleep men learn what death is like. Therefore Eichler, in one of his most compelling inventions, designed the image as half a living man, and half a skeleton. The black and white robe refers to night and day, or death and life. The horn from which fumes rise indicates that sleep was be-

lieved to be caused by vapors, which, rising to the head, cause the brain to sleep. The winged, snake-entwined staff of Mercury, the caduceus, had the power of granting either sleep or death to mortals. The juice of the grape induces sleep, too. The darkness of the scene is intentional, for sleep comes best in darkness.

[Ripa, 1603, p. 464; Ripa, 1767, V, p. 190]

The *fatto:* In the dark background, Jacob is seen sleeping on the ground in the wilderness. In his dream he sees the angels mounting and descending a great ladder which leads up into Heaven, where God is seen floating in a cloudy sky. This is, of course, the "Jacob's Ladder."

[Genesis 28: 10–22]

DREAMS

In sleep on the hard ground did Jacob lie,
And the Lord and His Hosts in a dream did spy.

SOMNIUM.

Nox erat, insomnis vidit Iacob atria coeli,
Lumina cum placido victa sopore jacent.

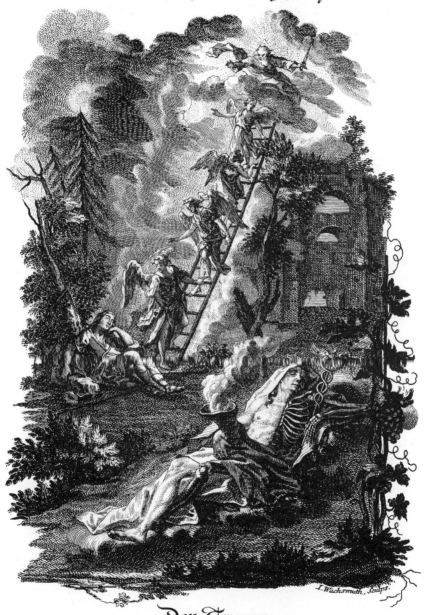

Eichler, del.

I. Wachsmuth, Sculps.

Hertel, excud.

Der Traum.
Iacob ruht auf hartem Steine,
siehet Gott, und sein Gemeine.

MAGNIFICENCE
The rewards of virtue are always glory and praise;
Mordecai is honored with the royal mantle.

This allegory is personified by Alexander the Great, the greatest hero of the ancient world. He is dressed in classical armor, with his helmet encircled by a victor's wreath, and holds lightning bolts in his hand. He stands on a pedestal, around which are heaped all sorts of military trophies, largely the weapons of the vanquished, and palm leaves and oak branches. The lightning bolts symbolize great worldly fame, for nothing makes more noise than thunder and lightning. When Apelles painted Alexander's portrait, he is said to have put a lightning bolt (also the symbol of Jupiter, the king of the gods) in his hand. Another story is that Olym-

pias, when pregnant with Alexander, dreamed of a lightning bolt, which was taken as a prophecy of her son's future fame. The military trophies are the standard symbols for the victorious, and the palm and oak were used for different sorts of victor's crowns.

[Ripa, 1603, p. 15]

The *fatto:* In a sumptuous setting, with porticos, obelisks, and arches, Mordecai is seen on horseback, dressed in regal robes and being led through the applauding and adoring crowds by Haman.

[Esther 6:11]

MAGNIFICENCE
Mordecai displayed for all to see
His royal state most splendidly.

MAGNIFICENTIA.

Præmia virtutis sunt semper gloria laudes,
Tegmine regifico Mardocheus colitur

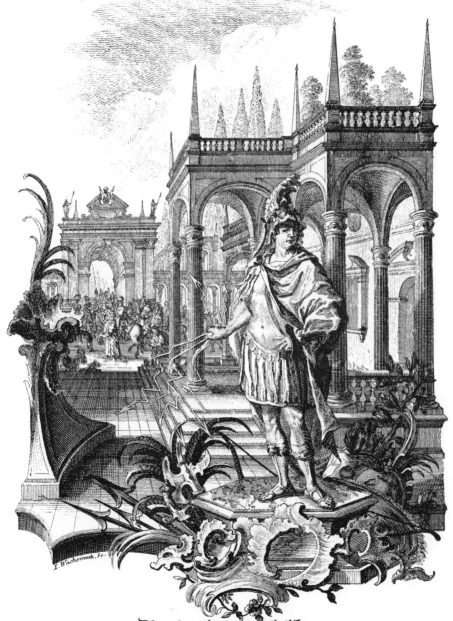

Große Ehr. ü: Herrlichkeit.
Mardochai herrlich prangte,
Königliche Ehr erlangte.

I. Wachsmuth, Sc.

Eichler. del

Hertel, excud

ENVY
*Many adventures and long-lasting dangers were in the life of
Joseph, man of prophecy, but also great glory.*

The personification of Envy is an aged and very ugly woman sitting half nude, before a cave. Her shriveled breasts are exposed; she is livid in color and has snakes instead of hair. She eats a human heart, while resting her hand on a hydra, and a lean and hungry-looking dog watches nearby.

Her livid color is due to the absence in envy of all warmth and charity, so that she is very cold. She is old and ugly, for envy is the ancient enemy of all virtue (which is beautiful). The snakes on her head are the evil thoughts of Envy, who is always spreading poison. Her continual envy of others causes her heart eternal disquiet, and she literally consumes herself in the envy of others—in other words, she "eats her heart out." The hydra with its many heads has a poisonous breath, killing all who inhale it, and is thus a suitable symbol for envy, which poisons its own life and that of all around it. When one of the hydra's heads is cut off, another immediately grows in its place; this is like removing the cause of enviousness, only to see another reason for it spring up in its place. Being furnished with so many heads, the hydra, like envy, never sleeps. The lean dog is an old symbol for envious selfishness, for he wishes to keep everything for himself. Pliny says (*Natural History*, Book 25, chap. 8) that the dog, when bitten by a serpent, eats of a certain herb as an antidote, but out of selfish fear that someone might learn of this, always eats it out of sight. The old story of the dog in the manger is another version of the same idea.

[Ripa, 1603, pp. 241–243]

The *fatto:* Young Joseph, weeping bitterly, is being sold by his envious elder brothers to the traveling merchants. One of the brothers points down into the well into which they had first cast him.

[Genesis 37: 25–28]

ENVY
*Joseph, through his brothers' hatred cold,
A slave into far Egyptland was sold.*

INVIDIA.

Multiplices casus et longa pericula vitæ,
Fatidici Ioseph, gloria magna fuit.

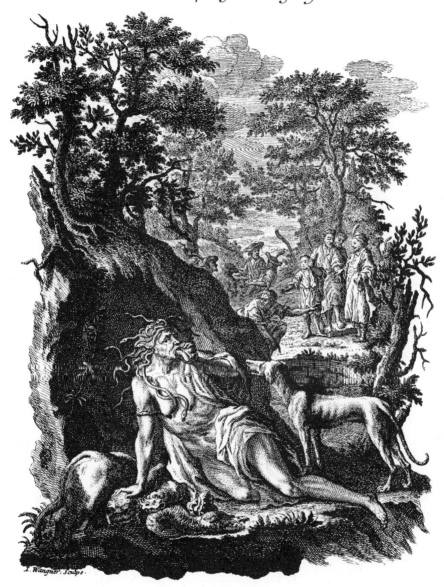

I. Wangner. Sculps.

Der Neid.

Ioseph durch Brüder Haß dur Schand,
verkauft wird in Egypten land.

Eichler. del. *Hertel. excud.*

AFFLICTION
Before her eyes now stands the grievous image of death;
Hagar despairs, fearing the death of Ishmael.

In a lugubriously wild setting, a woman, personification of Affliction, sits on a rocky hummock. Her dark clothing is in disarray, and her hair disordered. She looks upward despairingly and gestures wildly. At her bare bosom she holds a serpent which is biting her. The sufferer from grave affliction tends to neglect his appearance, hence the disorder in the woman's hair and garb. Her gestures and glance are those of the griefstricken. The displeasures and the grief which come into human life eat at the heart like a serpent and poison the soul with bitterness and rancor.
[Ripa, 1603, pp. 90–91]

The *fatto:* Having been cast out by Abraham at Sarah's instigation, poor Hagar has wandered with her young son, Ishmael, in the wilderness. Their water and food having given out, Ishmael seems near death and Hagar despairs for him.
[Genesis 21: 9–21]

AFFLICTION
Poor Hagar to the heavens did cry
For fear son Ishmael would die.

CORDOLIUM.

Ante oculos jam stat tristissima mortis imago,
Ismaelis letho discruciatur Hagar

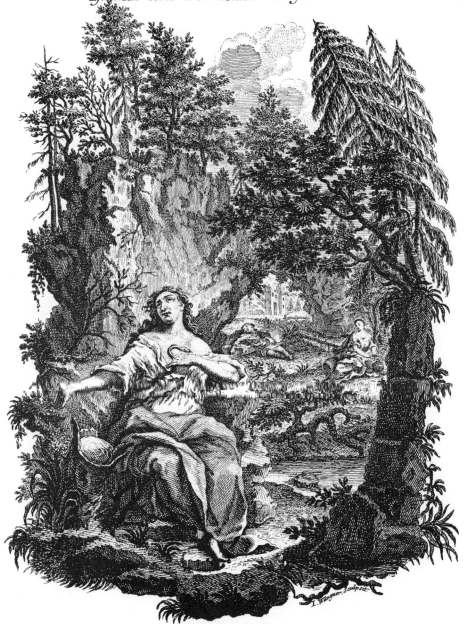

Daß Herzenleydt.

Hagar kan auf bitt und flehen,
Ismael nicht sterben sehen.

Eichler, del.

Hertel, excud.

DESPAIR
Iscariot died in despair; he hung,
a grim weight, from a high branch.

The personification of Despair is a woman seen against a backdrop of ruins. She has a dagger thrust into her breast, and falls backward swooning. In one hand she holds a cypress branch; she gestures with the other. At her feet lies a broken compass.

The cypress branch, once cut off, will not grow again, just as he who gives in to despair gives up all chance of hope and salvation. The broken compass indicates that in despair one loses all reason and cannot even enjoy good guidance. The dagger in the woman's breast symbolizes the ultimate crime of the despairing, suicide.

[Ripa, 1603, p. 106]

The *fatto*: Judas, overcome with despair at the enormity of his betrayal of Christ, commits suicide by hanging himself from a tree branch.

[Matthew 27: 3–10]

DESPAIR
To his betrayal, Judas gave no thought,
But later hanged himself for what he'd wrought.

DESPERATIO.

Effudit vitam desperans Iscariotes,
Sublimi ligno triste pependit onus.

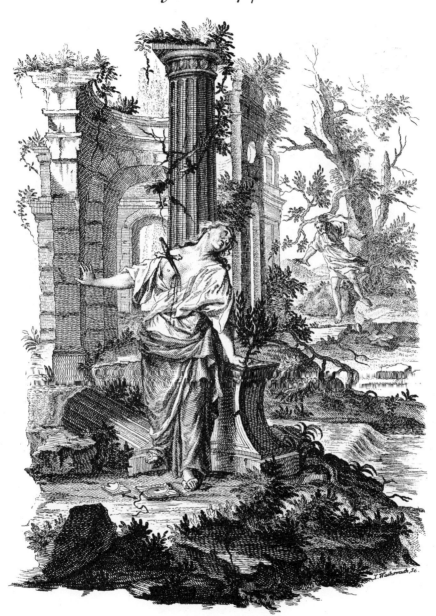

Die Verzweiflung.
Iudas Verräther nicht bedenckt,
waß er gethan, und sich erhenckt.

Pichler. del.

Hertel. excud.

PUNISHMENT
Everything lies in flames, and Sodom has sunk into the ashes;
Lot alone survives the fire.

The personification of Punishment is a man dressed in the rough garb of a woodsman or peasant, with a fierce and severe expression on his face. He holds a large axe up as if about to strike with it. Behind him amid some trees a lion is tearing apart a she-bear.

The axe is, of course, an old symbol for punishment: the lictors' rods in ancient Rome were bound around an axe to indicate the power of the state to chastise and kill as punishment for crimes. The lion and bear are characters in the story of the lion, the bear, and the dog who were raised together and lived together in harmony. One day, however, the bear killed the dog, its old friend. The lion, overwhelmed at this bestial crime against companionship, then killed the bear.

[Ripa, 1764, I, p. 330 (see Plate 47)]

The *fatto:* As a punishment for their sins, God sends down a rain of fire on the cities of the plain, Sodom and Gomorrah. Only Lot and his family are spared, but are told to flee from burning Sodom without looking back. Lot's wife disobeys and turns into a pillar of salt.

[Genesis 19: 15–26]

PUNISHMENT
With fire did God lay Sodom low,
To Lot and his did mercy show.

Cuncta jacent flammis et Sodom mersa favilla,
Lothus in his flamis integer ipse manet.

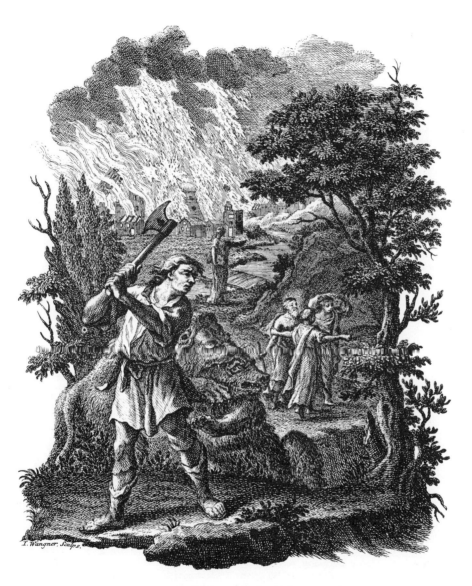

Die Züchtigung.
Gott ſtraffet Sodom durch den Brand,
Loth und die ſeinen Gnade fand.

I. Wangner, Sculps.

Eichler, del. Hertel excud.

These arts strongly sway the minds of men;
hearts soften and rudeness flees.

Part IV

Histories and Allegories

designed and drawn

by

Gottfried Eichler the Younger,

published

by the author,

Johann Georg Hertel,

Augsburg

The above legend is inscribed on a rococo cartouche topped by a bust of the goddess of wisdom, Minerva. Seen behind it is a handsomely decorated room hung with pictures, obviously the study of an amateur of the arts. He is seen seated at a table perusing some illustrated books, a number of which also lie open on the floor. If not actually a representation of the image invented by Orlandi for "Emblema," the science of emblems—of the "painted enigma," as he calls it (Ripa, I, 1764, p. 323)— the association of this concept with a serious man in a study hung with pictures certainly inspired Hertel and Eichler in this little scene. It might also be considered a bit of printseller's advertising.

In solitude and quiet ease
Art cheers the heart and th' eye doth please.

Hæ policent animos hominum fideliter artes,
Pectora mollescunt asperitasque fugit.

So dient in stiller Einsamkeit /
die Kunst zur Lust u: Augen weyd.

LIBERTY
Freedom is not well sold even for much gold;
Tell won with the apple; cease, shameful yoke.

The personification of Liberty is a seated woman of matronly aspect, dressed in white robes, with a classical helmet and corselet. She rests her right arm on a shield decorated with a sheaf of arrows, and in her right hand holds a scepter and a staff on which is hung a Phrygian cap. She holds high in her other hand a palm leaf and an olive branch. She leans against a broken column to which a shield and a quiver of arrows are bound with a vine. Underfoot are the lictors' rods, and besides her stands a cat.

In her dress, and leaning on a shield, Liberty looks very much like representations of the goddess Roma. Her scepter represents liberty's absolute power to pervade all human affairs. The Phrygian cap was that worn by the newly freed slaves of ancient Rome, and has come to be a symbol of liberty (as in the French Revolution). The palm leaf and the olive branch are symbols of victory and peace. The cat, since it will not tolerate any sort of control or limitation of its freedom of movement, is an old symbol for liberty, and many of the Germanic tribes, lovers of liberty all, who fought against the Romans, used it as their emblem.
[Ripa, 1603, pp. 292–293]

The *fatto:* Near an Alpine town surrounded by high mountains, William Tell raises his crossbow in triumph toward the tyrant Gessler, who looks down at him from his horse with displeasure. Nearby stands Tell's son with the arrow-pierced apple still on his head. By a tree in the middle distance stands the pole on which Gessler had hung his hat, requiring that all bow to it as a symbol of his power; this started the whole story of the trial by archery.
[Aegidius Tschudi, *Chronica*]

LIBERTY
The Swiss, since Tell the apple shot,
A foreign yoke have suffered not.

LIBERTAS.

Non bene pro toto libertas venditur auro,
Dell vicit pomo, desine turpe jugum.

I. Wachsmuth, Sc.

Eichler, del:

Hertel, excud:

Die Freyheit.

Dell den Apffel hat getroffen,
Schweißer auch kein Joch mehr hoffen.

ARISTOCRACY
The rule, the decorum, the reign of Sabacos are praised;
all the land will come under his dominion.

On a splendid throne composed of rocaille and draperies, sits a woman—the personification of Aristocracy—richly dressed and wearing a crown. She holds the *fasces*, the symbolic bundle of lictors' rods, on her knee; it is topped with a laurel wreath. Near the cushion on which she rests her feet are an axe, a cornucopia spilling out coins, and a thyrsus. She holds a plumed helmet on her other knee.

She is shown in the prime of life for that is the best, the aristocrat of ages. Her throne, her crown, her sumptuous robe are all the outward symbols of the wealth and magnificence of those of high estate. The lictors' rods bound together, which sometimes indicate that a state must be united within itself to survive, have here the more usual meaning of the power to punish held by the ruling classes. But the bundle is crowned with laurel, the prize given those who work for the benefit of the *res publica*, suggesting that here, as would be expected in the age of absolutism, patrician rule is con-sidered desirable and beneficent. The helmet and the money refer to the aristocratic ruler's need for skill in arms and great wealth for maintaining his state; he must stay proficient in the one and very liberal with the other. And behind all this lies the axe, age-old symbol of drastic punishment for those who oppose rulers.
[Ripa, 1764, I, p. 160]

The *fatto:* Hertel and Eichler, in spite of the somewhat ambivalent symbolism of the main allegory, chose a very lofty example for the "history," the story of Sabacos, black king of the Ethiopians, who drove out the king of Egypt and reigned for fifty years in his stead. A true aristocrat, he governed with wisdom and justice. He is shown dressed in rich oriental robes. Accompanied by several sages, he marvels at the light of God, in the form of a radiant disk, shining down on the royal bed with its brocaded canopy.
[Herodotus II, 137 ff., 152]

ARISTOCRACY
Since Sabacos so justly reigned,
Great praise for his long rule he gained.

Laudatur Sabaci regimen decus imperiumque,
Totaque sub regno terra futura suo est.

Regiment der Vornehmsten im Volck.
Deß Sabaci gut Regiment
man billich recht, u. löblich nent.

Eichler. del. Hertel. excud.

MAGNANIMITY
There is virtue in Darius and courage in his breast;
facing the enraged mob, he wipes out its anger.

Before a pedestal which supports an elaborate rococo urn is a handsome woman of majestic appearance, who personifies Magnanimity. She is dressed most splendidly in cloth of gold and wears many jewels and a royal crown. She holds a scepter in one hand. She is seated upon a large and splendid lion, while behind her a putto spills coins out of a large cornucopia.

Ripa points out that Aristotle, in his work on physiognomy, states that the magnanimous person has a broad forehead and a rotund nose. The figure's dress and her imperial crown are, of course, symbols of splendor, worldly power, and greatness. Her crown also represents nobleness of thought, and the scepter, the power to put this thought into effect. The lion is the most noble of beasts, for he not only fears no other animal, even if it is larger than himself,

but also never hides from hunters; indeed, he shows himself to hunters to distract them from other animals so that they can escape. The horn of plenty spilling out coins indicates that a magnanimous person deals with material things like money with a sort of careless generosity, paying little attention to how much he spends.

[Ripa, 1603, p. 300]

The *fatto:* The Persian king Darius III, ahorse, fleeing from Alexander the Great, addresses his restless warriors fearlessly, impressing them with his magnanimity and courage.

[Curtius Rufus, *Historia Alexandri Magni,* V, 8 and 9]

MAGNANIMITY
Darius himself a hero showed;
The raging, wicked horde he slowed.

MAGNANIMITAS.

Virtus inest Darioque animusque in pectore præsens,
Mente furit populus, destruit is furias.

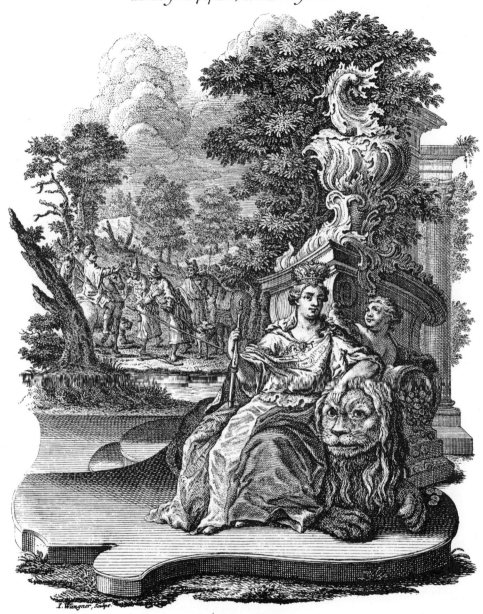

I. Wangner, Sculps.

Die Großmuth.
Darius sich Heroisch stelt,
die Wuth der bösen Roß abhält.

Eichler del.

Hertel excud.

SECURITY
The fool does not take care, but scorns the gravest dangers;
Archias rushes headlong to his doom.

The personification of Security is a seated woman dressed in classical drapery and wearing an olive wreath, who leans on a column and holds up her head with one hand, for she is asleep. She embraces a long spear which leans on her shoulder. The column represents stability or firmness, and the spear, power. Thus she feels so secure that she can relax her vigilance and sleep. The olive wreath is, of course, the symbol of peace, the time for feeling safe.

[Ripa, 1603, p. 453]

The *fatto:* In a richly decorated elevated round banqueting hall in Thebes, Archias (immortalized by the phrase "Business tomorrow") and his court sit feasting. Enjoying himself, he postpones reading a note sent by Archinas warning of the arrival of the Spartans in Athens. His majordomo descends a ramp to where a sentinel is so busy watching the festivities that he, like the little dog sleeping at his feet, does not notice the armed men of Pelopidas advancing on the palace.

[Cornelius Nepos, *Vitae*, XVI, 3]

SECURITY
Careless Archias nothing feared,
Tho' danger 'fore his eyes appeared.

Non curat spernit funesta pericula stultus,
Projicit in præceps Archia fata sua.

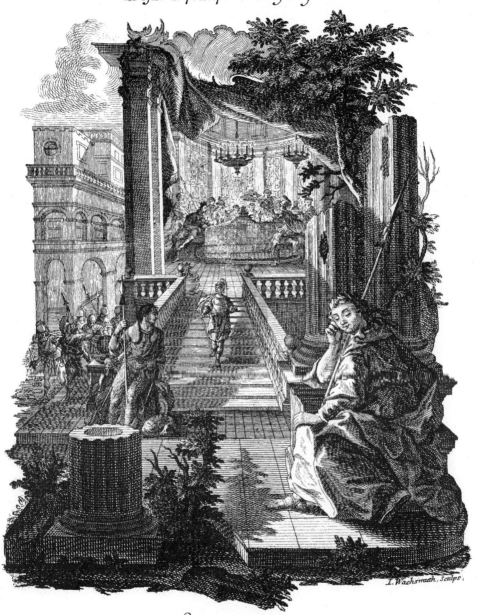

I.Wachsmuth, Sculps.

𝔇𝔦𝔢 𝔖𝔦𝔠𝔥𝔢𝔯𝔥𝔢𝔦𝔱.
Archias gar zu Sorgloß lebt,
als ihm Gefahr vor Augen schwebt.

Eichler, del. Hertel, excud:

66

COURAGE
The Tartar challenged all to a proud contest;
Scanderbeg slays with his sword him who boasted so.

The personification of Courage is a man of heroic physique, almost nude save for a cloak and the armor on his right arm. He thrusts his mailed fist into the open mouth of a ferocious lion, upon whom he kneels, having subdued him. Represented is Lysimachus, son of Agathocles, a nobleman of Macedonia, who, as punishment for procuring poison for his imprisoned teacher, the philosopher Callisthenes, was thrust by order of Alexander the Great into an arena with a huge lion. Having secretly protected one arm with armor, the seemingly defenseless and nude Lysimachus overcame the lion, driving his armored fist down into his throat and pulling out his tongue, whereupon the beast expired. So impressed was Alexander by such courage and boldness that he made Lysimachus one of his immediate circle; this enabled the youth eventually to rise high in the world, for he became one of the king's successors.

[Ripa, 1603, p. 24]

The *fatto:* In an arena, under the eyes of many richly dressed Orientals, a nude heroic fighter hacks off the head of his beaten opponent. The victor is Georg Kastriota, called Scanderbeg (1403–1468 A.D.), the national hero of Albania, and its defender against the Turks.

COURAGE
The Tartar's head, his boasts to stop—
Off did Scanderbeg it chop.

Tartarus ad sævum certamen quemque vocabat:
Talia jactantem Scanderbeg ense necat

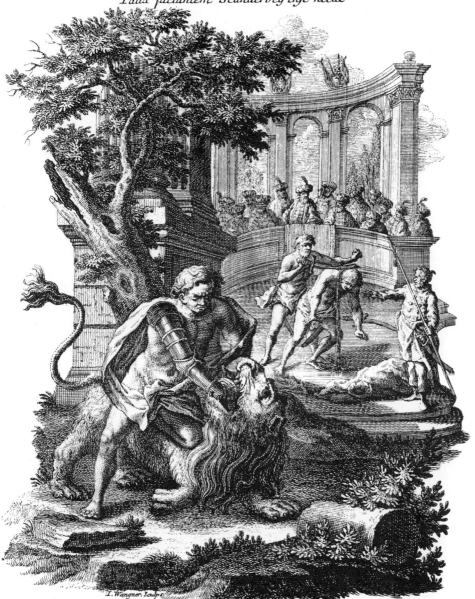

I. Wangner, Sculps.

Der unerschrockne Muth.

Dem Tartar für Großsprecherey
haut Scanderbeg den Halß entzwey.

Eichler, del.

Hertel, excud.

LAUGHTER
As you laugh there is such grace in your charming laughter;
that of Democritus was of a less attractive kind.

The personification is a laughing young man in a fanciful, varicolored costume, who holds a black mask away from him with disdain. Youth being the time for joy and laughter, he is shown young. He wears a flower garland across his chest and a plumed hat on his head. The gay colors, the flowers, and the fancy dress are all things associated with hilarity and amusement. The black mask being held in disdain stands for all the ugly, indecent things which are without decorum, and which true honest laughter avoids.

[Ripa, 1603, p. 437]

The figure of Laughter is pushed off to one side in this plate, for the *fatto* takes up the major part of the space available. In the foreground, Democritus, dressed in scholar's robes, rises from his grave and looks, jeering and marveling, at the scene in the background. An elaborate pedestal, decorated with a skull and topped with an urn, rises behind him. A lighted lamp rests on it. What he sees in the grandiose building in the back, a building decorated on its roof with statues of Apollo and the poets, is a topsy-turvy world.

One wall is lined with books; at a table before it sits a monkey with spectacles, who writes in a book with a quill pen. Its hand is guided by a female figure of rather complex significance. She carries the Phrygian cap on a pole, and as such could be interpreted as Liberty (see Plate 62); the putto removing chains from her ankles might attest to this meaning. But her association here with an ape mimicking a savant suggests that she is Liberty gone too far, and has become License. The birds around her head are probably foolish thoughts.

Working at an easel on the other side of the room, where the wall is lined with shelves supporting pieces of sculpture or plaster casts, is a donkey, busy drawing a classical torso displayed at the back of the room. Behind the donkey stands the figure of Envy (see Plate 57) with her snakes for hair, eating a human heart; a pelican stands next to the group. Although usually associated with such things as charity, piety, and goodness, the pelican is also, according to both Horapollo and Piero Valeriano, considered to be a symbol of madness and imprudence. In his invention for Alchemy (1764, I, pp. 69–73), Cesare Orlandi gives a long involved story of the bird's stupidity and how it and its young die as a consequence of it.

Thus Democritus sees a world filled with false authors, jackass artists, license, envy, and dangerous stupidity, all worthy of ridicule.

LAUGHTER
Democritus dissolved in laughter,
Marv'ling at what the world was after.

RISUS.

Dum rides lepido tanta est tibi gratia risu,
Democriti risus ingeniale decus.

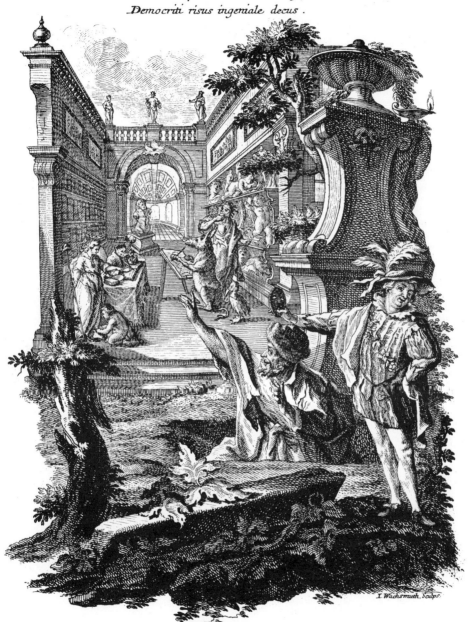

I. Wachsmuth. Sculp:

Daß Lachen.
Democritus von ferne lacht,
bewundert waß die Welt jetzt macht.

Eichler. del: Hertel. excud:

DEPRAVITY
Fierce Tullia does not spare her father—what great savagery!
Riding her chariot, she crushes and lacerates him under its wheels.

The personification of Depravity is a wicked-looking dwarf, all out of proportion, and with a squint. He holds a seven-headed hydra in his arms. He also has a dark complexion and red hair. Since everything about the dwarf—his size, his squint, and his coloring—are departures from the "norm" of human appearance, they are like vices, which are departures from the normal life which strives for virtue. Thus they are against nature, too. Once red hair, a squint, or a dark skin were considered to be indications of a vicious nature. The whole image of Depravity or Vice is based, then, on the old idea that a pure soul expresses itself in good looks and fine proportions, and the opposite does the contrary. The hydra, as said before, is a standard symbol for evil. Its seven heads here are the seven mortal sins. When one is cut off, it quickly grows back again and is stronger than before; the same thing happens with vices, for half measures never help but only make things worse. Just as all the hydra's heads must be cut off, so too must all vices be avoided.

[Ripa, 1603, p. 443, "Sceleratezza"; p. 515, "Vizio"]

The *fatto:* In a square in the city of Rome, Tullia, seated on her horse-drawn chariot, has it ride over the body of her murdered father, Servius Tullius.

[Livy I, 48; Ovid, *Fasti*, VI, 585–610]

DEPRAVITY
In evil was Tullia so completely ensnared,
Not even her very own father was spared.

VITIUM.

Non parcit Patri, laceratum, quis furor urgens,
vecta terit curvis Tullia: saeva rotis.

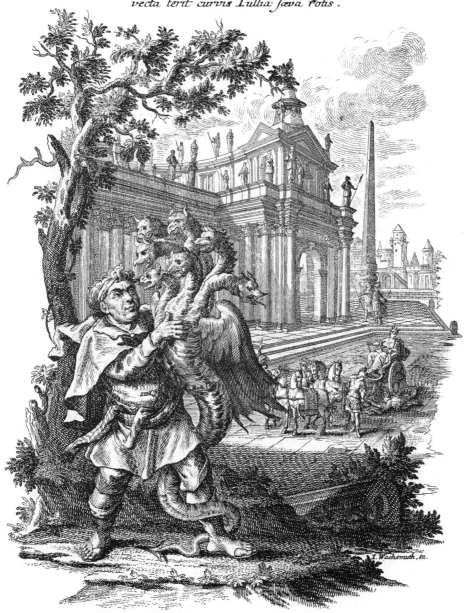

Daß Laſter.

Tullia ſehr übel lohnet
nicht deß eignen Vaters ſchonet.

Bichler, del.

Hertel, excud.

RAPINE
The rape of the Sabines eliminated unhappy wars;
the barbaric theft brought about happy results.

The personification of Rapine is a belligerent-looking woman in classical garb, armed with helmet, sword, and shield. Striding forward, she peers over her shield, apparently looking for prey. There is an owl atop her helmet, and on the shield the abduction of Proserpina by Pluto is depicted. A wolf lies at her feet. She is armed because it is through violence that the property of others is usually taken from them. The owl on her helmet, indicative of her kind of mind and thinking, is notoriously a rapacious bird which lives off others, stealing their food. The wolf, too, as is well-known, lives by violence and theft, preying on innocent flocks and carrying off the sheep in order to devour them.

[Ripa, 1603, p. 428]

The *fatto:* There is no more famous example of rape or abduction (except, perhaps, for the one depicted on the shield) than the Rape of the Sabine Women. Eichler here places the scene in an open hall or portico with a statue of Apollo in the foreground, basing his illustration on the many representations of the event by the greatest artists of the Baroque period.

[Livy, I, 9; Plutarch, *Life of Romulus*]

RAPINE
The Sabines' rape, one must concede,
With the Romans peace did breed.

SPOLIUM.

Præda Sabinorum tollebat tristia bella,
attinet eventus barbara præda bonos.

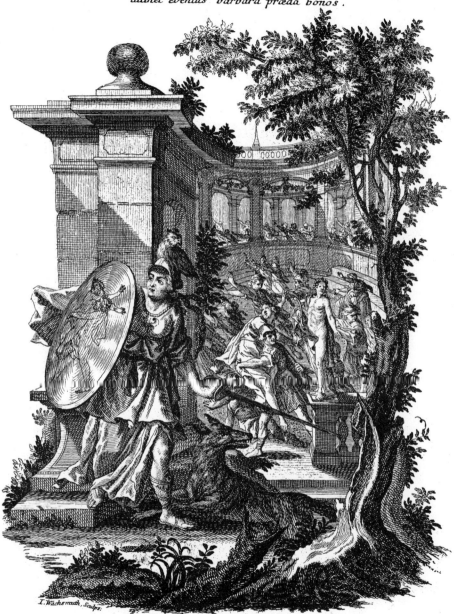

I. Wachsmuth, Sculps.

Der Raub.

Der Sabiner Raub mußt stillen,
beeder Völcker Eintrachts Willen.

Eichler. del.

Hertel, excud.

LEWDNESS
"How great the harm you do alone, O Pleasure, when you infect the mind."
Wicked and wretched was Sardanapalus.

Reclining languorously on a richly decorated and somewhat rumpled bed, a beautiful woman, scantily draped and bedizened with jewels in her blonde hair and on her person, fondles blindfolded Cupid, who holds his bow and arrow. She holds a sprig of colewort (*eruca*), an edible cabbage-like plant, in one hand. On the footstool at her feet sits a partridge; near it is a goat.

The physically attractive woman has always been a symbol for lasciviousness, especially in association with a bed. That she here plays with blind Love is also an obvious allusion to the allegory. Colewort was considered an aphrodisiac by the ancients; like ivy and the grapevine, it was also associated with sexual passion. The partridge was considered the most libidinous of birds, and the goat the most potent and easily aroused of animals; hence their presence here.

[Ripa, 1603, p. 294, "Libidine"; p. 295, "Lussuria"]

The *fatto*: In a luxurious apartment, Sardanapalus, King of Assyria, sits in bed with one of his women on his lap, while another, equally naked, offers him a cup of wine. He looks into a mirror, engrossed in himself and his pleasures, while his scepter and crown, symbols of his duties and responsibilities, lie on the floor beside him, as do the distaff and spindle, evidence of his effeminate degeneracy. The first line of the Latin couplet is a quotation from Silius Italicus, *Punica*, XV, 95.

[Justin, *Historiae*, I, 3, 1]

LEWDNESS
So base was Sardanapalus' whim
That ev'n his God abandoned him.

IMPUDICITIA.

Quantum Sola noces animis illapsa voluptas,
Impius atque miser Sardanapalus erat.

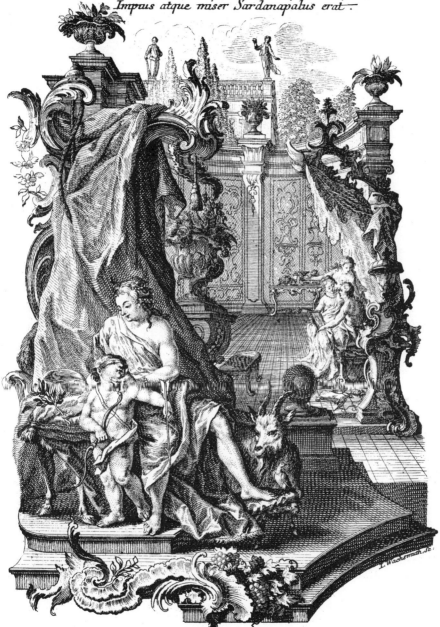

Die Unkeuschheit.
Sardanapalus Wollust übt,
und dadurch seinen Gott betrübt.

Eichler. del.

L. Wachsmuth. Sc.

Hertel excud.

THE SCOURGE OF GOD
Attila! "Who was the first to invent the horrible sword?
How wild he was and how truly made of iron!"

A man of venerable appearance, but very angry, robed in red, holds a whip with many lashes in one hand and a lightning bolt in the other. Around his feet are several huge grasshoppers or locusts.

The man represents God. Red is the color of anger. The whip is the punishment meted out to those who can still be saved and corrected, making them worthy of God's pardon, whereas the lightning bolt is for the incorrigible, who must be destroyed for their sins. The grasshoppers or locusts represent plagues, the universal punishments inflicted by God on erring mankind, like the plagues sent down by God to punish Pharaoh in his obstinacy (Exodus 10: 1–20).

[Ripa, 1603, p. 165]

The *fatto:* A group of oriental warriors give a curved sword to a cowherd, while in the background a horde of mounted warriors engage in a pitched battle. Attila the Hun, who was called the "Scourge of God," was considered to be a form of divine punishment inflicted by God upon man. After the word "Attila" in the Latin superscription, the quotation is from Tibullus, *Elegies*, I, 10, lines 1–2.

THE SCOURGE OF GOD
Attila was called this openly;
Ever a raging tyrant he.

FLAGELLUM DEI.

Attila quis fuit horrendos qua protulit enses,
Quam ferus et vere ferreus ille fuit.

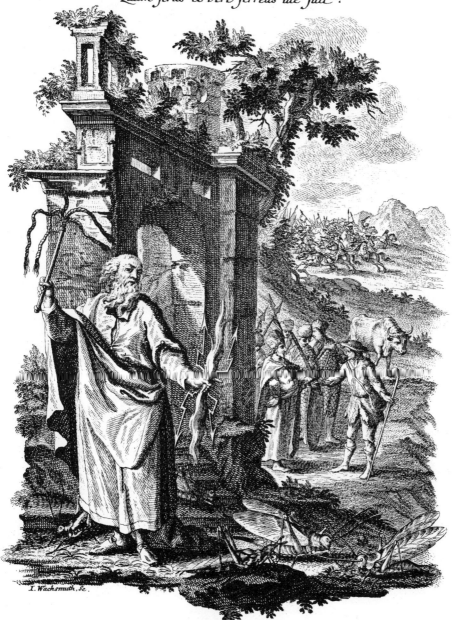

I. Wachsmuth, Sc.

𝔊𝔢𝔦ß𝔢𝔩 𝔊𝔬𝔱𝔱𝔢𝔰.
Attila fich fo gefchriben,
ü: ſtets ein Thrann verbliben.

Eichler, del. Hertel, excud:

WAR
*Wars thunder, and discord shakes the whole world;
at such a time a shorter road to sad death is opened.*

The personification of War is a woman with wild and bloody hair dressed in classical armor, with a red robe underneath. Mounted on a fiery horse, she drives a spear at a square column or pier. On her helmet is a dragon, and she holds a flaming torch in one hand. On a banner attached to her spear is the inscription "Nulla calamitas sola" (No calamity comes alone). There are military trophies behind her, and up above, the personification of Fame, a nude winged female, holds her trumpet and a shield inscribed "Ad arma, ad arma" (To arms! To arms!).

The column toward which War throws her lance is a reference, as given by Ripa, to the ancient Roman custom of declaring war by standing near the *colonna bellica*, the column of war, and throwing a lance in the direction of the enemy. She is dressed in red for it is the color of anger. The dragon on her helmet

is a symbol of the monstrous nature of war; and with a lighted torch Bellona, the goddess of battle, "lights the fires of war."

[Ripa, 1603, p. 198; the figure of Fame, p. 143]

The *fatto:* Hertel has composed his own application of the allegory here. In the background we see the figures of Peace, with her palm leaf and olive crown (Ripa, 1603, p. 376), and Prosperity, with her cornucopia and crown of violets (Ripa, 1766, IV, p. 419), holding between them an olive wreath, which Mars, the god of war, is about to slash in two with his sword. Nearby a putto applies calipers to a globe of the world, indicating that war is concerned with territorial loss or gain, while bound prisoners sit near him. In the distance are seen military trophies, men at arms, and a burning city.

WAR
*Where Mars, the god of war, holds sway,
Peace and Concord fade away.*

BELLUM.

Bella tonant totumque quatit discordia mundum,
Tunc brevior diræ mortis aperta via est.

I. Wachsmuth, Sc.

Der Krieg.

Wo sich Mars pflegt einzufinden,
Frid und Einigkeit verschwinden.

Eichler, del.

Hertel, exc.

STRATEGY
The forces converge and challenge the enemy with loud cries;
it is beneficial to use the right moment for decamping.

Peeking out of a tent is the personification of Strategy, a resolute-looking man in full body armor, but with a hat on his head. On a banner flying over his tent is the motto "Fide, sed cui vide" (Trust, but watch whom you do). Through a hole in the tent wall he manipulates cords which control a wire mesh trap for birds. Some are already eating the bait within it, others are flying into it. Near the tent is a cage upon which sits a bird observing the whole operation.

Since strategy has to do with military astuteness and trickery in battle, the allegorical figure is that of a warrior. He is fully armed, for the true warrior is ever ready to do battle, and ever ready to use any chance or trick to gain victory. The motto, actually a translation into Latin of the old German proverb "Trau', schau' wem," refers to the need for eternal vigilance, even with apparent friends or allies. The bird trap is an obvious metaphor for a strategic device for gaining power over others. The bird seated on the cage, watching, is undoubtedly the decoy who leads the unwitting victims into the trap. The whole image seems to be Hertel's invention for although Ripa provides an allegory for "Strattagemma militare" (1767, V, p. 236), it is totally different.

The *fatto:* In a great harbor, with a city in the background, two ships of war, loaded with armed men, move against two other ships, equally filled with soldiers.

STRATEGY
Not strength but guile more oft achieves
That one the victor's palm receives.

STRATAGEMA.

Miscentur magnisque vocant clamoribus hostem,
tempestate frui signaque ferre juvat.

I. Wachsmuth, Sc.

Die Kriegs List.

Der Feind offt mehr durch List als Macht,
hat waß er wünscht zu wegen bracht.

Eichler del:

Hertel excud:

Falsa Eudoxia Paulin Suspicione necabat,
Nunc brevior diræ mortis aperta via est.

Præstat
iniuriam accipere
quam facere.

Der Argwohn.

Eudoxiæ Unschuld Verdacht,
Paulin den Tod, Jhr Elend bracht.

Eichler, del. Hertel, excud.

TREASON
The master imparts to his pupils false teachings;
therefore he pays with his life as he deserves.

The personification of Treason is a man dressed in fantastic armor, who embraces and kisses a fair-haired youth dressed in rich garments, while hiding a dagger behind his back.

The kiss, an act of affection and good intent, is, when used to mask hatred and the desire to do harm (represented by the hidden dagger), a clear example of betrayal. The unarmed youth represents the innocent, the betrayal of whom makes treason that much greater a crime. The fact that the evil-doer is fully armed is a commentary on the cowardly nature of traitors, for they are as careful as they can be to run few risks themselves.

[Ripa, 1603, p. 489]

The *fatto:* Both Livy (V, 27) and Plutarch (*Life of Camillus*) tell the story of the treasonous schoolmaster of Falerii who lured his pupils into the hands of the Romans besieging the city. Marcus Furius Camillus, the Roman leader, was a man of such virtue that he refused to take advantage of this act of betrayal. He sent the children back, along with the traitorous teacher, whom he had the pupils beat with rods on the way.

TREASON
Whoe'er would children falsehood teach
Should stay outside his pupils' reach.

PRODITIO

Falsa suis dederit pueris præcepta Magister,
Propterea poenam morte luit merita.

I.Wachsmuth Sculps.

Die Verrätherey.

Weil der Lehrer falsch beschaffen,
ihn die Schüler müssen straffen.

Kichler del.

Hertel excud.

TERROR
*Both greedy guests and fearful slaves were dismayed by
Domitian's entertainments at dinner.*

The personification of Terror is a powerful figure robed in a garment of shifting, changing colors. Striding purposefully forward, it holds a whip in one hand. It has the head of a lion instead of a human one, for the lion inspires terror and symbolizes the frightening aspects of life which awaken terror in the heart of man. The whip, an instrument used to force others to do one's will, represents the terror caused by pain and violence, and by the apparent success of evil. The changing colors of the robe symbolize the inexplicable changes in life which are so frightening, but also the various passions which race through the soul of the terrified.
[Ripa, 1603, p. 484]

The *fatto:* In a noble hall, the Emperor Domitian (81–96 A.D.), not exactly noted for his benevolence, watches in amusement as his guests look about in a frightened manner at the banqueting hall's decorations. The dark walls of the room are decorated with skulls and bones and other macabre items.
[Gottfried, *Historische Chronica*, p. 334]

TERROR
*Domitian's feast's gruesome décor
Inspires his guests with pure terrór.*

TERROR.

Convivas avidos coenam Servosque timentes,
Turbavit ludis Domitianus eos.

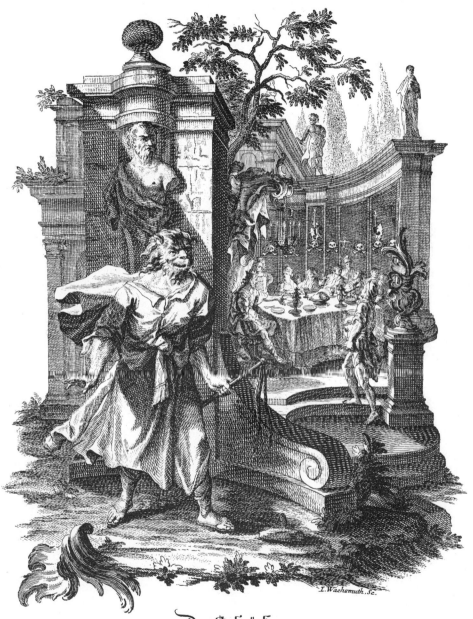

Der Schröcken.
Domitian Faßnacht Spil
die Gäst bekümert abwil.

Eichler, del:

I.Wachsmuth. Sc.

Hertel. excud:

CRUELTY
Cruel Phalaris first cut out his tongue with a sword;
then, enclosed in the brazen figure, the man bellowed dreadfully like a bull.

The personification of Cruelty is an elderly woman with a red face and a wicked look in her eyes. Her red garments are in disarray. She is strangling a baby. A nightingale sits on her head, while at her feet a tiger (in spite of the spots!) tears at the belly of a lamb.

The red color of her face and dress is the color of blood. The murder of the baby, like that of the innocent little lamb, are the extremest forms of cruelty, the harm done to those too helpless to protect themselves. The nightingale refers to the cruel tale of Philomela's family told by Ovid in Book VI of the *Metamorphoses*. (Philomela was raped by Tereus of Thrace, husband of her sister Procne; Tereus also cut out Philomela's tongue. In revenge, Procne fed Tereus the flesh of their son Itys. Procne was subsequently transformed into a swallow, Tereus into a hoopoe, and Philomela into a nightingale.) The tiger is cited again and again as the cruelest of beasts, preying on the helpless, and of a particularly ferocious and bloody temperament.

[Ripa, 1603, p. 99]

The *fatto:* Phalaris, the cruel tyrant of Agrigentum, had the tongue of the sculptor Perillus cut out and the hapless craftsman roasted alive in a glowing oven shaped like a bull, which the man had just made for him.

[Pliny, *Nat. Hist.*, XXXIV, 89]

CRUELTY
Phalaris devises a fate most dire!
The luckless artist is thrust in the fire.

CRUDELITAS.

Immittis Phalaris lingua prius ense resecta,
Dirus more bovis clausus in ære gemit.

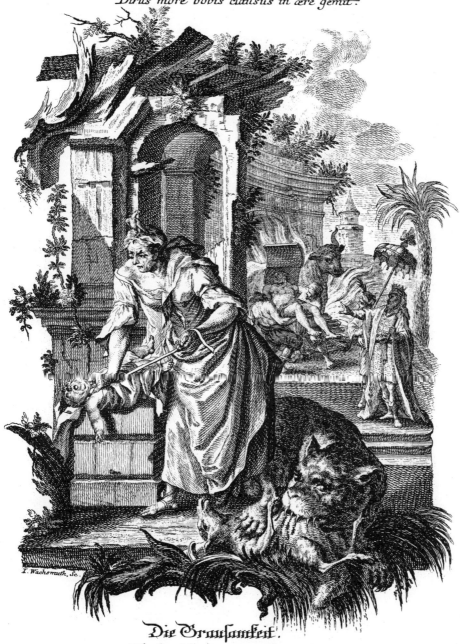

I. Wachsmuth, Sc.

Die Grausamkeit.
Phalaridis der Ungeheur-
Den Künstler schaft zur Prob ins Feur.

Eichler del:

Hertel, excud:

VICTORY

*Having slain the enemies, the victor is received with the sound
of rejoicing; the soldiery chants loudly, "Triumph!"*

The personification of Victory is a young woman wearing classical armor over her white robe. She is seated on a heap of vanquished enemies, arms, and banners. Her helmet is encircled with a laurel wreath, symbol of strength crowned with victory. In one hand she holds a crown encircled by a snake, the symbol of prudence, for victory is gained by the prudence of princes. In the other she holds the palm leaf of victory and honor, and a pomegranate, the symbol of union, for only with united strength can one achieve victory. She rests her hand on the lictors' rods, the fasces, wound with vine, representing the victorious and therefore strong leader.

[Ripa, 1603, pp. 515–518]

The *fatto*: Depicted is a triumphal procession in ancient Rome, identifiable by the triumphal arch, the column of Trajan, and the magnificent buildings.

VICTORY

*Whoever wins o'er the enemy,
Led in with triumph shall he be.*

Hostibus occisis victor plausuque sonoque,
accipitur. Miles voce triumphe canit.

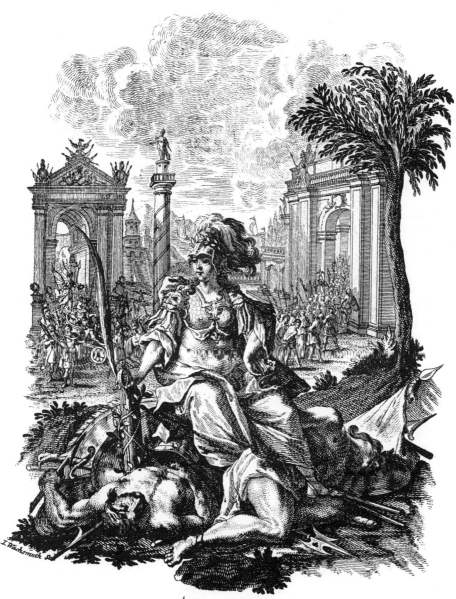

Der Sieg.
Wer obsiegt und die Feinde fält
mit vil Triumph den Endsig hält.

Eichler　　　　　　　　　　　　　　　　　　　Hertel excud.

79

PEACE

Let the ox be yoked and the seed be planted in the plowed earth;
peace nourishes Ceres, Ceres is the friend of peace.

The personification of Peace is a winged young woman dressed in white, with a wreath of grain and olive branches on her head and a palm frond tucked under her arm. She puts a flaming torch to a heap of weapons and banners. Nearby a putto is seated on an overflowing horn of plenty, holding an olive wreath in his hand. Above flies a winged putto, wearing an olive wreath too; he holds a banner inscribed "Concordia res parvae crescunt" (Through concord small things grow great).

The olive was always a symbol of peace, among the Greeks and Romans as well as in the Bible. The wreath of grain and olive represents the fruits of the earth, necessary to mankind, which can only be produced in time of peace. The cornucopia is the symbol for the abundance which is the result of peace. The woman sets fire to the heap of arms, for universal peace and love between peoples consumes the evidence of hatred and violence.

[Ripa, 1603, pp. 375–378]

The *fatto*: In another apparently invented allusion to peace, Divine Providence, as depicted later in Plate 162, and Concord (Ripa, 1603, p. 81) stand flanking a globe of the earth and hold a palm frond and an olive branch over it. Behind them, between two obelisks wound with laurel, symbolizing victorious peace, lies the warrior Mars, apparently now asleep. Although storm clouds and lightning can be seen over him, there is a rainbow in the sky above a round temple.

PEACE

Where Providence joins with Unity,
The commonweal shall savéd be.

PAX.

Sub juga bos veniat Sub terras Semen eratus,
Pax Cererem nutrit, pacis amica Ceres.

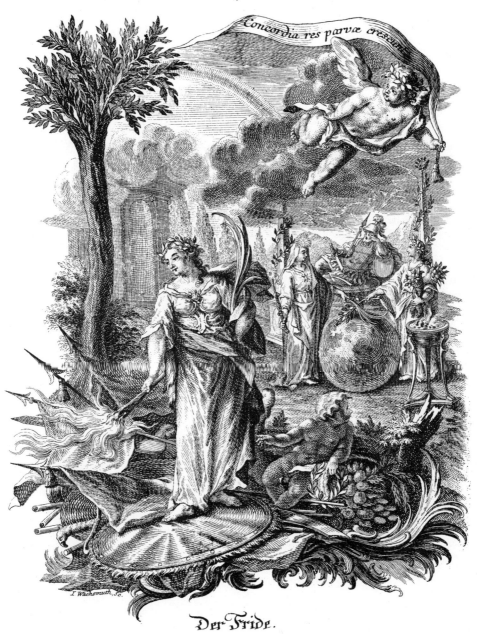

Concordia res parvæ crescunt

I. Wachsmuth, Sc.

Der Fride.

Wo Providenz und Eintracht paart,
da wird der Völcker Heyl bewahrt.

Eichler, del. :

Hertel, excud.

80

LOVE OF VIRTUE
All is aflame and buried in tragic ashes; the aged escape,
a woman looks for the incense [to placate the gods].

The personification of Love of Virtue is a winged young boy, scantily draped, and wearing a laurel wreath in his blonde hair. He holds two other laurel wreaths in his right hand, and yet another one in his left. Love of Virtue is fair and young for this love exceeds all other kinds in its lofty nobility, just as virtue itself is superior to all other qualities known. The laurel wreaths are a sign of great honor, for the laurel is evergreen and the form of the wreath is a circle, hence a perfect form, without beginning or end, just as virtue is perfect. The fact that he wears one wreath on his head implies prudence, a necessary quality for the virtuous. The three wreaths in his hands are the three cardinal moral virtues: Justice, Fortitude, and Temperance. The number three is moreover, a perfect number, and a very important mystic one.
[Ripa, 1603, pp. 18–19]

The *fatto:* The city of Catania in Sicily is seen, being engulfed and set aflame by the wildly erupting Mt. Etna. Out of the city gates, Amphinomus and Anapus carry their aged mother and father.
[Valerius Maximus, V, 4]

LOVE OF VIRTUE
Citizens rescue from the fires
Their belovéd dames and sires.

Cuncta jacent flammis et tristi mersa favilla,
Aufugiunt cani, foemina tura petit.

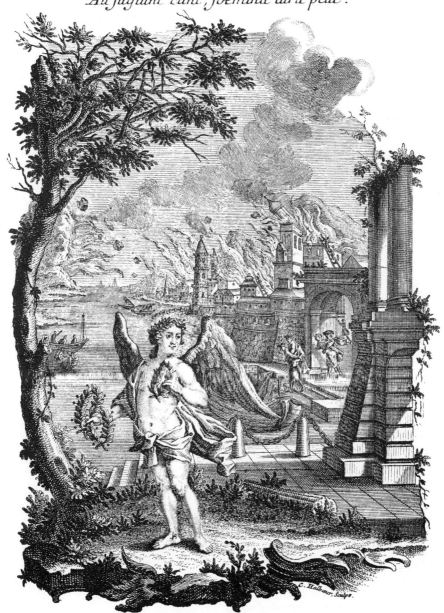

Liebe zur Tugend.
Bürger, retten aus den Flammen
Ihren allerliebsten Stammer

Eichler. del. Hertel, excud.

Part V

Histories

and

Allegories

Designed and drawn

by Gottfried Eichler the Younger;

Published by the Author

Johann Georg

Hertel,

Augsburg

From an open grave, a bearded sage, the philosopher Heraclitus, rises up and, holding a handkerchief to his face, weeps at what he sees. Under the cartouche with the title lies the slab which had covered the grave, bearing the inscription "Tumulus Heraclyti" (The tomb of Heraclitus). Behind him, a high pedestal which supports a sarcophagus bears the inscription "Sta Viator et considera Monumentum Philos. antiqui" (Stay, traveler, and contemplate the monument of the ancient philosopher). The object of the philosopher's grief is seen in the middle ground, where, in an open, round, domed, room, a man, obviously representing human intellectual activity, is seated at a table reading and calculating. The building is topped with statues of Apollo, Minerva, and Philosophy with her book and scepter. In the background, a group of connoisseurs stroll among ruined buildings and pause to study a landscape painting hanging there. They probably represent the study and criticism of art and architecture. The entire subject is the contrasting counterpart to the representation of Democritus in the allegory of Laughter (Plate 67).

Out of the grave I rise forlorn,
To tempora *and* mores *mourn.*

It túmulo vultû deploraturus acerbo
ætatem miseram progeniemque malam.

Pars VI.
Historiæ
et
Allegoriæ
Projectæ ac designatæ
à Gottfr. Eichler jun.
Excusæ ab Auctore
Joh: Georgio
Hertel
Aug: Vind:

I. Wachsmuth. Sc:

Seu Viator
si consideras
hoc monumentum
Pulvis antiqua

Ich muß aus dem Grab erscheinen,
Zeit, und Leuthe zu beweinen.

PREDICTION OF HAPPY EVENTS
*She who is completely ignorant of wedlock and man's touch
has given birth to God with her virginity intact.*

The personification is a seated elderly woman dressed in more or less medieval costume, with a six-pointed star on her head. She holds an augur's staff (which looks like a shepherd's crook); there is a scroll on her lap and others on the ground beside her. She points upward to a bird. A swan swims at her feet, and a globe of the world and an obelisk are behind her.

Obviously a prophetess of some sort, she is probably supposed to be the Cumaean Sibyl, who predicted the Annunciation to the Virgin (see Ripa, 1767, V, p. 126), but she has been combined with the allegories for "Augurio Buono," the Prediction of Happy Events, which Ripa presents in the figure of a youth, and Divination, described as a woman. Many different features are present here. The star is the ancient symbol of good fortune and happy success. The woman should be dressed in green, which is the color for favorable augury, since the green plants foretell the coming of the fruits and good crops. The staff is the

kind with which augurs are always represented. The swan was often considered to be the bird of phophecy, being sacred to Apollo (Plato *Phaedrus*, and Vergil, *Aeneid*, I), and its song was called a foretaste of heavenly joy (Aelian, *De natura animalium*, V, 34), which would certainly be appropriate here, at the Annunciation. The obelisk refers to ancient Egypt, land of magic, and the globe, of course, to the worldwide importance of this particular joyous prophecy. The Sibyl looks and points upward to the birds, for one of the favored forms of augury among ancient peoples, especially the Romans, was the interpretation of the flight of birds.

[Ripa, 1603, p. 33, "Augurio Buono"; Ripa, 1765, II, p. 258, "Divinazione"]

The *fatto:* Behind the figure of the Sibyl, the Annunciation to the Virgin can be seen, with the Dove of the Holy Ghost floating above, and the Angel Gabriel in the clouds.

PREDICTION OF HAPPY EVENTS
*Heav'n told Mary joyously,
That without sin, with child she'd be.*

PRÆDICTIO BONI.

Quæ penitus thalam tactusque ignara virilis,
Peperit intacta virginitate Deum

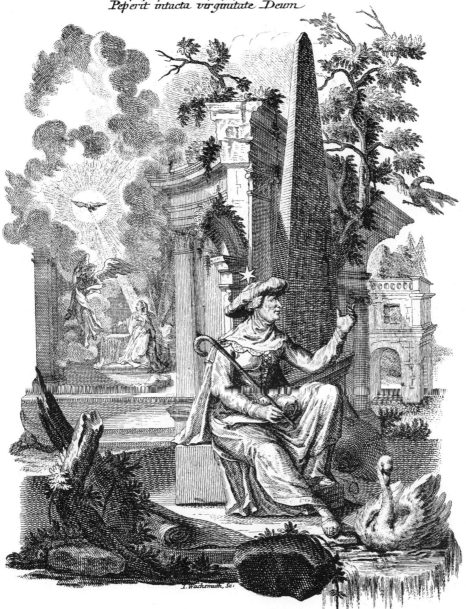

I. Wachsmuth, Sc.

Weißagung des Guten.

Mariæ wird daß Heÿl verkünd
gebähren soll Sie ohne Sünd

Eichler, del.

Hertel, excud.

DOCTRINE
*That which you should shun and do, the gentle tongue of Christ teaches
in the holy Temple; with this guide you will be secure.*

The personification of Doctrine is a seated woman of mature age, dressed in iridescent purple (like that of a peacock), with an open book in her lap; she extends her open arms. In one hand she holds a scepter tipped with the sun. Behind her, dew falls to earth from a cloud.

She is of mature age, for it takes much time to learn and to understand doctrines, be they sacred or secular. The open book and the open arms represent the liberality of doctrine, which tries to embrace all and explain all to those willing to hear. The scepter with the sun represents the dominion of doctrine over the horrors of the night of ignorance, the sun being the symbol of light and truth. According to Horapollo, the dew which makes young plants tender and causes old plants to harden and toughen, is like doctrine, which makes young minds malleable and receptive, while it ignores the naturally ignorant and obstinate mind.

[Ripa, 1603, p. 113]

The *fatto:* Through an archway with a cartouche atop it inscribed "Pietas est fundamentum virtutum omnium" (Piety is the basis for all virtue), the twelve-year-old Jesus is seen preaching to and arguing with the elders in the Temple. Prominently displayed are the Tables of the Law.

[Luke 2: 42–52]

DOCTRINE
*What Christ did teach within the Temple
Should serve for others as example.*

Quid fugias peragasve docet Christi pia lingua ,
ædibus in sacris. Hoc duce tutus eris.

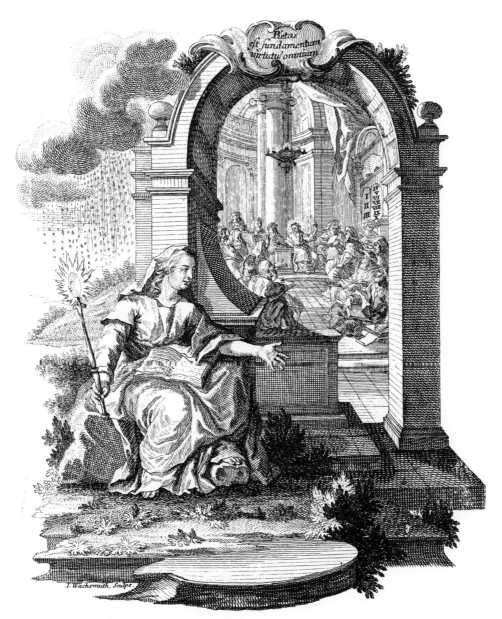

Pietas
est fundamentum
virtutum omnium

Die Lehre.
Christus lehret in dem Tempel,
dienet andern zum Exempel.

I. Wachsmuth, Sculps.

Eichler del. Hertel excud.

84

FAITH

Regarding his son, Abraham had faith in You, Father of the world,
You who are ready to sacrifice Your own Son.

The personification of Faith is a woman dressed in white and wearing a helmet, who stands on a low pedestal and reads a book held in one hand. In her other hand she holds a heart bearing a lighted candle. Next to her a putto holds a large cross and a chalice, topped with the Host, which bears the image of the Lamb of God. At her feet lies the Decalogue.

Hertel has combined two allegorical figures of Ripa, Catholic Faith and Christian Faith, to make a composite figure. White is, of course, the symbol of purity and the unique nature of Faith. The open book and the Decalogue represent the Old and New Testaments, the source of learning and maintaining faith. The figure wears a helmet, a protection for the head, to indicate that her mind is well protected against the injuries and dangers of false doctrines. The heart and the lighted candle show the illumination of the mind brought about by faith, which comes from the heart and not just the brain. The light chases away the shadows of ignorance and lack of faith. The Cross and the chalice with the Host represent the two main elements of Christian faith according to St. Paul, the belief in Christ crucified and in the miracle of the Sacraments.

[Ripa, 1603, p. 149, "Fede Cristiana"; pp. 150–151, "Fede Cattolica"]

The *fatto:* In the background is the well-known scene from the Old Testament which was considered an allusion to God's sacrifice of His own Son on the Cross; Abraham about to sacrifice his son Isaac at God's command. The angel stops his hand, for his faith has been tested, and a ram is substituted for the boy.

[Genesis 22: 1 ff.]

FAITH

Abraham submitted to God's will,
Tried the sacrifice to fulfill.

In qua prole patrem mundi te credidit Abram
Es promptus sobolem Sacrificare, tuam

L. Wachsmuth. sc.

Der Glaub.

Abraham nach Gottes Willen
sucht das Opffer zu erfüllen.

Eichler. del. *Hertel. excud.*

85

CONFIDENCE
The disciples, trusting in Christ, spread out their nets;
thus a great and varied haul of fish is made.

The personification of Confidence is a woman with long, loose, wavy hair, dressed in flowing garments. She holds a two-masted ship in her arms and looks confidently heavenward. Ripa's definition of confidence is the recognition of imminent danger with the simultaneous firm belief in escaping it unscathed. The sailing ship is a symbol for confidence, for mariners must be well supplied with it when they venture out in ships upon the dangerous seas (Horace, *Odes*, I, 3).

[Ripa, 1603, p. 82]

The *fatto:* Christ and His disciples in two boats have cast their nets into the sea, as He had told them to, and are hauling them in full of fish.

[Luke, 5, 1–11; John 21, 1–8]

CONFIDENCE
Since Christ's command they had not spurned,
A mighty catch of fish they earned.

Discipuli Christo confisi retia pandunt,
hinc ingens capitur variorum turba natantum.

I. Wachsmuth, Sc.

Das Vertrauen.

Christi Wort die Jünger trauen,
alßdañ reichen Fischfang schauen.

Nichler. del.

Hertel, excud:

HUMILITY
That foolish pride might not spoil excellent behavior, Christ,
once and for all, set before us an example of humble service.

The personification of Humility is a barefoot woman in a humble pose, with downcast eyes and arms crossed on her breast. She is dressed in simple garments of white and grey, and holds a ball in one hand. At her feet are, on one side, a golden crown, and on the other, a lamb.

Her general appearance, pose, and dress are indications of the inner recognition of one's inadequacy and lack of merit, which characterizes the humble. The ball she carries represents the idea that, like a ball thrown into the air, which must come down again, or like a ball bounced on the ground, which returns, the

truly humble person remains aware of his humility, no matter how highly placed or with what force he may experience a change of condition. The crown underfoot shows that true humility places no value on the greatness of this world or on its exterior signs. The lamb is the symbol of the meek and peaceful man, that is, of Christ.

[Ripa, 1603, p. 214]

The *fatto:* In a lighted banqueting hall, Christ, surrounded by the disciples, is seen washing the feet of one of them.

[John 13: 3–17]

HUMILITY
What better model can there be
Than the Master serving to see?

SUBMISSA MENS.

Inquinet egregios ne stulta Superbia mores,
Semel proposuit nobis Christus famulatus.

I. Wachsmuth. Sculp.

Die Demuth, Nidrigkeit,

Der Meister dient, und macht den Knecht,
ists Beyspihl vor die Jünger recht?

Fuchler. del.

Hertel. excud.

PATIENCE
*Job is struck down by affliction; patience, which knows
how to support ill with a strong heart, wins through.*

The personification of Patience is an elderly woman sitting on a rock, her hands clasped before her. She is dressed in dark grey and wears sandals. Under her feet are thorny vines, and a lamb lies beside her.

Advanced years being the time when sorrow and affliction are likely to appear, she is shown old. Her pose, the clasped hands, and sorrowful expression indicate that patience reveals itself in times of sadness and distress. The fact that she is seated on a rock is a visual pun, which is, as has been seen, one form of visual metaphor. Knowing how to have patience in adversity is a very *hard* thing to do, but the truly patient manage it easily. The thorns underfoot are the many pricks and pinches our honor and spirits suffer from the sorrows of life. But, as here, they only bother the feet of the patient,

his most "earthly" parts, and therefore only have meaning and importance in the purely physical sense. The head, the most noble part of man, and the rest of his body, do not feel them. In other words, they do not affect the soul. The lamb, meek and mild, is also a sweet-tempered animal, as is the patient person. As the symbol for Christ, it is also the symbol for Christian patience in suffering.
[Ripa, 1603, p. 380]

The *fatto*: Exemplifying patience in suffering and faith in God is Job, seen covered with boils, lying naked among his friends. Above him flies the devil with a scourge, the source of the plagues which torment him.
[Job 2: 7–13]

PATIENCE
*His plagues and boils Job did sustain,
For to his God he'd not complain.*

PATIENTIA.

Afficitur poenis Iobus; patientia vincit,
quæ novit forti pectore ferre malum

I.Wangner, Sculps.

Die Gedult.

Hiob dulcet Creuz und plagen
will un Gott doch nicht verdagen.

Eichler, del.

Hertel, excud:

SERVICE
*Scarcely has the evil demon abandoned Christ and vanished into
thin air, when at once the heavenly hosts appear.*

The personification of Service is a fair young man dressed in a short white coat and with wings on his feet, who holds one hand to his breast and has a lighted candle in the other. He stands amid thorn bushes. Beside him is a crane holding a stone in one foot. In the foreground is a cartouche bearing the inscription "Aliis inserviendo, me consumo" (In serving others, I consume myself).

He is young, for youth is the time of life when labor can best be supported. His coat is short, for there should be no hindrance in performing true service; it is white, because that is the color of the purity of the true servant's loyalty. His feet are winged, for good service is performed with speed and dispatch.

The lighted candle alludes to the motto in the cartouche, for in giving light, the candle is consumed, just as the good servant wears himself out in waiting on the wishes of his master. The thorny ground represents the pains and suffering which the man in servitude often must endure. The crane with the stone has already been described as the symbol of vigilance (Plate 51), which is a prime requisite for true service.
[Ripa, 1603, p. 450]

The *fatto:* Christ is being served by angels in the wilderness, after being tempted by the Devil and withstanding him.
[Matthew 4: 11; Mark 1: 13]

SERVICE
*Still pure from Satan's snare preserved,
Our Lord is now by angels served.*

SERVITIUM.

Deservit Christum terræsque recessit in auras,
vix Dæmon torvus, mox astant agmina sacra.

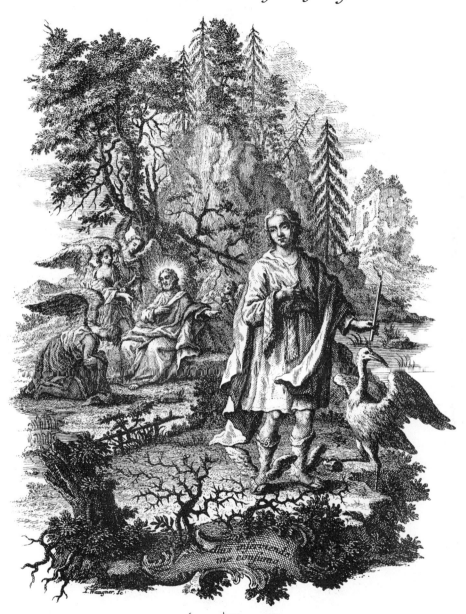

J. Wangner, Sc.

Der Dienst.

Weil Satan weg, der Herr allein,
drum stellen sich die Engel ein.

Eichler, del:

Hertel, excud:

89

OBEDIENCE
An obedient spirit led Christ to suffer so many trials,
to undergo so many toils, verily, even a wretched death.

The personification of Obedience is a woman of noble countenance dressed in white robes, who holds over one shoulder a yoke from which depends a ribbon inscribed "Suave" (Sweet). She looks lovingly at a crucifix which she holds up in her other hand.

The yoke with the motto represents the ease of obedience, when spontaneous and voluntary —gentle submission. The woman wears white for its purity; the crucifix she holds symbolizes the obedient person's love of religion, which, indeed, requires obedience of the true believer.
[Ripa, 1603, p. 363]

The *fatto sagro* is the greatest example of obedience to God, Christ allowing Himself to be crucified for the sake of mankind.

OBEDIENCE
Christ, as Gospel hath maintained,
Obedient unto death remained.

Volvere tot casus Christum tot adire labores,
quin mortem miseram mens impulit obsequiosa.

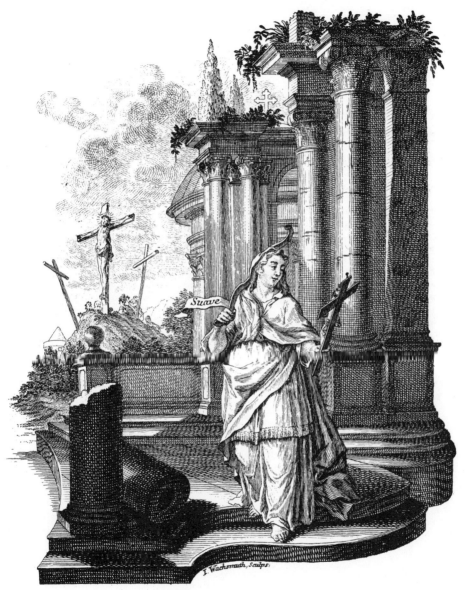

Der Gehorsam.

Christus wie dort steht geschrieben,
folgsam biß in Tod verblieben.

Eichler. del: Hertel. excud:

HYPOCRISY

*The Pharisee, hiding his sin with fine words, wished to appear
more virtuous than the publican before God.*

The personification of Hypocrisy is a lean and pallid female, her head covered and lowered, dressed in a shoddy and ragged garment of dark grey, who reads from a prayer book which she holds. With her other hand she ostentatiously offers alms to a lame and ragged young beggar crouching at her feet. Her feet, however, are not those of a human, but of a wolf. She stands before a church collection box with a slot in its top; on the steps before her is a cartouche inscribed "Exemplis non est judicandum sed legibus" (One should judge not by actions, but by principles).

She is lean and pale and generally shabby, for hypocrites often neglect their appearance so that they will not be thought vain or concerned with worldly things. Her covered head indicates false humility, and the open prayer book a false show of religious devotion. Her dark grey garb is made of linsey-woolsey (in Italian *mezzalana*, literally half-wool); it is half of wool and half of linen. It symbolizes those who present a false appearance of innocence to the world, for wool represents the good, and flax, evil. The very public giving of alms is a variety of hypocrisy, for it seeks praise and attention for being charitable. Her feet show that hypocrites are, as St. Matthew said, like lambs outside, but ravening wolves inside.
[Ripa, 1603, p. 200]

The *fatto:* One looks through an archway, over which hangs a cartouche inscribed "Vive ut vivas" (Live so that you may live [hereafter]), into the Temple. There, before the altar on which rest the Tables of the Law, kneels the Pharisee in prayer, while the tax gatherer stands outside, bowing in reverence. Represented is the parable of the Pharisee and the publican.
[Luke 18: 9–14]

HYPOCRISY

*In God's eyes the Pharisee
More than he is would wish to be.*

HYPOCRISIS.

Obvolvens pulcris vitium verbis Pharisæus,
justior esse Deo coram voluit publicano.

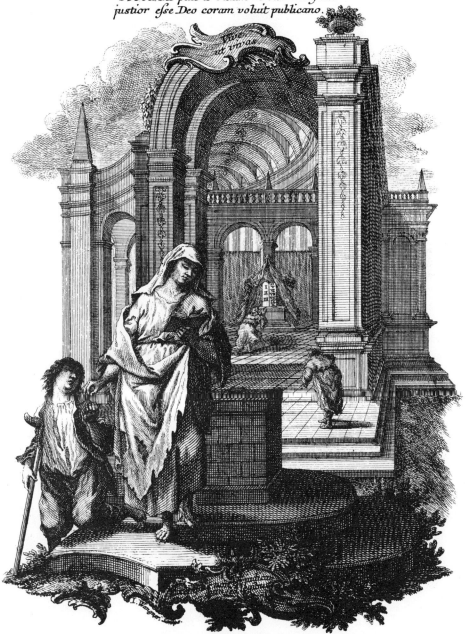

Die Heucheley.

Der Pharisäer nach dem Schein,
vor Gott will mehr als Zöllner seyn.

Kichler. del.

Hertel excud:

IMPIETY
*Three times impious Jezebel ignored the terrible commands of God;
now dogs rend her body and entrails with their teeth.*

Against a fanciful ruined setting, stands a woman of uncertain years, but no longer young, the personification of Impiety, who sets fire to a pelican's nest with a flaming torch. She is dressed in verdigris green. At her feet lie some dead pelican chicks, while behind her a hippopotamus is seen (apparently Eichler preferred to design a classical sea-horse here rather than the African animal).

The color of her dress denotes her malign nature. Her brutal destruction of the pelican with its young, a well-known symbol for charity, loving self-sacrifice, and the Church (the pelican, to feed its hungry young, would tear open its own breast to nourish them with its blood, if no food were to be had), means that the impious willfully destroy the efforts

of the charitable for their own selfish ends. The hippopotamus also represents impiety, for it was believed that when it matured it strove to copulate with its mother; when the father resisted, the wicked beast slew him. The impious person is much the same; in order to satisfy his own raging appetites, he will sacrifice even his benefactors and his own family.

[Ripa, 1603, p. 224]

The *fatto:* Wicked Queen Jezebel is torn to bits by dogs, after King Jehu, seeing her on her balcony while driving by in his chariot, has ordered the impious and lascivious woman thrown down to her death.

[II Kings 9: 29–37]

IMPIETY
*Evil was Jezebel's sole creed,
'Til dogs upon her flesh did feed.*

Iussa verenda Dei ter Iezabel impia Spernit,
Et laniant corpus, viscera, dente canes.

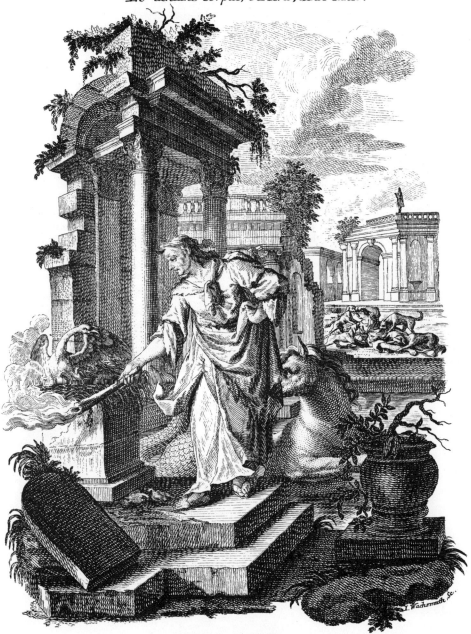

Die Gottloßigkeit.

Iesebel lebt sehr vermessen,
Sie zulezt, die Sunde freßen.

Eichler del. Hertel excud.

DISOBEDIENCE
He who once was the happy resident of Paradise lost it
through forbidden fruit and the Serpent's wiles.

The personification of Disobedience is a woman with a resolute frown on her face. She is dressed in red and wears three peacock plumes in her hair. She is standing on a bridle. At her feet lies an asp, with one ear held to the ground and the tip of its tail covering the other.

Disobedience—the deliberate and voluntary transgression of divine and human laws—holds her hand upraised to indicate the firm resolve needed to so transgress. The color of her robe indicates the same qualities. The peacock plumes signify that disobedience comes from pride and presumption. The bridle trampled underfoot shows that the uncontrolled satisfaction of passions and appetites can lead to disobeying laws. The asp covers its ears so that it will not hear the voice of the singer, the snake charmer—a reference to Psalm 58: 4, 5. [Ripa, 1603, p. 236]

The *fatto* shows Man's first act of disobedience, the eating of the forbidden apple in Eden. Eve plucks the apple from the tree while Adam looks on, as does the Serpent in the tree. [Genesis 3]

DISOBEDIENCE
Alas, Man did all fair Paradise forfeit
When he, the Serpent's pawn, into the apple bit.

INOBEDIENTIA.

Incola qui quondam fuerat felix Paradisi,
hunc perdit vetito fructu, serpente doloso.

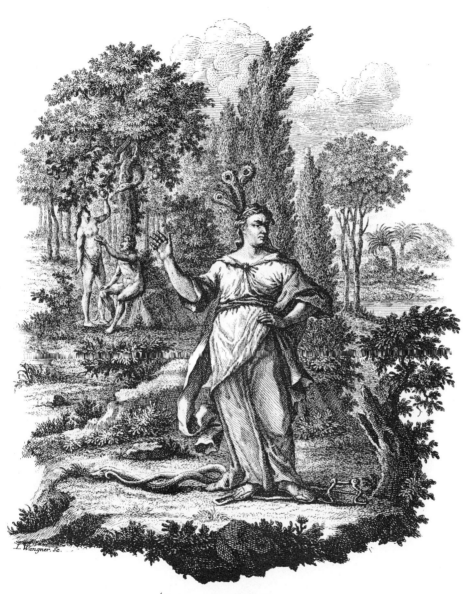

L. Wangner, Sc.

Eichler. del.

Der Ungehorsame.
Der Mensch verlohr das Paradiß,
durch List der Schlang u: Apffel biß

Hertel, excud.

93

DEBT
The master pardons his servant and forgets his guilt;
he, however, imprisons his fellow for his debts.

The personification of Debt is a ragged young man who leans disconsolately against a parapet. He wears a green cap. Around his ankles are heavy iron bands. He holds a basket in his mouth, and a whip with weighted thongs in his hand. Behind him is a large hare.

He is young, because in youth people are often careless about money and tend to incur debts. Since he is in debt, he has no credit and must go about in rags. The green cap is the sort which, in some countries, debtors were required to wear (to be *ridotto al verde*, reduced to the green, is still an Italian expression for being penniless). In the past, debtors were often put in iron manacles, but the Boeotians are said to have condemned debtors to sit in the public square with an empty basket held in their mouths, to signify that they had eaten up all their substance. Up to the time of Constantine, Roman debtors were whipped with such whips as shown here. The hare is like a debtor, always afraid of being caught, and therefore habitually timid. But if the debtor is smart, he can run like the wind, as the hare does.

[Ripa, 1765, II, p. 121]

The *fatto*: Before a palace topped with an image of Justice, a seated crowned man, richly garbed, is apparently pardoning a servant, who gesticulates vehemently. This same servant is then seen in the background, laying hands on another, apparently arresting him for the same crime for which he himself had been pardoned. This is the parable of the merciless servant.

[Matthew 18: 23–35]

DEBT
Though the knave's trespasses pardoned be,
Of doing likewise thinks not he.

Dat veniam servo Dominus culpamque remittit,
hic contra socium vinclis ob debita claudit.

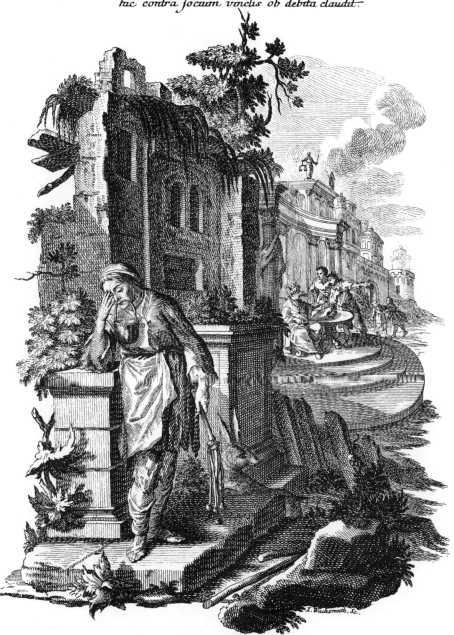

I. Wachsmuth, Sc.

Die Schuld.

Dem Schalcks-Knecht wird die Schuld geschenckt,
Er aber nicht deßgleichen denckt.

Eichler. del :

Hertel excud:

CALUMNY
*The impious is not afraid to injure even the just
with his malicious tongue, and never sees his own defects.*

The personification of Calumny is a woman of ferocious aspect, wearing classical armor, her helmet topped with a basilisk. She holds a long trumpet in one hand and points with the other. Behind her, on the ground, is a flaming brazier.

Here Hertel made up another composite personification. Some of the elements come from Ripa's description of Calumny, but others come from those of Detraction and Blame. The woman is armed, for calumny, like the fierce warrior, causes fear. Her weapons are intended to wound the body, just as calumny wounds the spirit. The basilisk, or cockatrice, on her helmet is a mythical beast with a cock's head and a stinging serpent's tail; its look alone was lethal, and was like calumny, which also harms without contact. The long trumpet is used to spread calumnies far and wide, and also produces an ugly sound, just as do voices raised in calumny. The flaming brazier represents the destructive power of calumny and its power to make the guilty redden with shame, their faces enflamed. The pointed finger is that of derision.

[Ripa, 1603, p. 47, "Calumnia"; p. 103, "Detrattione"; p. 434, "Riprensione"]

The *fatto:* A man leans forward, pointing to something in the eye of an older man seated against a wall. He is apparently pointing out the mote in his eye, for from his own eye a whole piece of wood protrudes. It is the parable of the mote in the eye, teaching that the man who notes the faults of others should be aware of what are perhaps greater ones in himself.

[Matthew 7: 3; Luke 6: 41]

CALUMNY
*Who others' failings quick assaults,
Is often blind to his own faults.*

CALUMNIA.

Non timet et justos petulanti lædere lingua,
Impius, et numquam perspicit ipsa mala.

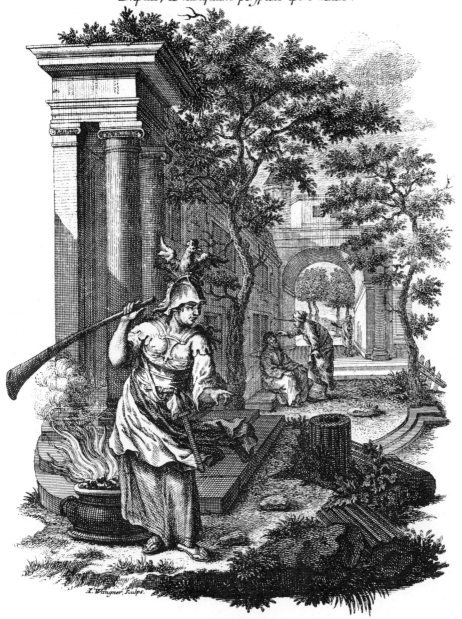

I. Wangner, Sculps.

Das Splitter-Richten.

Wer andre schilt und Splitter richt
sieht selbsten offt den Balcken nicht

Eichler. del: Hertel excud

MENDACITY
*Ananias, who wished to fool Peter with his words,
paid for his crime with sudden death.*

The personification of Mendacity is an ugly and rather common-looking young girl dressed in a garment of shifting colors, who stands with her back to the viewer. She wears a cloak decorated with masks and tongues. She is lame, leaning on a crutch, while one leg is raised on a short wooden support. In one hand she holds a burning bundle of straw, and in the other a mask.

She is young but ugly, for lying is a vice of the base and servile. By her elegantly colored dress, she is trying to make things seem what they are not. The mask in her hand and the masks and tongues on her cloak represent the falsehoods she invents to mask the truth, and the lies she tells. A lie, like ignited straw, which quickly flares up and as quickly dies out, is quickly invented and quickly used up. She is crippled because, as an Italian saying goes, lies have short legs—that is, one doesn't get very far with them.

[Ripa, 1603, p. 46]

The *fatto:* Ananias is struck dead at the words of St. Peter, whom he has tried to mislead with his lies. His wife, Sophia, looks on, not yet suffering the same fate, but about to.

[Acts 5: 1–11]

MENDACITY
*Petrus the swindle had decried;
Ananias to his god had lied.*

MENDACIUM.

Fallere qui voluit Petrum verbis Ananias
admissum crimen morte luit Subita.

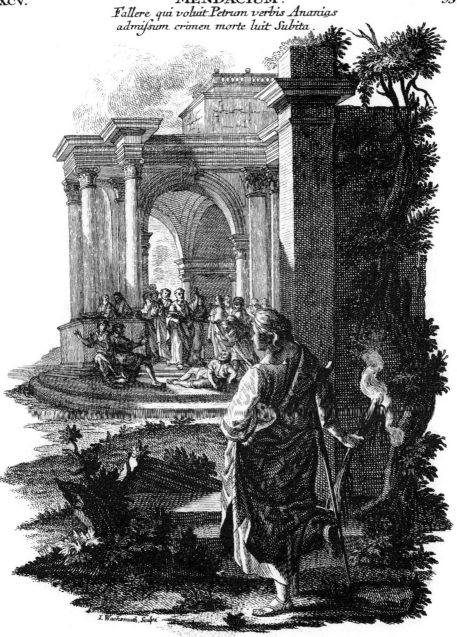

J. Wachsmuth, Sculps.

Die Lügen

Petrus hat es wohl erwogen.
Anania Gott gelogen.

Eichler. del. Hertel, excud.

HERESY

Arius schemes in vain to destroy the doctrines of Christ;
the Fathers win, and the dogmas remain firm.

The personification of Heresy is an ugly old woman of terrifying aspect, almost nude and with her long, dried-out breasts exposed, her hair wild and tangled. She stands holding a book against her hip. In her other hand she holds a bundle of wriggling snakes, some of whom are falling, scattered, to the ground. Fire and smoke issue from her mouth. At her feet, an old ragged book is propped against a broken column.

She is old, because just as old age is the last stage in the life of man, so heresy is the last and lowest level of perversity. She is ugly, for she is utterly lacking in faith, Christianity, or truth, all of which are beautiful and make people beautiful. She is totally without virtue, and hence is nude. Her wild hair represents her evil thoughts; her dry breasts, like heresy, are deprived of all vigor. The fire and smoke from her mouth symbolize the false arts of persuasion used by the heretic and his desire to consume all ideas that oppose him. The book she holds is full of false doctrines. The snakes are heresy's abominable ideas, and she is busy spreading them about.

[Ripa, 1603, p. 216]

The *fatto storico sagro* is the Council of Nicaea (325 A.D.), where the assembled Church Fathers command Arius to stop his heresy concerning the nature and substance of Christ. He, standing at the opposite side of the table, rebels.

HERESY

Arius' teachings sure shall be
Eradicated gradually.

Sternere doctrinas Christi molitur Arius,
nec quicquam. Vincunt patres; stant dogmata firma.

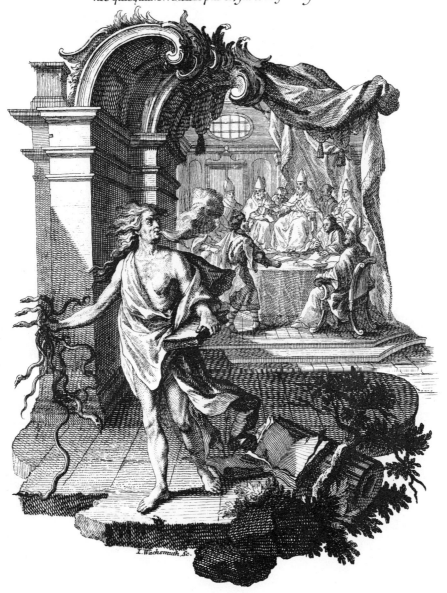

L. Wachsmuth. Sc.

Die Ketzerey.

Arii Gotts vergeßne Lehr,
ward verfolgt je mehr und mehr.

Eichler, del: Hertel, excud:

REFORM
Josiah the just destroys the images of the gods;
the king and people offer pure hearts to God.

The personification of Reform is a smiling elderly woman, simply dressed, who holds in one hand a curved pruning knife, and in the other an open book inscribed "Pereunt discrimine nullo Amissae Leges" (Abandoned laws disappear without making any difference). She stands on a heap of broken idols, augur's equipment, scrolls, and a broken obelisk covered with hieroglyphics.

She smiles, for reform is a beneficent action. She is elderly, because Plato, in his *Republic*, considered advanced age the proper one for reforming and ruling others. Her clothing is of great simplicity, for sumptuous dress can lead to excess. Just as the pruning knife is used to cut off the excess growths on a plant, so reform does with man's laws. The book represents laws and constitutions written down for posterity, and the sense of the motto, which comes from Lucan (*De Bello Civili*, Book III), is that laws should always be brought back to their original meaning. Although such things all seem to refer to civil reform, the heap of idols and other things related to idolatry and superstition makes this an image of religious reform, the purifying of religious practices as well. Among the idols can be seen the bull's head of Apis, the falcon's head of Horus, and the head of Diana crowned with the crescent moon. The augur's staff and the hieroglyphics refer to ancient soothsaying and magic.

[Ripa, 1603, p. 435]

The *fatto:* Josiah as king, seated on his throne, listens to the high priest Hilkiah read the long-lost and newly found Laws of Moses. Outside, obviously at Josiah's command, men hack away at pagan altars and sacred groves, and pull down an obelisk, while other men watch and marvel.

[II Kings 22: 8 ff.]

REFORM
Foreign idols and altars, Josiah destroyed
As in cleansing the Temple he was employed.

Deftruit Iosias justus, Simulacra Deorum,
Rex populusque ferunt, pectora pura Deo.

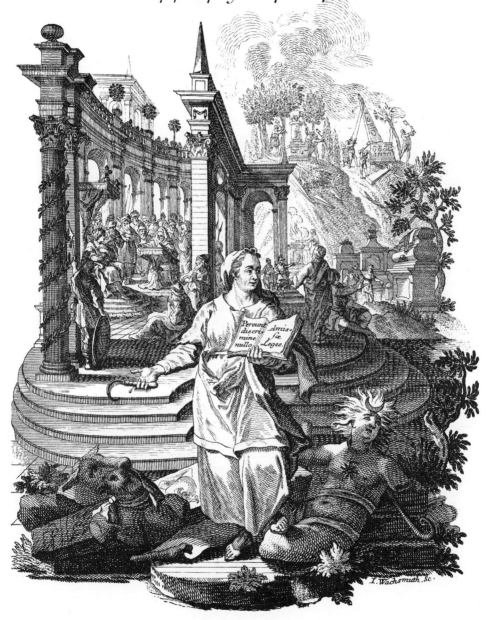

Reformation.
Iosias Bild, Altär zernicht,
nach dem Gesez im Tempel richt.

Eichler, del : Hertel, excud:

CONVERSION
Saul rages against Christ's flocks; a voice is heard from heaven:
"Why do you persecute me?" Believing, he is changed by the voice.

The personification of Conversion is a beautiful young woman, her white robe slipping from her shoulder but being held up modestly by her arms crossed on her breast. She is barefoot and has short clipped hair, her long blonde tresses lying on the ground in front of her. With tears in her eyes, she looks up at a beam of light from the sky. Behind her is an altar or pedestal on which rests a skull covered by a green scroll inscribed "In te Domine speravi" (In Thee, O Lord, have I trusted). At her feet are a jewel chest and a rich robe. Before her stands a hydra with its seven heads, wings, and pointed tail.

She is beautiful, for her soul, now that she has seen the light of God, is pure as the whiteness of her raiment. She weeps the tears of true repentance. Her long tresses, symbolic of vain thoughts, have been cut off and her mind is now directed solely toward God. The scroll with the trusting motto is green—the color of hope—and it covers the skull, for its promise of eternal life conquers death. The jewels and rich dress on the ground are the things of this world, which, like the long blonde locks, have been rejected. The woman stands fearlessly before the hydra, symbol of sin so resistant that it cannot be put down except with extreme difficulty.

[Ripa, 1765, II, p. 69]

The *fatto:* The conversion of St. Paul is the obvious historical allusion for this subject. He is seen falling, blinded, from his horse, as a voice from the heavens calls: "Saul! Saul! Quid me persequeris" (Saul, Saul, why persecutest thou me?).

[Acts 9: 1 ff.; 22: 6 ff.: 26: 12–18]

CONVERSION
The voice of God did persecuting Saul
Convert to Christ and make him Paul.

CONVERSIO.

Saul furit in gregem Christi, vox fertur ad auras ·
Quid me persequeris. Credens mutatur ab illa .

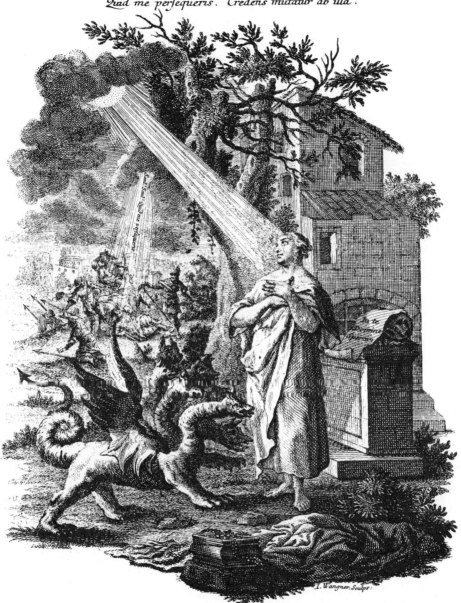

Die Bekehrung.

Saul verfolgt der Chriſten Orden ,
glaubt der Stim iſt Paulus worden.

Eichler. del :

I. Wangner. Sculps:

Hertel. excud

JUDGMENT
*Great was Solomon, but his glory grew when his spoken judgment
settled the strife between the mothers in their presence.*

The personification of Judgment is a
dignified-looking man in a long and heavy
robe, like that of a magistrate. He wears a
golden chain around his neck; hanging from
it is a heart-shaped pendant incised with the
image of Truth, which he contemplates fixed-
ly. On a ledge near him is a mirror encircled
by a serpent, symbol of Prudence. At his feet,
two putti sit among books. One of them looks
at an open book with an illustration of the
personification of Truth, with her book and
palm in one hand and a sun symbol in the
other. The man does, in fact, represent a
judge. He contemplates the image of Truth
on his jewel, for the proper judge should always
be studying truth (Piero Valeriano, Book LI).
[Ripa, 1603, p. 186]

The *fatto:* Through a very ornate rococo
opening, the judgment of Solomon is seen.
The young king, seated on his lion-supported
throne in an interior with twisted columns,
orders his soldiers to cut in two the infant
over which the mothers are quarreling. The
true mother, out of love for her child, offers
to give it up, as long as it is not killed. The
false claimant, mother of a dead child for
which she has wished to substitute the other's
child, looks on with equanimity, for if she
cannot have it, then the other shall not either.
From his observation of their reactions,
Solomon got at the truth and awarded the
living child to its proper mother.
[I Kings 3: 16–28]

JUDGMENT
*King Solomon's wise decision wrought
That the child to its true mother was brought.*

Magnus erat Salomo, sed crevit gloria, demta
Iudicio matrum lite per ora sua.

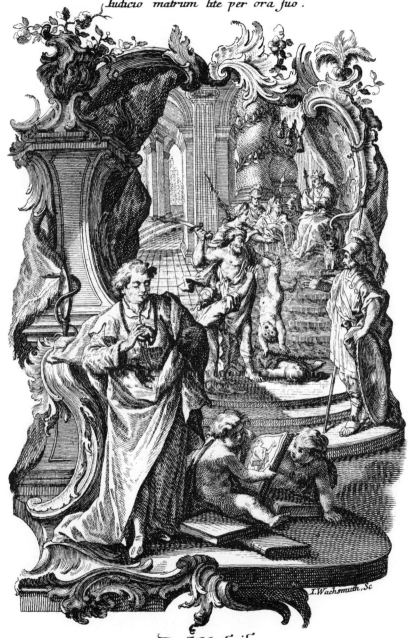

I. Wachsmuth, Sc.

Das Urtheil.
Salomonis kluges Richten
weiß der Mütter Streit zu schlichten.

Bichler, del.　　　　　　　　　　　Hertel, excud.

100

GRACE

*God, drying up the waters of the Deluge, gave a sign
of perpetual peace; the rainbow was the proof.*

The personification of Grace is a pleasant-looking woman with soft draperies covering her nude form. She sits upon a cloud. Her head is encircled with an aureole of light. She looks, smiling, up toward the heavenly light streaming down. She holds an olive branch in one hand, and with the other hand points to a chalice and book at her side. At her feet is another book, open, and behind her a cornucopia.

Her appearance is the one to be expected for such a treasured and desired quality as divine grace. Her seat on a cloud shows her to be not an earthly quality but a celestial one. She looks upward to Heaven, the source of heavenly mercy. The olive branch represents the sign ·the dove brought back to Noah that the waters of God's wrath had receded—the peace the pardoned sinner gains through grace. The

book is also a source of wisdom and divine grace. The chalice indicates that grace is a draught from God's cup of love. The aureole shows that grace is filled with God's light. The cornucopia is filled with things of sacred and profane use and many flowers. Hertel here combined two of Ripa's allegories, Divine Grace and Gratitude to God.

[Ripa, 1603, p. 195, "Gratia Divina" and "Gratia a Dio"]

The *fatto:* Noah and his family kneel in prayer after descending from the ark, seen high above, lodged on the peak of Mt. Ararat. A heavenly light streams down upon them in several beams, as they look transfixed into the sky, where a rainbow can be seen, God's promise of the remembrance of the Covenant.

[Genesis 9: 8–17]

GRACE

*God's sign to Noah doth ensure
That the Covenant shall endure.*

Pacis perpetuæ dedit inviolabile pignus,
Diluvium sivans, iride teste, Deus.

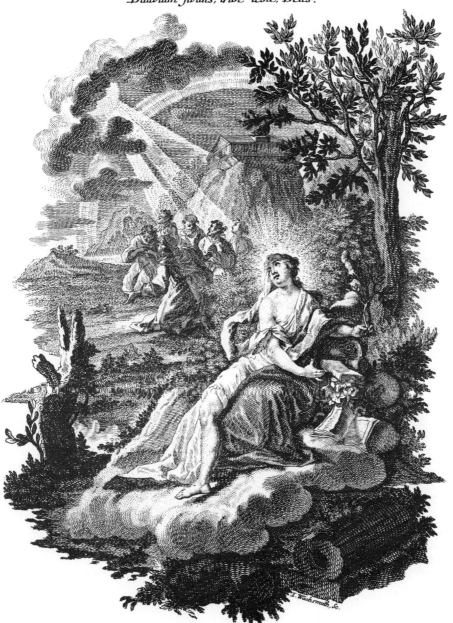

I. Wachsmuth, Sc.

Die Gnade.

Gott zeigt Noæ durch ein Zeichen,
daß sein Bund nicht solle weichen.

....del: *Hertel, excud:*

If, O sly Momus, you point out every vice and disparage all behavior, I wish you would first look within yourself.

Part VI

Histories

and

Allegories

Designed and drawn

by

Gottfried Eichler the Younger;

Published by the Author,

Johann Georg Hertel, Augsburg

Behind the title cartouche, a man, obviously representing the artist, crouches, with a scroll and brush lying before him and next to him a lamb, symbol of meek and patient innocence. He holds, propped up against a book, apparently the Hertel edition of Ripa, a mirror to permit Momus to see his reflection in it.

Momus, the Greek personification of criticism and ridicule, is a composite figure here, obviously an invention of Eichler. He is made up of a number of different allegorical figures from Ripa, although it is chiefly "Biasimo vittioso," Vicious Criticism, which he represents with the god Momus. He is lame, and supported on crutches. He holds a glass to one eye, and points with his free hand. He wears a hedgehog skin. Instead of hair, he has a head of serpents, and he has donkey's ears.

He is lame because the Lie, one of the components of the figure as taken from Ripa, has, according to an old Italian proverb, short legs —is crippled, in other words and thus does not get very far. His snake-hair comes from the description of Envy, and represents evil thoughts. From the allegory of Defamation, he gets his hedgehog pelt, which has spines like the pricks of evil gossip; just as the spines prick the flesh, so does gossip prick the reputation. The personification of Derision, which also wears a hedgehog skin, provides the ass's ears and the pointing finger—which could also come from Arrogance. The eyeglass indicates that it is others who are being watched and criticized. The scene takes place before a classical ruin flanked by statues of Mercury, god of business affairs, and Apollo, patron of the arts—obviously the patron deities of Hertel's whole enterprise. Beyond, a handsome Italian villa can be seen.

[Ripa, 1603, p. 27, "Arroganza"; p. 44 "Biasimo vittioso"; p. 46, "Bugia"; p. 101, "Derisione"; p. 242, "Invidia"; p. 302, "Maldicenza"]

If Momus wishes my book to decry,
His own fool image he should espy.

Omne vafer vitium si tangis, Mome secasque
mores inquiras velim tua viscera princeps

Solte Momus mein verachten
mag er sich mir selbst betrachten.

EUROPE

It leads the rest of the world, for, being the most fertile of all,
it supplies the materials for all activities.
The men themselves are most ingenious and intelligent and honor the true God.

The richly dressed woman who here represents Europe is modeled chiefly on the personification of the goddess of Rome or on Minerva, goddess of wisdom, for she wears armor rather than the regal robes and crown with which Ripa equips her. In one hand she has a spear, and in the other a quill pen, which she is handing to a putto who holds a book, and undoubtedly represents literature or history. Another putto, who holds a pair of compasses and hands her a scroll, represents science. At her feet lie books, a plan for a fort, a compass, a palette with brushes and a mahlstick, and a bust and chisel. Nearby are other instruments for measurement and a globe. A heap of boxes and bales, a barrel, and moneybags refer to commerce.

[Ripa, 1603, p. 332]

The *fatto:* In the background is a round open temple, Ripa's symbol for the true religion, topped with statues of Faith, Hope, Charity, and Prayer. Over the entrance is the triangle-symbol of God, with the Eye, whose beams of light shine down into the building. Within is seen an altar on which rest a chalice surmounted by the Host, an open book, a lighted candle, and a crucifix. On a side table rest an imperial crown, a royal crown, and a bishop's mitre.

EUROPE

The faith of Christ, and wit, and arts
Have always reignéd in these parts.

EUROPA.

Reliquas orbis partes præcedit. Namque cum fertilissima est, omnium rerum apparatus suggerit. Ipsi homines sunt ingeniosissimi et acutissimi, ve - rumque colunt Deum.

Eichler del :

L. Wachsmuth, Sc:

Hertel, excud:

EUROPA.

Der Chriſtlich Glaub nebſt Kunſt und Wiß,
von Alters her alhier den Siß.

ASIA

*The major part of this land is inhabited by fierce
and barbarous peoples adhering to the religion
which Mohammed taught. Merchants often go
to them and buy and sell goods there.*

The personification of Asia is a bejeweled woman, richly dressed in oriental robes, who stands before two palm trees. She wears flowers in her hair and holds a smoking incense burner in one hand, while with the other she offers flowers, herbs, and spices to a pipe-smoking merchant in a fur-trimmed robe, who stands behind a rope-bound bale of goods. On the ground behind her are an open chest filled with gold and jewels, a bow and quiver, and some growing plants. On a stool nearby lies a jeweled turban, topped with the crescent moon of Islam, and a sword.

Hertel and Eichler follow Ripa fairly closely, save that, like good citizens of Augsburg, a merchant city, they emphasize the commercial importance of Asia a bit more. The plants the personification holds are, according to Ripa, cassia, pepper, and cloves. The camels which Ripa suggests including to symbolize Asia are here placed in the *fatto* scene.

[Ripa, 1603, p. 334]

The *fatto*: The entire background is taken up with an oriental harbor. There is an oriental temple, whose towers—one of them a pagoda tower—are topped with the crescent moon. Worshippers kowtow before the temple, and outside it bearded, turbaned merchants move about, observing some camels and their riders. A ship with the crescent on its mainmast moves forward out of the harbor between the legs of a huge statue, probably the Colossus of Rhodes (one of the wonders of the ancient world), which stands astride the exit from the harbor. The statue is nude, holds an arrow in one hand and a flaming light in the other, wears his bow strung across his chest, and bears a crown. In the distance can be seen a city of many towers, all with the crescent, and with a step pyramid.

ASIA

*Mohammed's words here worshipped be,
And much commerce doth cross the sea.*

ASIA.

Magna ejus pars a feris barbarisque nationibus incolitur,
religio ni, quam Mahomedes docuit deditis. Ad eas
mercatores sæpe comeant, ibique merces
emunt venditantque.

I. Wachsmuth, Sculps.

ASIA.

Mahometh wird da verehret,
durch die Handlung vil verkehret.

Eichler del.　　　　　　　　　　　　　　　　　　　　　　*Hertel, excud.*

AFRICA

The people of this region, filled with superstition,
honor Mohammed above all. Many regions there
are bare and wild.

The personification of Africa is a dusky-hued native chieftain, almost nude, with feathers on his head and around his waist and calves. He stands holding a large dart or arrow, and leaning against a parapet on which hangs a fur pelt, he allows a ragged dark fortune-teller (a gypsy?), who carries her child on her back, to read his palm. Before him kneels a bearded and robed man, an augur, who traces a circle in the sand with his augur's crook, while a bearded ape mimics him and does the same with a stick. A large parrot perches nearby. In the middle ground an ostrich strolls by, in front of a yucca plant or cactus.

Ripa's personification is a female, but has some similarities to this one. The skin is dark from sunburn, for Africa is quite exposed to the fierce rays of the sun. The various references to fortune-telling represent the superstitions prevalent in Africa. The animals are, of course, typical of the exotic ones which live there. The ape, in addition, alludes to the foolishness of such activity as that of the augur.

In the background are palm trees, and a blazing altar before two pyramids, those of Egypt, of course. Some natives are seated under a palm fishing, while others escape from a crocodile. In the far distance are some sailing ships.

[Ripa, 1603, p. 335]

AFRICA

The Koran's worshipped here as much as there,
And many regions lie all wild and bare.

AFRICA.

Natio hujus terræ Superstitione capta ma,
xime Mahumedem colit. Multæ sunt ibi re,
giones nudæ incultæque.

AFRICA.

Dort Alcoran ein gleiches gist,
ja manches Land, ligt Wüst u. Wild.

Eichler, del.

Hertel, excud.

AMERICA
Here everything is in abundance, especially gods,
whom blind superstition has created.

The personification of America is a dark man, a native chieftain certainly, who sits among many objects associated with America. He is elaborately tattooed, and wears a feather head-dress, many beads, and a decorated animal hide. He holds a spear with a jagged head. An equally dark and naked attendant behind him hands him a feather-tipped scepter and holds a large, long-handled feather fan. About the main figure are bits of coral, pearls, a basket of gold dust (?), arrows, spotted hides, a large nautilus shell, a human head, war clubs, a bow, and a monstrous animal, perhaps an iguana or an armadillo.

Since America was unknown to the ancients, says Ripa, there are no classical sources for its representation. Instead, he studied the writings of such men as Padre Girolamo Gigli, Ferrante Gonzales, and the Jesuits, and also got much information from a certain Fausto Rughese of Montepulciano. His representation of America has largely to do with Middle and South America, so much better known to Catholic Europe.

Hertel and Eichler, on the other hand, obviously used Theodor de Bry's engravings of the illustrations John White and Jacques Le Moyne had brought back from the New World.

The background is filled with references to the religious beliefs and practices of the American natives. They worship a totem of a deer, while dressing themselves in deerskins to hunt these animals. The severed head refers to cannibalism, believed to be prevalent there, and the giant lizard being fought in the background is the alligator, an animal often used as a symbol of America. On the left is a pole with a human arm hanging from it, while another pole is topped with a hat or a clump of hair. Poppy pods (cocoa pods?) lie on the ground about them. In the water a native rows a boat, and others ram a shaft into the mouth of an alligator. There is a native stockade, a hut, and in the harbor a European sailing ship. High, jagged mountains can be seen in the distance.

[Ripa, 1603, p. 338]

AMERICA
With superstition badly ridden,
Treasures in these lands are hidden.

AMERICA.

Ut copia omnium rerum ita Deorum
præcipue, quos cæca finxit pietas,
abundat.

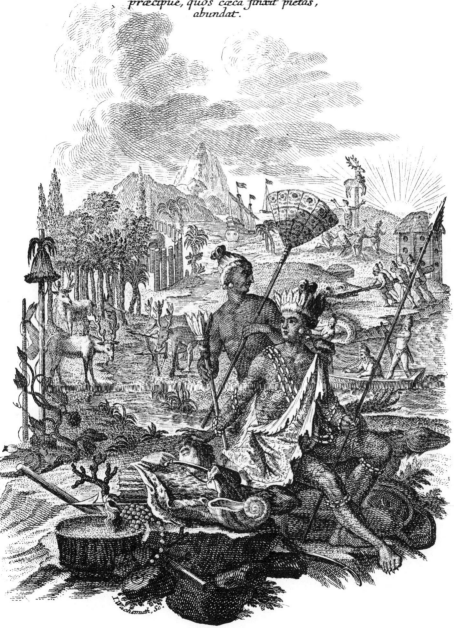

AMERICA.

𝕬𝖇𝖌ö𝖙𝖙𝖊𝖗𝖊𝖞 𝖍𝖎𝖊𝖗 𝖎𝖒 𝕲𝖊𝖇𝖗𝖆𝖚𝖈𝖍
𝖉𝖎𝖊 𝕰𝖗𝖉 𝖘𝖊𝖍𝖗 𝖗𝖊𝖎𝖈𝖍 𝖆𝖓 𝕾𝖈𝖍ä𝖙𝖟𝖊𝖓 𝖆𝖚𝖈𝖍.

Eichler. del.

Hertel, excud.

SANGUINE TEMPERAMENT
*The gifted youth, overstimulated, abandons proper
behavior and spends his days in play and amusement.*

The personification of Sanguine Temperament is a blonde youth, rosy-cheeked and a bit heavy, wearing rich and fanciful garb and a wreath on his head. He is playing a lute at a rococo music stand. Behind him is a goat (according to Ripa, the animal should be a ram) holding a cluster of grapes in his mouth. In a heap before the young man lie an open book of music, a set of bagpipes, a wine bottle, and a rose garland.

In this first of the representations of the four human temperaments, or "humors" as they were also called, the Augsburg artists follow fairly closely the description of Ripa, although there was available at the time a wealth of other material they could also have used. This temperament is "sanguine" because as far back as ancient times, a person having it was believed to be well-supplied with good, "well-tempered" blood, which gave him his ruddy complexion and, while making him strong, made him rather fleshy. As a result of all this blood, the sanguine man is something of an extrovert, given to pleasure and the satisfaction of his appetites. The goat (ram) and the grapes symbolize the sanguine man's dedication to Venus and Bacchus, the goat and ram being among the animals noted for sexual prowess, and the grape being of course the symbol for wine. Ripa also points out that grape seeds were supposed to arouse sexual appetite. He bases his description of this temperament on Hippocrates, Galen, Avicenna, Aristotle, and Piero Valeriano.

[Ripa, 1603, p. 76]

The *fatto:* In the background, in a formal garden under an arbor, a young couple dance to the music of a pair of musicians; all are in eighteenth-century costume.

SANGUINE TEMPERAMENT
*In lively spirit, gifts of mind,
Shall this type expression find.*

Excitati ingenii juvenis plerumque mo-
ribus solutis totum diem per ludum jo-
cumque consumit.

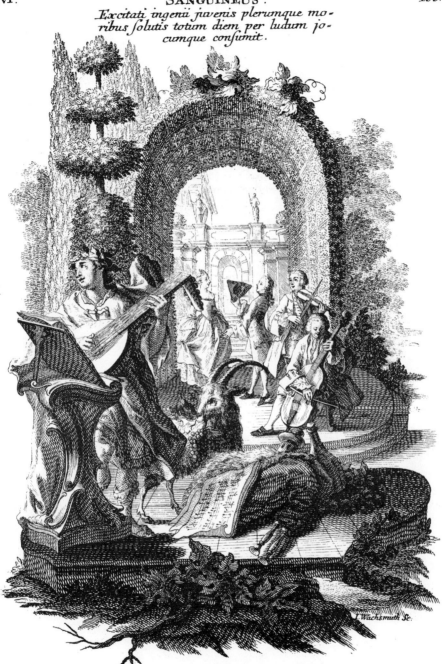

SANGUINEUS.

𝔄𝔲𝔰𝔤𝔢𝔴𝔢𝔯𝔠𝔨𝔢𝔫 𝔐𝔲𝔱𝔥, 𝔲𝔫𝔡 𝔊𝔞𝔟𝔢𝔫
𝔴𝔦𝔩𝔩 𝔡𝔢𝔯𝔤𝔩𝔢𝔦𝔠𝔥𝔢𝔫 𝔉𝔯𝔢𝔲𝔡𝔢 𝔥𝔞𝔟𝔢𝔯.

Eichler. del. Hertel, excud.

CHOLERIC TEMPERAMENT
*Letting ourselves go and persisting in our inconsiderate rage,
we often damage others and ourselves run into trouble.*

Pacing menacingly about is a muscular, half-naked man—the personification of Choleric Temperament—with wild hair and an angry expression on his face. He holds his bare sword with its tip pressed against the ground. Behind him stands a ferocious lion, and on the ground before him lies a round shield with a flame emblazoned on it. He has a rather yellowish pale complexion, his color coming from the overabundance of yellow bile in his system, which was also supposed to make him very easy to excite and anger. He is, in short, the most violent of the four temperaments, and is also supposed to give off a great deal of heat when enraged, which explains the flame on his

shield. He is young, for the choleric man lacks judgment like the young. His naked sword is at the ready, for the choleric type is always ready to fight. The lion, of course, is the most courageous and spirited of animals, and the proudest, and thus has many affinities with the choleric man.

[Ripa, 1603, p. 74]

The *fatto:* In the background scene, a clearing in a forest, a duel on horseback is taking place. One of the men has been hit and falls back. There are two spectators to this scene, the result of anger and a clear example of the choleric temperament in action.

CHOLERIC TEMPERAMENT
*A man who oft in rage doth burn
May find it back on him can turn.*

Animo nostro obsequendo inque præcipiti ira
perseverando sæpe aliis injuriam facimus ipsi-
que in malum incurrimus.

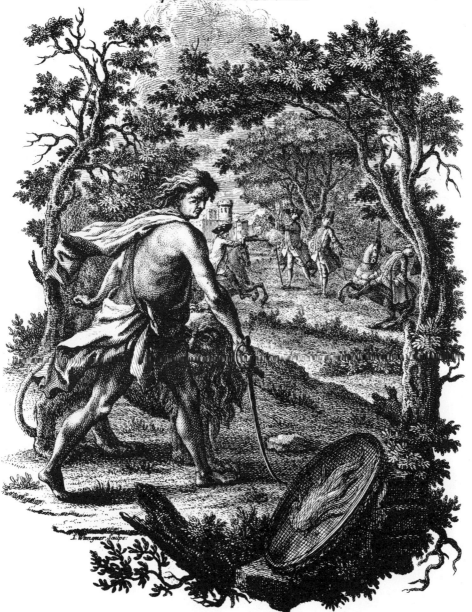

CHOLERICUS.

So wird Toller Sinn gebrochen,
ja am Leben selbst gerochen.

Eichler. del. Hertel. excud.

PHLEGMATIC TEMPERAMENT
Stirring the flames and sitting by the fire, as the aged do
in particular, so they all mitigate the cold and recover vital heat.

Leaning against a parapet and dozing is the personification of Phlegmatic Temperament, a man wearing a long fur-trimmed robe and a tasseled nightcap, and holding a long pipe. On the ground near him is a large, tattered book, and at his feet a turtle crawls.

The phlegmatic man is slow and always chilly. Just as plenty of yellow bile makes the choleric man warm, too much phlegm in his system makes the phlegmatic man cold; if leanness comes from heat, the phlegmatic man then tends to be fat. The pipe and the old book, the sort of pleasures old folk have, are appro-

priate to this type of temperament, which acts old even if it is not. The fur on the man's robe and cap is badger fur, for this animal is very lazy and sleepy, according to Ripa. The slowness of the turtle is proverbial.

[Ripa, 1603, p. 78]

The *fatto:* One looks past bare and snow-covered trees into the background where an old bent man approaches a house through whose open door one can see a fire burning in the fireplace.

PHLEGMATIC TEMPERAMENT
Their chilled and sluggish limbs to warm,
Such folk about the fire do swarm.

PHLEGMATICUS.

Excitando flammas ignique adsidendo, ut senes
præcipue, ita omnes mitigant frigus vitalemque
recipiunt calorem.

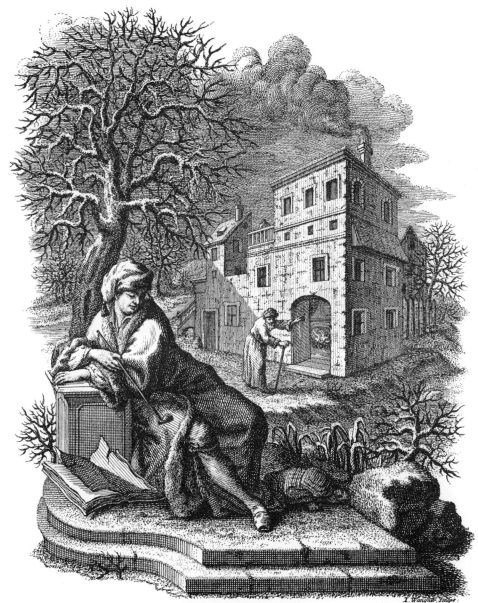

PHLEGMATICUS.
Die erkalte matte Glieder,
sehnen nach der Wärme wieder.

Eichler, del:

J. Wangner, Sculps:

Hertel excud:

109

MELANCHOLY TEMPERAMENT
*The man who suffers from black bile indulges too much
in worry and too often plunges himself into unnecessary ruin.*

In a rather funereal setting of overgrown ruins and somber pine trees, a man, the personification of Melancholy Temperament, stands leaning against a wall. He wears a long robe, and has a gag tied over his mouth. He frowns while reading the large book he holds in one hand; he clutches a closed purse with the other. On the wall beside him is a small bird, a sparrow, a bird supposed to love solitude.

The gag symbolizes the melancholic man's tendency to be silent, for he has a cold, dry nature, and if heat makes for loquacity, according to Galen, so a chilly nature makes for taci-

turnity. The open book represents the melancholic man's tendency to be a scholar, engrossed in all sorts of studies; the closed purse signifies that he has a close and rather selfish nature, not sharing even his thoughts with others.

[Ripa, 1603, p. 79]

The melancholic man's tendency to gloom and a sense of futility and despair provide the subject for the *fatto* in the background, where a man is about to commit suicide by throwing himself into a river.

MELANCHOLY TEMPERAMENT
*Idle thought oft generates
Such gloom, it tragedy creates.*

MELANCHOLICUS.

Homo atræ bilis curis angorique nimis in-
dulgendo Sæpius ruit in perniciem non ne-
cessariam.

MELANCHOLICUS.

Durch vill Sorgen eitle Grillen,
läßt ein Unglück sich erfüllen.

Eichler. del.

Hertel. excud.

110

SIGHT
Diogenes lay on the ground exposed to the sun; when Alexander the Great observed him, he asked him to move out of his light.

The personification of Sight is a young man dressed in fanciful clothes, who looks into a mirror that rests on a cartouche inscribed "Cognitionis via" (The way to enlightenment). Framed within the cartouche is a picture of an eagle and its young flying up toward the sun. At the young man's feet stands a lynx.

The representations of the senses in this plate and the following are based, with a few changes, on Ripa's suggestions for depicting them, and rely on his use of the Latin quotation "Nos aper auditu, linx visu, simia gustu,/vultur odoratu, superat aranea tactu" (The boar excels us in hearing, the lynx in sight, the ape in taste, the vulture in smell, and the spider in touch). Save in the representation of Smell, Hertel used these animals as the symbolic accompaniment to his personifications. The use of the mirror is obvious; only the inscription, which refers to self-knowledge, is added. The

picture of the eagle refers to the fable of the eagle making her young look up at the sun to be certain that they are really her own. If they can endure the light, she is assured; if they cannot, she abandons them.

[Ripa, 1603, p. 447]

The *fatto*: Beyond the obelisk and sphinx which accompany the main figure, the famous episode of Alexander the Great's visit to the philosopher Diogenes is shown as the historical equivalent of the sense of sight. Standing before the great Cynic philosopher, who sat in his barrel, the Greek hero asked him what favor he could bestow upon him, whereupon Diogenes asked him to move out of his light, for he wished to sun himself. Thus he rejected all worldly things, in accordance with the Cynic doctrine.

[Valerius Maximus, IV, 3]

SIGHT
*All that Diogenes would ask
Was freely in the sun to bask.*

VISUS.

Diogenes Soli expositus jacuit humi
quem cum videret Alexander M. pe-
tiit, ut cederet Soli.

Das Geſicht.
Diogenes ſein Bitt erreicht,
der Held ihm auß der Sonne weicht.

Eichler, del. Hertel, excud.

111

HEARING

The disciples of Pythagoras, each required to remain silent
for five years, learn the principles of erudition more by
listening than by talking and asking questions.

The personification of Hearing is a young man, rather romantically cloaked and dressed, who sits before an overgrown column and strums on a lute. Wading through the rushes of a stream in the foreground is a huge wild boar. That music has to do with hearing is obvious. The boar is credited with having hearing superior to that of man.

[Ripa, 1603, pp. 447 and 449]

The *fatto*: Seen inside a house is the sage Pythagoras, seated in his study and lecturing to his pupils. A statue of a putto above him holding its fingers to its lips represents Harpocrates, god of silence.

[Iamblichus, XVII, 22]

HEARING

Pythagoras silence did command,
Listening from students did demand.

AUDITUS.

Principia eruditionis Pythagoræ Discipuli, si-
lentio unicuique per quinque annos imposito,
magis audiendo quam loquendo quærendoq3 imbibunt.

J.Wachsm: Sc:

Das Gehör.
Pythagoras ein Stillseyn dingt,
die Schüler nur zum hören zwingt.

Eichler, del.

Hertel, excud:

112

TASTE
Bacchus and Silenus, the gods of pleasure and inebriation,
celebrate the bacchanale.

The personification of Taste is a fat man in eighteenth-century peasant dress, who sits on a bench beside a barrel. He holds a tankard in one hand and a foaming glass of beer in the other. On the barrel is a wooden plate with a sausage; another sausage is on the ground at the man's feet. Several large tankards stand on the ground; from behind one of them, a grinning ape shows its face. A pretty peasant girl stands beside the man, holding a basket of fruit.

Being a temperate Italian, Ripa had suggested for this personification only the girl with her basket of fruit, peaches. It was obviously not enough for the Augsburgers, whose tastes ran to beer and sausage. Hence the presence of the fat and jolly toper. The ape was credited by the ancients with a very highly developed sense of taste, as indicated in the Latin quotation cited earlier (see Plate 110).

[Ripa, 1603, p. 448]

The *fatto:* The personification˙is illustrated by a representation of a Bacchanalian procession, with Bacchus, wreathed and drinking, astride a donkey, and Silenus on a goat, led along by a satyr. Other fauns, nymphs, and satyrs dance about, drinking and blowing horns.

TASTE
Bacchus' crew were ever intent
On food and drink and merriment.

GUSTUS.

Bachus Silenusque voluptatis ebrietatisque
Dii Bachanalia celebrant.

I. Wachsmuth, Sculps.

Der Geschmack.

Bachus und sein guter Sauffer
nichts als schwärmen Fressen Sauffen.

Eichler, del.

Hertel, excud.

TOUCH

Empress Constance indulged her love for a certain courtier too much,
for which the courtier suffered greatly.

The personification of Touch is an elegant young woman in eighteenth-century hunting costume, who sits beneath an elaborate rococo trellis. She holds a hooded falcon on her wrist. In an opening at the top of the trellis, a spider has woven a web. Below the trellis, a fountain plays a jet of water into the air, balancing a ball on it.

The claws of the falcon clasping the girl's wrist signify touch; so does the falcon's use in hunting, for it grasps its prey in its claws. The ball balanced on the water jet is, of course, touching the water, if just barely. The spider was proverbially supposed to have an excellent sense of touch, as indicated earlier (see Plate 110).

[Ripa, 1603, p. 448]

The *fatto:* Before a basilica, on the order of the Emperor Henry VI who is seated there, the courtier with whom Empress Constance was suspected of having a love affair is being tortured. Chained to a chair, the seat of which is full of sharp nails, and under which a fire is being blown up with a bellows, the unhappy man is having a crown nailed to his head. In front of him a torturer either stirs a smoking pot or heats something in a flaming brazier.

[Gottfried, *Historische Chronica*, p. 560B]

TOUCH

Constance was thought to have betrayed her royal mate,
So her suspected lover met a gruesome fate.

TACTUS.

Amori cujusdam aulici Imperatrix Constantia ni-
mis indulget. Aulicus multum mali sibi contrahit.

Das Fühlen.

Constantia komt in verdacht
der Höfling wird zur Folter bracht.

Eichler. del :

I. Wangner, Sculps.

Hertel excud :

SMELL

*At Xerxes' command the tomb of Belus is opened. In it is found the body
of the deceased floating in sweet-smelling oil. A nearby inscription tells
[Xerxes] that his fortune will be great but adverse.*

The personification of Smell is a young boy dressed in green, who stands smelling the flower of a large potted carnation. A potted rose bush stands next to it. Beside him a large dog lies stretched out. On the elaborate parapet behind stand various potted plants and orange trees.

The scent of roses, carnations, and orange blossoms is very strong and pleasant, and is appropriate to the idea of the sense of smell. The dog, a bloodhound, is famous for its sense of smell, and is a much more appealing substitute for the vulture proposed by the ancients in the quotation given earlier (see Plate 110).

[Ripa, 1603, p. 448]

The *fatto:* In the background, men remove a sarcophagus from a ruined pyramid, while King Xerxes looks on. A ruined obelisk nearby bears the somewhat garbled inscription "Vir qualiscumque sit, monument: adaper: nec oleo vas repl. sciat se vitam male esse finitum" (Whoever opens this grave without filling the vessel with oil, should know that his life will end badly). Xerxes tried but could not and left sorely troubled by this bad omen. He did, indeed, die at the hand of his own son.

[Aelian, *Varia Historia*, XIII, 3]

SMELL
*The scented oil of Belus' grave
To Xerxes grief and trouble gave.*

*Beli monumentum jubente Xerxe aperitur. In quo inventum
est mortui corpus oleo innatans odoratissimo denunciat adja-
ciens scriptum fortunam adversam eandemque maximam.*

Der Geruch.

Beli riechend Oehl und Grabe,
Xerxi, Noth und Jamer gabe.

Eichler, del: I. Wangner, Sculps.

 Hertel, excud:

GREED
*Darius, king of the Persians, has the tomb of Queen Nitocris opened,
not doubting that he will find great treasure therein. In vain!*

The personification of Greed is a pale, thin elderly woman with a melancholy expression on her face. Barefoot and dressed in ragged peasant clothing, she contemplates a purse she holds in her hand. She leans on a parapet before a herm of King Midas, with his crown and donkey's ears. Before her stands a large lean wolf.

Her inordinate love of money does not permit her to care for herself, hence her unhealthy look and poor clothing. She stares at her purse, for the greedy prefer to look at money rather than spend it. The wolf is traditionally considered a voracious and avid beast. His leanness indicates his insatiability. The story of King Midas and the golden touch is a famous classical legend of the consequences of greed (though he gained the donkey's ears by preferring Marsyas to Apollo in their music con-

test).

[Ripa, 1603, pp. 29–33]

The *fatto*: King Darius stands before a ruined pyramid studying a tablet. Out of the doorway to the tomb a man emerges. Above the entrance is the inscription "Ni te malae mentis homines insat: auri cupid: dux:" (Let not evil-minded men lead you [astray] with an insatiable greed for gold). A donkey nearby busily eats thistles. Queen Nitocris of Babylon had left a prominently displayed tomb with an inscription to the effect that any future king of Babylon truly in need of money would find plenty within. Darius, however, found no money, but an inscription saying that only a shamefully greedy man would open a tomb.

[Herodotus, I, 187]

GREED
*On Nitocris' tomb it said
How Darius' greed him had misled.*

AVARITIA.

Reginæ Nictocris Sepulchrum Rex Persarum
Darius aperiendum curavit, non dubitans magnas
se inventurum esse ibi divitias. Falso.

Der Geiß.

Nictocris Grab, und Tafel lehrt,
wie Darium der Geiß bethört.

Eichler, del.

Hertel, excud.

THEFT

King Rhampsinitus has a tower built to hold his treasures. The architect,
who was able to do so, removed the stone and entered in to steal.

In a nocturnal setting, a man, personification of Theft, stands with a furtive expression on his face. He wears a cap and a ragged wolfskin coat tied with a rope. He has rabbit's ears. In one hand he holds a purse, in the other a knife and a skeleton key.

His wolfskin garment refers to the habits of the wolf, which steals the food of others. The rabbit ears indicate the continual fear of the thief of getting caught (hence he is a friend of the night). The purse represents booty, and the knife and skeleton key symbolize the violence and the guile with which he performs his robberies.

[Ripa, 1603, p. 179]

The *fatto:* A fantastic tower dominates the scene. At its base, a man can be seen creeping into it through an opening he has made by removing one of the stones. He is being observed by some people in a boat (his sons?). In the distance is a city. This is the story of King Rhampsinitus and his architect. As Herodotus tells the story, it is the two sons of the architect who carry out repeated thefts after their father has told them his secret on his deathbed.

[Herodotus, II, 121]

THEFT

The master builds, but leaves himself a breach,
That he may thief-like enter and the treasure reach.

FURTUM.

Turrim ad custodiendos thesauros ædificari Rex
Rampsinitus jubet. Eam opifex lapide, qui po-
terat, remoto, furaciter inscendit.

I. Wachsmuth, Sculps.

Der Diebstahl.

Der Meister baut, läßt loß ein Stein,
steigt selbst als Dieb, zum Schatz hinein.

Eichler, del:

Hertel, excud

INJUSTICE
*Cambyses, king of the Persians, great practitioner of justice,
had the unjust judge Sisamnes flayed alive, and the skin hung in the tribunal,
that it be a terrible example for all.*

The personification of Injustice is a tall woman of commanding appearance, wearing a turban and a rich robe. Her white cloak is spattered with blood, and she holds a blood-stained scimitar in one hand. At her feet lie torn scrolls, parts of a broken pair of scales, broken tablets of the Decalogue, and a fragment of an obelisk. On her shoulder sits a toad.

Her spotted white robe represents purity corrupted by injustice. Her turban and robe suggest the barbarous lands where injustice is common. The curving scimitar symbolizes twisted justice, while the broken scales, tablets, and scrolls represent broken faith in justice. The toad is a symbol for greed, upon which much injustice is founded.

[Ripa, 1603, p. 230]

The *fatto:* Cambyses, seated on his throne, watches while the naked Sisamnes is flayed alive. In the background the hapless man's skin is being nailed to the judge's seat in the court where he had performed his office dishonestly.

[Herodotus, V, 25]

INJUSTICE
*Sisamnes, the venal judge, was flayed
When Cambyses discovered he had strayed.*

INIUSTITIA.

Injusto Iudici Sisanæ Persarum Rex Cambyses, Iustitiæ studiosis
simus vivo adhuc cutem detrahendam eamque tribunali affi-
gendam curavit, ut esset omnibus terrori exemploque.

I. Wachsmuth, Sculps.

Eichler. del:

Die Ungerechtigkeit.
Sisana Recht um Geld verschaft,
Cambyses ihn deßwegen straft.

AMBIGUITY
Many came to Delphi to ask what they ought to do in this or that matter.
To those consulting her, the Pythia would answer ambiguously.

The personification of Ambiguity is a youth dressed in clothes of shifting, changing colors, with sandals and a hat, who walks during the night. He scratches his forehead with the hand in which he carries a staff. He carries a lighted lantern in the other hand.

The changing colors of his clothing typify the confusion he experiences. He is young, for youth is the age in which most confusion reigns. The staff represents experience upon which the confused can lean, and the lantern represents the light of reason which can illuminate the mind. The shadows through which the young man moves are the doubt and the uncertainties which infest human life.

[Ripa, 1603, p. 118]

The *fatto* depicts various sorts of pagan attempts to foretell the future. On the left is the Pythia of Delphi seated on her tripod and being supported in her frenzy by a priest. A statue of Apollo stands behind her. In the center of the cave in which the whole scene is placed, a priest is standing before a sacred tree and blowing on a small flute. On the right a priestess is holding up the heart she has just torn from the breast of a human sacrifice. Various oriental figures stand around. One of them lies prostrate before the Pythia; he has a rabbit on his back, an allusion to his abject fear and his superstition.

[Vergil, *Aeneid*, III, 444]

AMBIGUITY
Delphic oracle am I named;
For hazy answers am I famed.

*Multi venere Delphos deliberatum, quid in hac
illave re faciendum esset. His consulentibus Pythia
ambigue respondebat.*

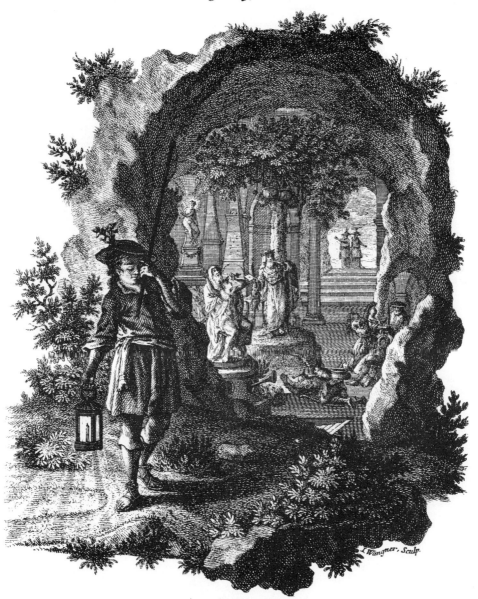

I. Wangner, Sculp.

Eichler, del. Hertel, excud.

Der Zweifel.

Oraculum ward ich genannt,
Zweydeutig nun die antwort fand.

CONSCIENCE
*Bessos destroyed the swallows' nests, and when asked why he
did so, said: "They do not cease accusing me of parricide."*

The personification of Conscience is a woman robed in white who contemplates a human heart which she holds. On her head is a tiny pyramid. She points with her free hand to a field half overgrown with thorns, and half filled with flowers. At her feet sits a putto holding an iron file and a human heart that is gnawed by a snake or worm. He props up a tablet inscribed "Heu quantum misero poena mens conscia donat" (Alas, how much punishment does the sense of guilt afford the transgressor).

The white robe represents the purity of conscience, and the tiny equilateral pyramid its eternal, unchanging nature. The woman contemplates her heart, for she looks within herself to become aware of her fault. She stands barefoot in the field of flowers and thorns, which represent the good and the bad path through life; life is pleasurable if traveled with a clean conscience and full of pricks of conscience if not. The heart gnawed by a worm symbolizes the sense of guilt which eats away at one's conscience. The file works in the same way as the conscience; it rasps away the unwanted parts, leaving what is desired, just as the conscience works away at the spirit until it is free of guilt.

[Ripa, 1603, p. 83]

The *fatto:* Plutarch tells the story of Bessos (sometimes given as Belsus), who amazed his guests one day by destroying the nests of swallows, claiming that they were continually accusing him of parricide. Thus attention was drawn to him, he came under suspicion, and then his murder of his father was revealed and he was punished.

CONSCIENCE
*Through his destruction of the swallow's nest
The parricide of Bessos was redressed.*

Hirundinum nidos Bessus vexavit. Cur id faceret ro-
gatus, non desinunt inquid de paricidio mihi exprobare.

Das Gewißen.

Beßus plagt der Schwalben Rester,
ihn der Baters Mord noch fester.

Eichler. del.　　　　　　　　　　　　　　　　Hertel. excud

JUSTICE
King Zaleucus had made a very severe law. His son having broken it,
he commanded that one of his own eyes and one of his son's be gouged out.
This is to be attributed to his love of justice.

The personification of Justice is a blindfolded woman robed in white and wearing a crown, who is seated at a table. She supports a pair of scales in her lap with one hand. Her other hand holds a bared upright sword, and rests on a bundle of lictors' rods, from around which a serpent is unwinding. A dog lies at her feet. On the table are a scepter, some books, and a skull.

She is robed in white, for the judge must be without moral blemish which might impair his judgment and obstruct true justice. She is blindfolded, for nothing but pure reason, not the often misleading evidence of the senses, should be used in making judgments. She is regally dressed, for justice is the noblest and most splendid of concepts. The scale, used to measure quantities of material things, is a metaphor for justice, which sees that each man receives that which is due him, no more and no less. The sword represents the rigor of justice, which does not hesitate to punish. The same meaning is embodied by the lictors' rods, the Roman symbol of the judge's power to punish and even execute. The snake and the dog represent hatred and friendship, neither of which must be allowed to influence true justice. The scepter is a symbol of authority; the books, of written law; and the skull, of human mortality, which justice does not suffer, for it is eternal. Hertel has conceived his representation as a combination of several sorts of justice described by Ripa.

[Ripa, 1603, pp. 187–189, "Giustitia retta che non si piegha per amicizia né per odio" (Inflexible Justice which bows to neither friendship nor hatred)]

The *fatto*: Zaleucus, King of Locris, wearing his crown, orders one of his son's eyes to be put out. He himself has a bandage over one eye, which he has had put out, for he wished to assume half the punishment his son deserved for breaking the severe law against adultery Zaleucus had established.

[Valerius Maximus, VI, 5, ext. 3]

JUSTICE
Zaleucus lets no lawless act go by;
He and his erring son each lose an eye.

Rex Zaleucus tulerat legem eandemque severissimam.
Cujus filius cum eam violasset ut sibi filioque alter
ex duobus oculis erueretur, præcepit. Id amori ejus
Iustitiæ merito potest tribuere.

I. Wangner, Sculps.

Die Gerechtigkeit.

Zaleucus sein Gesetz nicht bricht,
man Ihm und Sohn, ein Aug außsticht.

Eichler, del. Hertel, excud.

*The bird sacred to Jove cleaves the broad expanse of
the heavens with his wings, moving toward the sun,
along uncharted paths leading to the praise of God.*

Part VII

Histories and Allegories

Designed and drawn

by Gottfried Eichler the Younger;

Published by the Author,

Johann Georg Hertel,

Augsburg

Behind the cartouche bearing the title inscription is the globe of the world, above which the eagle can be seen flying up toward the human-faced sun high in the sky. On either side are the allegories of the way of virtue and that of vice. On the left, a winged putto holds an open book inscribed "Via ad vitam" (The road to life), and points to the rocky, thorn-grown road leading to a hill. At the top of the stairs up this hill is a round temple, surmounted by a cross, and in whose interior a crucifix can be seen. On the right, the winged putto holds an arrow, and is busy manipulating a trap for birds made out of netting. Beyond him a smooth path, overgrown with pretty flowers, can be seen leading into the caverns of Hell, filled with fire and flying devils. These two roads, of course, are the narrow path of virtue and the wide path of vice, as in St. Matthew, but with the author's own embellishments.

The eagle refers to the legend (found in the *Physiologus*) of the aged eagle flying up to the sun, where his old feathers are burned off, thus renewing (rejuvenating) him—a metaphor for the eternal life. The putto with the book gives good counsel, while his malevolent counterpart seeks to trap and harm the innocent.

*As sure as the eagle flies to the sun,
Will he who chose Good, true peace have won.*

Ales sacra Iovi latam secat æthera pennis,
ad Solem tendens. Ad laudes invia ducunt.

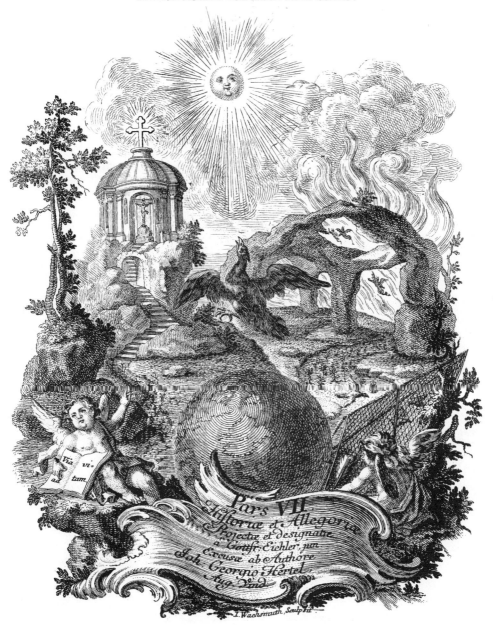

Der Adler eilt der Sonne zu,
Wer Gutes wählt find wahre Ruh

HISTORY

*Christ appeared to the disciples who departed for Emmaus. He asked
them what they were talking about among themselves, and Cleophas said:
"You are the only man who lives in Jerusalem and does not know
what has happened there during these days."*

The personification of History is a woman robed in white, who stands with one foot resting on a square block of stone and looks backward. She writes in an open book supported on the back of a winged figure of Time, who is represented as Saturn. At their feet lie a globe, a scroll, another open book and an empty cornucopia. Time, who is bearded and nude, eats a stone. In one hand he holds a pruning knife or sickle, and the serpent ring of Eternity.

History is shown with her foot resting on the stone block, for history must always have a firm foundation, be based on facts, the truth, and be written with objectivity. She looks backward while writing, for history is the record of notable things that happened in the past. The book is supported on the back of Time, for history is related inextricably with the passage of time, being, indeed, a chronicle of it. The objects lying on the ground all relate to the written records of what has happened in the world.

The empty cornucopia suggests things already consumed, plenty already enjoyed. Time is shown as Saturn, or C(h)ronos, eating the stone given him instead of his son Jupiter, whom he planned to devour. The sickle or pruning knife refers to the removal by Time of all that has served its time on earth. The serpent ring of Eternity is, of course, always associated with him.

[Ripa, 1603, p. 218]

The *fatto*: Christ appears to the two disciples walking to Emmaus, who do not recognize Him. He asks them what they are talking about, what event they are discussing, and one says to Him in astonishment that He must be the only man in Jerusalem who does not know of the miraculous events newly taken place—the Crucifixion and the Resurrection of Christ.

[Luke 24: 18]

HISTORY
*As to Emmaus the disciples slowly walk,
Of the recent miracles they can only talk.*

HISTORIA.

Diſcipulis Emahum profectis Chriſtus apparet: Quærenti, qualis inter eos ſermo ſit, Cleophas dixit: Tu ſolus comoraris Hieroſolymæ, et non noſti, quæ in ea facta ſunt his diebus.

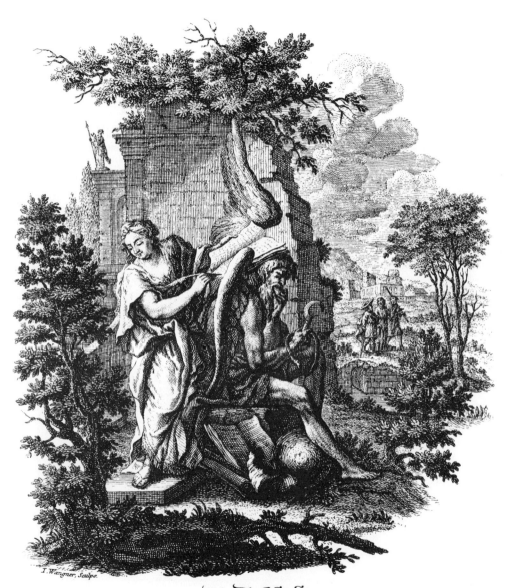

I. Wangner, Sculps.

Die Geſchicht.

Nach Emahus die Jünger gehn,
die Frag entſteht, waß kurß geſchehn.

Eichler, del. Hertel, excud.

DECORUM
*The disciples of Jesus were fishing, when one of them saw Christ
standing on the shore. He covered his nude body with a garment
and threw himself into the sea.*

The personification of Decorum is a blonde handsome youth, richly dressed in classical garb, with a lion skin over his shoulders, who stands calmly holding in one hand a blooming amaranth. He wears elaborate classical buskins (cothurni) on his legs, but on one foot also wears a clog. Seated at his feet is a putto holding a cube inscribed with the zodiacal symbol for Mercury, and a rocaille cartouche inscribed "Sic floret decoro decus" (Thus decorum engenders decorum)..

The youth is fair, for decorum is an ornament of life. He is calm, for the decorous person never goes to extremes and always has a clear conscience, since decorum is always united with honesty. The lion skin refers to Hercules, the embodiment of all virtue, and to the generous nature of the lion, the most noble of animals. The youth is nobly dressed, for the decorous man dresses fittingly, yet he wears a clog on one foot because the simple decorous man dresses according to his station in life. The buskins cover his legs in a decent fashion. With the clog on one foot, moreover, the man with decorum moves slowly, as is proper and decent. The amaranth is an eternal flower, never losing the beauty which is appropriate to it, but maintaining its proper appearance under all circumstances, as does the man with decorum. Even if it seems to suffer badly from a lack of water, a few drops restore it to its full beauty, just as the decorous man may seem to suffer if he encounters bad times, but by virtue of the self-assurance and self-esteem which decorum engenders, soon returns to good spirits as before. The sign of Mercury on the cube refers to the gravity and consistency of the man with decorum, for Mercury was called "Tetragones" by the Greeks—the stable (like a cube), the serious, the prudent.

[Ripa, 1765, II, p. 125, invented by Giovanni Zaratino Castellini]

The *fatto:* Christ standing on the shore of the Sea of Tiberias calls to his disciples, who are out in a boat fishing. Recognizing his Lord, Peter puts on some clothing so as not to appear before Him in unseemly nudity, and leaps into the water.

[John 21: 1–8]

DECORUM
*Peter leaped into the sea,
First covering his nudity.*

DECENTIA.

Discipuli Iesu piscabantur. Quorum unus cum videret Christum
littori adstantem, nudum indumento corpus cinxit inque
mare se conjecit.

I. Wachsmuth, Sc.

Die Wohlanſtändigkeit.

Petrus als der Herr gekomen /
Gürtel Hembd ü. flucht genomen.

Eichler, del.: Hertel, excud.

SOCIETY
Happily the parents receive Tobias
who has returned with Raphael.

The personification of Society is a happy, smiling youth, richly dressed in green and with a laurel wreath on his head. In one hand he holds a staff wound with pomegranate and myrtle, tipped with a tongue. Bowing politely, he stands before a classical building bearing the inscription "Vae soli" (Woe to him who is alone). At his feet lies a stone tablet inscribed "Qui in communi societate vivere nequit aut Deus est, aut Bestia" (The man who cannot live in society is either a god or a beast).

The personification is young, for that is the age when one likes company and makes many friends. He is dressed in green, the color of pleasure and happiness. The laurel wreath is the symbol of good company and conversation. He carries what is actually supposed to be a caduceus, the staff of Mercury, the escort god, save that instead of the traditional serpents it is entwined with pomegranate and myrtle vines, both in flower; they are among the sweetest-smelling of flowers, just as the society of human beings is the sweetest. According to Piero Valeriano, moreover, these two vines seek one another out and like to grow near each other (Book LV). Instead of the wings which top the caduceus of Mercury, this staff has a tongue, the symbol of human communication, which brings men together. The young man bows, for politeness helps good company. The inscription on the building comes from the proverbs of Solomon, and that on the tablet on the ground from Aristotle's *Politics*, Book I.
[Ripa, 1765, II, p. 61]

The *fatto:* In the background, walking over a stone bridge, is young Tobias, dressed as a traveler, accompanied by the Archangel Raphael. A little dog runs out to meet him.
[Tobit 6 ff.]

SOCIETY
Tobias safe can feel himself to be,
For he doth walk in angel's company.

SOCIETAS.

Tobiam una cum Raphaele reversum
parentes læti accipiunt.

Die Gesellschafft.
Tobias raißt in dem Geleit,
des Engels fort, mit Sicherheit.

Eichler del.

Hertel, excud.

125

INCREDULITY
Thomas refused to believe that Christ had risen until he had recognized
the marks of the nails and thrust his hand into His side.

The personification of Incredulity is a rather stupid-looking woman with donkey's ears, seated under a palm tree. She wears an elaborate robe, part of which is covered with fish scales. The dark turban on her head is topped with a bat. Over her eyes is a dark but transparent blindfold. She carries a bulrush in one hand and points with the other hand to the scene in the background. Her feet rest on the ground, which is covered with thorny vines. Next to her is seated another richly dressed woman, who wears a branch of coral atop her head; at her breast rests a small rat. Both women look and point to a group of turbaned Orientals who are bowing before a camel garlanded with flowers, while another man, apparently a priest, points to it. In the background is a harbor city, with many towers and a huge mosque-like building, all topped with the crescent moon.

Hertel and Eichler have taken several allegorical figures from Ripa and combined them to make these personifications of ignorance, superstition, and stupidity. The main figure, who actually dominates the scene, is Ignorance, who is rather ugly, because wisdom makes one fair, while ignorance does the opposite. Her bandaged eyes signify that she persists in her error, refusing to see evidence to the contrary; the bat, a creature of the dark, symbolizes the darkness of ignorance. Her donkey's ears are, according to Piero Valeriano, an ancient Egyptian representation of ignor-

ance, for the donkey is an animal without sense or reason (Book XII). Her cloak covered with fish scales refers to the stupidity of the fish, an old symbol for ignorance. Moreover, just as a fish's scales can easily be removed, so can ignorance be eliminated by a bit of serious study. The reed she holds is a fragile thing, useless in supporting anything, and represents the slender evidence upon which ignorance bases its beliefs. Since she represents not simple ignorance but willful refusal to believe the truth, she is shown stepping barefoot among thorns, for she has strayed off the true path and finds herself in trouble. Her subordinate companion, who looks in marvel at the worship of the camel, must represent simple-minded Superstition, for she wears a branch of coral on her head; coral was believed to guard against devils and monsters. The rat at her breast symbolizes, in accordance with Horapollo, the obscuring of the clarity of the mind which accompanies superstition. The oriental worship of the camel alludes to pagan idolatry and superstition.

[Ripa, 1603, p. 68, "Cecità della Mente"; p. 222, "Ignoranza"]

The *fatto:* The fronds of the palm tree form a field on which is depicted the incredulity of Thomas, who had to touch the wounds of Christ before he believed.

[John 20: 24–29]

INCREDULITY
Only when Christ's wounds he could feel
Did Thomas find the Resurrection real.

INCREDIBILITAS.

Resurrexisse Christum Thomas negavit credere, usque donec
in latus ejus imiserit manum, cognitis clavorum vestigiis

Eichler, del.

J. Wachsmuth, Sc.

Hertel, excud.

Der Unglaube.

Thomam Nägel=Maal und Seiten,
müßen erst zum Glauben leiten.

PRIDE

*Lucifer and his followers were so filled with pride that they rebelled
against God and made war on Him. Vanquished, they were driven from Heaven.*

Standing before an elaborate rococo alcove, a richly dressed woman, the personification of Pride, all in red, wearing many jewels, admires her reflection in a mirror. Near her stands a peacock.

She is dressed in red, for pride is most often found among sanguine or choleric types of people. Her rich and bejeweled garments represent the physical evidence of their own superiority which the proud seem to require. She admires herself in a mirror, for the prideful always see themselves as good and beautiful, refusing to admit to any imperfection. In this, they resemble the peacock, a bird notoriously so proud of his showy plumage that he supposedly refused to associate with other birds.
[Ripa, 1603, p. 479]

The *fatto*: In the sky in the background, St. Michael is seen driving the rebel angels out of Heaven and casting them down to Hell.
[Apocalypse of St. John 12: 7–9]

PRIDE

*Lucifer flaunted his pride before all,
And thus did he achieve his fall.*

SUPERBIA.

Lucifer ejusq; asseclæ nimis elati a Deo desciscunt cique faciunt bellum. Victi e coelo detruduntur.

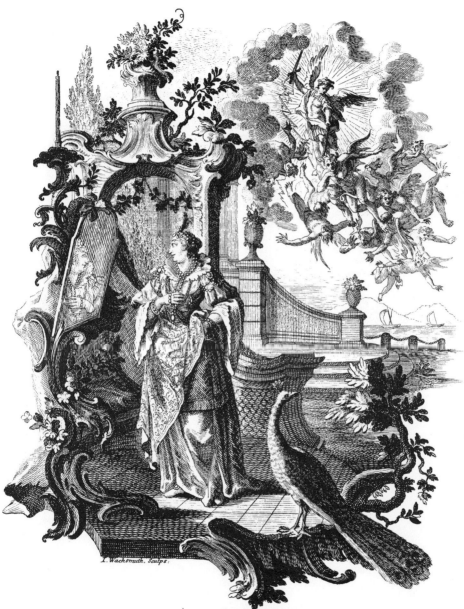

I. Wachsmuth, Sculps:

Der Hochmuth.
Lucifer mit Hoheit pranget,
und dadurch den Sturß erlanget.

Eichler, del:

Hertel, excud.

DECEIT
*Joab, because he had conceived an implacable hatred for Abner on account of
the killing of his brother, murdered him treacherously.*

Leaning against the base of a ruined and overgrown column, a slyly smiling elderly woman, personification of Deceit, lifts a mask from her face. She wears a cloak decorated with many masks, has a goatskin over one shoulder and a fish net over one arm. She carries a fishing rod with a long line and a hook. A spotted panther sits at her feet. Before her are a bouquet of flowers in which a snake is hidden, and two urns, one filled with water and the other with flames.

Deception is personified in the old woman who hides her real ugliness under the mask of a pretty young woman. Her cloak covered with masks symbolizes the many disguises the deceitful wear. The goat is much loved by the sargo, a kind of fish, and the clever fisherman, according to Alciatus, covers himself with a goatskin in order to lure the infatuated fish into his net; thus the deceitful person, through an appearance of innocence or affection, tricks the unwary. This also explains the fishing gear the woman carries. The panther, by hiding his head and only showing his beautifully spotted back, attracts those who marvel at his appearance, and then springs up and devours them. The serpent amid the flowers represents the misleading sweet perfume of apparent goodwill which hides the poison of an enemy. The urns of fire and water are incompatible and bad for each other as deceit is for virtue; they also represent the idea that deceit is really the exact opposite of what it appears to be.

[Ripa, 1603, p. 228]

The *fatto:* Under a huge Roman arch, Joab stabs Abner with his sword. Abner had, as a general of Saul's armies, slain Asahel, Joab's brother, in a battle with David's forces. Joab desired vengeance, and later, when Abner came to David on an embassy, he pretended great friendship for him until he could get him aside and murder him.

[II Samuel 3: 24–27]

DECEIT
*Abner, thinking naught amiss,
Is killed, betrayed by Joab's kiss.*

FALSITAS

Ioab, quod ob cædem fratris sui implacabile odium
in Abnerem susceperat, eum insidiis interficit

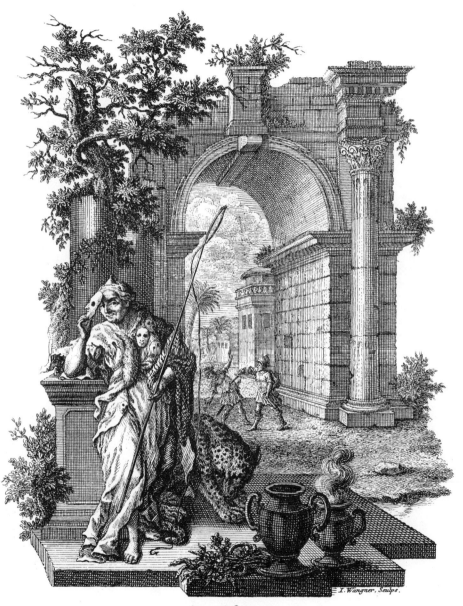

I. Wangner, Sculps.

Die Falscheit.
Abner hat es nicht erwogen,
wird durch Ioabs Kuß betrogen.

Eichler del.

Hertel. excud.

INGRATITUDE
*Ten lepers are healed by Christ; of them only one returns
to express his great thanks.*

The personification of Ingratitude is a young woman dressed in rust-colored raiment, seated beside a ruined building that has an ivy plant growing up the side of it. She holds two serpents in her lap, one of which has the head of the other in its mouth. In the water at her feet swims a horse with a fish tail. The base of the column is inscribed "Nutri canes, ut Te edant" (Feed dogs, until they eat you).

Rust, a product of iron, destroys it. The ivy plant in growing up the side of a building, which it needs for its own existence, nevertheless contributes ungratefully to the decay of the building. The female viper, after enjoying the male in the spasms of love, very often kills him, crushing his head in her mouth. The fish-tailed horse is a "hippopotamus," a river-horse, whose ungrateful treatment of his parents has already been described (see Plate 91), and is based on the authority of Horapollo. The inscription on the base of the column refers to the story of Actaeon devoured by his own dogs, as told by Ovid and others; here it serves as an example of the ingratitude of which dogs were considered capable.
[Ripa, 1603, p. 232]

The *fatto*: Christ standing among His disciples points to the one leper who has stayed to thank Him for curing him, while at a distance, the other nine who have also been cured walk away ungratefully.
[Luke 17: 12–19]

INGRATITUDE
*Of all ten lepers whom He had cured,
One alone Christ of his thanks assured.*

INGRATUS ANIMUS.

Leprosi decem a Christo sanantur, quorum ex
medio unus tantùm reversus gratias egit maximas.

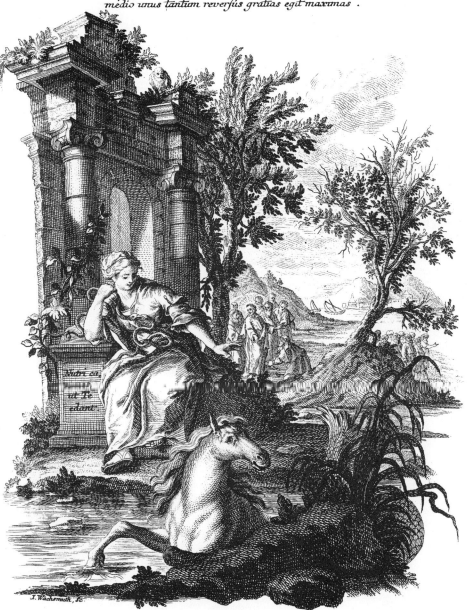

Nutri ea,
ut Te
edant.

J. Wachsmuth, Sc.

Der Undanck.

Ob Zehen zwar, vom Außsatz rein,
doch einer mir, wolt danckbar seyn.

Eichler, del. Hertel, excud.

DERISION
Christ, after being derided by the Jews, spat upon,
and beaten with rods, is then crucified.

The personification of Derision is an ugly woman, frowning and sticking out her tongue. She points to the right with one hand, and holds a bunch of peacock feathers in the other. She is barefoot, and wears a hedgehog pelt over one shoulder. She leans against a braying donkey.

To deride is to make fun of others, laugh at their suffering, and point out their defects, not in order to admonish them, but purely for one's own pleasure. The ugly act of sticking out the tongue is an example of great disrespect; one often finds ignorant children of low degree doing it. The woman points with her finger to call attention to the errors, defects, and mis-fortunes of others. Like the lowly hedgehog with its spines, the derider manages to prick those who come close to him with his remarks. The peacock feathers remind us that such people are filled with pride and an overweening sense of their own perfection, and hence feel free to criticize others. The braying donkey is, of course, a symbol of the stupidity and malicious glee of those who deride others.
[Ripa, 1603, p. 101]

The *fatto:* Within a Piranesi-like prison chamber, Christ, seated, is being derided by the soldiers.
[Mark 15: 15 ff.]

DERISION
Christ, Who Heaven and Earth doth rule,
Must suffer the mob's ridicule.

ILLUSIO

Christus a Iudæis illufus, confpulus
virgisque cæfus in crucem agitur

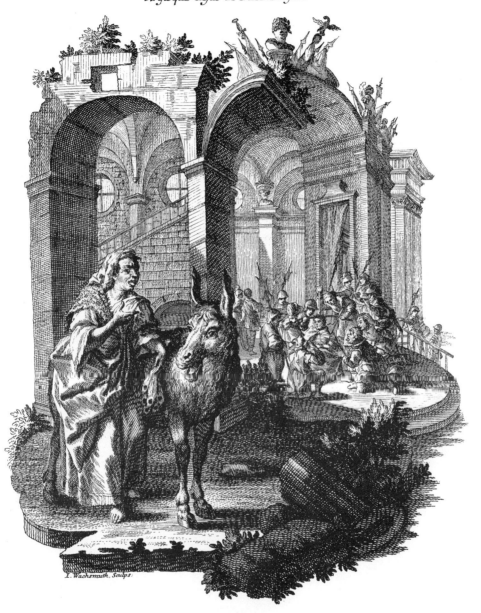

I. Wachsmuth, Sculps:

Die Verspottung.

Gott des Himels und der Erden,
muß zum Spott der Leuthe werden.

Eichler, del:

Hertel, excud:

130

RAGE

When David sang to the harp, Saul, shaken with the rage of his evil spirit, wanted to transfix him with a spear. He, however, avoided the danger happily enough.

The personification of Rage is a large, angry-looking man with a ruddy face, wearing classical armor. He strides forward, carrying a bared sword in one hand, and leaning on a shield on which is depicted a lion, which kills its own young in rage. On his helmet, decorated with plumes, a serpent is twisted.

The lion as depicted on the shield was the hieroglyph for uncontrolled rage, according to Alciatus. The serpent is also an emblematic animal signifying rage, for the minute he feels himself endangered or offended, he falls into a state of terrible anger, and does not rest until he has spewed forth all his venom to the damage of the offender. Sometimes he even dies of rage, when he cannot revenge himself on his enemy. The red complexion of the personification comes from his sanguine nature, which tends to quick and easy anger. He is shown as a belligerent warrior, for such is the spirit of those who give way to rage.

[Ripa, 1603, p. 177]

The *fatto:* In a noble hall, seated under a baldachin, Saul hurls a spear at young David, who flees, carrying his harp with him.

[I Samuel 18: 10–11]

RAGE
Enragéd Saul would David spear,
Refusing his harp's tones to hear.

Quum David cithara canit, Saul mali spiritus furore agitatus,
eum hasta trajicere vult. Is vero id periculi sat feliciter evitat.

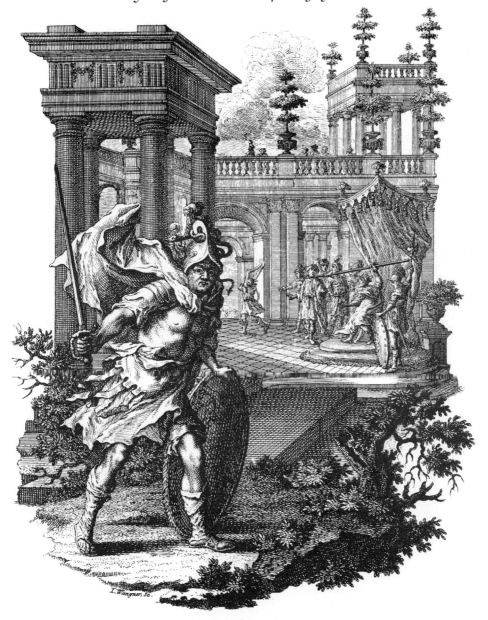

Die Raserey, Zorn, Grimm.
Saul ergrimt will David spißen,
nichts von Thon der Saiten wißen.

Eichler. del. *Hertel. excud.*

REBELLION

*Paul departed with Silas for Thessalonica. Speaking there, he alienated
many people. When this had happened, an uprising came about.*

The personification of Rebellion is an angry-looking bearded man in classical armor, wearing a rather oriental-looking helmet, who holds up a bundle of arrows in one hand and clenches the fist of the other. The bundle of arrows about to be thrown signifies the weapons, both literal and figurative, which the enraged carry with them to do their work of destruction. The clenched fist, angry look, and belligerent pose are all appropriate to such a personification.
[Ripa, 1603, p. 176]

The *fatto*: The enraged Thessalonicans, not finding Paul and Silas, vent their anger on their host Jason and other brethren, binding and stoning them.
[Acts 17: 1–9]

REBELLION

*The angry mob into Jason's house went,
On him and the brethren their anger to vent.*

SEDITIO

*Paulus cum Sila Teſſaloniam profectus ibique concionatus multo
rum animos alienavit. Quod cum factum eſſet ad ſeditionem
pervenit.*

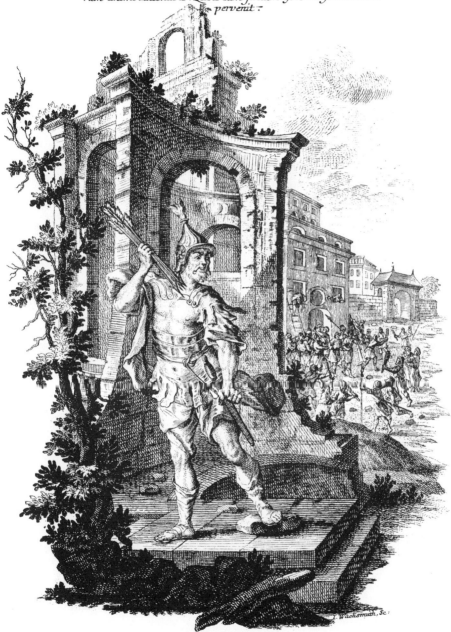

J. Wachsmuth. Sc.

Die Aufruhr.
Der Pöbel dringt in Iaſons Hauß,
nimt ihn ü: mehr der Brüder rauß.

Eichler. del:

Hertel. excud:

132

DEBAUCHERY

King Belshazzar holds magnificent banquets with his courtiers;
after consuming too much wine, he has gold and silver vessels brought
from the holy temple. As these are defiled, there is written on the wall,
by some hand, what is destined to take place.

The personification of Debauchery is a naked, goat-footed satyr, crowned with a wreath of vine leaves and *eruca* (colewort). Drinking from a wine bottle, he leans against a goat, on whose back blindfolded Eros, holding an arrow, lies in drunken stupor. Nearby stands a large wine ewer, and next to it lie a mask and a tambourine. Among the trees which frame the scene, a nymph and a faun embrace.

The many indications of the consumption of wine all refer to its encouragement of libidinous acts. Colewort was supposed to have the same effect. The satyr, half demigod and half goat,

is a symbol for the animal side of love. The goat is a prime symbol for sexual excess. True love, as personified by Cupid or Eros, seems in this case to have been overcome by the effects of wine. The mask and tambourine represent revelry.

[Ripa, 1603, p. 295]

The *fatto:* In a splendid banquet hall, King Belshazzar and his guests sit at a richly set table. Above, a hand emerges from a cloud and writes on the wall.

[Daniel 5: 1–5]

DEBAUCHERY
Belshazzar to license gave his all,
Until that hand wrote on the wall.

LUXURIA.

Magnifica Rex Belsazer cum aulicis habet convivia, vinoque
usus lar giore templi divini ex auro argenteoq; vasa adferri præ=
cipit. Quibus violatis manu nescio qua parieti, quid eventurum
sit, inscribitur.

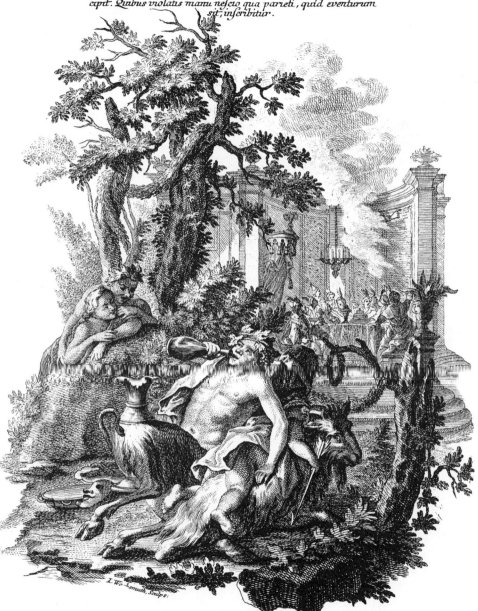

I. Wolcismuth, Sculps.

Die Schwelgerey Wohlleben.
Belsazer in Wolluft schwebet,
biß sich jene Hand erhebet.

Eichler, del.

Hertel, excud.

FAMINE

The sons of Jacob, forced by acute famine, went off to Egypt.
At this time almost all power was in the hands of Joseph, who, recognizing his brothers,
conceded them all they wished. Each one's sack is filled with grain, and added to it
is the money they paid for it.

The personification of Famine is a thin and ragged woman with a desperate expression on her face, who stands near an almost leafless tree. With one hand, in which she holds a piece of pumice stone, she points to a ragged little child asleep under the tree, his bowl lying empty beside him. She points with her other hand to a large gaunt cow standing nearby.

The tree is presumably a willow, which, like the pumice stone, is supposed to be a sterile thing. The woman's appearance, like that of the child, refers to the hunger and grief which famine brings. The lean cow is an allusion to Pharaoh's dream of seven fat and seven lean cows, which figures so prominently in the story of Joseph; each lean cow represented a year of famine.

[Ripa, 1603, p. 63]

The *fatto*: Standing under an umbrella before a fantastic building, Joseph receives his brothers, who, carrying their shepherd's crooks, kneel before him in supplication. In the middle distance, they can be seen opening the sacks of grain they have purchased and finding the purchase money within. The obelisk and pyramid identify the Egyptian milieu.

[Genesis 42 ff.]

FAMINE
Jacob doth his sons command
To bring back food from Egyptland.

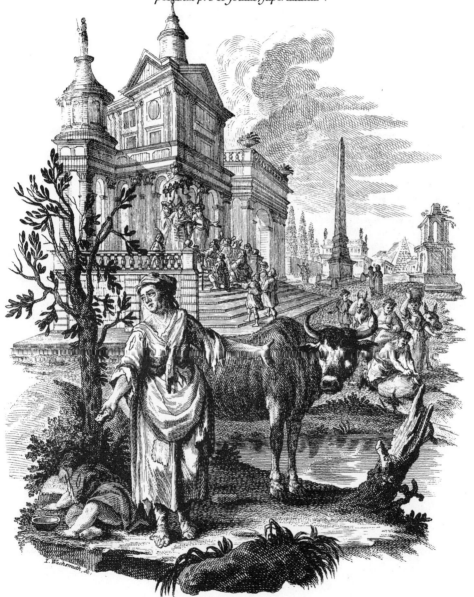

ANONÆ CARITAS.

In Aegyptum Iacobi filii summa anonæ caritate coacti, abierunt. Penes Iosephum tunc summum fere imperium erat, qui, cognitis fratribus, quæ, cunq petierant annuit. Vnius cuiusque saccus frumento impletur eique pecunia pro eo soluta, superadditur.

Die Theurung.
Iacob seinen Söhnin befohlen
in Egypten Frucht zu hohlen.

Eichler. del:

Hertel, excud:

PESTILENCE
David, becoming proud, has the population of Israel counted.
He does not do this with impunity and must choose one among three evils.
A pestilence attacks, in which a great multitude perishes.

The personification of Pestilence is a yellow-complected woman in a beige garment, with a garland of dark clouds around her wild hair. She holds up a whip with bloody, weighted thongs. At her feet sits a basilisk, or cockatrice, and behind her corpses lie in a heap.

The woman's ugly and frightening appearance is as detestable and horrible as the plague. Her yellow color suggests infections of the body, for this color is always found in the pus that forms. The clouds around her head and the beige color of her dress represent the bad air and the appearance of the sky when pestilence comes. The bloody scourge is the plague which torments everyone, regardless of age, state, or sex. The heap of corpses represents human mortality. The basilisk, whose breath and very glance are lethal (see Plate 94), suggests the invisible danger of the plague, which though unseen, kills.

[Ripa, 1603, p. 397]

The *fatto*: King David, proud of his flourishing kingdom, decides to have the people of Israel counted. Because he thus seems to put a numerical limit on the power of the Lord, he must be punished for his *hubris*, and is given the choice among three disasters. Having chosen a three days' pestilence, he kneels in despair as the plague strikes down his people. The angel of the Lord appears in the sky with a flaming sword.

[II Samuel 24]

PESTILENCE
King David to count God's people tried,
And suffered a pestilence for his pride.

PESTILENTIA

Plebem Ifraeliticam David elatus curavit numerandam. Id
non impune tulit, eique ex tribus malis unum est eligendum.
Ingruit pestilentia, qua ingens multitudo abfumitur.

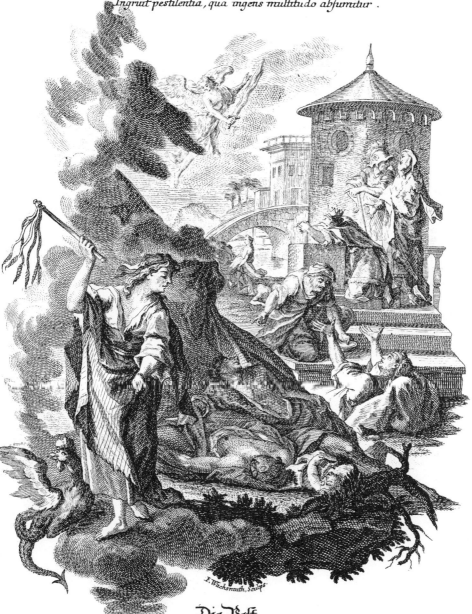

I. Wachsmuth, Sculpt.

Die Peſt.
David Gottes Volck ließ zählen,
muß zur Straffe Peſt erwählen.

Eichler, del.

Hertel, excud.

EARTHQUAKE

Paul converts Lydia and drives out an impure demon from a certain maiden.
Beaten for this, he is placed in prison. Through an earthquake he is liberated,
and the jailor is converted.

A man, grimacing with fear, clambers desperately out of a fissure in the earth, while whole buildings fall about him, and people are buried under the debris. Without any special attributes or symbols, the wild-haired man serves to represent the terror and danger caused by earthquake. The falling buildings and the many buried people also indicate its effects on human existence.

[Ripa, 1603, p. 486]

The *fatto*: Paul and Silas stand in a huge prison, having been freed from their cells by an earthquake. The jailor, so impressed by a God who will thus free His servants, is converted to Christianity.

[Acts 16: 14 ff.]

EARTHQUAKE

Paul and Silas for the God witness bear
Who by miracle can save them then and there.

TERRÆ MOTUS.

*Paulus Lydiam convertit, inpuramq̃, ex quadam puella
expellit diabolum; ob eam rem cæsus custodiæ traditur.
Facto terræ motu ille liberatur et carceris janitor convertitur.*

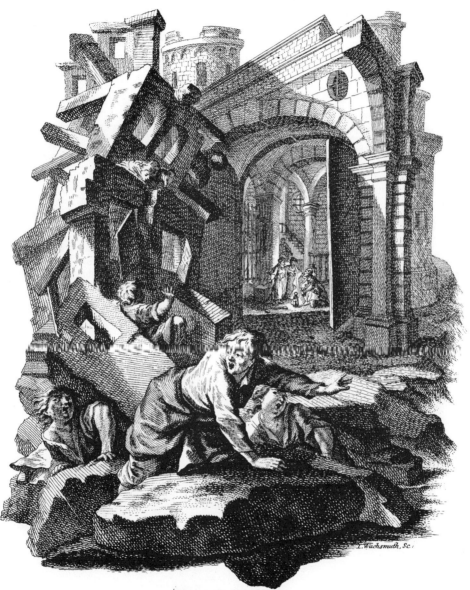

J. Wachsmuth. Sc.

Das Erdbeben.
Paulus, Sila, für Gott treffen,
der durch Wunder kan erretten.

Eichler del.

Hertel, excud.

WISDOM

*The Queen of Araby goes to Solomon, for she has heard that he is a man of
great wisdom. Arriving, she cannot admire his wisdom and his riches enough.*

The personification of Wisdom is a beautiful woman dressed in robes of white and turquoise, with a sun symbol on her breast. She stands looking up to a stream of light which comes down from the sky. She tramples underfoot a crown, a scepter, a gold chain, and money. Some books, scrolls, and a lighted lamp lie nearby.

Wisdom, according to Ripa, is the same as faith in God and the contemplation of His nature. Hence things of the world are despised by the wise man—the crown and gold on which the figure tramples. The sun is the symbol for light, which in turn symbolizes wisdom. The beam of light from the sky indicates that all wisdom comes from God. The woman looks up at it with joy and devotion. Her hands are free, for she, being wise, has given herself wholly to the contemplation of the divine. The books represent the written records of wisdom, which help preserve the wisdom of the past. The lamp, which symbolizes the light of intellect, dispels the shadows of ignorance and untruth which all too often obscure human life.

[Ripa, 1603, p. 440]

The *fatto:* In an elaborately decorated hall, Solomon, seated on a high dais, receives the Queen of Sheba, who sits below, accompanied by a large and colorful escort, some of whom bear gifts.

[II Chronicles 9]

WISDOM
*Sheba's queen from far Arabia came
To savor wise Solomon's wealth and fame.*

SAPIENTIA.

Arabiæ Regina ad Salomonem proficisitur, quem magno
esse ingenio audiverat. Quo cum perveniret, nec pruden-
tiam nec ejus thesauros sat admirari potuit.

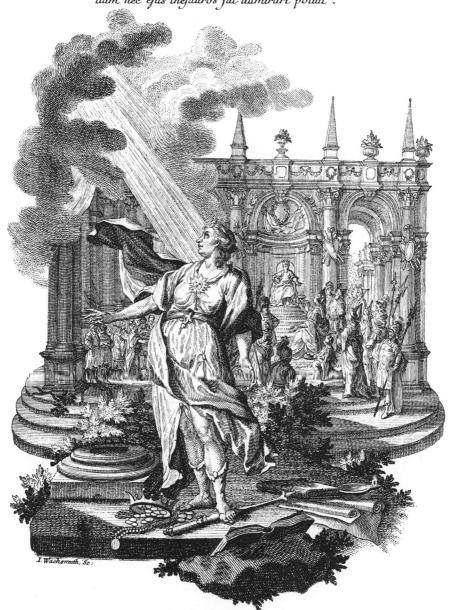

I. Wachsmuth, Sc:

Die Weißheit.

Arabia vorhin gehört,
waß Salomon nochmahls vermehrt.

Eichler, del.

Hertel, excud.

PROTECTION

Seeing that prophets have been destroyed by the queen, pious Obadiah twice provides food and water for fifty of them, hiding them in safe refuges here and there.

The personification of Protection is a fair young woman dressed in classical armor, her helmet topped with a tiny figure of a crane holding a stone in its claws. She stands with a naked sword in one hand and a lighted torch held downward in the other. Her shield, emblazoned with a porcupine, lies at her feet, where a large goose also stands.

The authors have taken two images from Ripa—the one symbolizing protection against enemies, and the one for vigilance—to make up this allegorical figure. The maiden is armed, for one must be to fight off enemies. The unsheathed sword is all ready to be put to use and the torch gives light to see by. The shield with the porcupine signifies defense, for, according to Piero Valeriano, this animal, which

curls itself up when attacked and protects itself with its sharp quills, is a perfect natural example of defense. The crane on the figure's helmet refers to vigilance, as explained before (see Plate 51). The goose is supposed to wake up twelve times a night, and is also an allusion to the story from Livy in which the geese kept on the Capitol awakened the guards with their cackling and alerted them to the Gauls who were secretly attacking the hill.

[Ripa, 1765, II, p. 192, "Difesa contra a' Pericoli"; 1765, III, p. 231, "Guardia"]

The *fatto:* In a huge, rocky cavern, Obadiah hides and feeds the prophets he has rescued from the persecution of wicked Queen Jezebel.

[I Kings 18: 3,4]

PROTECTION
Obadiah scores of prophets hides,
With food and safety them provides.

PROTECTIO.

Deletis a Regina prophetis pius Obadja quinquage-
nos hic illicve in latebras absconditos cibo aquaq; procurat.

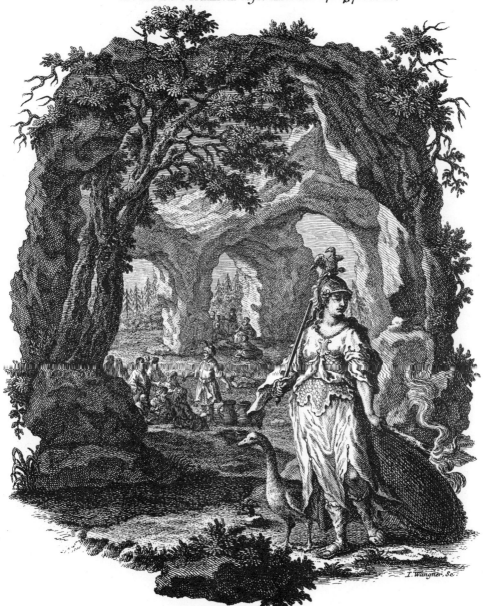

I. Wangner, Sc.

Die Beschützung.

Obadja die Propheten speißt,
und vor Gefahr zu schützen weißt.

Eichler, del: *Hertel, excud:*

138

ALMS

*A poor widow to whom Fortune had left nothing more, cast a farthing
into the sacred chest. Thus she gave more than all the rich.*

The personification of Alms is a woman clothed in long and dignified robes, with a transparent veil over her face and her head crowned with a wreath of olive and a lighted lamp. She distributes coins with both hands to two begging children.

The woman's transparent veil allows her to see the needy, but does not allow them to recognize her; this is true and modest charity. Her hands are almost hidden from sight by her long robe, for, as St. Matthew says, one should not let one's left hand know what one's right hand is doing. The lighted lamp, which can light another with its flame without being diminished, is like charity, for, as the Lord promised, give and you shall be rewarded a hundredfold for your charity. The olive wreath represents that sense of mercy and pity which moves one to give to those in need.

[Ripa, 1603, p. 120]

The *fatto:* In a high and very stately hall of the Temple, Christ, seated, points out the widow leaving her small offering at the collection box.

[Mark 12: 41–44]

ALMS

*Two pence for alms, the widow's mite,
Are more than riches in God's sight.*

STIPS.

Quadrantem vidua inops, cui præter illam fortu-
na nil reliquum fecit, immittit arcæ divinæ. Quo
factum est, ut plus immitteret, quam omnes divites.

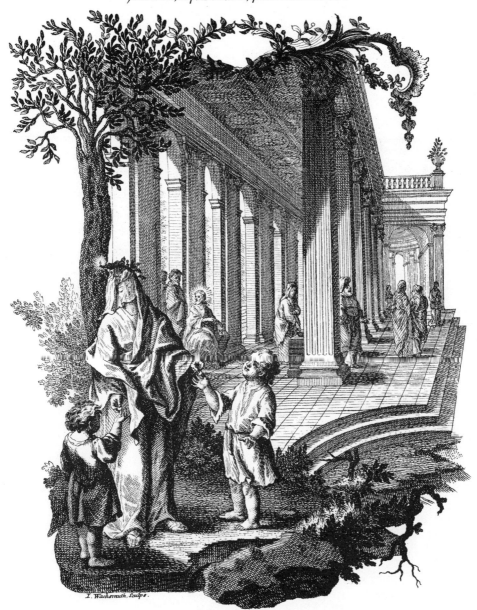

I. Wachsmuth, Sculps.

Das Almosen.

Die Wittwe legt zwey Schürflein ein,
Thut mehr als Haab der Reichen seyn.

Eichler. del. Hertel excud.

CONSTANCY
Shadrach, Meshach, and Abed-nego are thrown into the fiery furnace because they refused to worship a golden idol. The flames do not harm them; they remain unscathed.

The personification of Constancy is a young woman in classical robes, wearing a helmet and holding a sword in one hand as she embraces a column. She holds the other hand over a flaming brazier, ready to let it burn.

Constancy is armed with righteousness and unshakable faith in her beliefs. The column she embraces is an old symbol for firmness and stability. To "put one's hand in the fire," as an expression of absolute faith in what one is saying, is an old expression. It probably refers to the fearlessness of Mucius Scaevola, who put his right hand in the fire to show Porsenna that he did not fear him (Livy, II, 12)—an example of having the courage of one's convictions.

[Ripa, 1603, p. 86]

The *fatto:* Nebuchadnezzar, ahorse and under a canopy, watches the multitudes worship the golden idol he has set up, while in the background the three Israelites are seen to be unharmed while standing within the blazing furnace, whose flames billow out and slay the bystanders.

[Daniel 3]

CONSTANCY
The one true God the men do praise
Who stand unscathéd in the blaze.

CONSTANTIA.

*Ardenti in iciuntur fornaci Sadrach, Mesach
et Abadnego, auream ad orare imaginem re-
cusantes. Nec nocuit illis flama manseruntq; illæsi.*

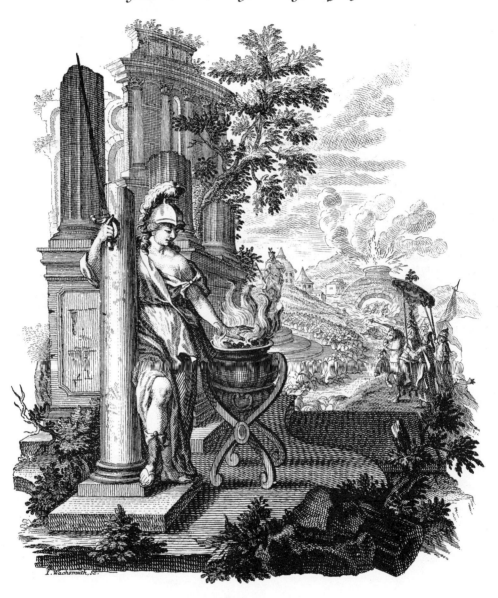

Die Beständigkeit.

Gott allein die Männer ehren,
Sie die flamen nicht versehren.

Eichler. del.

Hertel. excud.

140

REWARD
God calls everyone to account for the things He has entrusted to them.
The good, for their great faith, are given a special reward, eternal salvation.

Standing on a fine carpet under a rich canopy is a man of grave and dignified aspect—the personification of Reward—dressed in a rich costume of white with a golden mantle. He holds two wreaths of laurel in one hand, and a palm frond entwined with oak in the other.

The white robe and the cloak of gold represent truth accompanied by virtue; for these are necessary if reward is to be just and deserved. The laurel crowns are the ancient symbol for rewards. The palm and oak branches signify honor and utility, both components of a proper reward.

[Ripa, 1603, p. 411]

The *fatto* depicts the parable of the talents. In a noble hall, one servant receives five bags of gold from the master, and the other servant two bags, amounts by which they had increased the talents entrusted to them. In the background the stupid servant digs up the talent he had simply buried.

[Matthew 25: 14–30]

REWARD
The servants' skill and loyalty
With gold and joy rewarded be.

PRÆMIUM

*Bonorum unicuique demandatorum Deus poscit
rationem. Boni fideq́; magna præcipuum ferunt
præmium, æternam quip͜pe salutem.*

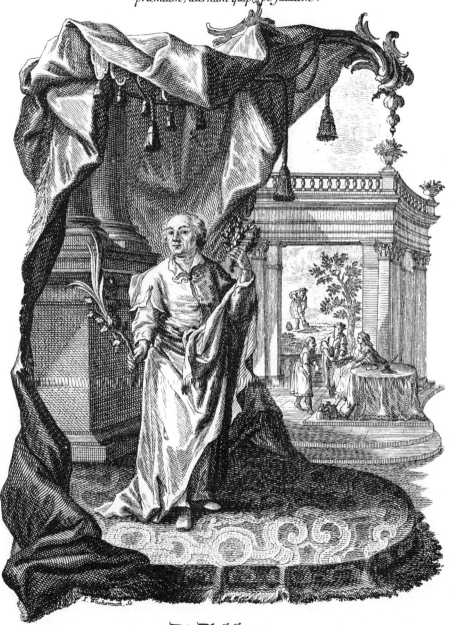

Die Belohnung.

Der Knechte Treu der Herr zuletzt,
durch jenen lohn, und Freud ersetzt.

Eichler del:

Hertel, excud

Oh, cares of Man! Oh, how empty are the things of this world!
Who can read of these things and not be of malicious spleen
and immoderate laughter?

Part VIII

Histories and Allegories

Designed and drawn

by Gottfried Eichler the Younger;

Published by the Author,

Johann Georg Hertel,

Augsburg

Above the cartouche bearing the title is a scene which is certainly the invention of Hertel, for it has no counterpart in Ripa, although the various elements within it are to be found among his allegories. In a forest clearing sits the globe of the world. On its left a baby satyr wearing a grape-leaf garland has inserted a bellows into a crack in the globe and is working it. On its right stands a putto wearing an elaborate feathered hat and carrying a cornucopia full of artist's tools. He points to the globe. Above the globe, standing on a wall, is Cupid, who shoots an arrow at the globe, while bees fly about his head. Out of a large crack on the top of the globe fly insects, and little slips of paper inscribed variously "Musica," "Idea," "Pittura," "Phantasia," "Satyrae," "Varia," "Capricio," "Pensiere," "Processus," "Astrologia," "Botanic.," "Arithm.," "Medic.," "Poesia," "Geomet.," "Architectura," "Mathem.," and "Chiromant." In the distance is a circular temple surmounted by a statue of

Apollo; in the clouds in the sky, Pegasus can be seen.

The basic idea apparently is that the world is filled with all sorts of foolish notions (like art, philosophy, music, imagination, etc.). In German foolish notions are called *Grillen*, also the word for "cricket," and the artist has used the image of insects flying about to symbolize them. The little satyr probably represents caprice or low comedy, and he is stirring up the internal fires of the world to agitate the *Grillen*; the other putto is certainly the artist, with his plentiful tools and his fanciful thoughts, symbolized by his elaborate hat. Love, his head also attacked by all sorts of silly ideas, is only complicating matters with his arrow. But in the back is the noble temple of the mind, and in the sky, the symbol of art and poetry, Pegasus, far removed from this hurly-burly. The American equivalent of the insect idea might be "to have bees in one's bonnet."

This mad old world's outstanding quality
Is that with silly notions it ever plagued will be.

O curas hominum, ó quantum est in rebus inane .
quis legat hæc nec sit petulanti splene cauhino .

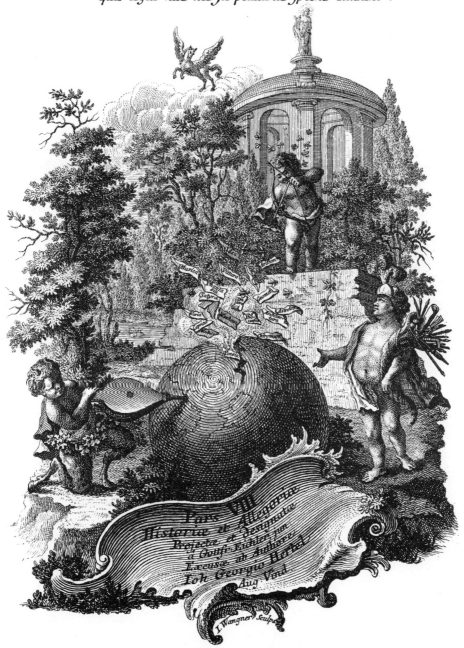

Pars VIII
Historiæ et Allegoriæ
Projectæ et designatæ
à Gottfr. Eichler jun.
Excusæ ab Authore.
Ioh. Georgio Hertel
Aug Vind

I. Wangner Sculps.

Der Welt ihr Sinn u. Eigenschafft,
mit Grillen wie du sehn behafft .

IGNORANCE

*Laius, King of the Thebans, fathered Oedipus, who the oracle predicted
would be the murderer of his father, if he were not killed in childhood. This
task was entrusted to slaves, who spared the boy and hid him in the forest.
Found there by a certain shepherd, he was brought to Polybus, who had him
raised. Grown up, during a revolt, he slew his father, though unknowingly.*

The personification of Ignorance is a quite old and ugly woman with a fat and deformed face, dressed in cloth of gold and gems, and wearing a wreath of poppies in her hair. She walks barefoot through a patch of thorns. On the ground before her lies an open, badly torn book. She points upward to a flying bat and to an owl perched in the window of a nearby ruined building.

Hertel and Eichler have used Ripa's representation of Ignorance before, in inventing their allegory of Incredulity (Plate 125), and simply repeat it here with one or two changes or additions. This is the sin of ignorance, the deliberate refusal to see the truth, and the disparagement of knowledge. The woman is ugly because wisdom makes one fair, and ignorance otherwise. Her rich dress represents the arrogance of ignorance, which shows itself off in an ostentatious manner. The poppies represent the sleep of the mind. She walks barefoot through thorns, for she has strayed from the path of virtue. The bat and owl, both creatures of the night which avoid the light, symbolize the ignorant, who refuse to see the light of wisdom and knowledge.
[Ripa, 1603, p. 221]

The *fatto:* In a field a group of men are fighting; one of them already lies on the ground killed. This is the murder of Laius by his own son, Oedipus, just as the oracle had predicted.
[Sophocles, *Oedipus Tyrannus*, 715 ff.]

IGNORANCE
*Laius believed his son was dead,
Who unwittingly slew him instead.*

Thebanorum rex Lajus genuit Oedipum quem parentis sui interfectorem prædixe-
rat oraculum, ni in pueritia interimeretur. Id negotii servis mandatur, qui puero
parcunt eumque in sylvis occultant; Ibi á pastore quodam inventus fertur ad Po-
lybium, qui eum educandum curat. Seditione coorta, adultus patrem interficit,
licet ignarus.

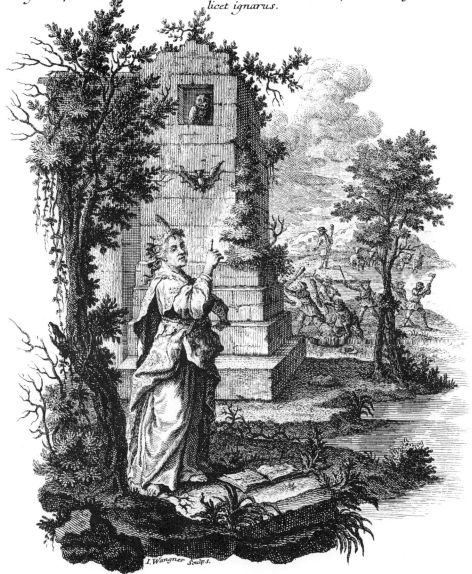

I. Wangner Sculps.

Die Unwißenheit.
Lajus den Sohn hat Tod geglaubt,
der unbewußt ihms leben raubt

Eichler, del. Hertel, excud.

MEMORY

Julius Caesar, the first of the emperors, had a memory not less fertile than his wit was sharp. He would write, reply to others, and dictate those things which were to be written, all at the same time, and with neither discomfort nor mistake.

The personification of Memory is a middle-aged woman, seated, dressed in black, with jewels in her hair, who tugs at her earlobe with one hand and holds a quill pen and an open book in the other. Seated beside her is a large black dog. On a pedestal at the right is a bust with two faces, wearing as a headdress the head of an elephant. Above, attached to a wall, is a cartouche inscribed "Est in aure ima memoriae locus, quem tangentes attestamur [antestamur]; Plin. lib. II" (The earlobe is the seat of memory, and we touch it when calling someone to witness; Pliny, Book 2).

The personification is middle-aged, for that is the best age for having a good memory. Just as her jewels are an ornament for her head, so memory is an ornament of the mind. She is dressed in black to signify the firmness of memory. The dog is famous for his good memory. The two-faced bust indicates memory's concern with what is happening in the present, and its ability to remember all that happened in the past. The elephant headdress refers to this animal's proverbial good memory.

[Ripa, 1603, p. 312]

The *fatto:* In a circular study, open to the sky, Julius Caesar sits, dictating to secretaries, reading, and receiving a message, all at the same time.

[Plutarch, *Life of Caesar*, 17]

MEMORY
Listen and read and write, all of these three
Could Caesar do at once, a genius he!

Iulius Cæsar imperatorum primus non minus fuit felici me-
moria, quam acri ingenio. Scribebat respondebat aliis, in calamum
dictita- bat, quæ essent scribenda, et hæc omnia simul nec
infeliciter nec incongrue.

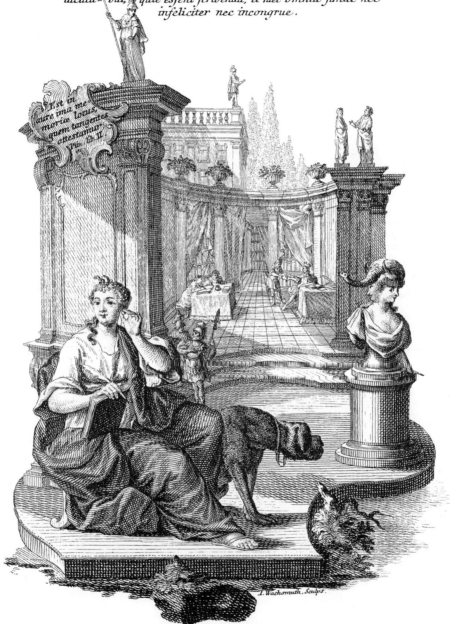

Das Gedächtnis.
Cæsar, hören lesen schreiben
u: noch mehr zu gleich fort treiben.

Eichler, del.　　　　　　　　　　　　　　　　　　Hertel, excud.

J. Wachsmuth, Sculps.

COUNSEL

Between Agamemnon and Achilles a serious quarrel and rivalry arise.
Nestor, now three hundred years old, persuades both to take advantage of his advice,
proved to be good by experience and practice.

The personification of Counsel is an elderly, very dignified man, seated; he wears a red robe, and around his neck is a golden chain from which hangs a heart. He holds a book on his knee, and gestures with his free hand. On a high pedestal behind him is a three-headed bust, made up of a dog's head, a lion's, and that of a fox or wolf. On a ledge nearby stands a mirror, and behind the man's stool, almost invisible, is a boar.

He is elderly, for that is the age when one is wise enough to be able to give good advice. He holds a book, for good counsel is based on the study of wisdom. His robe is red, for that is the color of charity, and the giving of counsel to the doubtful is considered one of the seven acts of spiritual charity. The heart on his chain signifies that true counsel comes from the heart, which was considered the seat of such charitable sentiments. The three animal heads refer to the qualities needed for giving good counsel. The dog signifies benevolence, for the counselor wishes to help; the lion, nobility of character and courage; and the fox (or wolf), the guile sometimes needed to get good advice accepted. The boar, whose outstanding quality is his excellent hearing, is present because good advice needs to be heard if it is to be effective. The mirror is that of prudence, a needed quality when advising others, for the prudent man knows his own limitations and abilities, just as one knows one's reflection in a mirror.

[Ripa, 1603, p. 85]

The *fatto:* On the shore of the sea, in the Greek camp, Nestor is seen advising Agamemnon and Achilles, both of whom look angry.

[Homer, *Iliad,* I]

COUNSEL

Agamemnon and Achilles' disagreement great,
Old Nestor's wit and counsel try to eliminate.

CONSILIUM.

Inter Agamemnonem Achillemque magna oritur altercatio
atque certamen. Vtrumque monet Nestor annos jam trecentos
habens ut suo utatur consilio, experientia ipsoque usu probato.

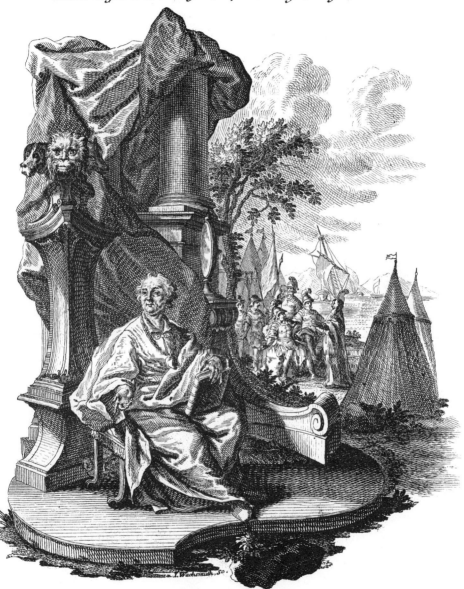

I. Wachsmuth, Sc.

𝕽𝖆𝖙𝖍 𝖚𝖓𝖉 𝖀𝖓𝖙𝖘𝖈𝖍𝖑𝖆𝖌.
Agamem und Achillis ſtreit,
legt Neſtors Witz ũ: Rath beyſeit.

Eichler, del. Hertel, excud.

VIRTUOUS ACTION

Antiochus, king of Syria, besieges the monarchs Ptolemy and Cleopatra,
with whom the Romans are allied. The envoys sent to him by the Senate meet
him at Eleusin after he has crossed the river. Popilius gives him the tablets
with the message, and commands him to read them. After Antiochus has read them
and said that he would deliberate on his course of action, Popilius marks a
circle around the king with a rod, and says: "Before you leave this circle,
you must give me the answer to bring back to the Senate." Astounded, Antiochus
says: "I will do what the Senate thinks right."

The personification of Virtuous Action is a handsome man of heroic build, dressed in classical armor and a cloak of gold, with a symbol of the sun on his breast and a wreath of amaranth around his helmet. He holds a lance, with which he impales the head of a horrible serpent. Before him lie a sword and an open book inscribed "Famam extendere factis hoc Virtutis opus" (To gain fame through deeds is the work of virtue). Behind him is a high pedestal at the base of which rests a skull; the pedestal is surmounted by a statue of Hercules. The base is inscribed "Sola Virtus expers Sepulchri" (Only virtue escapes the grave).

The cloak of gold worn by the hero indicates that true heroic virtue is for those who are great, such actions being too difficult for those of low estate. The sun symbol signifies that as the sun lights the earth, so virtue lights the heart and leads to good deeds. The serpent represents evil or vices, which the virtuous combat. The amaranth flower, of the deepest red, never fades, just as virtuous action is never forgotten or diminished by time. The statue of Hercules refers to the hero who was the sum of all virtues and became a god. The skull at the base of the pedestal indicates that only virtuous actions escape death and live forever. The sword and the book are means by which fame is achieved and recorded for posterity. The inscription on the book comes from Vergil (*Aeneid*, X, 468–469), and that on the base of the statue from Plautus.

[Ripa, 1764, I, p. 193]

The *fatto:* Before an open arcade in the Egyptian city of Eleusin, the famous encounter between Antiochus Epiphanes and the Roman senator Popilius Lenas, as described by Livy, is depicted. The Roman is shown drawing a circle around the Syrian monarch, while awaiting his answer to the message from the Roman Senate.

[Livy, XLV, 12]

VIRTUOUS ACTION
'Round Antiochus, Popilius a circle drew,
Restraining him from doing what he wished to do.

Syriæ rex Antiochus Ptolomæum et Cleopatram reges, quorum socii Romani, erant, obsidet. Missi a senatu ad eum legati ad Leusinem transgresso flumen occurrunt. Tabellas ei Popilius tradit scriptum habentes atque id legere jubet, quibus perlectis, quam se consideraturus, quid faciendum sibi esset, dixisset, virga circumscripsit regem, ac Priusquam hoc circulo excedas, inquit, redde responsum senatui, quod referam. Obstupefactus, faciam inquit quod censet senatus.

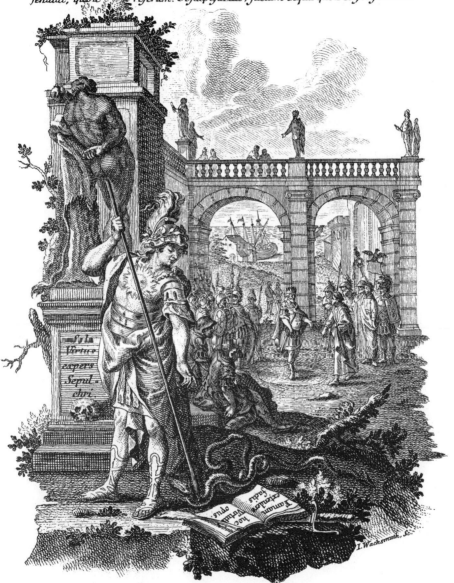

Die Tugendhaffte Verrichtung.
Popilius durch seinen Kreiß,
Zwingt Antioch nach art ü: weiß.

Eichler, del. I. Wachsmuth, Sc. Hertel, excud.

146

CUSTOM

The emperor of the Turks sent ambassadors to Dracula. They, fearing lest their ancient custom be abused, said that they would not pay him homage by removing their hats. He ordered that the hats be nailed to their heads.

The personification of Custom is a bearded old man, poorly dressed, who walks with the help of a cane. He reads from a paper in his hand, inscribed "Vires acquirit eundo" (It gains strength through moving forward). On his back he carries all sorts of carpenter's tools, saw, pincers, chisel, and rule. A large grinding stone with a handle lies on the ground behind him.

The man is old, for custom gains its power with time and the older it is, the stronger. This is also the meaning of the motto he holds in his hand. Just as the grinding wheel does not have the power to sharpen things unless it is put into motion, so custom cannot develop unless it is put into practice. The same idea is expressed by all the tools the man carries; their use only becomes skillful if it is habitual.

[Ripa, 1603, p. 86]

The *fatto*: Standing before a classical building by the sea, Dracula, dressed like a Hungarian magnate, orders his men to nail the hats of two Turkish envoys to their heads. This Dracula (which means "little dragon") is the late fifteenth-century Voivod of Transylvania, Vlad Tepeş, legendary for his cruelty, not the vampire created by Bram Stoker.

CUSTOM
*Dracula respect demanded
And old custom reprimanded.*

MOS ANTIQUUS.

Turcorum imperator legatos ad Draculum mittit. Qui cum veriti, ne mos antiquus violaretur, negarent, se pileis detractis eum esse veneraturos, jussit, eorum pileos unius cujusque capiti clavis affigi.

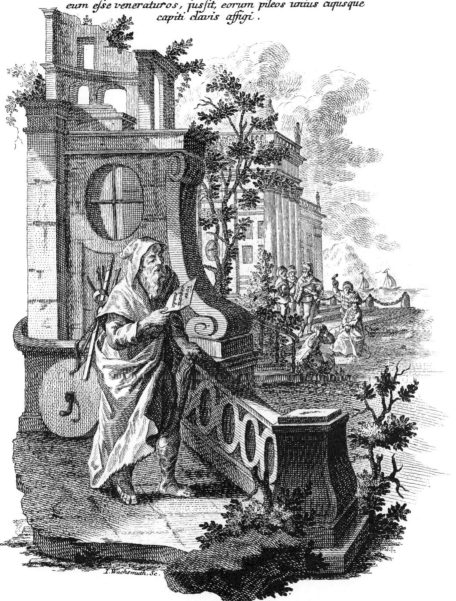

I. Wachsmuth, Sc.

Der Gebrauch.
Dracula sich Ehr verschaffet,
den Gebrauch sehr übel straffet.

Eichler, del. Hertel, excud:

DILIGENCE

Furius Chresimus cultivated a single field, truly more fertile than those
of his neighbors. They were vexed by this, and he was summoned into court, accused
of magical arts. The council being gathered, he entered with his daughter, who was
much more robust than all others of her kind, and showed the tools with which he
cultivated his field. Persuaded by this, the senate absolved him.

The personification of Diligence is a young woman dressed in red, who holds an hourglass and a sprig of thyme about which bees hover. Over her wrist hangs a spur. Beside her a rooster pecks at the ground, and behind her stand two beehives.

The industrious person is one who wishes to do something and finish it, hence the hourglass, which measures time—so important to the diligent. The spur is the stimulus to move ahead, to get something done. Another symbol for diligence is the sprig of thyme with the bees; although thyme is a very dry and ordinary sort of plant, bees do get honey from it, just as those who delight in arduous or difficult tasks also derive benefit from doing them. The rooster is a busy, fast-working bird, who separates the useful food from the undesirable grains of dust. The beehive is a standard emblem for diligence and industry.
[Ripa, 1603, p. 104; Ripa, 1765, II, p. 219]

The *fatto:* Standing before the court, C. Furius Chresimus, accused of witchcraft (about 150 B.C.), presents his husky daughter and his farming tools as the only means whereby he gets such excellent crops. Outside stand two oxen.
[Pliny, *Natural History*, XVIII, 41]

DILIGENCE
Though Chresimus accuséd be,
His diligence doth set him free.

INDUSTRIA

Vnicum Furius Crefinius colebat agrum, feraciorem vero vicinorum omnibus. Id ii ægre ferebant. Artis magicæ accufatus in jus rapitur. Concilio convocato ille intrat una cum filia, aliis fui generis multo robustiore, inftrumenta, quibus folebat agrum colere, oftentans. Quo motus fenatus eum abfolvit.

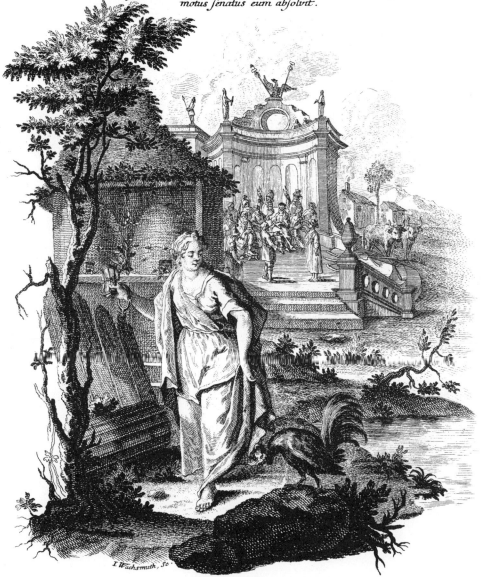

I. Wachsmuth, Sc.

Der Fleiß.

Crefinius kommt vor Gericht,
wo Müh u. Fleiß ihn glücklich spricht.

Eichler. del.

Hertel. excud.

HOUSEHOLD ECONOMY

*Too often a household is poorly administered. The rich, overcome by desire and
by pleasure, hold luxurious dinners and prepare banquets with every care and
great expense, with which they attract many. The poor man lives more happily, for,
contented with his own lot, he surpasses all the rest in the frugality
of his life and habits.*

The personification of Household Economy is a matron of serious appearance, who sits holding a pair of compasses in one hand and a large ship's rudder and a wand in the other. She wears an olive wreath on her head. Beside her is a large beehive.

The compasses she holds symbolize the measuring of one's resources and the controlling of expenditures accordingly, the very basis of a good budget. The wand is the symbol of the dominion of the master of a household over its other members, and the rudder represents his leadership in the house, for he alone guides it. The olive wreath is appropriate, for good household economic policies keep peace within a house. The beehive stands for industry and diligence, without which no well-run household can exist.

[Ripa, 1603, p. 118]

The *fatto:* Two scenes are contrasted in the little edifice in the background. In the richly decorated room on the left, a man, very carelessly dressed in costly clothing, sits at a table, but does not notice a pig stealing food from it. On the floor, coins and what appear to be bills are scattered. A viol lies on the floor, and against a wall in the back a table is seen laden with rich vessels. On the right, in a very humble but neat interior, a farmer and his wife and two children say grace before a simple meal, while outdoors men are seen harvesting grain.

HOUSEHOLD ECONOMY
*The rich man's house is oft a costly mess;
The poor man manages well with less.*

RES DOMESTICA.

Sæpius res familiares male administrantur. Pecuniosi libidine voluptateque
capti sectantur luxuriosa convivia, epulasque et cura et sumtu majore ap-
parant, quo plures in animi illiciuntur. Felicius vivit pauper qui sua
contentus sorte parsimonia victus atque cultus omnes vincit.

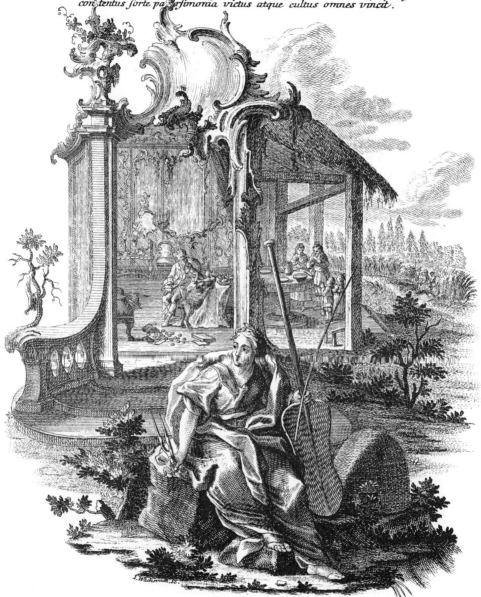

Die Haußhaltung.

Der Reiche hält offt übel Hauß,
ein Armer komt mit wenig auß.

Eichler, del. Herel, excul:

149

TEMPERANCE

Beaten in many battles, the Samnites asked peace of Manius Curius,
Roman consul, and accompanied their pleas with many gifts to win his favor.
At that moment he was seated by the fire cooking turnips. Learning their wishes,
he said: "So long as I eat these, I have no need of money, and I prefer to command
those who have great wealth rather than to possess it myself."

The personification of Temperance is a woman dressed in purple, who holds a bridle in one hand and the balance wheel of a clock in the other. Behind her stands an elephant.

Purple is a color made up of two very different colors, red and blue; just as neither of the component colors of purple dominates the other, so temperance is a happy balance between desire and reason. As a bridle restrains a horse, so does temperance hold appetites in check. The balance wheel of a clock is the part which marks off the units of time, just as temperance tells when it is time for action and time for quiet. According to Piero Valeriano (Book II), the elephant is the most temperate of animals, never eating any more than it needs.
[Ripa, 1603, p. 480]

The *fatto*: Before a kitchen fireplace, Manius Curius Dentatus (consul in 290 B.C.) kneels, cooking turnips and gesturing negatively to the Samnite envoys who offer him containers of money.
[Valerius Maximus, IV, 3, 5]

TEMPERANCE
Curius and his frugal meals
Typified his land's ideals.

TEMPERANTIA.

Samnites multis cladibus subacti petunt á Mannio Curio Rom: Consule pacem suamque rem multis donis ei comendant. Is eo tempore rapas assans igni adsidebat. Cognita eorum voluntate, dum his vescor, inquit nullius pecunia egeo. usque malo imperare, qui magnas opes habent, quam eas possidere.

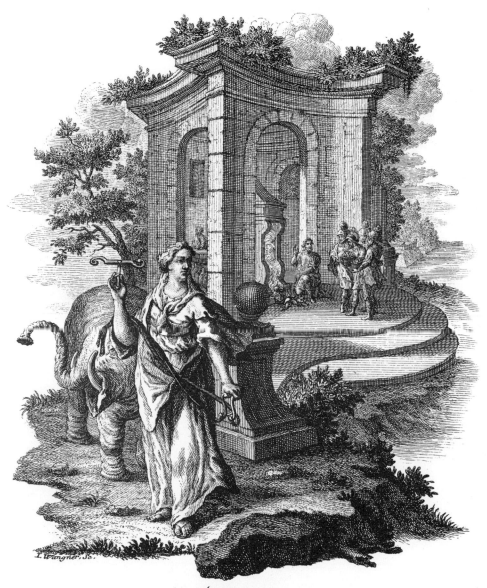

I. Wangner, Sc.

Die Mäßigkeit.

Curius bey schlechter Speiße,
lebt nach Standes art u: weiße.

Eichler, del.

Hertel, excud:

IMPROVEMENT

In many matters Julius Caesar brought innovations and in others made improvements.
Evidence of this is the calendar, whose correction is his work.

The personification of Improvement is a noble-looking woman, who sits holding an augur's staff and a scroll in one hand, and gesturing with the other. Before her an open book is propped against a stone.

The staff is a symbol of authority, and only those in authority are able to improve and correct institutions and actions. The scrolls and book represent the material which must be studied before one engages in correction. The woman is fine-looking because the desire to improve is a very praiseworthy activity; her gesture is one of admonition, the urging of reform and improvement.

[Ripa, 1765, II, p. 74]

The *fatto:* Seated in a princely library furnished with globes, Julius Caesar, with many books scattered about him, ponders the problem of the improvement of the calendar.

[Plutarch, *Life of Julius Caesar*]

IMPROVEMENT

To the calendar wise Caesar gave redress,
And law and order also helped no less.

Multis in rebus Iulius Cæsar partim nova attulit, partim meliora fecit.
Calendarium ejus opera emendatum pro argumento est.

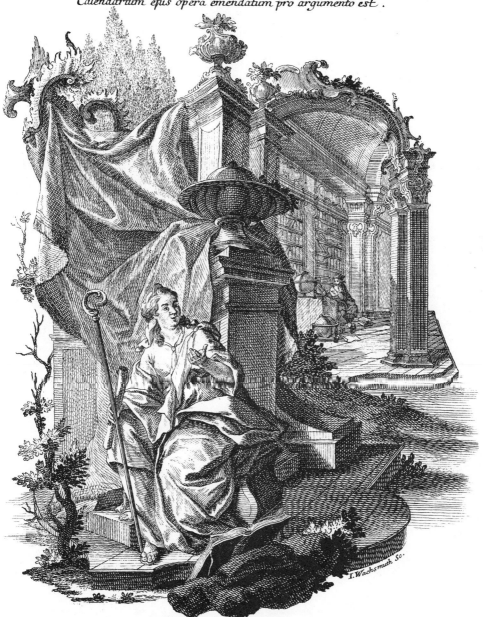

I. Wachsmuth Sc.

Die Verbeßerung.
Cæsar beßert den Calender /
Gsetz ü: Ordnung, auch nit minder.

Eichler, del. Hertel, excud.

GRATITUDE

By the emperor's command, a spectacle was ordered in which Androcles was to fight wild beasts. Loosed in the arena, they rushed forth. Among them was a lion, which, seeing Androcles and remembering the benefits received of him, stood motionless in front of him, lashing his tail, and saved him.

The personification of Gratitude is a handsome young woman dressed in classical draperies, who stands holding a large stork in her arms. She also points back into the scene where the *fatto* is taking place. On the left is a tree with a bean or lupine stalk growing up it.

The woman is beautiful because gratitude is a noble and edifying sentiment. She holds a stork because Pliny (*Natural History*, Book 18, chap. 14) says that the stork, out of gratitude, is very kind to its parents in their old age, building them a home, tending their plumage, and finding food for them. The beanstalk or lupine vine (either can be used) enriches the soil in which it grows and is thus also an example of gratitude in nature.
[Ripa, 1603, p. 196]

The *fatto:* In a Roman circus (strangely enough in a ruined condition), Androcles is seen standing nude in the arena. He pets the grateful lion, who was supposed to devour him, while the spectators marvel. In the background, an elephant is being led in (probably an afterthought of the designers, for Ripa also suggests an elephant as a symbol for gratitude, Piero Valeriano having pointed out how kind and considerate it is and how it always remembers past favors).
[Aulus Gellius, *Noctes Atticae*, V, 14]

GRATITUDE
Androcles was spared by the lion wild,
Its thankfulness making it sweet and mild.

GRATUS ANIMUS.

Imperatoris jussu parantur ludi, in quibus Androclo cum
bestiis est conflictandum. Proruunt emissæ, quas inter leo fuerat.
At ille Androclo viso, beneficia accepta recordatus, stat ante
illum imobilis, caudam jactando, eumque servat.

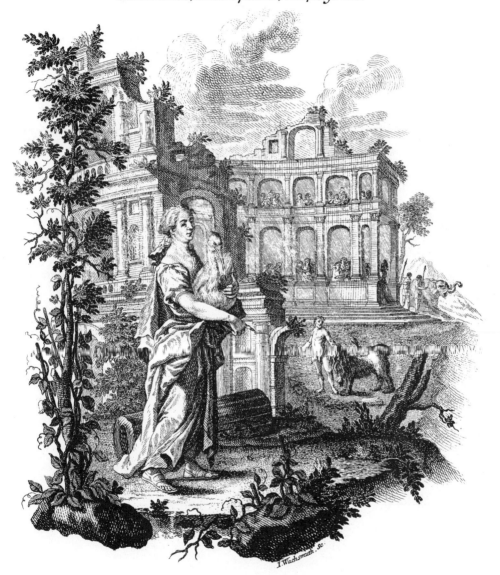

J. Wachsmuth. sc.

Die Danckbarkeit.

Androclum hat der Löw verschont,
die alte Treu an ihm belohnt.

Pichler, del.

Hertel, excud.

FORTUNE

Through good fortune, Polycrates becomes tyrant and gains great riches. On the advice of Amasis, king of the Egyptians, he tries his luck by throwing a ring into the sea. Beyond all expectations, it is found in the innards of a fish. Seeing this, Amasis dissolves the bonds of friendship, in order not to have to bring him aid, should he run into trouble.

The personification of Fortune is a beautiful nude winged female, blindfolded, who stands balancing on one foot on a large ball. She holds a cornucopia under each arm. From the one on the left spill money, crowns, medals, scepters, and marshal's batons; from the one on the right, pens, brushes, and scrolls. Above her on the left floats the winged figure of Father Time, holding his scythe and admonishing Fortune. Above her head a sphere covered with stars is suspended, and in her left hand she holds a staff topped with a wheel. The pedestal on which she stands is inscribed "Quisque suae Fortunae Faber" (Each man forges his own fortune). Around the base, reaching up to grasp the bounty pouring out of Fortune's horns of plenty, are a youth with his purse held open; the allegorical figure of Poverty with one outstretched winged hand and one hand dragged down by a stone chained to it, but holding a scroll and compass; the allegorical figure of Commerce, who has Mercury's winged hat and caduceus; and a poorly dressed man holding a pruning knife (a farmer?), who admires a warrior's helmet.

Fortune is lovely, for she is desired by all. She is blind, for she does not favor one over the other, and this without any apparent rhyme or reason. She balances on a ball, for she is unstable and always shifting and changing.

She dispenses all riches and honors of this world, hence the two cornucopias. Time is present, for he has the only influence on Fortune: with time, fortune changes. The celestial sphere above her head refers to the stars, which are in continual motion and in some unfathomable way influence the fortunes of men. The wheel atop the staff she holds (itself a symbol of authority) refers to the age-old symbol of Fortune, the turning wheel, with those on top soon to be those on the bottom. The eager youth, Poverty, Commerce, and the peasant who dreams of military glory, are all those referred to by the motto, each of whom, in his own way, must make his own fortune, but always hopes for the bounty of good luck.

[Ripa, 1603, p. 169]

The *fatto:* In a royal dining hall, Polycrates of Samos is seen sitting at table, being given the lost ring found in the fish. On the left is the kitchen where the cook found the ring. The reason Herodotus gives for Amasis' desertion of Polycrates is not unwillingness to lend aid, but a fear of sharing the distress which was bound to overtake Polycrates as retribution for his unusual good fortune.

[Herodotus, III, 39–43]

FORTUNE
Polycrates, curious how his luck will be,
Finds again in a fish the ring cast in the sea.

Fortuna Polycrates imperium magnasque opes est consecutus. Aegyptiorum rege
monente, qui Amasis vocabatur, tentaturus fortunam, anulum in mare mittit.
Ultra spem in cujus—dam piscis visceribus ille rursus invenitur. Quo facto Amasis
amicitiae solvit vinculum, ne, si quid mali ingrueret, auxilium ferre illi sit obligatus.

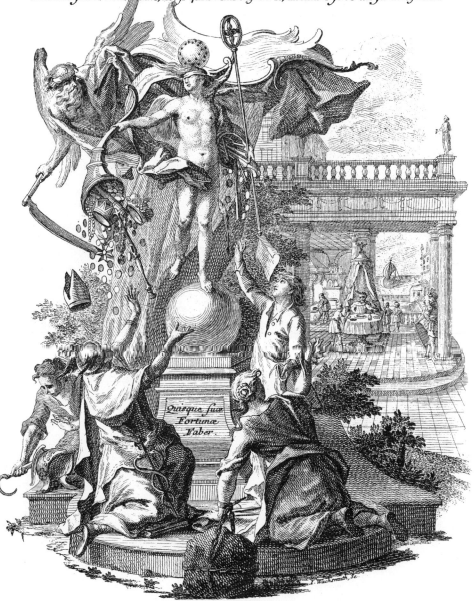

Quisque suae
Fortunae
Faber.

Das Glück.

Polycrates probiert das Glück
bekomt so gar den Ring zurück.

Eichler, del. J. Wachsmuth, Sc. Hertel, excud.

INCONSTANCY

Sesostris had four kings attached to the chariot in which he rode. One of the prisoners constantly looked at one of the wheels. Asked why, he replied: "Having confidence in fortune, so like a moving wheel, I have hopes of better things."

The personification of Inconstancy is a woman in a rich turquoise-colored robe, who stands holding up a crescent moon and contemplating it. In her other hand she holds a bulrush, and she has one foot resting on a crab. Some other bulrushes grow around her.

The turquoise of the woman's raiment alludes to the color of the sea, which is ever-changing and ever in a state of motion. The crescent moon symbolizes waxing and waning, continual change. The bulrushes are fragile, too weak to support anything; they indicate how little one can depend on the inconstant person, for he will prove unable to hold up under pressure. The crab is an irresolute animal in symbolic terms, for he walks forward and backward, and thus cannot be counted on to do one or the other.

[Ripa, 1603, p. 225]

The *fatto:* In a great square, moving toward a large triumphal arch, Sesostris of Egypt rides in his chariot, topped with an image of Victory. It is drawn by four crowned kings, one of whom looks back at one of its wheels.

[Pliny, XXXIII, 52]

INCONSTANCY
When the captive king the chariot's wheel doth see,
He thinks how Sesostris' fortune changed may be.

INCONSTANTIA.

Quatuor reges Sesostris ad currum, quo vehebatur, curavit jungendos. Captivorum quidam unam ex rotis cum in oculis semper haberet, quare id faceret rogatus, respondit: Fretus fortuna rotæ instar mobili spero meliora.

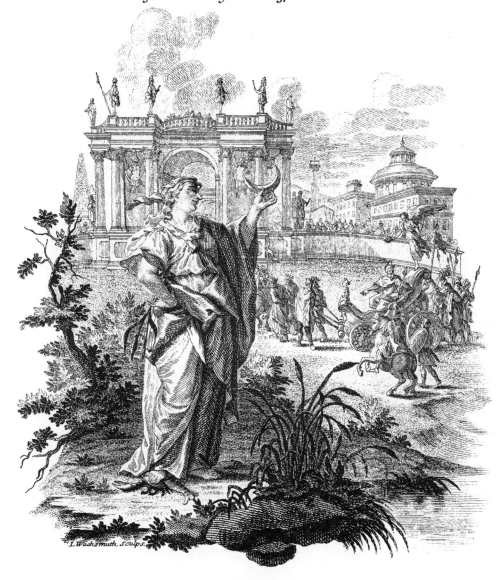

I. Wachsmuth. Sculps.

Die Unbeständigkeit.

Des Wagens Rad ein Sclav betracht,
und üblen Wahn Sesostri macht.

Eichler, del.

Hertel, excud.

ART

Zeuxis often painted bunches of grapes so realistically that birds were deceived and flew to them. But Parrhasius, without the knowledge of Zeuxis, painted a veil over them. Zeuxis, seeing it and thinking it was real, tried to draw it aside. From this it appears that Parrhasius was much superior to him.

The personification of Art is a seated woman robed in green, with a flame rising out of her head, who with one hand holds a scroll with a drawing on it, a brush, and a chisel, and with the other points to a statue of a woman, who in turn points to her own naked breast. Seated at the statue's feet is a large vulture. Scattered about on the ground are books, drafting instruments, a map, a lute, brushes, a spade, and a cornucopia filled with scrolls. A mattock also lies nearby. On the right a grapevine grows up a rod.

The personification of Art or Artifice is robed in green, the color of hope (it is hope of honor which spurs the artist on) and of youth and freshness (art conquers the passage of time and keeps everything fresh and young, particularly the inventiveness of the mind). She is of mature age, for that is when the mind and inventiveness of man are at their peak. The flame rising from her head, the symbol of Intellect, also means that through the flame of art, raw materials are softened, shaped, or hardened, and so transformed into the products of the mind. She holds the tools of the pictorial arts in one hand; these are used to produce works imitating nature, who is represented by the statue to which the woman points. Nature shows her breast, for she feeds man and all things, just as the vulture at her feet consumes all things. Lying about are the tools of all the arts and crafts, literature, architecture, cartography, music, and even agriculture, which is actually one of the most important arts of man. The grapevine also symbolizes the art of agriculture, for it is a practical art, sustaining life, and one which also deals with nature. The rod up which the vine grows is man's invention to help the tender young plant to flourish; it is an excellent symbol for his development of agricultural arts.
[Ripa, 1603, pp. 27–28]

The *fatto:* In an artist's studio, a man, apparently Parrhasius of Ephesus, stands admiring a painting of a basket of grapes, displayed on an easel. He reaches for a palette nearby. He is, presumably, about to paint the veil over the grapes, proving his superiority to Zeuxis, the painter of the grapes.
[Pliny, XXXV, 67]

ART

*The painted grapes of Zeuxis had the birds misled,
But Parrhasius's veil did Zeuxis fool instead.*

Zeuxis sæpius uvas pinxit, velut natura factas, quibus deceptæ advolabant
aves. Eas Parrhasius inscio illo pingit velamento. Id Zeuxis animadvertens,
credensqverum esse velamentum, vult illud amovere. Ex quo apparet,
Parrhasium illi multo antistare.

I.Wachsmuth, Sc.

Die Kunst.

Zeuxis Bögel hat belogen,
Parrhas ihne selbst betrogen.

Eichler, del. Hertel, excud.

155

HONOR

Horatius Cocles held back the Etruscans while others cut off the Pons Sublicius.
After the bridge was cut through, he threw himself fully armed into the Tiber, and
while many arrows fell about him, he swam unharmed toward his own people, thus
daring to do something which posterity would grant more fame than credence.

The personification of Honor is a woman robed in purple and wearing a crown, who stands holding a statue of Victory in one hand and pointing to a tall obelisk behind her, which is wound with palm fronds and laurel and topped with a winged trumpet. At her feet a cornucopia spills out wreathes of palm, laurel, and oak leaves. On her right is a globe of the world, near which lies an open book, with writing on its pages, and a quill pen over it.

Honor is the esteem and praise enjoyed by the successful man, be it for his achievements in war, government, works of the mind, or great wealth. Since it is the most noble reward one can receive from one's fellows, its personification is dressed in purple, a color reserved for royalty and the highest in the land. The crown also is a symbol of greatness and lofty estate. Honor holds a statue of Victory in her hand, for honor is the child of victory, deriving from it in every field of endeavor. The obelisk is the tangible evidence of honor,

a monument celebrating achievement. The palm and the laurel are the plants used to make the wreathes which once were the rewards of victors. The wreaths in the cornucopia represent the plentiful rewards which honor brings, rewards which are tangible and visible. The winged trumpet atop the obelisk is the symbol of Fame. The globe indicates that the greatest honor is universal, known all over the world. The book is the written record of victories and achievements, put down for posterity.

[Ripa, 1603, pp. 202–203]

The *fatto*: Horatius Cocles is shown ahorse, fighting off the Etruscans until the Romans can cut down the Pons Sublicius, so that the enemy cannot advance on Rome. In the distance he is seen swimming on his horse to the Roman side of the Tiber.

[Livy, II, 10]

HONOR

Horatius bravely the Etruscans fought
And honor and glory to his fatherland brought.

HONOR.

Etruscos Horatius Cocles, dum alii pontem Sublicium rescindunt sustinet.
Ponte rupto armatus in Tiberim desiluit, multisque super incidentibus telis
incolumis ad suos tranavit, rem ausus plus famæ habituram
ad posteros quam fidei.

Die Ehre.

Horatii sein Widerstand,
bringt Ruhm, u: Ehr dem Vaterland.

Eichler, del. Hertel, excud.

ENMITY

*Hamilcar of Carthage, as he was sacrificing, led his son to
the altar and made him swear that he would never be a friend of Rome.
He maintained the oath he made to his father.*

The personification of Enmity is a seated woman in a black robe decorated with red flames, who holds an eel in one hand and gesticulates with the other. Beside her, a dog and a cat observe one another.

Her robe is thus adorned because enmity is a mixture of rage (the red flames) and melancholy or evil thoughts (the black robe). According to Horapollo, the eel is so unfriendly that it avoids the company of all other fish.

The dog and cat, of course, have been natural enemies since time immemorial.

[Ripa, 1603, p. 233]

The *fatto:* Within a huge temple, before a statue of Jove (Baal), Hamilcar has young Hannibal swear an oath before the flaming and smoking tripod. Many people look on.

[Livy, XXI, 1, 4]

ENMITY

*Both Hamilcar and son an oath once swore
To be Rome's enemies forevermore.*

*Hamilcar Carthaginenfis, divina res dum conficiebatur, filiam
fuum ad aram adductum jurare juffit, nunquam fe in amicitia
cum Romanis fore. Jusjurandum patri datum confervavit.*

L. Wachsmuth. Sculp.

Die Feindschafft.

Amilcar nebst dem Sohn laut Eyde,
der Römer-Feind blieb allezeit.

Hertel. excud.

OBSTINACY

*Nine books of prophecies were offered for sale to Tarquin the Proud
by a certain Sibyl. Finding them too dear, he laughed at her, whereupon she burned
three of them and offered the rest for the original full price. Again, when Tarquin
did not change his mind, three of them were burned. This impressed him so much that
he paid the full price for those remaining.*

The personification of Obstinacy here is a youth in a multicolored sixteenth-century costume, wearing a plumed hat and pointing to his forehead. He holds a bellows in one hand and a spur over his wrist. On the balustrade behind him an outstretched dog watches. Above him is a wall fountain of a putto riding a dolphin and holding an armillary sphere on his head.

Strangely enough, Hertel and Eichler have used Ripa's image for Caprice for this allegory; they were surely equating stubbornness with capricious insistence on something. The boy is young, for that is the time of willfulness; his varicolored dress refers to the variety of things youth can get stubborn or enthusiastic about. He touches his forehead, for willfulness is a state of the mind, a determination to have one's own way. The spur is a goad, a means of imposing one's will on others, and the bellows is used to whip up the fire, just as persistence or stubbornness is whipped up by the desire to have one's way. The dog, of course, is known for his steady persistence in following a spoor.

[Ripa, 1603, p. 48]

The *fatto:* The Cumaean Sibyl is shown offering Tarquinius Superbus the nine books of prophecy about the future of Rome. Only three of them are left, for the first two times she offered them he refused, finding her price too high, and she burned three each time. Now that there are only three left, he decides he wants them and reaches for these remaining three, for which she insists he pay the same price she demanded for the nine.

[Pliny, XIII, 88; Aulus Gellius, I, 19]

OBSTINACY
*Proud Tarquin laughed the Sibyl's price to hear;
His stubbornness only made the books more dear.*

Tarquinio Superbo novem Vaticiniorum libri á Sybilla quadam veno ponebantur. Quibus justo carius æstimatis, ab illo derisa tres eorum igne consumsit, proque reliquiis, quantum pro omnibus po- poscit pecuniæ. Iterum, dum mentem Tarquinius haud mutat, tres creman- tur Id moverat eum, adeo, ut primum imperatam peccuniam, pro- iis, qui supererant libris, solveret.

Die Eigensinnigkeit.
Tarquinius das Weib versucht,
den Bücher-Kauff nur theurer macht.

Eichler, del. J.Wangner, Sc. Herdl, excud.

CONTENTION

*Romulus and Remus, desirous of founding a city in the region where they had
been abandoned and then raised, became greedy for power and developed an ugly
quarrel. The gods decided the matter with augury. Romulus took the Palatine
Hill and Remus the Aventine to watch for auguries. It is said that Remus saw
six vultures flying by first, but after that was made known, twice as many were
seen by Romulus. Each man's followers acclaimed him king, the one by right of
priority, the other by reason of the number of birds. Then the sides clashed,
anger leading to slaughter. Remus fell, struck down in the tumult.*

The personification of Contention is a man
dressed in red, with armor over his garment
and with a drawn sword in his hand. He
advances proudly and with determination.
Between his legs, a dog barks at a cat.

Contention is a desire to overcome those
opposing one's will, to impose that will on
others; hence the man is advancing against his
opponents fully armed so that he can overcome
them. Red is the color of spiritual pride and
of the passions, as in the sanguine tempera-
ment, which is contentious. It is the color of
blood churning when one is aroused and ready
to fight. The dog and cat are natural enemies
and quick to fight one another.
[Ripa, 1603, p. 88]

The *fatto* shows the augury scene on neigh-
boring hills. Remus on the right sees six birds
in flight, and Romulus on the left sees twelve.
Their followers stand about, watching. Behind
Romulus stands a tall pyramidal monument,
perhaps a reference to his future glory as sole
ruler of Rome.
[Livy, I, 4–7]

CONTENTION

*Romulus and Remus quarrel, who is king to be,
And try to decide the matter by bird-flight augury.*

Romulum Remumque ut urbis condendæ in iis locis, ubi expositi, ubique educati erant, ita regni cupido capit atque inde, foedum certamen cooritur. Rem Dii, discernunt auguriis. Palatinum Romulus, Remus Aventinum ad inaugurandum templa capiunt. Priori Remo augurium venisse fertur sex vultures : at nunciato jam augurio, quam duplex numerus Romulo se ostendit, utrumque regem sua multitudo consalutat, tempore illi præcepto, at hi numero avium regnum trahunt. Inde cum altercatione congressi, certamine irarum ad cædem vertuntur. In turba ictus Remus cecidit.

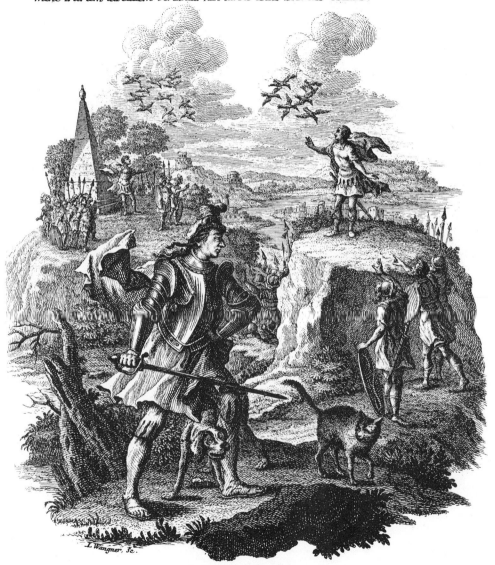

L. Wangner, Sc.

Eichler del.

Zanck, ü: Streit.

Romulus und Remus streiten
Vögel flug die Sache deuten.

Hertel excud:

DANGER

*Damocles, a courtier of Dionysius, praises the latter's good fortune
too much. Asked if he would like to have the same fortune for himself, he says,
"I wish it, and, I feel, not without justification." Then, by the king's command,
he is clothed in royal robes and led to a throne placed in such a manner that
above the head of anyone sitting on it, a sword is suspended by a hair drawn from
a horse's tail. Damocles, seeing this and realizing that kings must expose
themselves to danger, changes his mind.*

The personification of Danger is a young boy advancing toward a precipice, down which tumbles a wild waterfall. He looks back in pain as a lurking serpent bites his leg. He carries a bulrush in one hand. The whole setting is a wild and rocky one, with fallen trees, and with lightning in the sky.

The boy is young, for that is the age in which one exposes oneself more readily or more unthinkingly to danger. The snake refers to the ancient phrase "a snake in the grass" (*latet anguis in herba*) signifying an unexpected and treacherous danger. The bulrush the boy is using as a walking stick indicates that many of the things we use to prevent or avert danger are as fragile and useless as a reed. The setting —waterfall, trees, lightning—shows the dangers to be found in all the world; the youth is walking into them without noticing them. As another example of unexpected danger (not illustrated by Eichler) Ripa refers to the story of the turtle dropped on Aeschylus' head by an eagle (Pliny, *Natural History*, Book 10, chap. 3).

[Ripa, 1603, p. 237, "Insidia"; Ripa, 1766, IV, p. 367, "Pericolo"]

The *fatto:* In a dining hall, Damocles, royally dressed, sits under the royal canopy and unhappily looks up at the sword suspended above his head. Dionysius of Syracuse looks on, smiling ironically. This allusion was also provided by Orlandi in the Perugia edition, IV, p. 369, as the *fatto storico profano.*

[Cicero, *Tusculanae disputationes*, V, 61]

DANGER
*Damocles learns that the royal state
Has burdens and dangers that are great.*

Damocles Dionysii aulicus fortunas ejus nimis laudat: Rogatus an easdem sibi optaret, Opto ille inquit, nec ut opinor immerito. Quo facto regis jussu induitur veste regia, duciturque ad thronum, ita positum, ut capiti sedentis in eo immineret gladius pilo caudæ equinæ suspensus. Quem cum videret Damocles intelligeretque periculum regibus subeundum mentem mutavit.

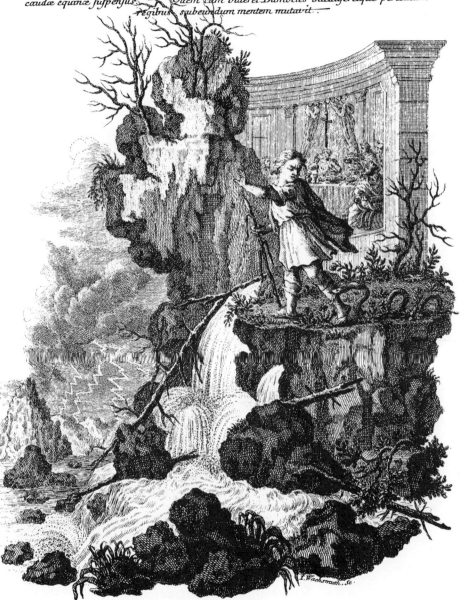

Die Gefahr.
Damoclis Prob, der Königs Würd,
anzeiget die Gefahr und Bürd.

Eichler. del. Hertel. excud:

DOMINION

*Mettius and Tullius Hostilius found a way in which they could decide
without great battles and much loss of blood which of the two peoples should
prevail over the other. By chance, there were triplet brothers in each of the
armies; they were the Horatii and the Curiatii. The kings arranged with the
threesomes that they should fight with swords, each for his own country, power
going to the country of those who won. The Curiatii were all killed and only one
Horatius remained alive as victor. Each army then buried their own, but with very
different feelings, for the Romans had gained power, while the Albans were now
the subjects of others.*

The personification of Dominion is a proud-looking man, very richly dressed in fanciful sixteenth-century costume, who stands making an imperious gesture of command. He wears a hat with flowing plumes amid which a snake is entwined. In one hand he carries a baton topped with a single eye.

According to Piero Valeriano, the serpent entwined around a hat is not only a symbol of prudence, but—even more importantly—refers, as a symbol for dominion, to the story that Septimius Severus, Maximian the Younger, and later, Azone Visconti, each had a snake wind itself around his hat while he was sleeping; this was taken as a sign that they would hold dominion over the Roman Empire, in the case of the former two, and over the Duchy of Milan in the case of Visconti, who later took the symbol as his coat-of-arms. The scepter with the eye is supposed to be a Pythagorean mystical emblem for the god Osiris, the lord with a scepter and one eye (or many eyes). It also means that the man who wants to dominate others must use power (the scepter) and vigilance (the eye).

[Ripa, 1765, II, p. 265]

The *fatto:* Two huge armies, those of the Romans and the Albans, stand and watch the three Horatii fight the three Curiatian brothers. Only one Horatian is left to fight the two remaining Albans.

[Livy, I, 24]

DOMINION

*Victorious over the Curiatians did one Horatian remain;
Thus over her Alban neighbors did Rome her power gain.*

Mettius cum Tullo Hostilio iniit viam, qua utri utris imperent, sine magna clade, sine multo sanguine utriusque populi poterat decerni. Forte in duobus tum exercitibus erant trigemini fratres, Horatios Curatiosque fuisse constat. Cum trigeminis agunt reges, ut pro sua quisque patria dimicent ferro: ibi imperium fore, unde victoria fuerit. Curatii cæduntur; victor Horatius. Ad sepulturam inde suorum nequaquam paribus animis vertuntur, quippe Romani imperio aucti, Albani ditionis alienæ facti.

J. Wachsmuth, Sculps.

Die Herrschafft,

Ein Horat Drey Albaner Zwingt,
die Herrschafft an die Römer bringt.

Eichler, del. Hertel excud.

O vain minds of men, by what Folly art thou led!
The sum of life is short: pale death spares no one.

Part IX

Histories

and

Allegories

Designed and drawn

by Gottfried Eichler;

Published by the Author,

Johann Georg Hertel,

Augsburg

On a high throne Death as a skeleton sits crowned and robed, with a baldachin over him inscribed "Aeternum Sub Sole NIHIL" (Nought under the sun is eternal). On the back of the throne is a large clock, and heaped around it are the tools of war and husbandry, science and the arts. In one hand Death holds a scythe and in the other a scepter, with which he points to a distant graveyard full of monuments, where there is an open grave. On his left sits Father Time blowing soap bubbles over a cushion on which lie a papal tiara, a royal crown, a scholar's fur hat, and a military order. On the right of Death, the nude figure of Fortune balances on a ball, and holds a staff topped with the wheel. Before the high dais and behind the cartouche bearing the title is a richly dressed woman with a human heart on her head, the personification of Divine Love. She holds chains in her hands to which are attached the figures of Envy with her serpent hair; of naked Debauchery with her vine wreath, leopard skin, and wine cup; of Avarice, who clutches her purse and refuses to aid a begging child; and of Pride with her peacock plumes and bedizened splendor.

The general idea behind this invention of Hertel is quite clear, namely that the things of this world are all vanities and that Death is the master of all. Time proves that the honors of this world (the crowns, etc.) are as bubbles in the wind, and Fortune, unstable as she is, is also not to be depended upon. The image of Death enthroned comes largely from Ripa's depiction of him (1603, p. 339). The idea of the lower group is, of course, that Divine Love holds and binds the enchained vices.

Thus is all that one can see
Naught but passing vanity.

O vanæ mentes, quæ vos dementia ducit!
Suma brevis vitæ: nulli mors pallida parcit.

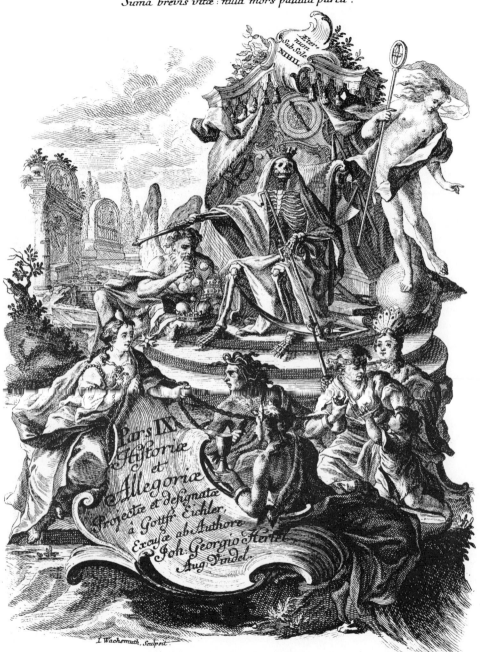

So ist alles wie du sehen,
Eitelkeit und muß vergehen.

DIVINE PROVIDENCE
Pharaoh has all the infant boys of the Israelites cast into the waters.
His daughter, strolling along the shore intending to bathe, sees a basket and
has it pulled out of the water. The boy found in it is then raised, and becomes
the man whom the Egyptians later came to know only too well.

Reclining upon the clouds, looking down on the scene below, which is the historical allusion to the main allegory, a robed female represents the allegory. In one hand she holds a scepter surmounted by a shining triangle with the Eye of God in its center, and in the other two large keys. She leans on a globe of the world, and behind her is a large, overflowing cornucopia filled with fruit and grain. Beside her a putto holds a large ship's rudder.

Just as the rudder guides the ship at sea, so does Divine Providence guide us through the sea of life. Her scepter is, as always, a symbol of dominion and authority. That it is topped with the symbol for God, indicates that all power comes from divine sources. The cornucopia shows that Divine Providence can give plenty. The key she holds, certainly inspired by the keys of St. Peter, also indicate that she

has the power to open up the labyrinthine ways of life on earth, to let us into the areas in which we can fulfill our destinies. The globe upon which she leans indicates her mastery over the world.

[Ripa, 1603, p. 414]

The *fatto:* The main part of the scene is taken up with the familiar representation of Pharaoh's daughter and her retinue, all dressed in the best eighteenth-century fashion, walking along the shore of the Nile and finding the infant Moses floating in a basket. The only slightly oriental touch in the scene, for even the house in the background is a European one, is the umbrella or sunshade held over the princess' head.

[Exodus 2]

DIVINE PROVIDENCE
When the Almighty so disposes,
Men are saved and thrive like Moses.

Ifraeliticos pueros Pharao in aquas conjiciendos curat; In littore ejus filia am-
bulans lotura, animadvertit arcam, eamq̄ mandat extrahi. Puer in ea inven-
tus educatur, qui talis vir evafit, qualem Ægyptii postea cognoverunt.

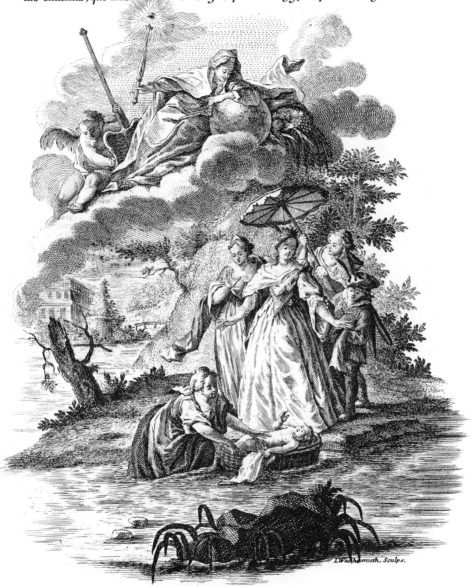

Die Göttliche Vorsehung.

Wen die Allmacht außerfehen,
wirds wie Mofen auch ergehen.

Eichler, del. Hertel, exc.

INNOCENCE
*Herod is deceived by the Magi. Furious with them, he has all
the boys of two years of age or less, killed.*

The personification of Innocence is a sweet small young girl, robed in virginal white, and with flowers in her hair, who stands washing her hands in a basin. Next to it lies a palm frond. At her feet sits a large lamb.

Youth is the age of innocence. Her ablutions indicate freedom from blemish of any kind, physical or spiritual. The palm frond symbolizes the purity received after baptism. The lamb, a symbol of Christ, is also that of innocence and purity.

[Ripa, 1603, p. 235]

The *fatto*: Before a splendid palace, from which he looks on, seated beneath an enormous canopy, King Herod watches the massacre of the innocent children of Israel.

[Matthew 2: 16]

INNOCENCE
*The slaughter of all little boys in the land
Did cruel King Herod wickedly command.*

INOCENTIA.

A Magis illuditur Herodes. Iis iratus omnes
pueros a bimulis et infra curat interficiendos.

Die Unschuld.

Der Unschuldig Kinder Orden,
läßt Herodes grausam morden.

Eichler, del. Hertel, excud.

SIN

*The scribes and the Pharisees take a woman in adultery and refer the matter
to Christ. According to the law, she should be stoned. To all this, Christ responds,
"Let him who knows himself to be without guilt of any kind cast the first stone
at her." All withdraw and the woman remains abandoned on the spot. He sends her
away unpunished by her accusers, admonishing her to sin no more.*

The personification of Sin is a dark, seminude youth who stands in a rocky setting. He is blindfolded, and has a serpent biting at his breast and an even larger one wound around his waist.

The man is young, for imprudent youth often sins. He is nude, for he is without heavenly Grace, and dark of color for he is impure (white being the color of purity and black the opposite). The serpent, from the time of Eden the symbol of the Devil, is present, for sin is the Devil's work. The snake gnawing at the youth's breast is conscience, which gnaws at the soul that has sinned. The blindfold is an obvious allusion to the willful blindness to God's commandments of the man who sins.
[Ripa, 1603, p. 383]

The *fatto:* Before a classical portico, Christ stoops down and writes on the ground, making his famous pronouncement concerning the bound adulteress standing before him. Various scribes and Pharisees look on with discomfiture, understanding His lesson.
[John 8: 3–11]

SIN
*He without sin, and he alone,
Can justly the adulteress stone.*

Scribæ Pharisæique mulierem in adulterio comprehendunt eamque rem ad
Christum deferunt. Pro lege lapidibus erat occidenda. Ad hæc Iesus re-
spondet: nullius noxæ sibi conscius primum in eam conjiciat lapidem.
Omnes digrediuntur, stat mulier in medio relicta. Haud condemnatam
ab accusatoribus ille dimittit, ad monendo ne in futurum peccet.

Die Sünde.
Dem der ohne Sünd will leben
soll das Weib ein Gleichnis geben.

Eichler. del. Hertel. excud:

MALEDICTION

A man called Shimei goes out to meet David, who has departed for Bahurim.
He curses David and throws stones at him and his followers.

The personification of Malediction is a frightening-looking woman with sunken eyes and wild hair, dressed in a robe of verdigris green, who kneels on a rock. She sticks out her tongue. She carries a basilisk at her bosom and lighted torches in each hand. Over one shoulder a hedgehog fur hangs.

Aristotle says in his *Physiognomy* that sunken or concave eyes are a symptom of malignity. The same is true of a particularly poisonous shade of green in color symbolism. Malediction carries lighted torches, for she ignites hatred and anger. Her tongue is the main tool she uses to do her evil work. The spines of the hedgehog, which jab and prick, are like the activities of malediction, which prick and injure honor and reputation. The deadly basilisk is her appropriate pet and companion.

[Ripa, 1603, p. 302]

The *fatto:* David and his army march by, while Shimei hurls stones at them and curses them. In the distance is a fanciful ruined house.

[II Samuel 16: 5–13]

MALEDICTION

Shimei cursed David, stoned him too,
Who patiently did see it through.

Davidi Bahurim profecto obviam it vir, qui Simei voca-
batur. Is Davidi maledicit et eum et servos ejus lapidibus
appetit.

I. Wachsmith, sculps.

Der Fluch.

Flucht Simei ü: wirst mit Stein /
will David doch gedultig seyn.

Eichler del. Hertel. excud.

CONFUSION

The descendants of Noah built themselves a city, which they called Babel,
and a tower than which according to their ideas none should be taller. God,
aware of this idea, and seeing that they intended to pursue it, was moved by this
to confuse their tongues and disperse them to all parts of the earth.

The personification of Confusion is a young woman with somewhat disordered hair, richly dressed in multicolored robes. She stands with her back to the viewer and gestures in astonishment at the Tower of Babel being built in the background. She stands on clouds, among which the Earth, the stars and planets, flames, and rain can be seen. Above is a cartouche inscribed "Babylonia undique" (Babel is everywhere).

She is young, for that is the age of confusion; her unkempt hair represents the wild and confused thoughts which obscure the intellect. The many colors of her garb are the various vain and disordered actions occurring in a state of confusion. The Tower of Babel itself is often used as a symbol for confusion. She stands upon the clouds, which represent Chaos (as described by Ovid in the first book of his *Metamorphoses*), the primal matter in which the four elements are poorly mixed, resulting in confusion. The four elements are represented here by the Earth (earth), the stars and planets (air), the flames (fire), and the rain (water).
 [Ripa, 1603, p. 82]

The *fatto:* On a point of land, the great spiral Tower of Babel is seen abuilding. Around it scurry hosts of workmen, and in the center King Nimrod can be seen discussing the project.
 [Genesis 11: 1–9]

CONFUSION

To Babel's tower to put an end,
Confusing tongues did God them send.

Turrim urbemque, quam Babel vocant, exstruunt Noæ posteri, qua
eorum opinione nulla sit altior. Id consilii Deus cognoscit, videtque,
hoc propositum eos esse tenturos. Qua motus re confundit lin-
guam eosque in omnes terræ partes disjicit.

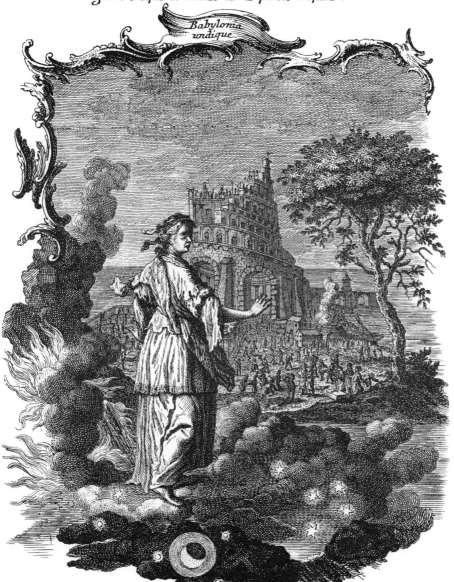

Babylonia
undique.

Die Verwirrung.
Gott thut Babels Hochmuth straffen
und dem Bau ein Ende schaffen.

Eichler. del.　　　　　　　　　　　　　　　　　Hertel, excud.

STRENGTH
Without his parents' knowledge, Samson married a Philistine woman.
As he was walking to Timnath for this purpose, he met a lion on the way,
killed him, and tore him to bits.

The personification of Strength is a husky, proudly posing woman who stands beside a tree. She is dressed in "lion-colored" clothing and wears armor and a helmet equipped with enormous bull's horns. Around her waist a lion's skin and an elephant hide are wrapped. She holds in one hand an oaken club, from which a few oak leaves are still growing. On the ground beside her lies a shield on which a lion fighting a boar is depicted. A base of a column lies nearby.

She is strong of body, which also denotes strength of character. Her "lion-colored" dress and the lion skin she wears are references to the strength of that animal. The club she carries is a reference to that of Hercules, the strongest hero of all times. The fact that the club is of oak denotes that the strong also have strength of spirit, or courage. Horapollo considers the bull and the elephant the strongest of animals (Book II), and it is then appropriate that her helmet be decorated with bull's horns, and that she wear the skin of the elephant. Piero Valeriano, in Book II of his *Hieroglyphica*, uses the lion fighting the boar as a symbol for strength of spirit, and points out that the lion, the symbolic animal for this allegory, fights with thought, while the boar is too precipitate and heedless in battle. Strength is often depicted leaning on a column; here only the base is shown.

[Ripa, 1603, p. 165, "Fortezza"; p. 171, "Forza"]

The *fatto:* In a clearing before some vineyards, Samson is busy tearing apart the lion which he encountered on his way to Timnath. The Latin at the top of the page is in error in one point: Samson's parents were not kept in ignorance.

[Judges 14: 5–6]

STRENGTH
Samson a lion fierce did fight
And, killing it, did show his might.

Insciis parentibus Simson ex filiabus Philistæorum ducit
uxorem. Temnath ea de caussa iter faciendo leonem necat
obvium eumque discerpit.

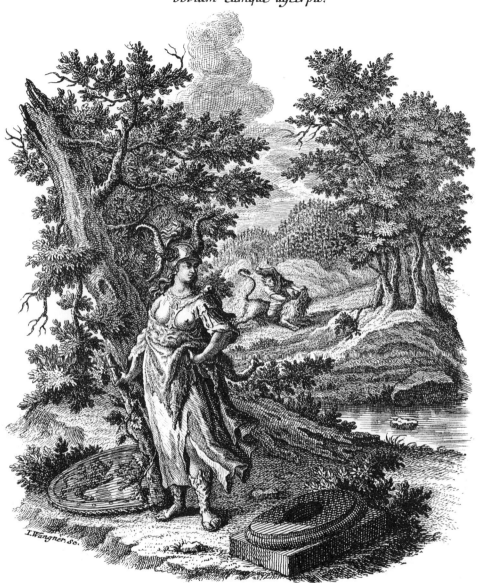

I.Wangner.sc.

Eichler, del.

Hertel, excud.

Die Stärcke.

Simson mit dem Löwen ringet,
ihne fället und bezwinget.

HOMICIDE

*Both Abel and Cain offer sacrifice. Nothing is more acceptable to God than
that of the former. When Cain sees this, inflamed with rage, he kills his brother.*

The personification of Homicide is an evil-looking man of pallid complexion, wearing classical armor and a red cloak. He has a tiger skin knotted around one shoulder. In one hand he holds a bloody sword and in the other, the severed head of the prostrate corpse on which he stands. Some large bones lie about and add to the grisly atmosphere of the scene.

The man is ugly, for murder is the most abominable of crimes. His pallor is the effect of both rage and fear of reprisal, as in the story of Cain and Abel. He is armed, because the murderer must be so to perform his gruesome work, but also because he must always remain so, since murder generates revenge, and he must remain forever on his guard. The red of his mantle is both the color of blood and of the unthinking rage and cruelty which causes murder. The tiger is the animal most noted for his bloodthirsty and cruel nature, so it is appropriate that the allegorical figure wear its skin.

[Ripa, 1603, p. 201]

The *fatto:* In the background, before the altar where they have been sacrificing, Cain slays Abel with a club.

[Genesis 4: 3–15]

HOMICIDE

*When Cain did Abel strike down dead,
Accursed was he with fear and dread.*

Vterque Abel et Cain facit sacrificium Priori nihil
Deo acceptius. Id Cain ut animaduertit, ira incensus
fratrem interimit.

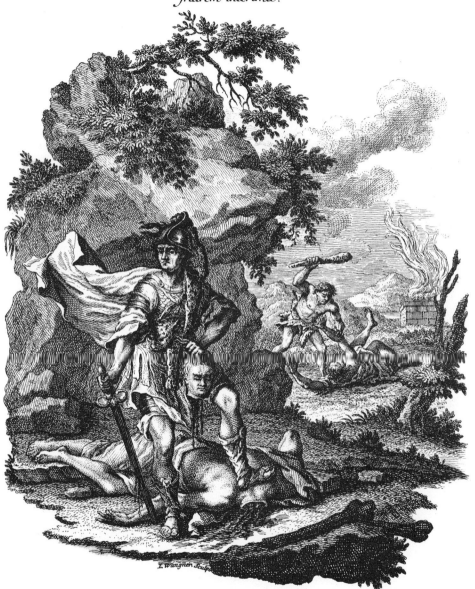

I.Wangner.Sculp.

Der Mord, Todschlag.
Als Cain schlug den Abel tod,
verfolgt ihn Fluch die Angst, u. Roth.

Eichler, del. Hertel, excud.

REVENGE

*Samson wishes to enter his wife's room. Her father, who wants
him to marry his younger daughter, says that he will not permit him to do so.
Enflamed with rage, and given the opportunity, he revenges himself for this offense.
He captures three hundred foxes, ties their tails together (in pairs), and
attaches inflammable material to them. This is lit and the excited foxes
run through the fields and burn down everything.*

The personification of Revenge is a woman with wild hair and with a sly expression on her face. Dressed in red, she has a breastplate over her garment, and stands holding a dagger. Behind her is a large roaring lion with a wound in his side, and on the ground is a large arrow or dart. The woman bites the index finger of her free hand as she stands in thought.

The bloody dagger, like the large dart, represents the violent act of revenge which usually causes the shedding of blood; this also explains the red robe. She is armored to suggest that by his own forces and preparations man easily revenges his injuries. She bites her finger, for the man who thirsts for revenge often seeks a minor hurt in order to have an excuse to avenge himself for the larger (perhaps imagined) one. The roaring lion with the bleeding wound in his flank is, as Piero Valeriano points out, an animal who never forgets an injury or misses an opportunity to revenge himself on his enemies.

[Ripa, 1603, p. 494]

The *fatto:* Samson sets fire to the foxes' tails and releases them into the Philistines' fields, so that they burn down all the crops. He thus revenges himself on his father-in-law.

[Judges 15: 1–5]

REVENGE

*With craftiness does Samson seek
His vengeance on his foes to wreak.*

Uxoris suæ cubiculum vult Simson ingredi. Id pater ejus, juniorem filiam ei collo-
caturus negavit, se esse passurum. Ira incensus data occasione id injuriæ ulciscitur.
Comprehendit trecentas vulpes, earumq̃ caudas colligat materia ignis interjecta.
Accenditur ea vulpesq̃ concitatæ agros percurrunt omniaq̃ consumunt.

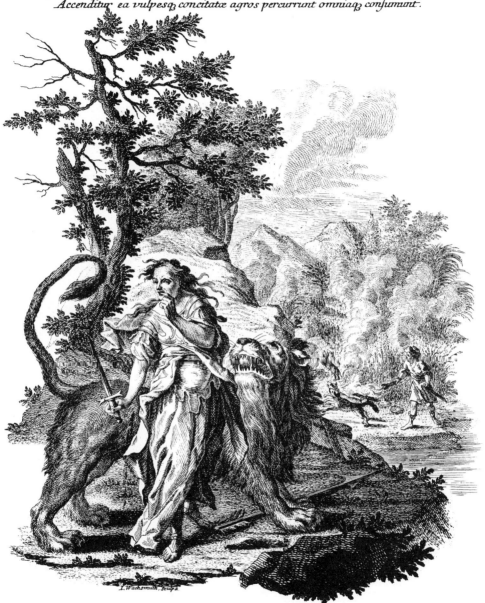

. Die Rache .

Lift und Rache Simsons Waffen /
womit er die Feind will straffen .

Eichler, del. J. Wachsmuth, Sculp.s Hertel, excul.

FEAR

Adam and Eve transgress the commands of God. For this reason they hide,
fearing the anger and the punishment of God.

The personification of Fear is a small frightened woman running with her hair on end. She wears the skin of a stag, with head and antlers still attached, over her shoulder. On her back sits a human-headed, crowned monster with bat wings and a stinging tail, which is obviously frightening her. Before her sits a large handsome rabbit.

According to the physiologist of the past, smallness of size led to pusillanimity. The woman's expression and the appearance of her hair are visible effects of fear. She wears the skin of a stag, for that animal is notoriously timid. The monster represents the fears which cause the emotion of fright, sometimes imaginary but always powerful. The rabbit is well known for his cowardly nature, which expresses itself in constant fear. Hertel and Eichler combined three different qualities from Ripa here—fear, fright, and cowardice.

[Ripa, 1603, p. 383, "Paura"; p. 487, "Spavento"; p. 504, "Viltà"]

The *fatto:* In the Garden of Eden, God appears to Adam and Eve as a disk of light enclosing His Name in Hebrew characters. They, frightened and guilty of having broken His commandment, try to hide.

[Genesis 3]

FEAR

Thus can the voice of God awake
In man great fear, and make him quake.

TIMOR.

Adam et Eva præcepta Dei negligunt. Quo facto
metuentes iram, poenamq̃; divinam se condunt.

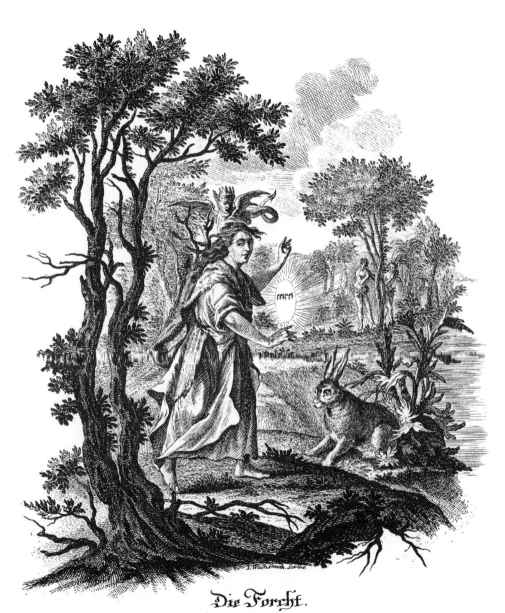

I. Wachsmuth, Sculps.

Die Forcht.

So kan Gottes Stimme wecken,
ü: die Forcht die Menschen schröcken.

Eichler, del.

Hertel, excud.

FLIGHT

The angel of the Lord appears to Joseph in a dream. On his advice,
he leaves for Egypt with the Child and the Mother, seeking safety in flight.

The personification of Flight is a resolute-looking woman, winged, with flowing hair and fluttering draperies, who runs through dangerous terrain with a baby in her arms.

The woman is winged, because speed is of utmost importance in escape from danger. Her unkempt hair shows that those in flight do not have time to take care of themselves. Her rather scanty draperies indicate that there should be as few impediments to speed and movement as possible if one wants to escape

easily. The baby is, of course, the innocent one with whom one escapes in order to save it from harm.

[Ripa, 1603, p. 175]

The *fatto:* In a completely Germanic wild forest setting, the Holy Family is seen crossing over a rustic bridge. In the distance, wanderers, presumably also refugees, are walking.

[Matthew 2: 13, 14]

FLIGHT
Who goes with God, on land or sea,
Shall surely well protected be.

FUGA.

*Domini Angelus in somnio Ioseph apparet. Ejus admonitu cum
puero et matre fuga salutem petit in Ægyptum profectus.*

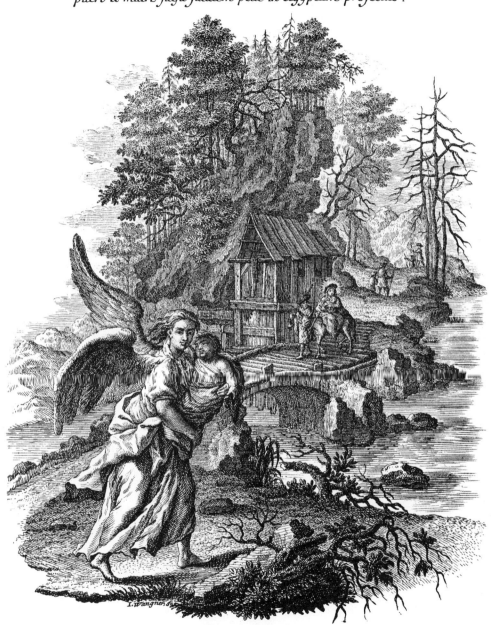

Die Flucht.

Die feinen Gott auch auf der Reiß,
vor Unfall zu beschüden weiß.

Eichler, del. Hertel. excud.

PILGRIMAGE

*Lot and Abraham, by God's command, depart from Egypt,
taking with them their wives, their children, and their herds. They go to Canaan,
the land He had promised them.*

The personification of Pilgrimage is a rather tired-looking man whose head is half shaved and half covered with long hair. He is dressed in the traditional garb of the pilgrim: the broad-brimmed hat hangs from his shoulders; his cloak is long and dark, and attached to his belt are his purse and his flask; he wears heavy high boots. The long staff he carries is topped with a swallow. He walks through a wild and desolate country.

According to Ripa's researches in Horapollo and others, the ancient Egyptians symbolized the pilgrim by the half-shaven and the half-betressed head. The pilgrim's garb shown here is traditional in European art, being based on medieval clothing. The swallow is a wandering bird, and thus appropriate to the subject.
[Ripa, 1603, p. 384]

The *fatto:* In the background, the Israelites under Abraham (actually, still Abram) are seen packing up their belongings and leading off their herds, setting out for Canaan, which was to be the Promised Land.
[Genesis 13: 1, 2]

PILGRIMAGE

*Here Abraham and his tribe one sees
Going to Canaan as the Lord decrees.*

Ex Aegypto Loth Abramusque jubente Deo discedunt,
secumque uxores liberos, et quantum pecoris habebant,
ducunt. Canaan petunt ab illo promissam .

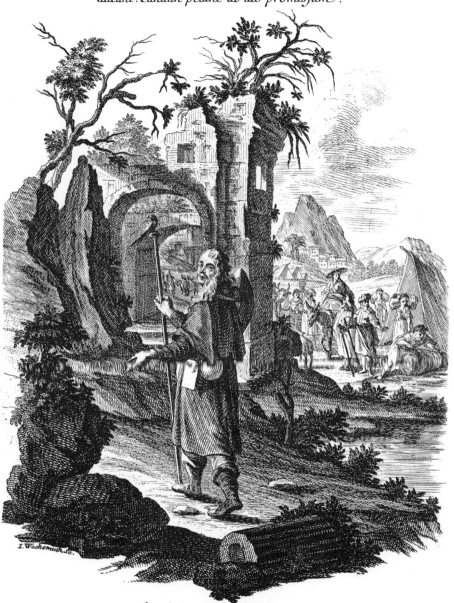

Die Pilgramschafft.
Hier Abraham nach Canaan,
mit allem tritt die Reiße an.

Eichler, del. Hertel, excud.

HUNGER

The Israelites pitch their camp in the desert of Sinai. They become very hungry and in their suffering they rail against Moses and Aaron. God comes to the aid of the hungry. Quails fall about them, and bread rains upon the camp.

The personification of Hunger is a haggard woman dressed in rags, who leans weakly against a tree and looks up to Heaven in despair. She points to a hungry child who raises its hands to her, imploring food. An empty bowl lies nearby.

Ripa, quoting Ovid (*Metamorphoses*, Book VIII), described Hunger as a starved-looking, emaciated person, pale of color and so thin his bones show through his skin. Hertel and Eichler have given the allegory an even more piteous character by their use of the poor mother and hungry child, certainly another allusion to Hagar and Ishmael.

[Ripa, 1603, p. 144]

The *fatto:* In a mountainous region, the Israelite encampment is seen. Around it the starving people are busy gathering from the ground and carrying away in baskets, the manna which has fallen from Heaven. No quails are shown.

[Exodus 16]

HUNGER

Quails and Manna God provided; Israel's hunger soon subsided.

In deserto Sinai castra Israelitæ ponunt. Ibi magna exoritur
fames, quam sentientes fremunt, et Mosen Aaronq; ægre ferunt.
Inopiæ Deus subvenit. Coturnices decidunt, pluitq; pane.

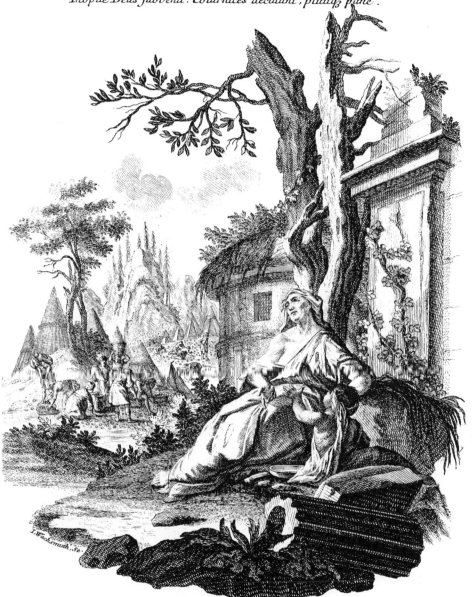

Der Hunger.

Wachtlen und der Manna Regen,
Israelis Hunger legen.

I.Wachsmuth, Sc.

Eichler, del. Hertel, excud.

174

PRAYER

Jesus withdraws somewhere to pray. When the prayers are finished, one of the disciples says, "O Lord, teach us to pray as John taught his disciples."

The personification of Prayer is a woman robed in green and white, who kneels before an altar, her hands clasped. She looks heavenward, and from her mouth issues a flame. On the altar is a burning and smoking incense burner, amid whose clouds of smoke appears a large key.

Green and white are, respectively, the colors of hope and purity. True prayer must be pure and it is an expression of hope. The woman kneels, for prayer is humble before God. She looks heavenward, for prayer concerns itself with heavenly matters. The flame issuing from her mouth is the all-consuming love of God ignited through prayer. The flaming and smoking incense burner is a symbol for prayer and adoration of the Divine. The key can have several meanings. Through prayer one finds the key to Divine Grace and the penetration of the mystery of God, through union with Him. The key can also be a reference to the keys of Heaven which Christ gave to St. Peter. Or it can mean that through prayer the way to Heaven is opened.

[Ripa, 1603, pp. 370–373]

The *fatto:* Seated among His disciples in a forest glade, Christ is seen, teaching them the Lord's Prayer.

PRAYER
*Christ His disciples prayer taught,
How they their God to honor ought.*

Secedit Iesus, nescio quo, precaturus. Finitis precibus discipulorum
quidam dicit: Domine nos doce orare, ut Ioannes docuit discipulos.

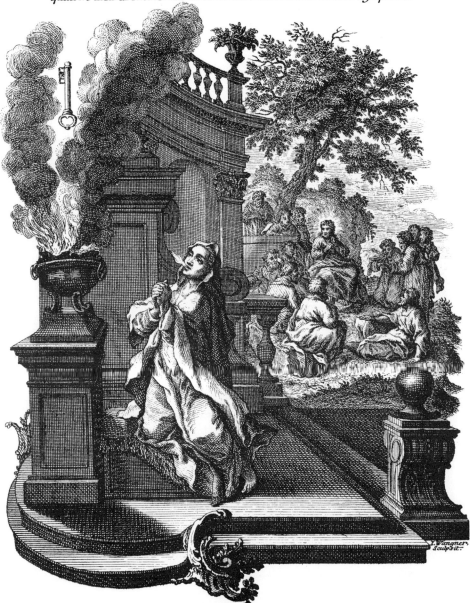

Das Gebet.
Christus will die Jünger lehren,
wie Sie sollen Gott verehren.

Eichler, del. Hertel, excud.

175

HOPE

*Palestine, which God promised to Abraham, Isaac, and Jacob, is shown
to Moses but he is not permitted to live there. God buries him when he dies.
The place of his burial is still uncertain.*

The personification of Hope is a beautiful woman, robed in transparent stuff, with a cloak of green, and wearing a wreath of flowers on her head. She stands looking up to Heaven, her hands clasped in prayer. At her feet, a putto holds an enormous anchor.

She is Ripa's invention and at the same time the standard representation of one of the three Christian Virtues. Green is the color of hope, and the anchor its symbol, for the anchor gives stability and security to the ship, as hope does to man on the tempestuous sea of life. The transparent robe represents the purity of hope. The flowering wreath denotes the promise which hope holds out to us, just as flowers are the promise of the rich harvest of the summer. The woman looks up to the heavenly light in prayer and ecstasy, for it is the source of all hope, and the goal of all truly lofty hopes.

[Ripa, 1603, p. 469, "Speranza"; p. 471, "Speranza divina e certa"]

The *fatto*: Atop a high hill with a stairway leading up it, Moses stands talking with God, who sits on the clouds. In the distance, the sun rises over the Promised Land, a fertile, peaceful country.

[Deuteronomy 32: 48–52; 34]

HOPE
*Moses might fair Canaan see,
But it enter could not he.*

SPES.

Palæstina, quam Deus Abraam, Isaac et Iacob promiserat,
ostenditur Mosi, habitatio vero in illa ei non conceditur.
Mortuum sepelivit Deus. Sepulturæ locus adhuc incertus est.

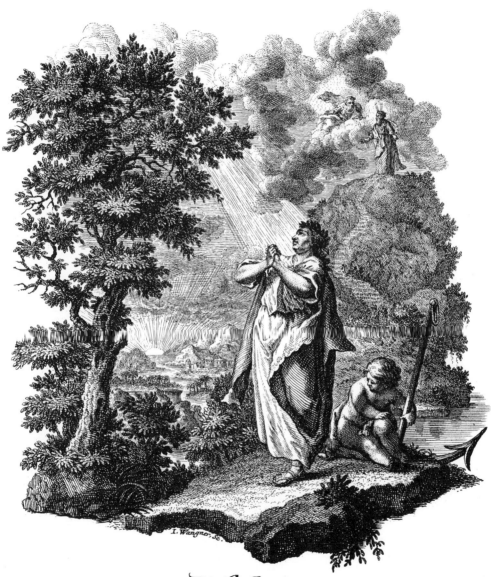

I. Wangner, Sc.

Die Hofnung.
Moses soll das Land zwar sehen,
aber nicht hinüber gehen.

Eichler. del.

Hertel, excud.

PENANCE

As John the Baptist preached the Divine Word in the land of Judaea,
he admonished the inhabitants to do true penance.

The personification of Penance is a gaunt woman with a melancholy look, dressed in dark rags. She kneels while beating herself with a whip with weighted thongs, and staring at a large cross propped up nearby. She rests her arm on a book lying open on the rock before her primitive wooden hut in the hollow of a hillside. Before her are a bowl of water and some fish and radishes, or turnips. Behind her lies a grill.

The grill is like penance, for it is between the fire and the thing being cooked, just as penance is between the committed sin and God's pardon. The woman, who bears a strong resemblance to Mary Magdalene in the desert, has the melancholy look of contrition on her face. She looks at the cross, asking pardon of God. The whip symbolizes the mortification of the flesh, and the fish, the radishes (or turnips), and the water all relate to fasting, an important part of penance.

[Ripa, 1603, p. 387]

The *fatto:* St. John the Baptist is seen preaching to the multitudes in the wilderness of the land of Judaea.

[Matthew 3]

PENANCE

John doth of repentance preach,
For only thus can man God reach.

Vt verbum divinum Ioannes Baptista prædicavit terræ Iudææ
ita incolas ejus admonuit, ut veram agerent poenitentiam .

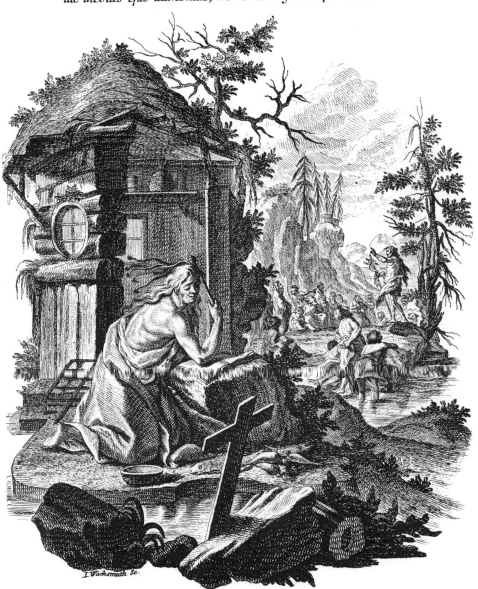

I. Wachsmuth Sc.

Die Buße.
Iohañes von der Buße lehrt,
ũ: seinen laut auf Christum kehrt.

Eichler, del. Hertel, excud:

SPIRITUAL AUTHORITY
*Peter reveals freely his belief in Christ. His answer pleases, and to him
and the rest of the Apostles is granted a great power over others. That which they
shall bind, shall be bound in heaven, and that which they shall loose,
shall be loosed there.*

The personification of Spiritual Authority is a handsome matron in regal attire, her cloak lined with ermine. Sitting upon a throne, she bears a scepter in one hand and two large keys in the other. Over the throne is a cartouche inscribed "Cedant ARMA Togae Cic." (Weapons must give way to the toga: Cicero). On the floor, books are scattered on the left, and a bundle of lictors' rods lies on the right. Banners and trophies can be perceived behind the throne.

The allegorical figure is matronly, for only maturity has true authority and the ability to wield it, according to Cicero in his essay on old age (*De senectute*). She is seated, for those in authority always sit while others stand. Her throne and splendid robes show that spiritual authority is raised above all others. Her scepter is the symbol of temporal power (which is subordinate to spiritual power), as are the weapons, the lictors' rods, the books, and the inscription taken from Cicero. The keys, however, are the main symbols of spiritual authority (Christ giving Peter the keys to Heaven, etc.). She holds them in her right hand, for that is the important hand and spiritual authority is the most important kind. She holds them up in the air to indicate that such power comes from Heaven.

[Ripa, 1603, p. 34]

The *fatto:* Christ gives kneeling Peter the keys to the Heavenly Kingdom, to which he points; Heaven is here symbolized by the round temple on the hill, a standard symbol for the True Religion.

[Matthew 16: 16–19]

SPIRITUAL AUTHORITY
*The power to free or place in bands
Christ put into St. Peter's hands.*

Petrus suam de Christo sententiam libere apperit. Placet responsio,
eique et reliquis Apostolis magna in alios conceditur potestas.
Quicquid ligaverint, sit ligatum, et quicquid solverint, solutum in coelis.

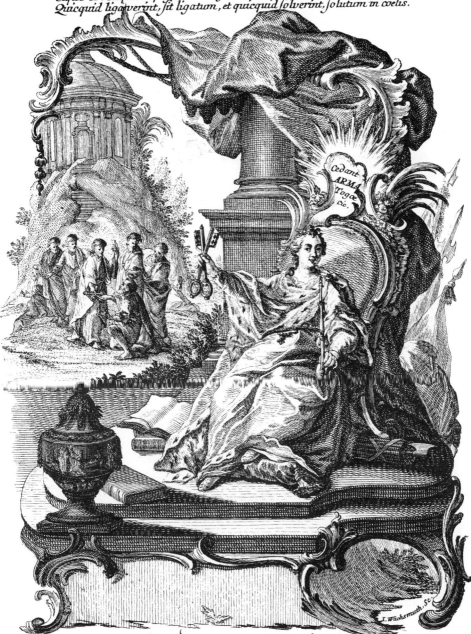

Die Geiſtliche Macht.
Chriſtus gibt zu löſen binder
Petro alle Macht in Sünder

Eichler del. Hertel, excud.

TAXATION

*The followers of the Pharisees ask Christ to give His opinion on the tribute
to be paid to Caesar. Well knowing their shrewdness, He asks the hypocrites,
"Why do you tempt Me? Show me a coin." All admit that the image and the
inscription on the coin are those of Caesar. Thus it came about that Christ called,
"Give unto Caesar that which is Caesar's."*

The personification of Taxation is a muscular youth in rustic dress, his sturdy limbs bare, an oak leaf wreath on his head. He is seated on a hummock with a lamb in his lap. He holds a pair of shears in one hand and points with the other to a bundle of grain, grapes, and olive branches held by a putto near him. The round pedestal behind him is inscribed "Vectigalia nervos esse Reip: semper duximus Marc: Tull:" (We have always believed that taxes are the sinews of the state: Marcus Tullius Cicero).

The youth is very muscular and healthy, for taxes make a community or state strong. The oak is a symbol for strength, hence his wreath of oak leaves. His bare limbs are clean and sturdy, for just as they are the tools of man, the means of his doing things, so taxes are the tools of a state and should be healthy, strong, and uncomplicated—in other words, a state should have a fair and workable tax system. The shears the youth holds represent the means of gathering taxes and the lamb represents the taxable public. They also refer to the emperor Tiberius' comment quoted by Suetonius: "Boni pastoris esse tondere pecus, non deglubere" (A good shepherd shears his sheep, but does not skin them). The ears of grain, olive branches, and grape clusters refer to the three things (in Italy) upon which most taxes were imposed—flour, oil, and wine.

[Ripa, 1765, II, p. 117]

The *fatto*: Christ stands talking to a group of richly dressed Pharisees, one of whom points to a coin in his hand. Christ is telling them to render unto Caesar that which is his, and unto God that which is God's.

[Matthew 22: 15–22]

TAXATION
*Give to Caesar what is his,
And unto God, what God's is.*

Pharisæorum diſcipuli rogant Chriſtum, ut ſuam de cenſu Cæſari dando aperiat ſententiam. Calliditate eorum probe cognita, hypocritæ inquit, quid me tentatis, numisma mihi oſtendite. Imaginem inſcriptionemque ejus eſſe Cæſaris omnes fatentur Quo factum est, ut exclamaret Chriſtus, quæ Cæſaris ſunt, date Cæſari.

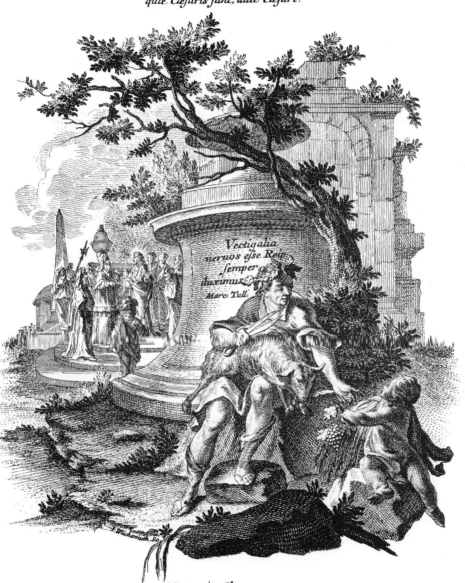

Die Schatzung.

Dem Kayſer ſoll gleichwie man liſt,
Gott geben auch was Gottes iſt.

Eichler, del. Hertel, excud.

PRUDENCE

Nabal ill received the servants of David; they were very differently received by his wife, a woman of great prudence. She offered them food and drink, and thus saved herself and hers.

The personification of Prudence is a woman in long classical draperies. She has a head with two faces, one of which is that of a bearded man, the other that of a woman. She wears a gilded helmet wreathed with mulberry leaves. On a chain around her neck hangs a skull. She looks into a mirror which she holds in one hand. In her other hand she has an arrow around which an eel is wound. Behind her lies a huge stag.

The figure has two faces, for the person possessing prudence looks forward and backward, that is, is aware of past events related to a decision to be made, and is aware of its possible results or consequences in the future. The gilded helmet signifies the wisdom of the prudent man, since, as has become evident in all these allegories, any special decoration of the head or its covering relates to the brain, to intellect. The garland of mulberry leaves around the helmet is also most appropriate, for, as Alciatus points out, the mulberry is a most cautious tree, which only blooms very late, when there is no danger of frost; the prudent man is also never precipitate, but comes to a decision slowly, always planning ahead. The arrow the figure holds symbolizes speed and good aim, but an eel is wound around it, and Pliny points out, in discussing this animal, that when it attaches itself to a ship's bottom it has the power of dragging it to a halt with its weight and strength. This means that prudence imposes a brake on speedy decisions. It also means, however, that the prudent man does not hold back in helping others, but combatting inertia (the eel), he speeds like an arrow to help. The stag is equipped with strong legs with which he can run swiftly, but his heavy antlers weigh him down, and unless he is very careful can get him entangled in the underbrush. So the stag is prudent. Indeed, he is also actually supposed to be chewing, is ruminative, which means symbolically that he is thinking things over, is "chewing them over." The skull the figure wears indicates the philosophical bent of the prudent man, who thinks about mortality and man's end a great deal, and is prepared for it.
[Ripa, 1603, p. 417]

The *fatto*: In the distant background, Abigail is seen kneeling before David, offering him and his army food and drink. Behind her is a donkey loaded with food.
[I Samuel 25]

PRUDENCE
Shrewd Abigail her aid afforded,
And was by David well rewarded.

Servos Davidis Nabal vehementer accipit: multo aliter uxor
ejus, magnæ sagacitatis femina. Suppeditat iis victum alimentumq̃,
Quo factum est, ut se suosque servaret.

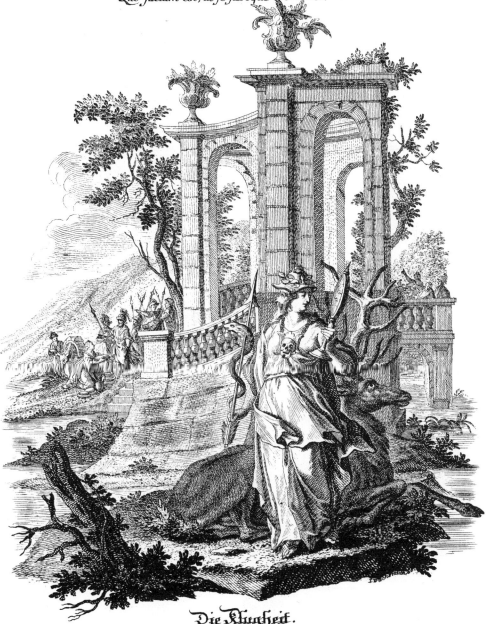

Die Klugheit.
Ein kluges Weib ohn heuchel Schein
will Abigail bey David seyn.

Eichler, del. Hertel, exc.

180

JOY

*Christ departs for Jerusalem. The inhabitants of the city come out to meet him,
and, spreading out garments and branches of trees, they receive him with exultation.*

The personification of Joy is a pretty blonde girl in white robes, who dances about. She has flowers in her hair, and a flower garland draped over one shoulder. She holds a palm frond in one hand. On the far left, a putto floats in the air holding another palm frond and an olive branch.

The girl is young and pretty, for youth is the age when joy is predominant, and her joyous nature expresses itself in her appearance. The flowers and garland she wears refer to the old custom of decorating oneself with flowers on happy occasions and at festivals. The palm and olive branches are reminders of the joy felt on Palm Sunday, and of the palm and olive branches with which the people of Jerusalem greeted Christ upon His entry.
[Ripa, 1603, p. 12]

The *fatto:* Before the gates of Jerusalem, shown as a large and fantastic city, crowds of people greet Christ with great joy, spreading out their coats and bearing palm fronds.
[Matthew 21: 8, 9]

JOY
*Though humbly Christ rides to the city's gates,
The town with joy His entry celebrates.*

GAUDIUM.

*Christus Hierosolymam proficiscitur. Ei procedunt ob-
viam incolæ urbis, eumque stratis vestimentis ramisq;
arborum ovantes excipiunt.*

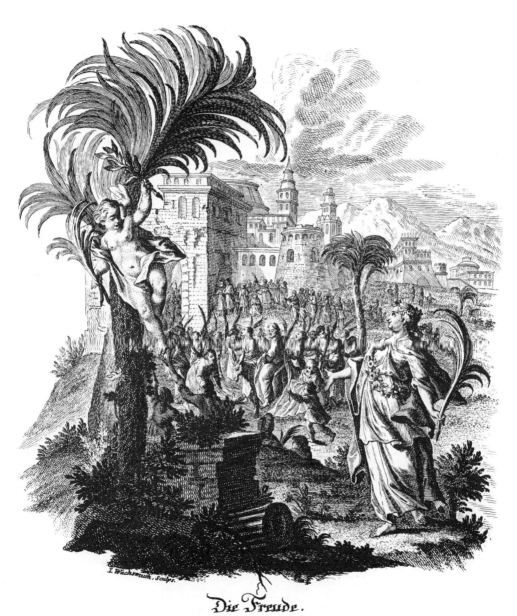

I. Wachsmuth, Sculps.

Die Freude.

Ob gleich der Einzug sehr gering /
die Freude doch nicht schlechter ding

Eichler. del.

Hertel. excud.

It is difficult not to write a satire, for who, observing the habits of man,
is so made of iron as to be able to contain himself?

Part X

Histories and Allegories

Designed and drawn

by Gottfried Eichler;

Published by the Author,

Johann Georg Hertel,

Augsburg

Above the cartouche containing the title is seen a room in which a number of figures are seated around a circular table. Moving clockwise from the left, they are: a scientist studying a celestial globe in order to draw a terrestrial map; a satyr working a bellows and blowing wind across the table with it; a Janus-headed, winged figure holding an umbrella over a reading man who has an inkpot and quill on his head, which is surrounded by flying insects; a schoolmaster in clerical garb holding a rod and a book and teaching a child; and a soldier with a glass of drink, who sits propping up his head with one hand and looking rather disconsolate. On the wall hangs a picture of a man looking through a telescope. On the balustrade above are statues of an Oriental, Pantaloon, and a woman with a book, who touches her head.

Again this is certainly an invention of Hertel, dealing with every variety of human foolishness. The scientist, who is the best example, is trying to do something impossible, or rather pointless, to use a map of the skies for measuring a map of the earth. The others are less clear. The satyr is again the satiric impulse blowing up a storm with his bellows, the two-faced figure is a combination of time and memory, who holds a regal umbrella, a sign of rank, over the man who seems to be a writer of some sort, and whose head is surrounded by *Grillen* (foolish fancies in the form of insects). The schoolmaster is the only one apparently taken from Ripa, for it is the image of Correction (1603, p. 91), but in the form of a man, and with a pupil. The soldier seems to be just the opposite of all the military glory and virtue celebrated in so many of Ripa's images. The whole thing suggests some private jokes between the creators of this edition, and might even indicate that they were not taking it so very seriously after all.

The sight of life's mad occupations
Leads to all sorts of observations.

Difficile est, satyram non scribere nam quis iniquos
dum cernit mores, tam ferreus ut teneat se .

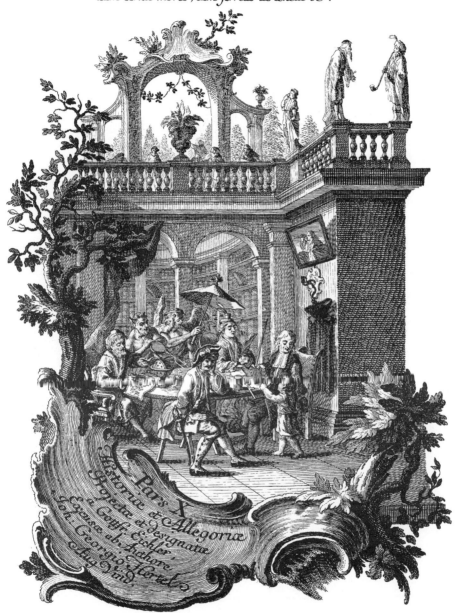

Pars X.
Historiæ et Allegoriæ
inventæ et designatæ
a Gottf. Eichler,
Excusæ ab Authore
Joh. Georgio Hertel
Aug. Vind.

So die Zeit der Menschen Leben,
vielerley Betrachtung geben .

INTELLIGENCE

*It is said that Protagoras was a porter. Democritus, seeing him
walking so quickly and easily, though burdened with a load of wood,
and observing how skillfully the load was tied and the wood was disposed,
asked him to rest a moment. Questioned as to who had prepared the load
of wood this way, he said that he had done it himself. Democritus,
admiring the man's keen eye and dexterity, took him away with him and
taught him philosophy.*

The personification of Intelligence is a handsome youth with blonde curly hair, dressed in cloth of gold. He wears a royal crown of gold, and from his forehead rises a bright flame. Seated, he holds a scepter in one hand and points with the other to the busts of Minerva and Apollo, which stand behind him on high pedestals. Before him are a sphinx and a large eagle.

Intelligence, being incorruptible and ageless, is therefore clothed in gold, which is also incorruptible, and is shown in the prime of youth. His blonde and curly hair represents the ingenuity of his thoughts. Since the intellect rules all, he wears a crown and carries a scepter, both symbols of dominion. The flame rising from his head represents the intelligent person's intense wish to know and understand, his "burning" desire for knowledge. The two gods represent, respectively, wisdom and genius. The sphinx refers to the story of Oedipus, who solved her riddle by using his intelligence. The eagle is the bird who soars the highest of all, just as the intellect rises high above all other aspects of humanity.

[Ripa, 1603, p. 238]

The *fatto:* In a country landscape, Democritus is seen talking with Protagoras, who is busy tying a bundle of wood.

[Aulus Gellius, V, 3]

INTELLIGENCE
*Protagoras so well performed his trade,
Democritus of him a philosopher made.*

Protagoras bajulus fuisse dicitur. Eum videt Democritus cum eo genere one-
ris tam impedito facile atque expedite incedentem, et vincturam et posituram
ligni scite factam considerans, petit, ut paululum accquiescat. Interrogatus,
quis id lignum composuisset, cum a se diceret, aciem sollertiamque hominis
demiratus Democritus eum abduxit et philosophiam docuit.

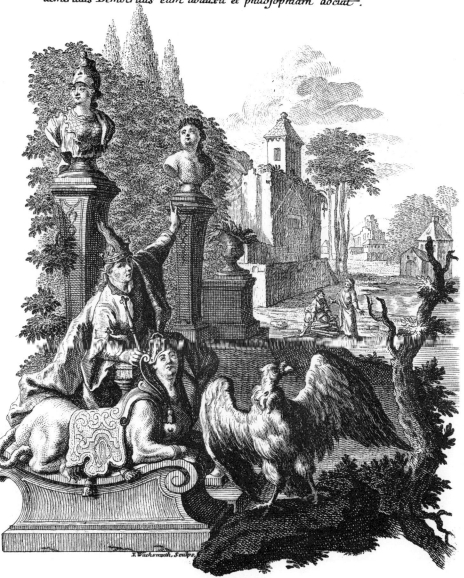

Der Verstand.

Durchs Holß so gar zeigt den Verstand,
Protagoras gleichwie bekant.

Eichler. del . Hertel. excud:

POETRY

*Homer gained immortal fame by his epic song. His poems please even
peoples outside of Greece, and are among the pleasures of kings and princes.
Ptolemy Philopator honored Homer with a statue and divine honors.*

On an elaborate rococo throne a full-bosomed female figure, the personification of Poetry, is seated. She is robed in classical draperies whose fabric is blue covered with stars. She wears a laurel wreath on her head, and holds a lyre and a scepter wound with laurel in one hand and a scroll in the other. The throne is topped with a small statue of Apollo, and has a grapevine growing on it. Inscribed on the back of the throne is "Brevi complector Singula cantu" (I tell of the unique in a short song). On her left, a garlanded putto holds a trumpet from which a banner hangs inscribed "Non nisi grandia canto" (I sing only of great things). On her right a baby satyr blows on pipes of Pan, standing before a cartouche on the ground inscribed "irridens cuspide figo" (Through ridicule I wound with pricks). Seated before her on the ground is a putto in Arcadian shepherd's garb—hat, purse, shoes and staff—who holds up a bulrush. A scroll at his feet is inscribed "Pastorum carmina ludo" (I play the songs of the shepherds). On a tree trunk near him, a set of bagpipes is hung, and behind him on the right, swans can be seen swimming on a lake.

The personification is young and lovely, for everyone, even the most rude, is entranced by the beauty of poetry. Her full breasts represent the richness of the imagination which is the soul of poetry. Her face should also be represented as flushed, for poetry's mind is full of inventions and metaphors which seem to spill out in a frantic tempo, a sort of divinely inspired fury of creativity. She wears a star-strewn blue robe to show that poetry is a heavenly art. She is crowned with laurel, which is evergreen and is a symbol for eternal fame. The lyre is the symbol of lyric poetry, and emphasizes the importance of harmonious sound in poetry. Lyric poetry, as the inscription on the throne points out, tells in a short song of unusual or noteworthy matters of an earthly nature. Her scepter wound with laurel symbolizes the great power of poetry and the effort involved in its composition. The putto with the trumpet is Epic Poetry, who sings only of great men and events, proclaiming their fame with the trumpet. The young satyr is Satiric Poetry, which pokes fun. The little shepherd is Pastoral Poetry, who sings of the bucolic and simple life of the country and the joys of nature. He holds a reed as an allusion to those out of which Pan constructed the first pipes, the very reeds into which his love, Syrinx, had been transformed. The bagpipes are another allusion to the simple country life which Pastoral Poetry celebrates. The swan, as many poets have told us, sings better as it grows older, just as poets do. The swans also represent the Greek belief that the souls of poets passed into swans and in this form continued to exercise their gifts (Plato, *Republic*, X).
[Ripa, 1603, pp. 406–408]

The *fatto:* In the background, seated under a rococo arbor, Homer, wearing his laurel crown, is seen seated writing poetry.

POETRY
*As eternal as his poetry
Shall Homer's monuments e'er be.*

Homerus carmine epico famam accquirit imortalem. Scripta
ejus gentibus extra græciam sunt accepta, et regibus et princi=
pibus in delicijs habentur. Ipsum Homerum Ptolomæus Philo=
pator statua divinoq̃ cultu honorat.

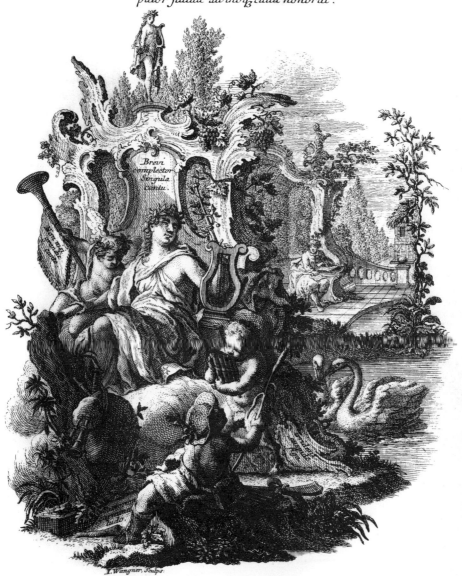

J. Wangner, Sculps.

Die Dicht Kunst.

Wie von Homero du leser
wird sein Denckmaal nicht verwesen.

Eichler, del: Hertel, excud:

LOGIC

Chrysippus, dedicated to the Stoic philosophy, was audacious in discussion
and quick in disputation. He became so self-confident that when asked by
someone to whom he should entrust his son, said: "To me. For if I thought there
were someone better, I myself would go and study philosophy with him."

Seated on a throne composed of rocaille, flowers, and an urn is a female figure—the personification of Logic—dressed in white, with a cloak of many colors. She has a transparent veil over her face, and wears a helmet on which sits a hooded peregrine falcon. Inscribed on the back of the throne is the motto "Verum et falsum" (True and false). She forcefully ties a knot in a thick, coarse rope. At her feet lie a twist of hemp, a rod, various books, and a pair of scales. On the armrest of the throne are four keys.

She wears a veil to indicate the difficulty of understanding things by sight, by their outward appearance, alone. Her white robe covered by the multicolored cloak denotes the purity of truth masked by the many things of the world which seem true, but are not. Her helmet represents the stability and truth of the scientific approach to knowledge, which favors logic. The falcon flies high and then swoops down on its prey, and thus does logic also move in the highest realms of thought to arrive at truth. The forcible way in which the woman ties a knot in the thick rope shows that logic, no matter what the effort, aims at the absolute conclusion or answer to a problem (the knot), in spite of the difficulty and complexity of the question (the rope). But the task of logic is not just to find the answers to existing questions (tying the knot in the rope): the twist of hemp at her feet shows that she must also concern herself with finding new problems and questions to solve, to make new rope too, figuratively speaking. The scales are, of course, the means of weighing the truth, and the keys are the four ways of arriving at the truth through syllogisms, a favorite method of logicians. The meaning of the motto inscribed on the throne is self-evident.

[Ripa, 1603, p. 298]

The *fatto:* In a forest glade, Chrysippus stands lecturing to an elegantly dressed boy, while two others stand by a braying donkey and, pointing, call his attention to a fox who has captured a bird.

LOGIC

In Chrysippus we an example see
Of reason's clash with stupidity.

Chrysippus Stoicæ addictus philosophiæ fuerat audax et in disserendo et disputando promtissimus. Tanta vero sui occupabatur fiducia, ut a quodam interrogatus, cui filium commendaret, diceret: Mihi. Nam si quempiam me excellere putarem, ipse apud eum philosophiæ operam darem.

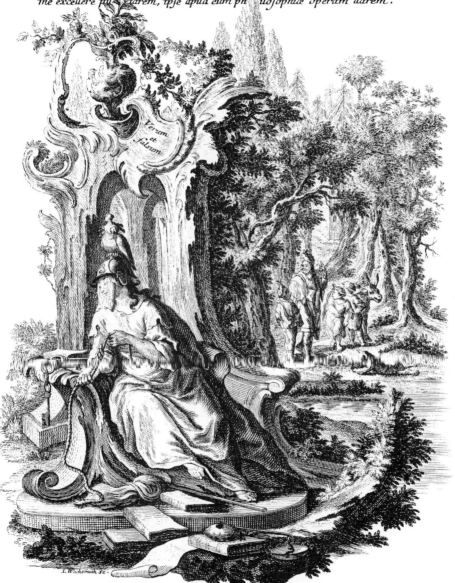

Verum
et
falsum

L. Wachsmuth Sc.

Die Vernunft Lehre.
Durch Grysippum anzudeuten
wie Vernunft ü Thorheit streiten.

Köhl...l. Tirol. excud.

185

IMAGINATION

One night, his body overcome with sleep, a Hebrew dreamed he was traveling
through narrow ways and over chasms, riding on a donkey. Awakening
and remembering his dream, he became so frightened that he died.

The personification of Imagination is a handsome female, richly dressed, with wings, and wearing a feather in her hair, who is seated on a stone and looks at her reflection in a mirror held for her by a page in sixteenth-century costume. Around her head, insects are flying, and she, seeing them, recoils from her reflection.

The richness of the woman's dress indicates the rich variety of thoughts and ideas of which the imagination is capable. The wings suggest the spiritual, that is, mental, nature of imagination, for it is not earthbound. The insects flying about her head are *Grillen* again, the foolish notions of which the fancy is also capable—what one would call in this country the bees in one's bonnet. That she is surprised and upset

by them is an indication that the healthy imagination does not find silly ideas very appealing. This is possibly an invention of the German authors, for it does not appear in either the 1603 edition or the comprehensive Orlandi edition of Ripa.

The *fatto:* In a forest glade beside a road, two travelers observe the sleeping Hebrew beneath a tree. In the background the man's dream can be seen. He rides a donkey over a slender bridge which spans a great abyss in a mountainous terrain.

[Marcello Donati, *De medica historia mirabili*]

IMAGINATION
The Hebrew's dream of a trip he was taking
Frightened him to death upon awaking.

Nocte quadam membris somno occupatis, somniavit Iudæus, se asino vectum iter per angustas et præcipites vias fecisse. Excitatus cum id somnii recordaretur, tanto perculsus fuit timore, ut obiret diem supremum.

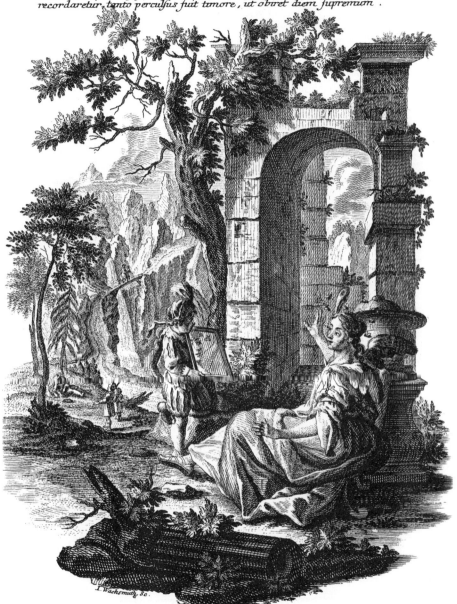

J. Wachsmuth, Sc.

Die Einbildung.
Der Schlaffend Jud gefährlich reißt,
die Einsicht Forcht zum Tod ihn weißt.

Eichler del. Hertel excud.

REFLECTION

Alexander hears that in the temple of Jove stands the chariot of Gordius, and that the oracle has prophesied that if anyone undoes the knot he will rule over all Asia. He goes there but cannot find the ends of the rope, hidden within the knot. He exploits the oracle in a very violent manner, cutting the rope with his sword.

The personification of Reflection is a woman of mature and sober appearance, somberly and simply dressed in a long robe, who sits pensively on a heap of books. She holds one book in her lap, marking her place in it with her finger. On a rock in the foreground is the inscription "Nihil est quod ampliorem curam postulet quam cogitare quid gerendum sit de hinc incogitantos sors non consilium regit. Auson." (There is nothing requiring greater effort than to reflect on what must be done; hence fate, not counsel, rules those who do not reflect: Ausonius).

Maturity is the age in which reflection is most practiced and has the best results. The woman rests her head on her hand in a pensive manner to show the weightiness of her thoughts. The heap of books on which she sits indicates that much study of the writings of the sages is an excellent foundation for thought. She is, indeed, reading, but has paused for reflection upon what she has read, and marks her place in the book with her finger so that she can continue after meditating for a while. The quotation in Latin is from Ausonius' *De ludo septem sapientum.*

[Ripa, 1603, p. 309]

The *fatto:* Standing before a huge ruined temple, Alexander, wearing armor and a crown, raises his sword to sever the knot which binds the chariot of Gordius. Various Orientals stand about, watching.

[Plutarch, *Life of Alexander*]

REFLECTION
Since Alexander his sword used,
Thus the knotted cord was loosed.

Audit Alexander in templo Iovis jugum Gordii positum, cujus nodum
si quis solvisset, eum in tota Asia regnaturum cecinisse oracula. Eo venit,
capita vero loramentorum intra nodos abscondita reperire non potest.
Violentius oraculo usus gladio loramenta cædit.

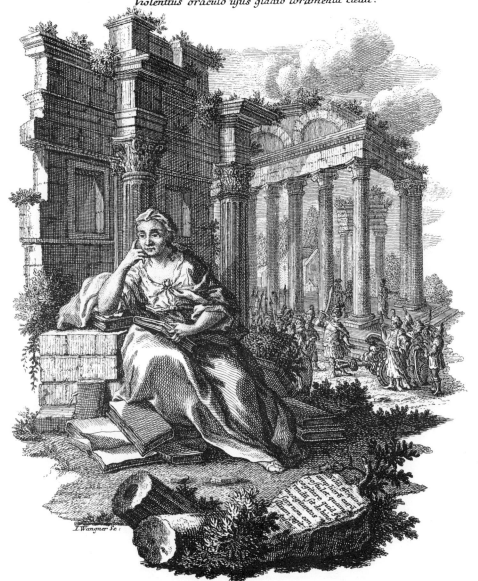

I.Wangner Sc:

Das Nachsinnen.
Weil Alexandri Schwerd entblößt,
So ward der Knoten aufgelößt.

Eichler, del: Hertel excud:

INVENTION

*The invention of typography, if one heeds the opinions of others,
is due to Johannes Gutenberg. Its usefulness is quite well known.*

The personification of Invention is a handsome woman dressed in white, with wings growing from her temples, who is seated holding a pencil in one hand and pointing to the *fatto* with the other. She rests one foot on a book. At her feet sit two putti, one leafing through a book and the other looking at a tablet marked with a pattern of circles. Behind her seat lies a large female bear licking her cub.

The figure is young and fair, for it is in the flower of youth that the warm blood stirs the spirits and inspires them to mix with the intellect, out of which combination invention comes. Her white robe represents the purity of true invention, which does not depend on the ideas of others, but is totally original. The wings on her head represent the elevation of all the intellectual aspects of the mind, which, mixed with the catalyst of the senses, produces the inventions desired. The books represent the main activity of the invention of typography, but since Hertel and Eichler are also concerned with the related branch of printing—etchings and engravings—she is shown holding a drawing pencil in her hand. The mother bear licking her cub refers to the legend that the cub is born without form or shape and that only by licking it does the mother give it the proper appearance; hence the expression "licking into shape," which means in this case that it is invention which gives visible form to the dreams and desires of man, satisfying them. The statue atop the archway through which the *fatto* is seen is the personification of Theory, who bears a pair of compasses on her head.

[Ripa, 1603, p. 240]

The *fatto*: Through an archway adorned with a statue on a console (of one of the Evangelists certainly, for the printing of the Bible was Gutenberg's great achievement) is seen a printer's workshop with all its typical activities.

INVENTION

*That Gutenberg did the art of printing find
Has been of greatest benefit to all mankind.*

Typographiæ inventum, si aliorum audiendæ sunt
sententiæ Ioanni a Guttenberg debetur. Magnum ejus
emolumentum sat constat.

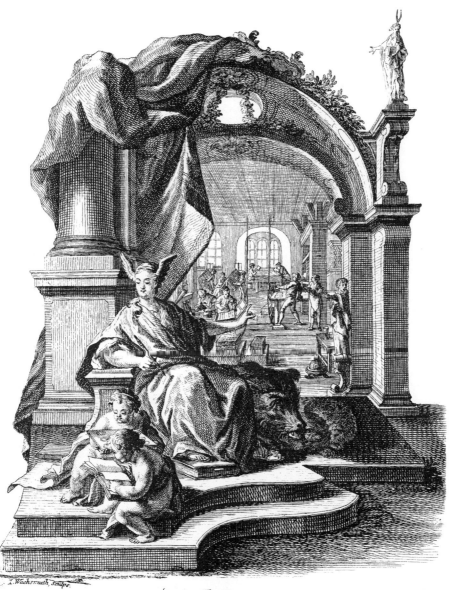

Die Erfindung.
Das Gutenberg die Druckerey,
erfunden gut und nüslich sey.

I. Wachsmuth. Sculps.

Eichler del. Hertel. excud.

KNOWLEDGE

*Ptolemy, king of Egypt, was very dedicated to the furtherance of studies
and arts. In fact, it was through his agency that the writings of others
were collected and were formed into a library.*

The personification of Knowledge is a serious-looking woman wearing stately robes and a diadem, with wings on her head, who sits holding a mirror. Her other hand rests upon a ball and holds a triangle. There are a number of books lying beside her, and a putto sits at her feet, reading a scroll. On the left is a golden tripod.

The wings on her head mean that there is no knowledge or science (this word is to be understood in its broadest sense, as the art of knowing) if the intellect is not elevated by the study of things. The mirror symbolizes the study of the visual appearance of things, leading then to the consideration of their true form or essence. True science is so evidently proved that it can have no opinions opposing it, just as a ball has no hindrance on its surface to its movement in any direction. Just as the triangle is made up of three sides, so three parts in a proposition result in its demonstration and its proof, so that it becomes true knowledge or science. The golden tripod has three legs, the perfect number, and alludes to the story of the fishermen of Cos, who found a golden tripod in their nets. Asking the oracle at Delphi what should be done with it, they were told to give it to the wisest of all. They offered it to Socrates, who presented it to the Pythian Apollo, saying that only the god deserved it, for only he could penetrate, know, and understand all things. This means, of course, that all knowledge comes from God. Since their catch had been bought beforehand by some merchants of Miletus, the tripod was claimed by them, much to the anger of the fishermen, who refused to give it up.

[Ripa, 1603, p. 444]

The *fatto:* Within a fanciful rococo pavilion, topped with obelisks, polyhedrons, and a cartouche inscribed "Nam nihil egregius quam res discernere apertas" (For nothing is so praiseworthy as recognizing the facts), sits Ptolemy. He wears a turban and crown and regal robes, and is discussing a tablet with a robed sage. Flanking him are a celestial and a terrestrial globe. Behind him can be seen a great library.

[Justin, XIII, 4, 10]

KNOWLEDGE
*The arts and sciences to flower did bring
Wise Ptolemy, Egyptian king.*

Aegypti rex Ptolomæus multum ad studiorum artium-
que incrementum contulit; Namque ejus opera factum est,
ut aliorum scripta colligerentur, et bibliotheca constitueretur.

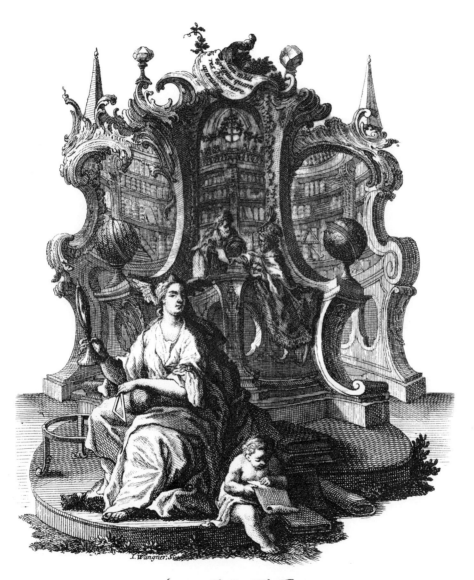

Die Wißenschafft.
Der Wißenschafft und Künsten Flor
bracht Ptolomæus hoch empor.

Eichler del. *Hertel. excud:*

PHYSICAL SCIENCE

*Pliny was a most active researcher and interpreter of nature; he would
have lived much longer, but, being too curious, he wished to penetrate
into nature's mysteries. In fact, he died as he set out to explore Vesuvius.*

The personification of Physical Science is a woman in classical draperies, seated at a table upon which stand various pieces of apparatus for experiments in physics. She rests her hand on a water clock. The other experiments deal with problems of water and air pressure primarily. On the ground are a terrestrial globe and various other experiments, chiefly a covered jar filled with water in which the devil rises and falls according to the barometric pressure, and a vacuum jar with a bird under it.

The globe shows that the physical sciences are concerned with things pertaining to this world and its laws. The water clock (clepsydra) also refers to physical laws which are subject to the movement of time and the changes it brings about. The other experiments are obviously appropriate here.

[Ripa, 1603, p. 397]

In the *fatto*, Vesuvius is seen erupting, and in its mouth one can see the tiny figure of Pliny the Elder, meeting his end in it. (Actually, he died from fumes far from the mountain itself.) Nearby is a fanciful view of a city, undoubtedly meant to be Naples.

[Pliny the Younger, *Epistles*, VI, 20]

PHYSICAL SCIENCE
*To research did Pliny dedicate
His life, and met a tragic fate.*

PHYSICA.

Plinius naturæ interpres et indagator fuit folertiſſimus, diu-
tius victurus, niſi curioſus nimis in naturæ arcana penetrare
cupiviſſet. Nam Veſuvium exploraturus periit.

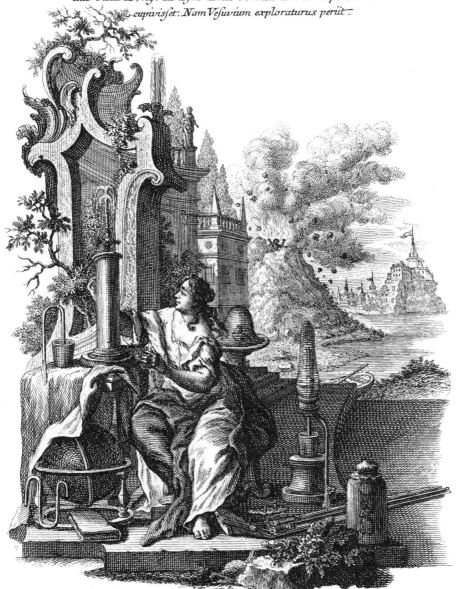

J. Wangner, Sc.

Die Natur Erforſchung.
Plinius ſucht zu ergründen
uuß dadurch ſein Leben enden.

Eichler del.

Hertel, excud.

IMITATION
*Stop here, O Reader, where you see youths who are painting a model from life.
Learn from them how difficult it is to follow the example of another.*

The personification of Imitation is a young woman in classical draperies, wearing a pointed diadem, who stands holding a mask and a paintbrush in one hand and pointing back into the life class with the other. At her feet, a monkey sits pensively, holding a book, and there are a number of brushes scattered about on the floor.

There are essentially three kinds of imitation dealt with here. The mask refers to the imitation of men by other men, as in the theater, of which the mask is often the symbol. The ape refers to the imitation of man by an animal, for the ape was considered man's animal coun-

terpart. The paintbrushes refer to the art of representing nature through the visual arts, for they are the tools used for the imitation of nature.

[Ripa, 1603, p. 223]

The *fatto*: Through an archway which takes up most of the space in the scene, and is made up of rococo C-curves and S-curves, with draperies and putti, a life class in art school is seen. Students are sitting around a nude model, drawing him or modeling him in clay.

IMITATION
*Who a good foundation in art would enjoy,
In such study must oft his time employ.*

Siste lector hic deprendis juvenes quendam ad vitam pingentes .
Disce ex his quantæ molis sit sequi alterius exemplum .

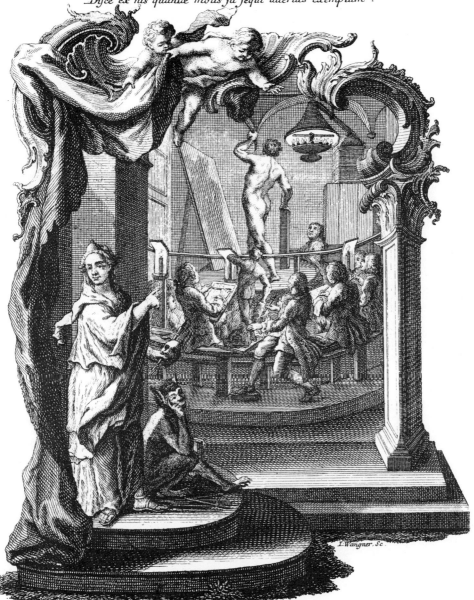

Fischler del .

I. Wangner. Sc .

Hertel, excud:

Die Nachahmung.
Wer den Grund zur Kunst will legen
muß dergleichen öfters pflegen.

GRAMMAR

*As varied as the writing of the ancients was the material on which they wrote.
They wrote on palm leaves, on tree bark, on stones, on cloth, on papyrus,
on leather, on parchment, and on paper.*

A barefoot woman in long draperies holds a spur and an iron file in one hand, and waters some plants from a pitcher held in her other hand. At her feet lie a whip, an urn full of coins, various tablets and scrolls, and a stone covered with hieroglyphs.

The personification is actually only that of Grammar, although a part of the background is also related—the busts of Cicero and Terence and the banner with the motto "Vox litterata et articulata" (the word correct in spelling and form). The spur and the whip the woman holds are the incentives used by the teacher—in other words, corporal punishment. Just as the water she pours from her pitcher makes the tender young plants grow, so does the study of grammar help develop tender young minds. It is for this reason that grammar was considered the first among the seven liberal arts and the basis for all teaching. The file symbolizes the function of grammar in polishing and sharpening the mind. The urn full of coins is the reward to be found in the study of grammar.

The two Roman busts are of men who were considered great stylists and models for anyone studying the Latin language. The motto in full is "Vox litterata et articulata debito modo pronuntiata" (the word correct in spelling and form and properly pronounced)—according to Ripa, the essence of grammar.

[Ripa, 1603, p. 194]

What should be the *fatto* is seen through the archway flanked by the busts of Cicero and Terence, and tends to obscure the division between allegory and *fatto*: the great orator Demosthenes is seen writing at a desk inscribed with his name, with books and scrolls scattered about. He actually represents not Grammar, but Oratory and Writing, both of which have here somehow become interchangeable with the main allegory, as Hertel's verse shows. Behind him what appears to be ancient Egypt can be seen, with a sage pointing to hieroglyphs incised on columns. An obelisk covered with hieroglyphs is also nearby.

ORATORY AND WRITING
*The ancients wrote, it is well known,
On bark and leather, wood and stone.*

Vt varia fuit antiquorum scriptura, ita materia, cui inscribebant,
non semper eadem. Inscripserunt foliis palmarum, corticibus ar-
borum, saxis, linteo, papyro, membranis, pergamenis, chartæ.

Die Red Kunst Schreib Kunst.
Die Alten schrieben insgemein,
auf Rinden, Leder Holz u. Stein.

Eichler del. *Hertel, excud*

MUSIC

*Orpheus so excelled in the art of song that when he sang rivers stopped flowing,
birds flew by, stones, forests, and winds listened to him, the sea
became calm, and all manner of inanimate things were moved to admiration.*

Seated before a high pedestal surmounted by a lyre, and with other musical instruments tied to it as a trophy, is the personification of Music, a beautiful young woman, richly dressed, reading a sheet of music which she has been writing with the quill pen in her hand. She sits upon a blue celestial globe studded with stars. Behind her an anvil can be seen, and leaning against her is a large viol. Some sheets of music and a pair of scales holding some tools lie at her feet. Before her a putto sits on a beautiful piece of rocaille ornament and plays a lute. A little bird sits at his feet, and a hurdygurdy, a recorder, and more music lie on the ground. Behind her on the right, a bewreathed wind god with butterfly wings, Zephyr, blows toward a group of swans floating in a pond.

The monument behind the allegorical figure is dedicated to Apollo, the god of music, whose symbol is the lyre. The woman herself is lovely and beautifully dressed, for music is a pleasurable and edifying experience. She is seated, for music is a repose for tired spirits. She is seated on the blue celestial sphere because, according to Pythagoras, all earthly harmony is dependent on the harmony of the spheres of Heaven. The anvil refers to the legend that Pythagoras,

hearing the melodious sounds of a hammer striking an anvil and the different tones discernible in the sound, hit upon the idea of developing a system of notation for these sounds and thus laid the basis for what Ripa calls "a light and lovely ornament for the comfort and delectation of mankind." The sheets of music are one of the means of imparting music and harmony to others, through their eyes. The scales represent the balance between voices to be sought in making harmonious music, by means of the ear and the other senses. The bird is evidently the nightingale, noted for its lovely song, and is an example of music in Nature. The musical instruments are, of course, the mechanical means of making music. The byplay between Zephyr and the swans refers to the belief that swans only sing when the mild west wind blows, ruffling their feathers softly, and they are thus "like some musicians who will only sing if they are soothed by the soft breeze of praise and admiration."

[Ripa, 1603, pp. 344–345]

The *fatto:* On a distant shore Orpheus sits beneath a tree, playing his lyre and charming the beasts.

[Ovid, *Metamorphoses*, X, 86–105; XI, 1–2]

MUSIC
*The song of Orpheus had the might
All things to charm and to excite.*

Tanta canendi peritia excelluit Orpheus, ut fluvii ad ejus cantum firma-
rentur, aves advolarent, saxa, sylvæ et venti auscultarent, mare seda-
retur, omneque rerum anima destitutarum genus in admirationem
raperetur.

Die Sing-Kunst.

Des Orphei sein ergözen,
alles kan in regung sezen.

Kichler. del. Hertel. excud.

MEDICINE

*Mithridates acquired great fame in the art of medicine. In fact,
he discovered many things and often avoided the plots of his guardians,
who tried to kill him with poison.*

The personification of Medicine is a handsome woman in green classical garb, with a laurel wreath on her head. She holds a cup in one hand, and a knotty club, around which a serpent is wound, in the other. She turns as she moves up the stairs to a small temple, whose roof is surmounted by a symbol of the sun. In turning, she looks down at two putti who are seated in the foreground, one of whom looks up from the open herbal in his lap to see her, while the other busily grinds something in a mortar. On the left stands a stork with a sprig of oregano in his beak. On the right, behind the putto, are a large clump of various herbs and medicinal plants, and a rooster.

Th woman is of mature years, for the older the doctor the better; moreover, the ancients felt that anyone calling on the aid of medicine before he was forty should be ashamed of his weakness. Green is the color of hope, which moves the sick to seek a cure, and it is the color of vigor, which they regain when they are cured. The laurel is used sometimes as a medicine and it was the custom in ancient Rome on the Kalends of January to present the new magistrates with a few laurel leaves as a sign that it was hoped they would remain healthy all year, for the laurel was believed to bring good health. The knotty club represents the difficulty of successful medicine, and the serpent wound around the club was the symbol of Aesculapius, the god of medicine. Moreover, the serpent is vigilant, as the doctor must be; also it renews its skin every year, casting off

the old, just as the successful medical cure renews the sick man, giving him new life. The cup the woman holds is, of course, filled with medicine. She ascends the stairs, for the practice of medicine uplifts and ennobles the man who practices it. The sun atop the temple (which is, presumably, the temple of health) refers to the idea that it is from the heat of the sun that all things live and flourish, just as it is the heat of the heart in the human body which maintains it in health. The two putti are simply practicing the art of making medicine out of herbs. The cock, like the serpent, is noted for his vigilance. The stork is supposed to eat the oregano to maintain his stomach in good order, "according to the belief of the ancient Egyptians," who supposedly used the stork often as a hieroglyph for medicine. They also used the ibis and the stag, who were supposed to have good health habits. The various plants are those of medicinal value, the gift of nature for man's good health.

[Ripa, 1603, pp. 310–312]

The *fatto* is the story (told by many authors) of King Mithridates of Pontus, whose way of practicing medicine was to render himself immune to poison by regularly taking small doses of it until he had built up an immunity. He is shown in his private quarters, drinking some, while some of his traitorous courtiers wait for him to die. Or he is taking an antidote against some poison already administered by them.

[Aulus Gellius, XVIII, 16, 1]

MEDICINE
*In medicine was Mithridates so much skilled
That, from taking poison, he was never killed.*

MEDICINA.

Mithridates magnum in medicinæ arte consecutus est nomen. Namq₃
multa invenit sæpiusq₃ tutorum evitavit insidias, qui veneno inter-
ficere eum paraverunt.

Die Artzney Kunst.
Mÿdritati Ardeneyer
Ihne selbst vom Tod befreyen.

Eichler. del.

Hertel. excud.

GEOMETRY

Archimedes was a great geometrician. Proof of this is furnished by the various examples of his art. Syracuse was being sacked; a soldier killed him while he was intent on his work.

The personification of Geometry is a seated female in flowing robes, wearing a container of pencils hanging from her belt, who looks at a surveying plan held up for her by a small boy. Behind him lie two books inscribed with the names of the French geometrician Le Clerc and the German Penther. She is surrounded by all manner of surveying tools, geometrical instruments, and articles used for drafting. She holds some in her lap. Behind her the pedestal supporting some ruined columns bears the inscription "Artem Geometriae addiscere atque exercere publice interest C. I. C. Lib 2" (It is in the public interest to learn and practice the art of geometry: *Corpus Iuris Civilis* [Justinian's Compendium of Civil Law], Book II). On the top of the pedestal various cones, pyramids, and polyhedrons are standing.

Although Ripa only suggests representing Geometry as a woman with a plumbline and compasses, or compasses and a triangle, in her hands, the Augsburgers have provided all sorts of instruments and examples of the application of plane and solid geometry to enrich the representation.

[Ripa, 1603, p. 183]

The *fatto* shows Archimedes (*ca.* 287–212 B.C.) working on some circles he has drawn on the floor. ("Do not disturb my circles") while a Roman soldier advances, drawing his sword. The studio is filled with scientific instruments.

[Livy, XXV, 31]

GEOMETRY

In all the sciences is found justification
For granting Archimedes great adulation.

Archimedes magnus fuit Geometra. Id varia suæ artis sat
probant specimina. Syracusa expugnatur: Eum miles operi
suo intentum interficit.

Die Feldmeßer-Kunst.
Biler Wißenschafften proben,
machten Archimedem loben.

Eichler, del. Hertel, excud:

MECHANICS
*Daedalus, if Plato is to be credited, constructed such ingenious machines
as to amaze all men. He made statues of men which moved, worked, and—when the
job was done—would have walked away if they had not been fastened down.*

The personification of Mechanics is a tall woman of mature years dressed in long flowing garments, who leans on some building blocks and rests her elbow on a book lying on them. She holds a scale with weights. Before her on the ground are a diagram of a problem in lifting weights, a book, a screw with a weight atop it, and a roller. On the ledge behind her is a primitive model of a crane.

The woman is mature, for at that age things are done best. Ripa also suggests that she wear a circle on her head, for most mechanical operations are done in a circular movement, and

that her dress be short, for there should be no impediment in performing difficult mechanical tasks. Neither of these suggestions was followed by Eichler and Hertel.
[Ripa, 1766, IV, p. 84]

The *fatto:* On the quay of a harbor, Daedalus is displaying one of his mechanical beings, a robot in the form of a woman in classical dress. In the background a large crane is loading square objects, bales or blocks of stone, onto a ship.
[Ovid, *Metamorphoses*, VIII]

MECHANICS
*What otherwise one to Nature leaves,
Great Daedalus through his art achieves.*

Dædalus, si Plato audiendus est, machinis affabre effictis omnes
in stuporem conjecit: Hominum simulacra fecit, qui semetipsos mo-
vebant, laborabant, reque perfecta, ni fuissent alligati abibant.

J. Wachsmuth Sc.

Die Hebe-Kunst.
Waß sonst die Natur vollbringet,
Dædalus durch Kunst erzwinget.

Eichler, del. Hertel, excud: .

ASTROLOGY

Thales of Miletus had dedicated himself wholly to the study of natural philosophy above all and of the mathematical sciences. From this great ambition of his spirit an anecdote arose, which is told about him, but with uncertain credence: while he was contemplating the stars with great concentration, he fell into a ditch, and a servant woman, who had seen him, laughed at him, saying that he who had been so intent on scrutinizing celestial things had not even seen that which lay before his feet.

The personification of Astrology is a winged woman dressed in blue, with a crown of stars on her head, who sits at a table on a dais. She holds a scepter in one hand, pointing with it to the sky. In the other hand she holds an open book. She has a telescope in her lap. About her feet are books and scrolls, an astronomical chart, and an astrolabe, and on the table is an armillary sphere. A celestial globe is nearby. Beside her sits an eagle. In the tall tower behind her, an early observatory, men stand on the roof looking through telescopes at the starry sky, which is filled with various constellations. The moon in the sky has a human face.

In this case the author has used the terms astrology and astronomy as having the same meaning, for it is really the scientific study of the stars which is meant, and not the art of foretelling the future through them. But in both cases it is the understanding of the stars which is being considered, and so, perhaps, for the eighteenth century the confusion is justified. The woman wears blue, for that is the color of the heavens, the abode of the stars. Her wings show that her thoughts are on elevated matters and remind one that the stars are very distant and difficult to reach. The scepter and the crown of stars represent the dominion of the stars over all other heavenly bodies. All the astronomical instruments show that astrology (in Hertel's—and Ripa's—sense of the word) is concerned with the measurement and tracking of the stars in order to understand them. The books and scrolls are the recorded knowledge of the stars which must also be studied. The eagle is the greatest flyer of all the birds, and thus gets closer to the stars than anyone else.
[Ripa, 1603, pp. 28–29]

The *fatto*: Under the same starry sky, Thales of Miletus, looking rather foolish, is shown sitting in the ditch into which he has fallen while observing the stars. The woman who saw him fall stands beside the ditch, laughing.
[Diogenes Laertius, I, 8]

ASTROLOGY
*The stars of Heaven did Thales so enthrall
That, studying them, in a ditch he did fall.*

Thales Milesius philosophiæ naturalis imprimis et mathematicarum scientiarum studio totum se dederat. Ab hac vehementi animi contentione narratiuncula orta est, quæ de illo incerta fide fertur: astris contemplandis intentum, cum in foveam decidisset, ab ancilla, quæ eum viderat, derisum esse, qui coelestibus scrutandis occupatus, ea non vidisset, quæ ante pedes sunt.

Die Stern Seh Kunst.
Die Grube Thalem fallen macht,
als er des Himels Lauf betracht.

Eichler. del. I. Wangner, Sculps. Hertel excud.

PAINTING

Protogenes, famous in the pictorial art, made a most ingenious painting.
By some chance Apelles came into possession of it and improved upon it.
When Protogenes saw it, he said: "I have been vanquished by you,
and in the future I shall give you every honor."

The personification of Painting is a very beautiful woman dressed in multicolored garments. Her rich curly hair is decorated with flowers and jewels. A cloth is bound over her mouth and her eyebrows are arched in surprise. She is seated, and rests one arm on a canvas on which is a preparatory drawing of the allegory of Poetry (Plate 183). She points with her other hand at the *fatto*. On a chain around her neck hangs a mask. At her feet lie a palette and brushes, a mahlstick, various instruments of measurement, a book, and a perspective diagram. Next to her, a smiling putto with a book points to an oval portrait of a man who is undoubtedly Gottfried Eichler the Younger, on a pedestal behind the main figure. Below the main group, a bit of rocaille bears the inscription "Imitatio" (Imitation). At the top of the rocaille frame of the *fatto* is the motto "Nulla dies sine linea" (No day without a line).

The woman's great beauty indicates the nobility and perfection of the art of painting. Her fine hair, decorated with much taste and imagination (the quality of hair often symbolizes that of the intellect), shows that the painter is always thinking about new images, new ways of representing nature, and new concepts to depict. The cloth bound over her mouth indicates that painting is a silent art, conveying its message by other means than words—it is mute poetry. Indeed, the drawing of Poetry on the canvas (the first step in making a painting) is a reference to the old *ut pictura poesis* problem. The bound mouth also means that the painter gains by silence and solitude, working better when alone. The golden chain is a symbol of the continuity and interlocking nature of painting, each man learning from his master and con-

tinuing his master's achievements in the next generation. The mask is an imitation of a human face, just as painting is an imitation of life. The woman's eyebrows are arched in surprise, for it is in the nature of painting to create things which astound us with the illusion of reality they present. The multicolored garment represents the infinite variety in painting which gives so much pleasure. The palette and other tools lying about are those of the painter, who must also be a master of geometry in order to produce correct perspective. The portrait pointed to by the putto is in praise of painters in general (it is obviously a self-portrait in the typical eighteenth-century manner, with the artist pointing back at one of his works), but it is also specifically in honor of Gottfried Eichler, who drew all the images in this book and gave visual form to the abstract concepts thought up by Hertel. (A comparison of this portrait with Eichler's oil in the Augsburg art collections, showing him with his new wife, confirms the identification, even though the painting is about ten years earlier. The portrait of the elder Eichler, also in Augsburg, has quite different features.) The motto "Imitatio" is clear; the other motto, which comes from Pliny (*Natural History*, Book 35, chap. 84), means that the artist must continually practice and must never let a day go by without having done some drawing.
[Ripa, 1603, pp. 404–405]

The *fatto:* In an artist's studio, Apelles is painting at an easel while Protogenes watches him through a doorway.
[Pliny, XXXV, 10]

PAINTING

Apelles' skill as painter was so great
That even Protogenes had to capitulate.

*Protogenes arte pictoria clarus picturam eandemque artificiosissimam
fecit. Eam nescio quo casu Apelles accipit facitque meliorem . Quod Proto-
genes ut animadvertit, a te inquit, victus sum inque futurum quemvis
honorem tibi habebo .*

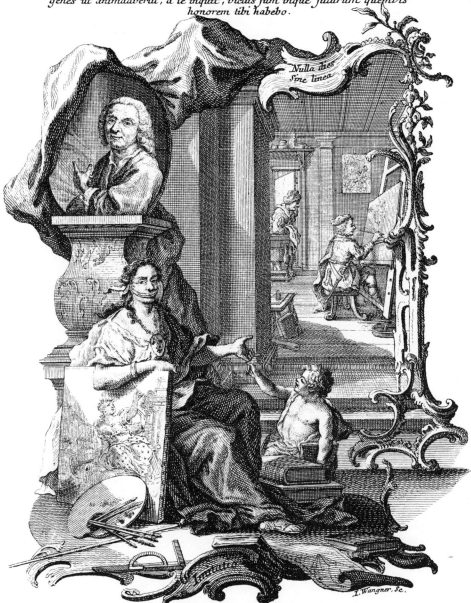

Die Mahlerey Kunst.
Weil Kunst u. Ruhm den Zweck erreicht,
Protogenes Apellem weicht .

Eichler. del:　　　　　　　　　　　　　　　Hertel excud:

PHILOSOPHY

Pythagoras was from Samos and was the founder of the Italic school
of philosophy. Of those who wished to be taken under his tutelage he
required, according to what he felt the case demanded, a silence of
either five or three or two years. According to his belief,
souls released on earth float about in the air. If they have been good,
they will reach the heavenly seat; otherwise they are sent into new bodies.

The personification of Philosophy is a woman of noble and venerable aspect, who stands on a globe of the world and bears on her head wings and a globe of the universe. Her eyes are lifted up to the heavens. She holds a scepter in the same hand with which she points to her forehead; in her other hand she holds a book. A Greek T-symbol (*tau*) is on the breast of her flowing dress, and on the hem is a Greek P-symbol (*pi*). Behind her is a broken obelisk covered with hieroglyphs; some books lie about on the ground. A putto with some books and a scale sits on a scroll and leans on the globe. Nearby, a stairway cut into the rock leads up a rock slope to a round temple. The inscription on the steps, reading upwards, is "ab imis ad summa" (From the depths to the heights).

Philosophy, according to Plato, is the study of all things, divine, natural, and human, and is thus worthy of the greatest reverence and honor. Therefore the woman is elderly and noble in appearance. The globe of the universe shows that she concerns herself with all things, and the wings indicate the loftiness of such intellectual concerns. She looks to the heavens, for all wisdom and knowledge come from God. She points to her forehead, for that is the seat of thought. The scepter is, of course, the symbol of power and dominion, for philosophy dominates all other kinds of thought. The closed book she holds contains the secrets of nature, so difficult to plumb, but which philosophy can reveal through study. She stands on a globe of the world, for she is superior to all earthbound things and dominates them. The

putto with the scales represents the judgment involved in true understanding of things. The symbols on the woman's dress come from a description of Philosophy made by Boethius in his *On the Consolation of Philosophy*, a description used by Ripa as an alternative version. The main point of this representation is that her dress should be of the finest stuff, but covered with a film of dust or soot with the *tau* at her neck and the *pi* at her feet. The fineness of the fabric symbolizes the subtlety of the arguments needed to analyze the inexplicable problems of the world. The soiled appearance denotes not only the antiquity of the study of philosophy, but also its neglect and the poverty of those who study and teach it. The Greek T stands for theory (actually, in Greek the word begins with a *theta*, not a *tau*, as Orlandi carefully points out in his edition of Ripa), and the P for practice, out of both of which philosophy is framed. Instead of placing a pattern of steps on the dress, as Boethius and Ripa suggested, Hertel and Eichler have created a set of steps nearby, which, with their apposite inscription, give the idea of moving from the lowest level, that of practice, to the highest, that of theory. They lead, moreover, to the round temple, a standard symbol for the true religion—in this case Christianity.

[Ripa, 1603, pp. 162–165]

The *fatto*: On the left, the philosopher Pythagoras, seated, is lecturing to his pupils in a large hall. Beside him is the image of a griffin, or sphinx.

PHILOSOPHY
Pythagoras the basis laid
For knowledge which the world remade.

Pythagoras Samius fuit, et Sectæ Italicæ auctor. Qui in disciplinam
ejus recipi cupiebant, eis vel quinquennii vel triennii, vel biennii, prout cir-
cumstantias postulare credebat, silentium imperabat.　　Pro ejus sen-
tentia animæ ejectæ in terram vagantur in aere, quæ　　si bonæ
fuerint, ad aerias sedes, si minus in nova im-
　　　　　mittuntur corpora.

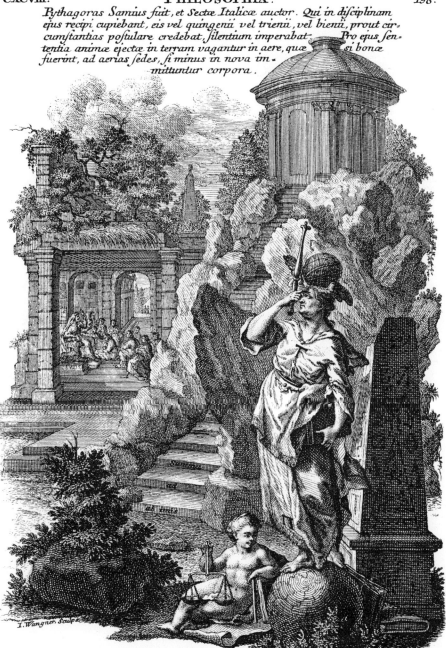

I. Wangner Sculps.

Die Welt Weißheit.
Pythagoras den Grund gelegt,
Zur Wißenschafft die viles regt.

Eichler. del.

Hertel, excud.

STATECRAFT

Lycurgus, a most noble name among legislators, protected the city
of the Spartans with many laws, and to give these authority he referred
them to Apollo; but he promised not to sanction anything in his laws
of which he should not be the first to furnish a good example in
himself. Preparing to leave, he asked them to swear on oath that they
would abide by these laws. They immediately fulfilled his request.

The personification of Statecraft is a mature woman of noble appearance who is seated holding a pair of scales. At her feet lie the lictors' rods, and she points back at the *fatto*.

The art of government is a matter of judging one side or one policy against another, and hence great judgment is needed. All this is symbolized by the scales. The lictors' rods represent here, as they have in several other allegories, the power of the state to punish and reward, or more specifically to punish and to execute. After having reached something of a crescendo in the complexity of their allegories of painting and philosophy, the authors were not able to work up anything half so spectacular for the penultimate and the final allegories in their book.

[Ripa, 1603, p. 411]

The *fatto*: Lycurgus, lawgiver of Sparta, has the citizens raise their hands and swear an oath that they will obey the laws he has established.

[Cicero, *De divinatione*, I, 96]

STATECRAFT
An oath to Lycurgus the Spartans swore
That they'd live by his laws forevermore.

Lycurgus, nobilissimum inter nomothetas nomen, variis legibus Spartano-
rum civitatem munivit, et ut iis auctoritatem conciliaret, eas ad Apollinem
retulit, ita tamen, ut nihil ulla lege in eos sanciret, cujus non ipse primus in
se documenta daret. Profecturus petiit ab illis, ut jurejurando eas
confirmarent. Mandatum prompti exsecuti sunt.

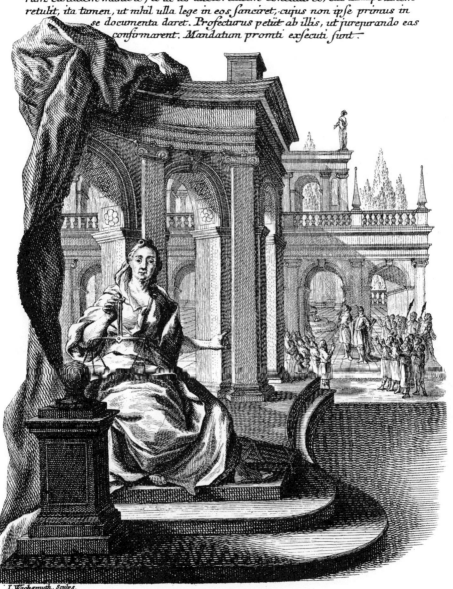

Staats Klugheit.

Eyd u: Pflicht das Recht macht stehen,
wie Lycurgus es versehen.

I.Wachsmuth, Sculps.

Eichler del.　　Hertel, excud.

2

GOVERNMENT

*The power of the Spartans grew from day to day. Learning of this,
the Thebans sent a certain philosopher there to find out the reason. On
his return he told them nothing, but had various instruments of torture
and execution brought before them. By this he wished to indicate that the state
flourishes if the wicked are punished.*

The personification of Government is a dignified woman in rich robes, seated on a dais. She holds a naked sword, around which olive branches are wound, over her shoulder. She points to the *fatto*. On the floor beside her lie the lictors' rods.

In this allegory of good governmental policy, Ripa expresses the ideas of the sixteenth century and certainly not of ours, for all that he offers in the way of symbols is the sword, the symbol of war, wound with olive, the symbol of peace. The lictors' rods are, as is known, the symbol of the power of the state to punish and even execute malefactors. The woman is very dignified, for the state and its government are to be respected. Hertel only adds an even less edifying touch to the consideration of the problem with his really rather brutal historical allusion in the *fatto*.

[Ripa, 1603, p. 194]

The *fatto:* In a city square of Thebes, a man points out to the people various instruments of torture displayed on a platform. This is the way in which the Spartans are governed, and this is why their power is increasing.

GOVERNMENT
*Where crime doth not unpunished go,
Good government can wax and grow.*

Lacedæmoniorum opes indies crescunt. Quibus auditis Philosophum quendam eo Thebani mittunt, qui caussam hujus rei cognosceret. Reversus nil refert, varia vero cruciatus instru= menta asportari jubet. Eo indicare voluit, florere tunc rempublicam, si mali punirentur.

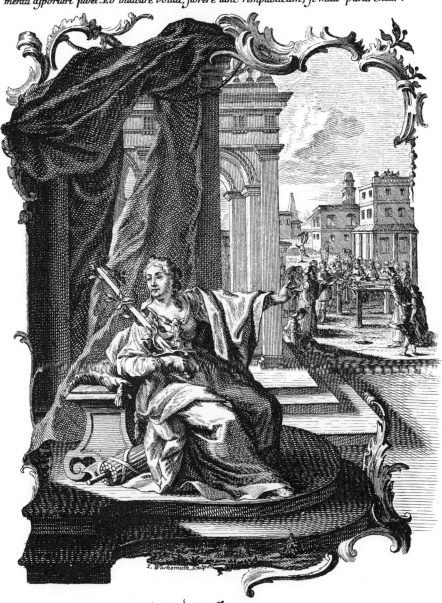

I. Wachsmuth, Sculps.

Die Policei.
Wo die Ubelthat zu straffen,
gut das Regiment beschaffen.

Eichler, del. Hertel, excud.

Register
derer fünff Theile, des Erften Band.

Index
quinque Partium primi Voluminis.

Index
Quinque Partium Secundæ Voluminis.

ENGLISH INDEX

A CATALOGUE OF SELECTED DOVER BOOKS
IN ALL FIELDS OF INTEREST

AMERICA'S OLD MASTERS, James T. Flexner. Four men emerged unexpectedly from provincial 18th century America to leadership in European art: Benjamin West, J. S. Copley, C. R. Peale, Gilbert Stuart. Brilliant coverage of lives and contributions. Revised, 1967 edition. 69 plates. 365pp. of text.
21806-6 Paperbound $2.75

FIRST FLOWERS OF OUR WILDERNESS: AMERICAN PAINTING, THE COLONIAL PERIOD, James T. Flexner. Painters, and regional painting traditions from earliest Colonial times up to the emergence of Copley, West and Peale Sr., Foster, Gustavus Hesselius, Feke, John Smibert and many anonymous painters in the primitive manner. Engaging presentation, with 162 illustrations. xxii + 368pp.
22180-6 Paperbound $3.50

THE LIGHT OF DISTANT SKIES: AMERICAN PAINTING, 1760-1835, James T. Flexner. The great generation of early American painters goes to Europe to learn and to teach: West, Copley, Gilbert Stuart and others. Allston, Trumbull, Morse; also contemporary American painters—primitives, derivatives, academics—who remained in America. 102 illustrations. xiii + 306pp. 22179-2 Paperbound $3.00

A HISTORY OF THE RISE AND PROGRESS OF THE ARTS OF DESIGN IN THE UNITED STATES, William Dunlap. Much the richest mine of information on early American painters, sculptors, architects, engravers, miniaturists, etc. The only source of information for scores of artists, the major primary source for many others. Unabridged reprint of rare original 1834 edition, with new introduction by James T. Flexner, and 394 new illustrations. Edited by Rita Weiss. 6⅝ x 9⅝.
21695-0, 21696-9, 21697-7 Three volumes, Paperbound $13.50

EPOCHS OF CHINESE AND JAPANESE ART, Ernest F. Fenollosa. From primitive Chinese art to the 20th century, thorough history, explanation of every important art period and form, including Japanese woodcuts; main stress on China and Japan, but Tibet, Korea also included. Still unexcelled for its detailed, rich coverage of cultural background, aesthetic elements, diffusion studies, particularly of the historical period. 2nd, 1913 edition. 242 illustrations. lii + 439pp. of text.
20364-6, 20365-4 Two volumes, Paperbound $5.00

THE GENTLE ART OF MAKING ENEMIES, James A. M. Whistler. Greatest wit of his day deflates Oscar Wilde, Ruskin, Swinburne; strikes back at inane critics, exhibitions, art journalism; aesthetics of impressionist revolution in most striking form. Highly readable classic by great painter. Reproduction of edition designed by Whistler. Introduction by Alfred Werner. xxxvi + 334pp.
21875-9 Paperbound $2.25

VISUAL ILLUSIONS: THEIR CAUSES, CHARACTERISTICS, AND APPLICATIONS, Matthew Luckiesh. Thorough description and discussion of optical illusion, geometric and perspective, particularly; size and shape distortions, illusions of color, of motion; natural illusions; use of illusion in art and magic, industry, etc. Most useful today with op art, also for classical art. Scores of effects illustrated. Introduction by William H. Ittleson. 100 illustrations. xxi + 252pp.

21530-X Paperbound $1.50

A HANDBOOK OF ANATOMY FOR ART STUDENTS, Arthur Thomson. Thorough, virtually exhaustive coverage of skeletal structure, musculature, etc. Full text, supplemented by anatomical diagrams and drawings and by photographs of undraped figures. Unique in its comparison of male and female forms, pointing out differences of contour, texture, form. 211 figures, 40 drawings, 86 photographs. xx + 459pp. 5⅜ x 8⅜.

21163-0 Paperbound $3.00

150 MASTERPIECES OF DRAWING, Selected by Anthony Toney. Full page reproductions of drawings from the early 16th to the end of the 18th century, all beautifully reproduced: Rembrandt, Michelangelo, Dürer, Fragonard, Urs, Graf, Wouwerman, many others. First-rate browsing book, model book for artists. xviii + 150pp. 8⅜ x 11¼.

21032-4 Paperbound $2.00

THE LATER WORK OF AUBREY BEARDSLEY, Aubrey Beardsley. Exotic, erotic, ironic masterpieces in full maturity: Comedy Ballet, Venus and Tannhauser, Pierrot, Lysistrata, Rape of the Lock, Savoy material, Ali Baba, Volpone, etc. This material revolutionized the art world, and is still powerful, fresh, brilliant. With *The Early Work,* all Beardsley's finest work. 174 plates, 2 in color. xiv + 176pp. 8⅛ x 11.

21817-1 Paperbound $2.75

DRAWINGS OF REMBRANDT, Rembrandt van Rijn. Complete reproduction of fabulously rare edition by Lippmann and Hofstede de Groot, completely reedited, updated, improved by Prof. Seymour Slive, Fogg Museum. Portraits, Biblical sketches, landscapes, Oriental types, nudes, episodes from classical mythology—All Rembrandt's fertile genius. Also selection of drawings by his pupils and followers. "Stunning volumes," *Saturday Review.* 550 illustrations. lxxviii + 552pp. 9⅛ x 12¼.

21485-0, 21486-9 Two volumes, Paperbound $6.50

THE DISASTERS OF WAR, Francisco Goya. One of the masterpieces of Western civilization—83 etchings that record Goya's shattering, bitter reaction to the Napoleonic war that swept through Spain after the insurrection of 1808 and to war in general. Reprint of the first edition, with three additional plates from Boston's Museum of Fine Arts. All plates facsimile size. Introduction by Philip Hofer, Fogg Museum. v + 97pp. 9⅜ x 8¼.

21872-4 Paperbound $1.75

GRAPHIC WORKS OF ODILON REDON. Largest collection of Redon's graphic works ever assembled: 172 lithographs, 28 etchings and engravings, 9 drawings. These include some of his most famous works. All the plates from *Odilon Redon: oeuvre graphique complet,* plus additional plates. New introduction and caption translations by Alfred Werner. 209 illustrations. xxvii + 209pp. 9⅛ x 12¼.

21966-8 Paperbound $4.00

DESIGN BY ACCIDENT; A BOOK OF "ACCIDENTAL EFFECTS" FOR ARTISTS AND DESIGNERS, James F. O'Brien. Create your own unique, striking, imaginative effects by "controlled accident" interaction of materials: paints and lacquers, oil and water based paints, splatter, crackling materials, shatter, similar items. Everything you do will be different; first book on this limitless art, so useful to both fine artist and commercial artist. Full instructions, 192 plates showing "accidents," 8 in color. viii + 215pp. 8⅜ x 11¼. 21942-9 Paperbound $3.50

THE BOOK OF SIGNS, Rudolf Koch. Famed German type designer draws 493 beautiful symbols: religious, mystical, alchemical, imperial, property marks, runes, etc. Remarkable fusion of traditional and modern. Good for suggestions of timelessness, smartness, modernity. Text. vi + 104pp. 6⅛ x 9¼.
20162-7 Paperbound $1.25

HISTORY OF INDIAN AND INDONESIAN ART, Ananda K. Coomaraswamy. An unabridged republication of one of the finest books by a great scholar in Eastern art. Rich in descriptive material, history, social backgrounds; Sunga reliefs, Rajput paintings, Gupta temples, Burmese frescoes, textiles, jewelry, sculpture, etc. 400 photos. viii + 423pp. 6⅜ x 9¾. 21436-2 Paperbound $3.50

PRIMITIVE ART, Franz Boas. America's foremost anthropologist surveys textiles, ceramics, woodcarving, basketry, metalwork, etc.; patterns, technology, creation of symbols, style origins. All areas of world, but very full on Northwest Coast Indians. More than 350 illustrations of baskets, boxes, totem poles, weapons, etc. 378 pp.
20025-6 Paperbound $2.50

THE GENTLEMAN AND CABINET MAKER'S DIRECTOR, Thomas Chippendale. Full reprint (third edition, 1762) of most influential furniture book of all time, by master cabinetmaker. 200 plates, illustrating chairs, sofas, mirrors, tables, cabinets, plus 24 photographs of surviving pieces. Biographical introduction by N. Bienenstock. vi + 249pp. 9⅞ x 12¾. 21601-2 Paperbound $3.50

AMERICAN ANTIQUE FURNITURE, Edgar G. Miller, Jr. The basic coverage of all American furniture before 1840. Individual chapters cover type of furniture—clocks, tables, sideboards, etc.—chronologically, with inexhaustible wealth of data. More than 2100 photographs, all identified, commented on. Essential to all early American collectors. Introduction by H. E. Keyes. vi + 1106pp. 7⅞ x 10¾.
21599-7, 21600-4 Two volumes, Paperbound $7.50

PENNSYLVANIA DUTCH AMERICAN FOLK ART, Henry J. Kauffman. 279 photos, 28 drawings of tulipware, Fraktur script, painted tinware, toys, flowered furniture, quilts, samplers, hex signs, house interiors, etc. Full descriptive text. Excellent for tourist, rewarding for designer, collector. Map. 146pp. 7⅞ x 10¾.
21205-X Paperbound $2.00

EARLY NEW ENGLAND GRAVESTONE RUBBINGS, Edmund V. Gillon, Jr. 43 photographs, 226 carefully reproduced rubbings show heavily symbolic, sometimes macabre early gravestones, up to early 19th century. Remarkable early American primitive art, occasionally strikingly beautiful; always powerful. Text. xxvi + 207pp. 8⅜ x 11¼. 21380-3 Paperbound $3.00

ALPHABETS AND ORNAMENTS, Ernst Lehner. Well-known pictorial source for decorative alphabets, script examples, cartouches, frames, decorative title pages, calligraphic initials, borders, similar material. 14th to 19th century, mostly European. Useful in almost any graphic arts designing, varied styles. 750 illustrations. 256pp. 7 x 10. 21905-4 Paperbound $3.50

PAINTING: A CREATIVE APPROACH, Norman Colquhoun. For the beginner simple guide provides an instructive approach to painting: major stumbling blocks for beginner; overcoming them, technical points; paints and pigments; oil painting; watercolor and other media and color. New section on "plastic" paints. Glossary. Formerly *Paint Your Own Pictures*. 221pp. 22000-1 Paperbound $1.75

THE ENJOYMENT AND USE OF COLOR, Walter Sargent. Explanation of the relations between colors themselves and between colors in nature and art, including hundreds of little-known facts about color values, intensities, effects of high and low illumination, complementary colors. Many practical hints for painters, references to great masters. 7 color plates, 29 illustrations. x + 274pp. 20944-X Paperbound $2.50

THE NOTEBOOKS OF LEONARDO DA VINCI, compiled and edited by Jean Paul Richter. 1566 extracts from original manuscripts reveal the full range of Leonardo's versatile genius: all his writings on painting, sculpture, architecture, anatomy, astronomy, geography, topography, physiology, mining, music, etc., in both Italian and English, with 186 plates of manuscript pages and more than 500 additional drawings. Includes studies for the Last Supper, the lost Sforza monument, and other works. Total of xlvii + 866pp. 7⅞ x 10¾. 22572-0, 22573-9 Two volumes, Paperbound $10.00

MONTGOMERY WARD CATALOGUE OF 1895. Tea gowns, yards of flannel and pillow-case lace, stereoscopes, books of gospel hymns, the New Improved Singer Sewing Machine, side saddles, milk skimmers, straight-edged razors, high-button shoes, spittoons, and on and on . . . listing some 25,000 items, practically all illustrated. Essential to the shoppers of the 1890's, it is our truest record of the spirit of the period. Unaltered reprint of Issue No. 57, Spring and Summer 1895. Introduction by Boris Emmet. Innumerable illustrations. xiii + 624pp. 8½ x 11⅝. 22377-9 Paperbound $6.95

THE CRYSTAL PALACE EXHIBITION ILLUSTRATED CATALOGUE (LONDON, 1851). One of the wonders of the modern world—the Crystal Palace Exhibition in which all the nations of the civilized world exhibited their achievements in the arts and sciences—presented in an equally important illustrated catalogue. More than 1700 items pictured with accompanying text—ceramics, textiles, cast-iron work, carpets, pianos, sleds, razors, wall-papers, billiard tables, beehives, silverware and hundreds of other artifacts—represent the focal point of Victorian culture in the Western World. Probably the largest collection of Victorian decorative art ever assembled— indispensable for antiquarians and designers. Unabridged republication of the Art-Journal Catalogue of the Great Exhibition of 1851, with all terminal essays. New introduction by John Gloag, F.S.A. xxxiv + 426pp. 9 x 12. 22503-8 Paperbound $4.50

✗ A HISTORY OF COSTUME, Carl Köhler. Definitive history, based on surviving pieces of clothing primarily, and paintings, statues, etc. secondarily. Highly readable text, supplemented by 594 illustrations of costumes of the ancient Mediterranean peoples, Greece and Rome, the Teutonic prehistoric period; costumes of the Middle Ages, Renaissance, Baroque, 18th and 19th centuries. Clear, measured patterns are provided for many clothing articles. Approach is practical throughout. Enlarged by Emma von Sichart. 464pp. 21030-8 Paperbound $3.00

ORIENTAL RUGS, ANTIQUE AND MODERN, Walter A. Hawley. A complete and authoritative treatise on the Oriental rug—where they are made, by whom and how, designs and symbols, characteristics in detail of the six major groups, how to distinguish them and how to buy them. Detailed technical data is provided on periods, weaves, warps, wefts, textures, sides, ends and knots, although no technical background is required for an understanding. 11 color plates, 80 halftones, 4 maps. vi + 320pp. 6⅛ x 9⅛. 22366-3 Paperbound $5.00

TEN BOOKS ON ARCHITECTURE, Vitruvius. By any standards the most important book on architecture ever written. Early Roman discussion of aesthetics of building, construction methods, orders, sites, and every other aspect of architecture has inspired, instructed architecture for about 2,000 years. Stands behind Palladio, Michelangelo, Bramante, Wren, countless others. Definitive Morris H. Morgan translation. 68 illustrations. xii + 331pp. 20645-9 Paperbound $2.50

THE FOUR BOOKS OF ARCHITECTURE, Andrea Palladio. Translated into every major Western European language in the two centuries following its publication in 1570, this has been one of the most influential books in the history of architecture. Complete reprint of the 1738 Isaac Ware edition. New introduction by Adolf Placzek, Columbia Univ. 216 plates. xxii + 110pp. of text. 9½ x 12¾. 21308-0 Clothbound $10.00

STICKS AND STONES: A STUDY OF AMERICAN ARCHITECTURE AND CIVILIZATION, Lewis Mumford. One of the great classics of American cultural history. American architecture from the medieval-inspired earliest forms to the early 20th century; evolution of structure and style, and reciprocal influences on environment. 21 photographic illustrations. 238pp. 20202-X Paperbound $2.00

THE AMERICAN BUILDER'S COMPANION, Asher Benjamin. The most widely used early 19th century architectural style and source book, for colonial up into Greek Revival periods. Extensive development of geometry of carpentering, construction of sashes, frames, doors, stairs; plans and elevations of domestic and other buildings. Hundreds of thousands of houses were built according to this book, now invaluable to historians, architects, restorers, etc. 1827 edition. 59 plates. 114pp. 7⅞ x 10¾. 22236-5 Paperbound $3.00

DUTCH HOUSES IN THE HUDSON VALLEY BEFORE 1776, Helen Wilkinson Reynolds. The standard survey of the Dutch colonial house and outbuildings, with constructional features, decoration, and local history associated with individual homesteads. Introduction by Franklin D. Roosevelt. Map. 150 illustrations. 469pp. 6⅝ x 9¼. 21469-9 Paperbound $3.50

JOHANN SEBASTIAN BACH, Philipp Spitta. One of the great classics of musicology, this definitive analysis of Bach's music (and life) has never been surpassed. Lucid, nontechnical analyses of hundreds of pieces (30 pages devoted to St. Matthew Passion, 26 to B Minor Mass). Also includes major analysis of 18th-century music. 450 musical examples. 40-page musical supplement. Total of xx + 1799pp.
(EUK) 22278-0, 22279-9 Two volumes, Clothbound $15.00

MOZART AND HIS PIANO CONCERTOS, Cuthbert Girdlestone. The only full-length study of an important area of Mozart's creativity. Provides detailed analyses of all 23 concertos, traces inspirational sources. 417 musical examples. Second edition. 509pp.
(USO) 21271-8 Paperbound $2.50

THE PERFECT WAGNERITE: A COMMENTARY ON THE NIBLUNG'S RING, George Bernard Shaw. Brilliant and still relevant criticism in remarkable essays on Wagner's Ring cycle, Shaw's ideas on political and social ideology behind the plots, role of Leitmotifs, vocal requisites, etc. Prefaces. xxi + 136pp.
21707-8 Paperbound $1.50

DON GIOVANNI, W. A. Mozart. Complete libretto, modern English translation; biographies of composer and librettist; accounts of early performances and critical reaction. Lavishly illustrated. All the material you need to understand and appreciate this great work. Dover Opera Guide and Libretto Series; translated and introduced by Ellen Bleiler. 92 illustrations. 209pp.
21134-7 Paperbound $1.50

HIGH FIDELITY SYSTEMS: A LAYMAN'S GUIDE, Roy F. Allison. All the basic information you need for setting up your own audio system: high fidelity and stereo record players, tape records, F.M. Connections, adjusting tone arm, cartridge, checking needle alignment, positioning speakers, phasing speakers, adjusting hums, trouble-shooting, maintenance, and similar topics. Enlarged 1965 edition. More than 50 charts, diagrams, photos. iv + 91pp. 21514-8 Paperbound $1.25

REPRODUCTION OF SOUND, Edgar Villchur. Thorough coverage for laymen of high fidelity systems, reproducing systems in general, needles, amplifiers, preamps, loudspeakers, feedback, explaining physical background. "A rare talent for making technicalities vividly comprehensible," R. Darrell, *High Fidelity*. 69 figures. iv + 92pp.
21515-6 Paperbound $1.00

HEAR ME TALKIN' TO YA: THE STORY OF JAZZ AS TOLD BY THE MEN WHO MADE IT, Nat Shapiro and Nat Hentoff. Louis Armstrong, Fats Waller, Jo Jones, Clarence Williams, Billy Holiday, Duke Ellington, Jelly Roll Morton and dozens of other jazz greats tell how it was in Chicago's South Side, New Orleans, depression Harlem and the modern West Coast as jazz was born and grew. xvi + 429pp.
21726-4 Paperbound $2.00

FABLES OF AESOP, translated by Sir Roger L'Estrange. A reproduction of the very rare 1931 Paris edition; a selection of the most interesting fables, together with 50 imaginative drawings by Alexander Calder. v + 128pp. 6½x9¼.
21780-9 Paperbound $1.25

AMERICAN FOOD AND GAME FISHES, David S. Jordan and Barton W. Evermann. Definitive source of information, detailed and accurate enough to enable the sportsman and nature lover to identify conclusively some 1,000 species and sub-species of North American fish, sought for food or sport. Coverage of range, physiology, habits, life history, food value. Best methods of capture, interest to the angler, advice on bait, fly-fishing, etc. 338 drawings and photographs. 1 + 574pp. 6⅝ x 9¾.
22383-1 Paperbound $4.50

THE FROG BOOK, Mary C. Dickerson. Complete with extensive finding keys, over 300 photographs, and an introduction to the general biology of frogs and toads, this is the classic non-technical study of Northeastern and Central species. 58 species; 290 photographs and 16 color plates. xvii + 253pp.
21973-9 Paperbound $4.00

THE MOTH BOOK: A GUIDE TO THE MOTHS OF NORTH AMERICA, William J. Holland. Classical study, eagerly sought after and used for the past 60 years. Clear identification manual to more than 2,000 different moths, largest manual in existence. General information about moths, capturing, mounting, classifying, etc., followed by species by species descriptions. 263 illustrations plus 48 color plates show almost every species, full size. 1968 edition, preface, nomenclature changes by A. E. Brower. xxiv + 479pp. of text. 6½ x 9¼.
21948-8 Paperbound $5.00

THE SEA-BEACH AT EBB-TIDE, Augusta Foote Arnold. Interested amateur can identify hundreds of marine plants and animals on coasts of North America; marine algae; seaweeds; squids; hermit crabs; horse shoe crabs; shrimps; corals; sea anemones; etc. Species descriptions cover: structure; food; reproductive cycle; size; shape; color; habitat; etc. Over 600 drawings. 85 plates. xii + 490pp.
21949-6 Paperbound $3.50

COMMON BIRD SONGS, Donald J. Borror. 33⅓ 12-inch record presents songs of 60 important birds of the eastern United States. A thorough, serious record which provides several examples for each bird, showing different types of song, individual variations, etc. Inestimable identification aid for birdwatcher. 32-page booklet gives text about birds and songs, with illustration for each bird.
21829-5 Record, book, album. Monaural. $2.75

FADS AND FALLACIES IN THE NAME OF SCIENCE, Martin Gardner. Fair, witty appraisal of cranks and quacks of science: Atlantis, Lemuria, hollow earth, flat earth, Velikovsky, orgone energy, Dianetics, flying saucers, Bridey Murphy, food fads, medical fads, perpetual motion, etc. Formerly "In the Name of Science." x + 363pp.
20394-8 Paperbound $2.00

HOAXES, Curtis D. MacDougall. Exhaustive, unbelievably rich account of great hoaxes: Locke's moon hoax, Shakespearean forgeries, sea serpents, Loch Ness monster, Cardiff giant, John Wilkes Booth's mummy, Disumbrationist school of art, dozens more; also journalism, psychology of hoaxing. 54 illustrations. xi + 338pp.
20465-0 Paperbound $2.75

THE PRINCIPLES OF PSYCHOLOGY, William James. The famous long course, complete and unabridged. Stream of thought, time perception, memory, experimental methods—these are only some of the concerns of a work that was years ahead of its time and still valid, interesting, useful. 94 figures. Total of xviii + 1391pp.
20381-6, 20382-4 Two volumes, Paperbound $6.00

THE STRANGE STORY OF THE QUANTUM, Banesh Hoffmann. Non-mathematical but thorough explanation of work of Planck, Einstein, Bohr, Pauli, de Broglie, Schrödinger, Heisenberg, Dirac, Feynman, etc. No technical background needed. "Of books attempting such an account, this is the best," Henry Margenau, Yale. 40-page "Postscript 1959." xii + 285pp.
20518-5 Paperbound $2.00

THE RISE OF THE NEW PHYSICS, A. d'Abro. Most thorough explanation in print of central core of mathematical physics, both classical and modern; from Newton to Dirac and Heisenberg. Both history and exposition; philosophy of science, causality, explanations of higher mathematics, analytical mechanics, electromagnetism, thermodynamics, phase rule, special and general relativity, matrices. No higher mathematics needed to follow exposition, though treatment is elementary to intermediate in level. Recommended to serious student who wishes verbal understanding. 97 illustrations. xvii + 982pp.
20003-5, 20004-3 Two volumes, Paperbound $5.50

GREAT IDEAS OF OPERATIONS RESEARCH, Jagjit Singh. Easily followed non-technical explanation of mathematical tools, aims, results: statistics, linear programming, game theory, queueing theory, Monte Carlo simulation, etc. Uses only elementary mathematics. Many case studies, several analyzed in detail. Clarity, breadth make this excellent for specialist in another field who wishes background. 41 figures. x + 228pp.
21886-4 Paperbound $2.25

GREAT IDEAS OF MODERN MATHEMATICS: THEIR NATURE AND USE, Jagjit Singh. Internationally famous expositor, winner of Unesco's Kalinga Award for science popularization explains verbally such topics as differential equations, matrices, groups, sets, transformations, mathematical logic and other important modern mathematics, as well as use in physics, astrophysics, and similar fields. Superb exposition for layman, scientist in other areas. viii + 312pp.
20587-8 Paperbound $2.25

GREAT IDEAS IN INFORMATION THEORY, LANGUAGE AND CYBERNETICS, Jagjit Singh. The analog and digital computers, how they work, how they are like and unlike the human brain, the men who developed them, their future applications, computer terminology. An essential book for today, even for readers with little math. Some mathematical demonstrations included for more advanced readers. 118 figures. Tables. ix + 338pp.
21694-2 Paperbound $2.25

CHANCE, LUCK AND STATISTICS, Horace C. Levinson. Non-mathematical presentation of fundamentals of probability theory and science of statistics and their applications. Games of chance, betting odds, misuse of statistics, normal and skew distributions, birth rates, stock speculation, insurance. Enlarged edition. Formerly "The Science of Chance." xiii + 357pp.
21007-3 Paperbound $2.00

PLANETS, STARS AND GALAXIES: DESCRIPTIVE ASTRONOMY FOR BEGINNERS, A. E. Fanning. Comprehensive introductory survey of astronomy: the sun, solar system, stars, galaxies, universe, cosmology; up-to-date, including quasars, radio stars, etc. Preface by Prof. Donald Menzel. 24pp. of photographs. 189pp. 5¼ x 8¼.
21680-2 Paperbound $1.50

TEACH YOURSELF CALCULUS, P. Abbott. With a good background in algebra and trig, you can teach yourself calculus with this book. Simple, straightforward introduction to functions of all kinds, integration, differentiation, series, etc. "Students who are beginning to study calculus method will derive great help from this book." *Faraday House Journal.* 308pp.
20683-1 Clothbound $2.00

TEACH YOURSELF TRIGONOMETRY, P. Abbott. Geometrical foundations, indices and logarithms, ratios, angles, circular measure, etc. are presented in this sound, easy-to-use text. Excellent for the beginner or as a brush up, this text carries the student through the solution of triangles. 204pp.
20682-3 Clothbound $2.00

TEACH YOURSELF ANATOMY, David LeVay. Accurate, inclusive, profusely illustrated account of structure, skeleton, abdomen, muscles, nervous system, glands, brain, reproductive organs, evolution. "Quite the best and most readable account,' *Medical Officer.* 12 color plates. 164 figures. 311pp. 4¾ x 7.
21651-9 Clothbound $2.50

TEACH YOURSELF PHYSIOLOGY, David LeVay. Anatomical, biochemical bases; digestive, nervous, endocrine systems; metabolism; respiration; muscle; excretion; temperature control; reproduction. "Good elementary exposition," *The Lancet.* 6 color plates. 44 illustrations. 208pp. 4¼ x 7.
21658-6 Clothbound $2.50

THE FRIENDLY STARS, Martha Evans Martin. Classic has taught naked-eye observation of stars, planets to hundreds of thousands, still not surpassed for charm, lucidity, adequacy. Completely updated by Professor Donald H. Menzel, Harvard Observatory. 25 illustrations. 16 x 30 chart. x + 147pp.
21099-5 Paperbound $1.25

MUSIC OF THE SPHERES: THE MATERIAL UNIVERSE FROM ATOM TO QUASAR, SIMPLY EXPLAINED, Guy Murchie. Extremely broad, brilliantly written popular account begins with the solar system and reaches to dividing line between matter and nonmatter; latest understandings presented with exceptional clarity. Volume One: Planets, stars, galaxies, cosmology, geology, celestial mechanics, latest astronomical discoveries; Volume Two: Matter, atoms, waves, radiation, relativity, chemical action, heat, nuclear energy, quantum theory, music, light, color, probability, antimatter, antigravity, and similar topics. 319 figures. 1967 (second) edition. Total of xx + 644pp.
21809-0, 21810-4 Two volumes, Paperbound $4.00

OLD-TIME SCHOOLS AND SCHOOL BOOKS, Clifton Johnson. Illustrations and rhymes from early primers, abundant quotations from early textbooks, many anecdotes of school life enliven this study of elementary schools from Puritans to middle 19th century. Introduction by Carl Withers. 234 illustrations. xxxiii + 381pp.
21031-6 Paperbound $2.50

THE PHILOSOPHY OF THE UPANISHADS, Paul Deussen. Clear, detailed statement of upanishadic system of thought, generally considered among best available. History of these works, full exposition of system emergent from them, parallel concepts in the West. Translated by A. S. Geden. xiv + 429pp.
21616-0 Paperbound $3.00

LANGUAGE, TRUTH AND LOGIC, Alfred J. Ayer. Famous, remarkably clear introduction to the Vienna and Cambridge schools of Logical Positivism; function of philosophy, elimination of metaphysical thought, nature of analysis, similar topics. "Wish I had written it myself," Bertrand Russell. 2nd, 1946 edition. 160pp.
20010-8 Paperbound $1.35

THE GUIDE FOR THE PERPLEXED, Moses Maimonides. Great classic of medieval Judaism, major attempt to reconcile revealed religion (Pentateuch, commentaries) and Aristotelian philosophy. Enormously important in all Western thought. Unabridged Friedländer translation. 50-page introduction. lix + 414pp.
(USO) 20351-4 Paperbound $2.50

OCCULT AND SUPERNATURAL PHENOMENA, D. H. Rawcliffe. Full, serious study of the most persistent delusions of mankind: crystal gazing, mediumistic trance, stigmata, lycanthropy, fire walking, dowsing, telepathy, ghosts, ESP, etc., and their relation to common forms of abnormal psychology. Formerly *Illusions and Delusions of the Supernatural and the Occult.* iii + 551pp. 20503-7 Paperbound $3.50

THE EGYPTIAN BOOK OF THE DEAD: THE PAPYRUS OF ANI, E. A. Wallis Budge. Full hieroglyphic text, interlinear transliteration of sounds, word for word translation, then smooth, connected translation; Theban recension. Basic work in Ancient Egyptian civilization; now even more significant than ever for historical importance, dilation of consciousness, etc. clvi + 377pp. 6½ x 9¼.
21866-X Paperbound $3.75

PSYCHOLOGY OF MUSIC, Carl E. Seashore. Basic, thorough survey of everything known about psychology of music up to 1940's; essential reading for psychologists, musicologists. Physical acoustics; auditory apparatus; relationship of physical sound to perceived sound; role of the mind in sorting, altering, suppressing, creating sound sensations; musical learning, testing for ability, absolute pitch, other topics. Records of Caruso, Menuhin analyzed. 88 figures. xix + 408pp.
21851-1 Paperbound $2.75

THE I CHING (THE BOOK OF CHANGES), translated by James Legge. Complete translated text plus appendices by Confucius, of perhaps the most penetrating divination book ever compiled. Indispensable to all study of early Oriental civilizations. 3 plates. xxiii + 448pp. 21062-6 Paperbound $2.75

THE UPANISHADS, translated by Max Müller. Twelve classical upanishads: Chandogya, Kena, Aitareya, Kaushitaki, Isa, Katha, Mundaka, Taittiriyaka, Brhadaranyaka, Svetasvatara, Prasna, Maitriyana. 160-page introduction, analysis by Prof. Müller. Total of 826pp. 20398-0, 20399-9 Two volumes, Paperbound $5.00

JIM WHITEWOLF: THE LIFE OF A KIOWA APACHE INDIAN, Charles S. Brant, editor. Spans transition between native life and acculturation period, 1880 on. Kiowa culture, personal life pattern, religion and the supernatural, the Ghost Dance, breakdown in the White Man's world, similar material. 1 map. xii + 144pp.

22015-X Paperbound $1.75

THE NATIVE TRIBES OF CENTRAL AUSTRALIA, Baldwin Spencer and F. J. Gillon. Basic book in anthropology, devoted to full coverage of the Arunta and Warramunga tribes; the source for knowledge about kinship systems, material and social culture, religion, etc. Still unsurpassed. 121 photographs, 89 drawings. xviii + 669pp.

21775-2 Paperbound $5.00

MALAY MAGIC, Walter W. Skeat. Classic (1900) ; still the definitive work on the folklore and popular religion of the Malay peninsula. Describes marriage rites, birth spirits and ceremonies, medicine, dances, games, war and weapons, etc. Extensive quotes from original sources, many magic charms translated into English. 35 illustrations. Preface by Charles Otto Blagden. xxiv + 685pp.

21760-4 Paperbound $3.50

HEAVENS ON EARTH: UTOPIAN COMMUNITIES IN AMERICA, 1680-1880, Mark Holloway. The finest nontechnical account of American utopias, from the early Woman in the Wilderness, Ephrata, Rappites to the enormous mid 19th-century efflorescence; Shakers, New Harmony, Equity Stores, Fourier's Phalanxes, Oneida, Amana, Fruitlands, etc. "Entertaining and very instructive." *Times Literary Supplement.* 15 illustrations. 246pp.

21593-8 Paperbound $2.00

LONDON LABOUR AND THE LONDON POOR, Henry Mayhew. Earliest (c. 1850) sociological study in English, describing myriad subcultures of London poor. Particularly remarkable for the thousands of pages of direct testimony taken from the lips of London prostitutes, thieves, beggars, street sellers, chimney-sweepers, street-musicians, "mudlarks," "pure-finders," rag-gatherers, "running-patterers," dock laborers, cab-men, and hundreds of others, quoted directly in this massive work. An extraordinarily vital picture of London emerges. 110 illustrations. Total of lxxvi + 1951pp. 6⅝ x 10.

21934-8, 21935-6, 21936-4, 21937-2 Four volumes, Paperbound $14.00

HISTORY OF THE LATER ROMAN EMPIRE, J. B. Bury. Eloquent, detailed reconstruction of Western and Byzantine Roman Empire by a major historian, from the death of Theodosius I (395 A.D.) to the death of Justinian (565). Extensive quotations from contemporary sources; full coverage of important Roman and foreign figures of the time. xxxiv + 965pp. 21829-5 Record, book, album. Monaural. $2.75

AN INTELLECTUAL AND CULTURAL HISTORY OF THE WESTERN WORLD, Harry Elmer Barnes. Monumental study, tracing the development of the accomplishments that make up human culture. Every aspect of man's achievement surveyed from its origins in the Paleolithic to the present day (1964) ; social structures, ideas, economic systems, art, literature, technology, mathematics, the sciences, medicine, religion, jurisprudence, etc. Evaluations of the contributions of scores of great men. 1964 edition, revised and edited by scholars in the many fields represented. Total of xxix + 1381pp. 21275-0, 21276-9, 21277-7 Three volumes, Paperbound $7.75

MATHEMATICAL PUZZLES FOR BEGINNERS AND ENTHUSIASTS, Geoffrey Mott-Smith. 189 puzzles from easy to difficult—involving arithmetic, logic, algebra, properties of digits, probability, etc.—for enjoyment and mental stimulus. Explanation of mathematical principles behind the puzzles. 135 illustrations. viii + 248pp.
20198-8 Paperbound $1.25

PAPER FOLDING FOR BEGINNERS, William D. Murray and Francis J. Rigney. Easiest book on the market, clearest instructions on making interesting, beautiful origami. Sail boats, cups, roosters, frogs that move legs, bonbon boxes, standing birds, etc. 40 projects; more than 275 diagrams and photographs. 94pp.
20713-7 Paperbound $1.00

TRICKS AND GAMES ON THE POOL TABLE, Fred Herrmann. 79 tricks and games—some solitaires, some for two or more players, some competitive games—to entertain you between formal games. Mystifying shots and throws, unusual caroms, tricks involving such props as cork, coins, a hat, etc. Formerly *Fun on the Pool Table.* 77 figures. 95pp.
21814-7 Paperbound $1.00

HAND SHADOWS TO BE THROWN UPON THE WALL: A SERIES OF NOVEL AND AMUSING FIGURES FORMED BY THE HAND, Henry Bursill. Delightful picturebook from great-grandfather's day shows how to make 18 different hand shadows: a bird that flies, duck that quacks, dog that wags his tail, camel, goose, deer, boy, turtle, etc. Only book of its sort. vi + 33pp. 6½ x 9¼. 21779-5 Paperbound $1.00

WHITTLING AND WOODCARVING, E. J. Tangerman. 18th printing of best book on market. "If you can cut a potato you can carve" toys and puzzles, chains, chessmen, caricatures, masks, frames, woodcut blocks, surface patterns, much more. Information on tools, woods, techniques. Also goes into serious wood sculpture from Middle Ages to present, East and West. 464 photos, figures. x + 293pp.
20965-2 Paperbound $2.00

HISTORY OF PHILOSOPHY, Julián Marías. Possibly the clearest, most easily followed, best planned, most useful one-volume history of philosophy on the market; neither skimpy nor overfull. Full details on system of every major philosopher and dozens of less important thinkers from pre-Socratics up to Existentialism and later. Strong on many European figures usually omitted. Has gone through dozens of editions in Europe. 1966 edition, translated by Stanley Appelbaum and Clarence Strowbridge. xviii + 505pp. 21739-6 Paperbound $2.75

YOGA: A SCIENTIFIC EVALUATION, Kovoor T. Behanan. Scientific but non-technical study of physiological results of yoga exercises; done under auspices of Yale U. Relations to Indian thought, to psychoanalysis, etc. 16 photos. xxiii + 270pp.
20505-3 Paperbound $2.50

Prices subject to change without notice.
Available at your book dealer or write for free catalogue to Dept. GI, Dover Publications, Inc., 180 Varick St., N. Y., N. Y. 10014. Dover publishes more than 150 books each year on science, elementary and advanced mathematics, biology, music, art, literary history, social sciences and other areas.

LADY

Written by BRIAN SCHIRMER

Illustrated by CLAUDIA BALBONI

Colored by MARISSA LOUISE, SHARI CHANKHAMMA, with LESLEY ATLANSKY

Lettering/Design by DAVID BOWMAN

Cover by CLAUDIA BALBONI & MARISSA LOUISE

Case File Written by DANI COLMAN

Edits by DANI COLMAN & JEREMY SALIBA

FAIRLADY created by BRIAN SCHIRMER & CLAUDIA BALBONI

Introduction

There's a segment of literary criticism that looks its precipitous nose down at any kind of "genre" writing – They might like a smattering of sci-fi (though they'll probably call it "speculative fiction" just to make sure you know they're talking about the high-brow stuff), but fantasy won't float their boat.

"Magic sucks" they say.

"There aren't any <u>rules</u>."

They don't know what the elf they're talking about. Fantasy has rules, just like any story does, otherwise it's meaningless twaddle and why would anyone stick around and keep reading that?

Writing stories is about establishing your characters, establishing your world, and making sure you have compelling reasons to want to see them through to the unexpected-but-ideally-also-quite-rewarding conclusion. Good writers do the work. Good <u>fantasy</u> writers do the work.

Fairlady does the work.

If you weren't already compelled by the cover and back cover copy, let me give you the quick skinny here – *Fairlady* is *Columbo* by way of *Conan*, a tight little pulp procedural with fantasy flare.

Brian, Claudia, Marissa, and David have built a compelling sword & sorcery space that's easy to understand and fun to explore. It tips its battle-battered helm to established conventions of the genre but doesn't let itself become entrenched in its clichés. Jenner and Oanu are confident and capable without feeling unbeatable or stiff. The cases they solve are smart, snappy, and satisfying.

The investigative done-in-one format gives the series a lot of momentum. Every issue rolls out with a clear goal and characters worth rooting for. There's no "writing for the trade" here (which is ironic considering that a trade is exactly where you're reading this intro) so you can settle in and enjoy five rock-solid tales instead of a listless string of To Be Continueds.

Each story works on its own while simultaneously revealing the people, places, and predicaments of past adventures, an elegant little flourish that brings added depth to the proceedings and an added allure of even greater stories to come.

Like I said, *Fairlady* does the work.

May her blade-bearing clientele never cease.

Jim Zub
July 13, 2019

Jim Zub has a marrow-deep love of pulp fantasy and has written a slew of swords & sassery comics, including Dungeons & Dragons, Pathfinder, Samurai Jack, and the Savage Sword of Conan.

LADY

Written by BRIAN SCHIRMER

Illustrated by CLAUDIA BALBONI

Colored by MARISSA LOUISE

Lettering/Design by DAVID BOWMAN

Cover A by BALBONI & LOUISE (after Quitely & Sinclair)

Cover B by TULA LOTAY

FAIRLADY Case File by DANI COLMAN

Edits by DANI COLMAN & JEREMY SALIBA

FAIRLADY created by BRIAN SCHIRMER & CLAUDIA BALBONI

Five days earlier...

The Feld
Population: 10,191

...THE SOONER YOU BOTH REALIZE THAT IT'S IN YOUR BEST INTEREST TO LEAVE THIS PLACE AND NEVER RETURN.

SNAP!

RRRRAAAHHH!

For no reason today I recalled the time they closed off The Feld to all outsiders.

The War was closer than it had ever been.

It would get closer.

I remember feeling trapped in my own home.

"OF COURSE I DIDN'T SEND THEM."

Merchant District
Upper Torso

I HIRED *YOU* TO FIND *SAMANDA* AND OUR MONEY. WHY WOULD I SEND SOMEONE TO RANSACK HER HOME AS WELL? IT DOESN'T MAKE ANY SENSE.

WELL, DO YOU HAVE ANY IDEA WHO MIGHT HAVE SENT THEM?

THE TRUTH?

I DON'T CARE. SOME THUGS WANT TO STEAL FROM *HER* WHILE SHE'S ON THE RUN AFTER STEALING FROM *ME*? NOT MY PROBLEM. I JUST WANT HER TO PAY.

I'M A BUSINESSMAN.

AND I'M NOT AN ASSASSIN.

YOU COME TO ME INSTEAD OF THE CONSTABLES TO FIND A RUNAWAY BOOKKEEPER, GREAT. I'LL TAKE THE WORK.

BUT YOU GET YOUR MONEY. YOU DON'T GET HER HEAD.

WHEN YOU SAID THAT YOU WANTED TO MEET, I THOUGHT YOU MIGHT HAVE FOUND HER, OR AT LEAST HAVE AN UPDATE.

I DIDN'T EXPECT YOU TO COME IN HERE AND COMPLAIN AND ASK FOR MORE MONEY.

I'M *NOT* COMPLAINING, *MR. AKEN*.

I JUST THOUGHT YOU'D WANT TO KNOW THAT THERE APPEAR TO BE OTHER INTERESTED PARTIES.

THEN, IT SOUNDS LIKE WE HAVE COMPETITION. MY ADVICE?

YOU GET BACK OUT THERE, YOU FIND THAT LITTLE *EMBEZZLER* AND THE MONEY SHE STOLE FROM MY CONSORTIUM, AND YOU DO SO BEFORE THESE

SOUNDS LIKE *THEY* HAVE NO COMPUNCTIONS WITH REGARD TO HER HEAD.

AND REMEMBER THAT THERE'S NO PRIZE FOR COMING IN SECOND.

CHNGK

GOOD HUNTING.

STILL, TWO DOZEN **LENDERS** IN THE FELD--

TWO DOZEN LENDERS IN THE FELD AND **HUSKER'S** ONE OF THE FEW WITH NO TIES TO THE MERCHANTS.

AND THAT'S WHY SHE CHOSE **HIM**.

I couldn't move. Couldn't speak.

"MAYBE SHE WAS GONNA PAY BACK WHAT SHE TOOK.

"MAYBE WHAT SHE TOOK WASN'T ENOUGH."

ENOUGH FOR WHAT?

AT THIS POINT, WE DON'T KNOW.

YOU KNOW THIS GUY?

I KNOW THIS GUY.

What was I even doing?

The Tower
Just outside The Feld

"PLENTY OF CLUES..."

...BUT NO ACTUAL LEADS.

AND NONE OF THE MONEY?

"A GLOVE. A DAGGER. HER JOURNAL."

NOTHING.

WHAT'S THIS?

THAT...

...IS A MYSTERY.

IT WAS JUST MIXED IN WITH EVERYTHING ELSE IN HER HOME.

BUT YOU THOUGHT IT COULD BE IMPORTANT?

A RANDOM BLUE ROCK. NO OTHER STONES, PRECIOUS OR OTHERWISE. MIGHT JUST BE SOMETHING SHE FOUND ON THE WALK HOME ONE DAY. STILL... IT STOOD OUT.

I LOOKED THROUGH *OZIAS'* TOMES, BUT COULDN'T FIND ANYTHING.

WELL, WE COULD JUST ASK *HER.*

SWALLOW YOUR PRIDE. YOU KNOW I'M RIGHT.

"*THE WAR* WAS NEARING ITS END, AND WHILE OUR SIDE WAS CONFIDENT OF AN ULTIMATE VICTORY, THAT JUST STOKED THE FLAMES OF DESPERATION ON THE OTHER SIDE.

"*THE BATTLE OF NERRAW* WAS AN ESPECIALLY BLOODY AFFAIR. ENEMY FORCES CONCOCTED AN ARTIFICIAL FOG TO OBSCURE THEIR UNITS.

"THERE WERE THREE *MAGES* FIGHTING ALONGSIDE THE *COALITION* TROOPS. THEY COMBINED THEIR TALENTS IN AN ATTEMPT TO DISPEL THE COVER AS QUICKLY AND COMPLETELY AS POSSIBLE.

"THEY UNWITTINGLY IGNITED IT.

"THE BLAZE JUST...

"MANY OF THE ENEMY SOLDIERS--AND AN UNFORTUNATE SHARE OF THE CIVILIAN POPULACE-- WERE REDUCED TO... *THIS*.

"SOME NOW CONSIDER THEM A SORT OF GOOD LUCK CHARM. A RATHER REPUGNANT NOTION, BUT STILL...

"WHY A *BOOKKEEPER* WOULD HAVE THIS, I HAVE NO IDEA. BUT AS I SAY...

"...IT COULD ONLY HAVE COME FROM ONE PLACE."

IS IT POSSIBLE SHE WAS IN THE WAR? SAMANDA?

OUTSIDE OF THE... SKULL... THERE'S NOTHING TO SUGGEST THAT.

YOU WERE IN THE WAR.

I WAS IN THE WAR.

Nerraw

Unclaimed Territory
Outside of Nerraw

It was a terrifying day, I cannot describe everything that took place.

I am completely broken and cannot seem to find myself.

This war will do with us whatever it will do.

I'm beginning to have my doubts about ~~you~~ me.

The Feld
Population: 10,191

Dram's The Feld Left Leg

Earlier

"I NEVER SHOWED YOU THIS."

Constabulary Headquarters
The Feld
Center Torso

MY PEOPLE HEAR THAT I'M HELPING OUT A FAIRM-- PERSON... AND I MIGHT JUST AS WELL RESIGN.

FAR AS ANYONE KNOWS, I'M IN HERE CHEWING YOU OUT FOR BEING A PAIN IN MY ASS.

WHICH ISN'T FAR FROM THE TRUTH.

WHICH ISN'T FAR FROM THE TRUTH.

NOT MUCH OF AN INCIDENT REPORT, CAMERSHON.

NOT MUCH TO REPORT. MAN VERSUS DRAGON.

DRAGON WON.

DRAGON.

RIGHT.

Image Comics Presents...

FAIR

The Dead Fairman Mystery

LADY

Written by BRIAN SCHIRMER

Illustrated by CLAUDIA BALBONI

Colored by MARISSA LOUISE

Lettering/Design by DAVID BOWMAN

Cover A by BALBONI & LOUISE

Cover B by BENJAMIN DEWEY

FAIRLADY Case File by DANI COLMAN

Edits by DANI COLMAN & JEREMY SALIBA

FAIRLADY created by BRIAN SCHIRMER & CLAUDIA BALBONI

Two Leagues South of The Feld

MAYBE HE HAD SOMETHING ON THE SIDE.

MAYBE HE WAS JUST TIRED OF HIS WOMAN.

MAYBE HE'S JUST DEAD.

SUBJECT: "EASE"
OCCUPATION: FAIRMAN

SUBJECT: OLOMO HUNT
OCCUPATION: FAIRMAN

ENEMIES? SURE.

HE WAS A FAIRMAN, HE HAD ENEMIES. WE ALL DO.

I SUSPECT EVEN YOU MIGHT.

TELL YOU WHAT... IF THIS WERE MY CASE...

...I'D SUSPECT EVERYONE.

FAIRMEN. CONSTABULARY. THE SPOUSE.

SUBJECT: MIRZ FEATHERSTONE
OCCUPATION: FAIRMAN

"EVEN YOU?"

ESPECIALLY ME.

ARE-- ARE YOU SAYING THAT SOMEONE BURNED HIM ALIVE?

WELL, ALL I CAN SAY FOR SURE IS THERE WAS NOTHING LIKE A DRAGON INVOLVED.

I TALKED WITH THE CONSTABLES. I TALKED WITH SOME FAIRMEN. I VISITED THE SCENE.

AS OF RIGHT NOW, THERE'S STILL NOTHING TO PROVE THAT HE'S STILL ALIVE.

PLEASE. YOU MUST PRESS ON.

AT THE VERY LEAST WE KNOW THAT THE CONSTABLES LIED ABOUT THE DRAGON.

I CAN PAY YOU MORE MONEY.

THE CONSTABLES SHOWED ME A REPORT ON YOUR HUSBAND.

THEY STRONGLY SUSPECT HIS INVOLVEMENT WITH THE BLACK MARKET.

DAMN IT!!!

THEY'RE COVERING THEIR TRACKS.

WHO? THE CONSTABLES?

YES, THE CONSTABLES!

THE COMMITTEE REFUSED TO GRANT GALIN'S FAIRMAN APPLICATION UNTIL HE AGREED TO DO SOME WORK FOR THEM ON THE SIDE.

EXTORTING BUSINESSES, INTIMIDATING WITNESSES, SPYING ON...

...PEOPLE WHO DON'T WANT TO BE SPIED ON.

HE'D BEEN A SOLDIER IN THE WAR. HE WANTED TO BE A FAIRMAN.

IT'S ALL HE KNEW HOW TO DO. HE DIDN'T HAVE A CHOICE.

HE FINALLY DECIDED HE COULDN'T DO IT ANYMORE, AND HE TOLD THEM SO.

THREE DAYS LATER, THEY TOLD ME HE'D BEEN KILLED BY A DRAGON.

I WAS LONG UNDER THE IMPRESSION THAT THE CONSTABULARY PREFERRED SUCH DOCUMENTS NOT LEAVE THEIR CARE.

YEAH. I THINK I HEARD THAT SOMEWHERE, TOO.

SO, IS THERE ANYTHING THERE TO SUPPORT THE WIFE'S CLAIM?

NEJLA, IF THEY WERE DOING WHAT SHE SAYS THEY WERE DOING, THEY'RE NOT GOING TO WRITE IT IN A LEDGER.

NO, I SUPPOSE THEY WOULDN'T.

NEVERTHELESS, IF HE WAS INVOLVED IN SO MANY NEFARIOUS ACTIVITIES...

...THEN IT STANDS TO REASON THAT SOMEONE OUTSIDE THE CONSTABULARY WOULD BE ABLE TO SUBSTANTIATE IT.

ONE MORE THING, FAULDS.

WHETHER OR NOT HE WAS A CRIMINAL, A TOOL OF CORRUPTION, OR JUST A VICTIM OF EGREGIOUS MISFORTUNE...

...THIS MAN MIGHT WELL BE DEAD.

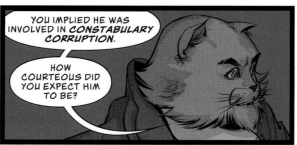

HE LISTENS.

HE WAITS.

I TALK UNTIL I'M TALKED OUT.

HE'S A GOOD FRIEND, OANU.

I'LL TELL HIM SO.

NEXT TIME.

I DON'T GET ENOUGH OF THIS.

TIME ALONE.

TIME TO JUST LET THINGS ROLL AROUND IN MY HEAD.

TIME TO JUST BE.

(NOW I SOUND LIKE NEJLA.)

(NEJLA, YOU'RE NOT
ACTUALLY... IN HERE...
RIGHT?)

I LIKE THE WALK.

THE FELD TO THE TOWER.

DAY OR NIGHT. THE SAME.

I KNOW THE ROUTE.

I KNOW MY WAY.

THE SOUNDS. THE SMELLS.

THE DARKNESS DOESN'T SCARE ME.

LIMITLESS SPACE FOR THINGS TO ROLL AROUND.
IN MY HEAD. THEY ROLL AROUND.
THEY SOMETIMES SETTLE
AND BECOME CLEAR.

I DON'T GET ENOUGH OF THIS. TIME ALONE.

AND THEN **THIS GUY** HAS TO GO AND SPOIL IT.

Later

OW. OW. OW. TOO DAMNED REMOTE. OW.

WHAT HAPPENED?!

WHO *DID* THIS TO YOU?! ARE YOU ALRIGHT?!

TOO MANY QUESTIONS.

FELT BETTER. HAD WORSE.

I WENT BACK TO THE CONSTABLES. I ACCUSED ONE OF THE SUPERVISORS OF CREATING FALSE EVIDENCE.

MAY I HAVE SOME TEA?

YOU *WHAT?*

I SAID I KNEW THE DRAGON STORY WASN'T TRUE. HE SENT A PAIR OF CONSTABLES TO KILL ME. I GOT LUCKY.

TEA, PLEASE.

"THE CONSTABLES KNEW THE DRAGON STORY WOULDN'T HOLD, BUT THEY NEEDED TO SEE WHAT IMELIA WOULD DO.

"SHE COULDN'T TRUST ANY OF THE LOCAL FAIRMEN. SUCH A TIGHT COMMUNITY.

"ANYWAY, THE CONSTABLES SUSPECTED SHE WAS INVOLVED IN THIS BUSINESS TOO, BUT THEY HAD NOTHING ON HER.

"IF YOU'D FAKED YOUR DEATH..."

...AND LET'S FACE IT, **WE ALL KNEW** YOU'D FAKED YOUR DEATH...

YOU'RE IN MY CHAIR.

"...THEN THEY FELT SHE'D LEAD THEM RIGHT TO YOU. BUT IT TURNED OUT SHE WAS JUST AS MUCH IN THE DARK AS THEY WERE...

"...BECAUSE YOU WERE CUTTING HER OUT.

"...MY FRIEND'S STILL WITH HER."

HEY.

"I TOLD HER HOW THE CONSTABLES DIDN'T LIKE MY QUESTIONS, HOW THEY CAME AFTER ME...

"...WHEN I ACTUALLY RAN INTO AN OLD FRIEND.

"HE MUST'VE FELT I WAS GETTING CLOSE.

"HE'D COVERED FOR YOU RATHER WELL WHEN WE MET AT DRAM'S.

"MAYBE HE DIDN'T THINK I'D BELIEVED HIM.

"MAYBE HE DIDN'T WANT TO CHANCE IT. IT WAS A BIG GAMBLE.

I GOTTA HAND IT TO YOU, *GALIN*, NO ONE EVEN THINKS ABOUT THESE OLD *CATACOMBS* UNDER *THE FELD* ANYMORE.

MAKES FOR A GOOD HIDEOUT.

SO, WHAT HAPPENS NOW?

EITHER YOU'VE GOT CONSTABLES WAITING AT THE EXIT--THAT'D BE THE SMART MOVE --OR YOU AND YOUR "FRIEND" CAME HERE SOLO.

MAYBE YOU THOUGHT YOU HAVE SOMETHING TO PROVE. MAYBE YOU DO, FAIRLADY. REGARDLESS, KNOW THIS...

YOU GET ONE SHOT WITH THAT.

YOU MISS AND I PROMISE YOU WON'T GET ANOTH--

THAP!

HE'LL LIVE.

YEAH, WELL, MY CONNECTIONS ARE ALL BUT DONE FOR.

YOU'D BE SURPRISED HOW MUCH OF MY BUSINE--

...

I'M GLAD KAVEN DIDN'T KILL YOU.

SORRY.

FAULDS!

WHILE OZIAS FROAT HAS ACCORDED TO YOU A FAIR AMOUNT OF LIBERTIES IN HIS HOME...

...PILFERING FROM HIS WINE CELLAR IS LIKELY NOT AMONGST THEM.

NEJLA, WE TURNED OVER THREE BLACK MARKETEERS TO THE CONSTABLES TODAY. I THINK OZIAS WOULD AGREE THIS IS EARNED.

MMMM, I SINCERELY DOUBT THAT.

HOWEVER, PERHAPS HE WOULD BE GRATEFUL THAT HE DID NOT LOSE HIS TOWER'S HEAD OF SECURITY IN THE COURSE OF THESE EVENTS.

PERHAPS THIS IS HOW THAT GRATITUDE MIGHT LOOK.

BE SURE TO CLEAN UP AFTER YOUR GUESTS, FAULDS.

End

"HIS NAME IS **KOTHAN**. **WAS** KOTHAN."

"HE DESCRIBED HIMSELF AS AN ADVENTURER OF SOME RENOWN.

"I'D NEVER HEARD OF HIM.

"OVER DRINKS AT **DRAM'S** HE TOLD ME STORIES OF MONSTERS AND MAYHEM, WENCHES AND WIZARDS, PIRATES AND PRINCESSES.

"THE USUAL.

"SAID HE WAS DONE WITH ALL OF THAT. WANTED TO GO INTO HIDING, BUT HE WANTED TO MAKE SURE HE WAS WELL-HIDDEN.

"SO, HE HIRED ME TO SEE IF I COULD FIND HIM, TO SEE HOW WELL HE'D COVERED HIS TRACKS.

"TOOK ME A WEEK."

WHERE'D YOU FIND HIM?

FLOPHOUSE OFF THE LEFT FOOT. TOOK A KNIFE TO THE BASE OF THE SKULL.

YOU KNOW I HAVE TO ASK: YOU PUT IT THERE?

DEAD CLIENTS DON'T PAY. AND MURDERING THEM IS BAD FOR BUSINESS.

HAD TO ASK.

CAMERSHON LET YOU GO! DRAM AND I HAD A WAGER.

YEAH? WHO WON?

YOU THERE!

STAND!

Image Comics Presents...

FAIR

The Case of
the Barbarian's Secret

LADY

Written by BRIAN SCHIRMER

Illustrated by CLAUDIA BALBONI

Colored by SHARI CHANKHAMMA

Lettering/Design by DAVID BOWMAN

Cover A by BALBONI & LOUISE

Cover B by CHRISTIAN WARD

FAIRLADY Case File by DANI COLMAN

Edits by DANI COLMAN & JEREMY SALIBA

FAIRLADY created by BRIAN SCHIRMER & CLAUDIA BALBONI

YOU'LL GET THE SWORD BACK WHEN WE'RE DONE HERE.

DOESN'T LOOK GOOD TO ALLOW A MURDER ON OUR DOORSTEP.

HMMPF.

THIS IS **NOT** KOTHAN.

WHAT DO YOU MEAN? HE CAME TO ME AND--

JUST WHAT I SAID. THIS IS NOT HIM.

WELL, I DON'T SUPPOSE YOU HAVE ANY IDEA WHO IT **IS** THEN, DO YOU?

IN FACT, I DO.

HIS NAME WAS **DUNKARR**, A THIRD-RATE BARBARIAN, UNFIT TO WIELD KOTHAN'S BLADE, LET ALONE HIS NAME.

HE'D SET HIS RUSTED SWORD ON FIRE AND CHARGE INTO BATTLE AT THE SLIGHTEST PROVOCATION.

HE WAS A MORON.

WHY WOULD HE TELL JENNER **HE** WAS KOTHAN?

AND WHY THE ELABORATE GAME OF HIDE-AND-SEEK?

MAYBE THERE **WERE** PEOPLE AFTER HIM. MAYBE GIVING ME A FAKE NAME WAS JUST ANOTHER WAY TO COVER HIS TRAIL.

YOU TWO HAVE ANY MUTUAL FRIENDS?

HE KEPT THE COMPANY OF TWO OTHER FOOLS WHO LAUGHED AT DEATH.

I DON'T REMEMBER THEIR NAMES. THEY SELDOM STRAYED FROM *THE HARSHLAND.*

I WOULD'VE KILLED YOU.

YOU WOULD'VE TRIED.

WELL, THANKS TO YOU ALL, I NOW HAVE A CONVOLUTED REPORT TO FILE.

TRY NOT TO STAB EACH OTHER ON THE WAY OUT.

COME, FAIRLADY, WE WILL DRINK TO THE HEALTH OF ABSENT KOTHAN. LET IT BE MY RECOMPENSE.

Dram's
The Feld
Left Leg

I WAS HERE EARLIER WHEN I HEARD THE NEWS. I MUST ADMIT...

...I WAS A TAD LOATH TO KILL THE ONLY FAIRLADY.

I MUST ADMIT, I WAS A TAD LOATH TO DIE.

I HEARD YOU WERE A SOLDIER DURING *THE WAR*.

...YES.

AND WHEN IT WAS OVER, YOU DECIDED TO BECOME THE FIRST FAIRLADY.

WHEN IT WAS *OVER*, SOMEONE GAVE HER A JOB AS HEAD OF SECURITY AT A TOWER OUTSIDE OF *THE FELD.*

ACTUALLY, *DRAM*, I'M THE *ONLY* SECURITY.

I *KNOW* THIS PLACE! A *WIZARD'S* LAIR!

OZIAS FROAT.

HE'S... TRAVELING.

HA! KOTHAN WOULD'VE LIKED YOU.

WOULD LIKE YOU.

WHEN I BELIEVED HIM DEAD, A PART OF ME HAD HOPED HE'D FOUND A PEACEFUL REST.

PERHAPS INSTEAD HE WAS TRULY ABLE TO SIMPLY RETIRE.

HOW DID HE WANT TO SPEND HIS RETIREMENT?

YOU MEAN TO FIND HIM.

HE ALWAYS BELIEVED THAT ONE DAY HE'D BE A KING BY HIS OWN HAND.

SOMETHING ABOUT ALL THIS DOESN'T ADD UP. WOULDN'T YOU LIKE TO KNOW HE'S ALL RIGHT?

BUT THERE ARE NO MORE KINGS.

YOU COULD COME WITH ME?

NO.

THANK YOU.

AFTER TODAY...

...I'LL PREFER TO SIMPLY BELIEVE HE'LL LIVE FOREVER.

The Tower
Just outside The Feld

NEJLA.

FAULDS.

YOU DON'T TYPICALLY MEET ME AT THE DOOR.

IN FACT, YOU'VE NEVER MET ME AT THE DOOR. WHAT'S GOING ON?

WE HAVE... GUESTS.

IT SEEMED PRUDENT TO NOTIFY YOU OF THIS BEFORE YOU CAME LUMBERING IN AS YOU'RE WONT TO DO.

I DON'T LUMBER.

OF COURSE NOT.

I COULD USE YOUR HELP ON A--

ANNNNND *THERE* IT IS.

WHAT?

YOUR RESPONSIBILITY BEGINS AND ENDS WITH THE SECURITY OF THIS TOWER.

ALL OTHER ELEMENTS ARE *MY* CONCERN.

YOU HAVE YOUR DOMINION AS I HAVE MINE.

I AM NOT HERE TO AID, ASSIST, OR ADVISE YOU IN ANY WAY.

THAT YOU WOULD CHOOSE TO FILL YOUR CONSIDERABLE FREE TIME WITH THE PURSUIT OF CUTPURSES, DRUNKARDS, AND RUFFIANS BAFFLES ME NO END.

SO, THAT'S A NO?

THAT IS *INDEED* A NO.

NOW, NORMALLY I WOULD REDIRECT YOU AWAY FROM ANY TOWER VISITORS, BUT THESE PARTICULAR GUESTS HAVE -- MUCH TO MY SURPRISE -- ASKED TO MAKE YOUR ACQUAINTANCE.

ONE IS AN... OLD FRIEND.

DO BE ON YOUR BEST BEHAVIOR, FAULDS. I DON'T TAKE KINDLY TO EMBARRASSMENT.

ARI, OOSK, ALLOW ME TO PRESENT JEN--

JENNER FAULDS...

...THE FAIRLADY.

YOU'RE THE REASON WE'VE COME.

Later

I HAD SENSED DUNKARR'S PASSING.

WE HADN'T SEEN HIM FOR MANY SEASONS...

...BUT THE THREE OF US WERE ONCE VERY CLOSE COMPANIONS.

PLEASE ACCEPT OUR CONDOLENCES, ARI.

THANK YOU. YOU WERE ALWAYS SO KIND, NEJLA.

WHEN I KNEW HE WAS GONE, I FOUND MYSELF SEIZED BY A STRONG URGE TO COME HERE...

...THOUGH AT THE TIME I DID NOT KNOW WHY.

AND STILL YOU CAME.

I STOPPED QUESTIONING SUCH FEELINGS A LONG TIME AGO.

YOU WERE WITH HIM AT HIS TIME?

NO. NO, I... FOUND HIM. I'M AFRAID I DON'T KNOW WHO WAS RESPONS--

I LOVED DUNKARR...

...BUT HE WAS A BRUTE AND A BRAGGART. SUCH AN ENDING FOR HIM SEEMED INEVITABLE.

I'M LIKEWISE SURE THE LIST OF SUSPECTS COULD EASILY BE AS LONG AS OOSK'S ARM.

GRARRAR!

BEFORE YOU ASK, NO. I HAVE NO... SENSE... AS TO WHO KILLED HIM.

PERHAPS MY INNER VOICE SIMPLY WANTED ME TO COME HERE, TO VISIT WITH AN OLD FRIEND, AND TO MAKE A NEW ONE.

THERE ARE WORSE THINGS IN LIFE.

IS THAT...

IS THAT IT?

I'M AFRAID SO.

WAS THAT DUNKARR *PAYING* SOMEONE? OR, WAS *HE* BEING PAID?

AND BY WHOM? AND FOR WHAT?

THAT COIN...

IT WAS OLD.

NO ONE USES THOSE ANYMORE.

ANY CHANCE IT COULD HAVE SOMETHING TO DO WITH A FARM?

I DON'T SEE HOW. WHY?

SOMETHING TANTANAH SAID.

ABOUT *KOTHAN*.

WHAT *KIND* OF FARM?

THMP!

One Month Later

MAYBE HE SAW US COMING AND DIDN'T WANT TO FIGHT AN ARMY.

WE ARE *NOT* AN ARMY, *DRAM*.

RIGHT. THEY'RE FRIENDS.

YOU'RE FRIENDS, RIGHT?

MAYBE HE WENT ON A SUPPLY RUN?

ON FOOT? HIS STEED IS STILL HERE.

NO SIGN OF A STRUGGLE.

MAYBE HE LISTENED TO YOU AND DECIDED DISAPPEARING WAS THE BEST THING TO DO?

AND HE LEFT THIS BEHIND?

SOMEONE WAS AFTER *HIM* ALL ALONG.

WHAT IF I LED THEM TO HIM?

End

THAT'S BETTER. SORT OF.

I HAVE TO ADMIT THAT FOR A WHILE
I DIDN'T KNOW WHAT WAS GOING ON.

KIDNAPPING WASN'T
UNHEARD OF IN **THE FELD**.

RANSOM? SACRIFICE?
PLAIN OLD SADISM?

"I WANT TO HIRE YOU."

YOU SEE? THAT'S DIFFERENT.

YOU'RE... WEARING A MASK? THAT IS A MASK, RIGHT? I'M SORRY. MY BEST FRIEND IS A *JESSU* AND--

YES, IT'S A MASK.

I'M AN IMPORTANT, RECOGNIZABLE FIGURE.

I CAN'T HAVE YOU KNOWING MY TRUE IDENTITY.

BUT... I WAS HOODED.

YOU COULD'VE JUST LEFT THE HOOD ON ME.

...

SHUT UP.

I NEED YOU TO FIND A BOOK.

IS IT CURSED? FULL OF SPELLS AND PROPHECIES? A LONG LIST OF TRAITORS AND ENEMIES?

A MYSTERY.

WELL, YES, IT IS, UNTIL YOU TELL ME WHAT--

NO. THE BOOK.

IT'S A LONGFORM YARN CALLED *THE OGRE GROANED AT SUNRISE* BY *ABIGAN NIL PORT*...

...AND IT IS THE MOST COMPELLING TALE OF THE IMAGINATION THAT I HAVE *EVER* READ.

BUT, IF YOU'VE ALREADY READ IT--

MY EDITION IS MISSING THE CRUCIAL FINAL PAGE. IT IS ON THIS PAGE WHEREIN THE AUTHOR REVEALS THE IDENTITY OF THE MURDERER.

Image Comics Presents...

FAIR

The Case of the Missing Page

LADY

Written by BRIAN SCHIRMER

Illustrated by CLAUDIA BALBONI

Colored by MARISSA LOUISE

Lettering/Design by DAVID BOWMAN

Cover A by BALBONI & LOUISE

Cover B by JUSTIN GREENWOOD & BRAD SIMPSON

FAIRLADY Case File by DANI COLMAN

Edits by DANI COLMAN & JEREMY SALIBA

FAIRLADY created by BRIAN SCHIRMER & CLAUDIA BALBONI

"I DON'T EVEN WANT TO KNOW."

Constabulary Headquarters
The Feld
Center Torso

THERE'S THIS BOOK--

WHAT'D I *JUST* SAY?

I'VE BEEN HIRED TO TRACK DOWN THIS BOOK, BUT EITHER NO ONE HAS A COPY OF IT, OR THERE'S SOME KIND OF CONSPIRACY TO MAKE SURE NO ONE--

DID YOU JUST USE THE *"C" WORD* IN MY PRESENCE?

ISN'T IT JUST POSSIBLE THAT THIS BOOK DOESN'T *EXIST?*

I'VE SEEN IT. I'VE READ IT.

THEN, WHY DO YOU NEED TO FIND ANOTHER COPY?

CAMERSHON!

THE LIBRARY DOESN'T WANT TO PURSUE THE MATTER...

...BUT THEIR *SECURITY GUARDS* WILL BE WATCHING FOR YOU.

DON'T GO BACK THERE, OR YOUR NEXT STAY HERE WILL BE LONGER THAN OVERNIGHT.

BUT, I DIDN'T *DO* ANYTH--

JENNER, JUST... GO.

AND STAY OUT OF TROUBLE.

"IT'S A BOOK."

LIKE A TOME? OR A SPELLBOOK?

A LIST OF TRAITORS AND ENEMIES?

IS IT CURSED?

IT'S A STORY.

IT'S A STORY ABOUT...

...A PRINCE WHO GOES ON THE RUN WHEN HIS KINGDOM IS OVERRUN BY...

...AND THE WITCH GIVES HIM A SWORD, BUT IT TURNS OUT IT'S A CURSED SWORD AND...

...BY THE TIME THE BODIES START PILING UP THERE'S THIS TROLL WHO...

SORRY, JENNER.

BUT, I'LL ASK AROUND.

MOST OF MY CLIENTELE AREN'T EXACTLY THE BOOK-READING TYPE.

THANKS, DRAM.

WHAT'S NEXT? BACK TO THE TOWER?

SEE IF YOU CAN GET NEJLA TO WAKE THE DEAD?

UNFORTUNATELY, NO.

I'VE GOT ONE MORE PERSON TO SEE.

"YOU'RE IN LUCK!

"I *DO* HAPPEN TO KNOW A COLLECTOR OF PRE-WAR LITERATURE."

Husker's
The Feld
Left Leg

I ALSO HAPPEN TO KNOW THAT HE HAS THIS PARTICULAR TITLE IN HIS RATHER IMPRESSIVE COLLECTION.

GREAT! WHAT WILL IT TAKE FOR YOU TO MAKE AN INTRODUCT--OH, IT'S YOU, ISN'T IT?

GUILTY!

RARE BOOKS? REALLY, *HUSKER?* YOU?

JENNER, YOU WOUND ME.

YOU THINK ME A *DRAGON* WHO SLEEPS NIGHTLY ATOP HIS *HOARD?*

MONEY IS MEANT TO BE SPENT, AND I AM A *CULTURED* MAN. AS SUCH, IT IS MY DUTY TO PRESERVE THE CULTURE IN ANY WAY THAT I CAN.

UH-HUH. I'LL GIVE YOU FIVE HUNDRED FOR IT.

A GENEROUS OFFER.

FOR SOME PEOPLE, THIS IS THE GLAMOROUS PART.
SNEAKING AROUND. GETTING IN FIGHTS.
RUNNING FROM THE BIGGER THREATS.
OUTSMARTING THEM WHEN YOU CAN.

IT'S NOT GLAMOROUS.
IT CAN BE BORING.
AND MESSY.
AND EXTREMELY FRUSTRATING.

BUT YOU WANNA KNOW THE TRUTH?

THE TRUTH IS IT'S A LARGE PART OF WHY I KEEP DOING THIS.
I ENJOY THE UNPREDICTABILITY.
NO TWO DAYS ARE EVER ALIKE.

SOMETIMES **THIS** IS THE JOB.
THE PART NO ONE EVER TELLS YOU ABOUT.
ACTUALLY, THERE IS NO TRAINING, NO RULE BOOK.

SOME DAYS ARE SPENT SITTING ACROSS
THE ROAD FROM THE HOME OF A SUSPECT,
WAITING FOR THEM TO COME HOME OR TO LEAVE.

OTHER DAYS, YOU TRAVEL FROM SUNRISE TO SUNSET,
JUST TO ASK ONE PERSON ONE QUESTION.

STILL OTHER DAYS CAN BE LIKE THIS--
HURRYING FROM PLACE TO PLACE,
NEGOTIATING OR FIGHTING WITH TOTAL STRANGERS,
ALL TO GATHER PIECES OF SOMEONE ELSE'S PUZZLE...

AND HOPING THAT ITS COMPLETION HELPS YOU CLOSE A CASE.

STILL SOUND GLAMOROUS?

WE HAVE BEEN... ASKED... TO BE OF SERVICE.

HOW MAY WE BE OF SERVICE?

THE PRIVATE SECURITY GUARDS WHO APPREHENDED ME LAST TIME. YOU HIRED THEM AFTER THE BOOKS WERE VANDALIZED?

CORRECT AND *INCORRECT*.

YES, WE HIRED SECURITY AFTER THE VANDALISM. HOWEVER, ONLY *ONE BOOK* WAS DAMAGED.

...

WHY GO TO SUCH EXPENSE INSTEAD OF GOING STRAIGHT TO THE CONSTABLES?

NO CHARGES AGAINST ME. NO CHARGES AGAINST THE VANDAL. WHY NOT?

IF YOU MUST KNOW...

...THREATS TO OUR IMAGE.

FEWER AND FEWER PEOPLE MAKE USE OF THIS LIBRARY.

WE MAY EVEN BE FORCED TO OPEN TO THE GENERAL PUBLIC.

THERE'S EVEN TALK OF LENDING OUT OUR BOOKS.

WHO'D PREFER TO READ THEM IN OUR GRAND ESTABLISHMENT.

A CRIMINAL GAINS ACCESS AND DEFACES A PART OF OUR COLLECTION?

AN INVESTIGATOR COMES ASKING QUESTIONS?

NEITHER OF THESE SERVES THE GREATER GOOD. NOR DO FORMAL CHARGES AGAINST EITHER.

IF WE PRESSED CHARGES AGAINST YOU AFTER FAILING TO DO SO FOR THE CRIMINAL-- VERY PUBLIC QUESTIONS WOULD ARISE.

AND IF WE'D PROSECUTED THE CRIMINAL...

"...WELL, WE FEARED WORD WOULD SPREAD OF HIS COMPETING ESTABLISHMENT."

I GET LIED TO A LOT.

COMES WITH THE TERRITORY.

AS YOU MIGHT IMAGINE, VERY FEW FOLKS JUST UP AND CONFESS WHEN YOU MENTION THEIR NAME IN CONJUNCTION WITH A CRIME OF SOME SORT.

AND PRETTY MUCH EVERYONE RUNS IF THEY CAN. BUT, TYPICALLY NOT UNTIL IT'S TOO LATE.

TAKE THIS GUY.

I GUESS HE FIGURED THAT HE'D SATISFIED ME WITH THE HISTORY LESSON A FEW DAYS EARLIER.

PROBABLY ASSUMED I WASN'T COMING BACK.

HE GAMBLED.

I WON.

SO TO SPEAK.

THE REAL QUESTION REMAINED--

DID HE COMMIT A CRIME?

"THIS IS A CRIME AGAINST *CULTURE*.

"YOU'VE DESTROYED *ART*.

"YOU'VE *ROBBED* THE *PEOPLE* OF... OF..."

"MAYBE THIS FEELS INCONSEQUENTIAL TO YOU. I DON'T KNOW."

"MAYBE YOU WERE JUST HAVING *FUN*. WAS THAT IT?"

"DID YOU FEEL YOU WERE GETTING ONE OVER ON YOUR *BETTERS?*"

"THERE'S MORE TO IT."

"I HOPE SO. FOR YOUR SAKE.
I INVESTED A NOT INCONSIDERABLE
AMOUNT OF MONEY IN YOU, FAULDS.

"I WANTED A BOOK.

"YOU BROUGHT ME A *MISCREANT*."

IT'S BEEN MORE THAN A WEEK.

I TOLD YOU I'D EXPECT UPDATES. I BROUGHT YOU IN FOR AN UPDATE.

HERE'S YOUR UPDATE--

THERE *IS NO LAST PAGE.*

OBVIOUSLY. MY BOOK, THE COPY AT THE LIBRARY--

NO.

TELL HIM.

TELL HIM WHO YOU REALLY ARE.

IT'LL BE OKAY.

EV--EVERYBODY HAS A BOOK, THAT FIRST BOOK THAT TRULY SPEAKS TO THEM.

IT'S THE BOOK THAT MAKES YOU WANT TO DO NOTHING BUT READ, OR THAT MAKES YOU WANT TO WRITE, OR THAT CHANGES THE WAY YOU SEE THE WORLD. REGARDLESS, NOTHING IS EVER THE SAME.

YOU CAN'T GET IT OUT OF YOUR HEAD. IT'S LIKE FALLING IN LOVE, I GUESS. BUT, IT'S NOT LIKE FALLING IN LOVE WITH A SINGLE PERSON. IT'S LIKE FALLING IN LOVE WITH LOVE ITSELF.

WHAAAAT IS HE TALKING ABOUT?

THIS BOOK...

...THE OGRE GROANED AT SUNRISE. THIS IS THE BOOK THAT SPOKE TO ME.

SO YOU'RE A FAN.

I WAS A SLAVE.

"BUT, I WAS AN IMPERFECT SLAVE. UNLIKE MY FELLOW SIMULACRA, I SLOWLY LEARNED FROM THE WORDS I PROCESSED. I LEARNED EVEN MORE FROM TRANSCRIBING THEM AGAIN AND AGAIN."

WHERE I WAS ONCE MINDLESS, A TOOL, THIS BOOK GAVE ME LIFE. NOT BECAUSE IT WAS BRILLIANT...

...BUT BECAUSE ITS ENDING WAS *TERRIBLE*.

PARDON ME?

ALL THOSE CHARACTERS, THE SUBPLOTS, THE BETRAYALS. *PORT* SET EVERYTHING UP WITH SUCH ELOQUENCE, SUCH FEELING...

...AND THEN DELIVERED A RESOLUTION SO UNWORTHY, SO UNEARNED...

...THAT I COULD NOT ALLOW IT TO INFECT ANOTHER LIVING THING.

HE TORE OUT THE LAST PAGE OF EVERY COPY HE COULD GET HIS HANDS ON.

WHEN THE ENEMY SOLDIERS ATTACKED, I'D ACHIEVED A LEVEL OF SELF-AWARENESS THAT TRANSLATED INTO SELF-PRESERVATION. I FLED, WHILE THE OTHERS REMAINED, MECHANICALLY COPYING UNTIL THE END.

THE COPY IN THE LIBRARY WAS ONE OF THE FEW THAT I'D MISSED.

WHAT DID YOU DO WITH THE PAGE?

IF I WERE LIKE YOU, I WOULD HAVE EATEN IT.

BUT, I'M NOT LIKE YOU.

WHAT DID YOU DO WITH IT?!?

I TORE. AND TORE. AND TORE. AND BY THE TIME THE CONSTABLES ARRIVED... ITS PIECES WERE SCATTERED ABOUT THE LIBRARY.

DO YOU...

DO YOU *REMEMBER* THE ENDING?

THANK YOU FOR DOING THIS, NEJLA.

I AM *NOT* DOING THIS FOR *YOU*, FAULDS.

I SIMPLY CANNOT WASTE ONE MORE SLEEPLESS NIGHT IN POINTLESS PONDERANCE.

AND THIS APPEARS OUR SOLE REMAINING SOLUTION.

WHAT BECAME OF THE SIMULACRUM?

HM?

OH. HE INVITED THE WORLD'S WEALTHIEST PARANOIAC TO PAY A VISIT TO HIS BOOKSHOP.

DON'T KNOW IF HE'LL BE WEARING THE MASK WHEN HE DOES.

"OUR."

WHAT?

YOU SAID "OUR" SOLUTION.

YOU COULD HAVE SAID "MY" SOLUTION, OR "THE" SOLUTION.

ENOUGH!

BE READY.

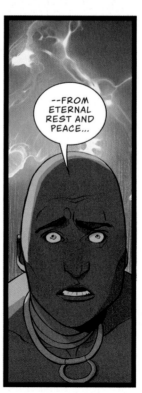

"PRETTY MUCH. YEAH."

End

I SHOULD'VE SEEN THIS COMING.

I CHOSE THIS LIFE AND I DON'T REGRET IT.

WELL... MOSTLY.

FAIRLADY. THE ONLY FAIRLADY.

THE ONE AND ONLY.

THAT MEANS SOMETHING.

THAT SHOULD MEAN SOMETHING.

SOMETIMES IT OVERTAKES ME.

SOMETIMES I WONDER IF I WOULD'VE BECOME ONE IF **OZIAS** HADN'T PICKED ME TO BE HIS HEAD OF SECURITY AT **THE TOWER**.

AND LET'S BE HONEST--I'M THE **ONLY** SECURITY AT THE TOWER.

WHAT DID **TANTANAH** CALL IT? A "WIZARD'S LAIR"?

NEJLA COULD HANDLE IT ALL HERSELF.

DID OZIAS HIRE ME JUST SO NEJLA COULD HAVE A FRIEND?

HA! THAT MIGHT BE THE FIRST TIME THAT I'VE THOUGHT OF US AS FRIENDS.

DID HE HIRE ME TO BE HER FRIEND?

DID HE KNOW THAT BY HIRING ME I'D DECIDE TO ALSO BECOME THE ONE AND ONLY FAIRLADY?

I MEAN, HE'S A WIZARD, A MAGE, A SPELLCASTER. HE KNOWS THINGS.

I WONDER WHERE HE IS RIGHT NOW.

I WONDER IF HE KNOWS WHERE **I** AM RIGHT NOW.

AND DOES HE CARE?

Image Comics Presents...

FAIR

The Case of
the Missing Murderess

LADY

Written by BRIAN SCHIRMER

Illustrated by CLAUDIA BALBONI

Colored by MARISSA LOUISE with LESLEY ATLANSKY

Lettering/Design by DAVID BOWMAN

Cover A by JEREMY SALIBA

Cover B by KATIE LONGUA

Edits by DANI COLMAN & JEREMY SALIBA

FAIRLADY created by BRIAN SCHIRMER & CLAUDIA BALBONI

I'M SORRY, BUT I FEEL I MUST REPEAT MY PROTEST.

GO RIGHT AHEAD.

I CAME TO YOU WITH THIS CASE FOR OBVIOUS REASONS.

I FELT THAT WE COULD POOL OUR RESOURCES.

YOU AND YOUR CONSTABLES. ME AND MY DIRECT TIES TO AND KNOWLEDGE OF THE INCIDENT.

DID I MENTION I'VE BEEN HIRED BY THE FAMILIES OF THE DECEASED?

BRINGING IN *JENNER FAULDS* IS UNWISE.

IS IT?

SHE'S UNPREDICTABLE, UNTRUSTWORTHY, MAYBE EVEN UNSTABLE.

AND WE ARE.

MORE THAN ONCE.

I FEAR HER PRESENCE WILL JEOPARDIZE THIS--

LISTEN, I'VE HEARD WHAT YOU HAVE TO SAY.

I MAY EVEN AGREE WITH SOME OF IT.

BUT SHE'S IN.

Constabulary Headquarters
The Feld
Center Torso

JENNER.

ROMAR,

GOOD. EVERYONE'S FRIENDS. LET'S TALK ABOUT WHY WE'RE HERE.

TWO DAYS AGO, ONE OF THE GUESTS AT *THE VILLAGE* BROKE OUT, KILLING THREE PEOPLE, INCLUDING A CONSTABLE.

SHE'S SINCE DISAPPEARED.

SAMANDA MESSILIS?

CORRECT.

SEVERAL MONTHS AGO, YOU BROUGHT HER THERE.

CARE TO TELL US WHY?

SHE'D ROBBED HER EMPLOYER AND VANISHED.

I'D BEEN HIRED TO FIND HER.

WE MANAGED TO TRACK HER TO A DUNG HEAP IN *NERRAW*.

SHE... WASN'T WELL.

THE VILLAGE SEEMED HER BEST BET.

SAMANDA WAS NON-VIOLENT.

BUT NONE OF THIS MAKES ANY *SENSE*.

SHE WOULD HAVE STAYED WHERE SHE FELT SECLUDED AND SAFE.

WELL, SHE'S NOT NON-VIOLENT ANYMORE.

SOUNDS LIKE SHE GOT TIRED OF SECLUSION, TOO. AS FOR SAFETY...

"...WHO KNOWS?"

The Village Six Leagues from The Feld

I KNOW YOU'VE BEEN HERE BEFORE, JENNER...

...BUT IT MIGHT BE BEST TO LET ME DO THE TALKING.

THE *CARETAKERS* ARE FAMILIAR WITH MY ROLE IN THE INVESTIGATION.

ALSO, BEST NOT TO ASK THEM ABOUT... WELL, YOU KNOW...

GREETINGS AND SALUTATIONS, FAIRLADY AND FAIRMAN...

AND, YES, ROMAR DARRY IS QUITE CORRECT.

WHILE WE ARE IN THIS WORLD, WE KNOW OF THIS WORLD ONLY.

"IT CAN ADMITTEDLY BE A... *DISORIENTING* EXPERIENCE FOR US.

"NEVERTHELESS, WE CHOOSE TO BE HERE. WE CHOOSE TO HELP, TO SHOW COMPASSION TO THOSE IN NEED.

"AND SUCH A NEED IS A CONSTANT IN THIS WORLD.

WE SHOULD LOOK INTO SAMANDA'S FORMER EMPLOYER. DOWN IN THE MERCHANT DISTRICT.

GOOD IDEA.

ALREADY CHECKED IT OUT.

THINK HIS NAME WAS AKEN? SHE STOLE FROM HIM AND HIS PARTNERS BEFORE TAKING OFF. THAT'S WHEN HE HIRED ME.

HE'S DEAD.

DEAD?

DEAD.

BODY TURNED UP A WEEK AGO OUTSIDE THE LEFT HAND.

HE'D BEEN MAULED BY...

WE'RE STILL TRYING TO FIGURE IT OUT.

THE VICTIMS' WOUNDS WOULD NOT HEAL.

RIGHT. HE SAID IT WAS A MAGIC BLADE.

THAT WOULD SEEM... LIKELY.

ALL GUESTS SURRENDER THEIR POSSESSIONS UPON ARRIVAL.

HOW WOULD SAMAN--*ANY* OF YOUR GUESTS GET SOMETHING LIKE THAT?

VISITORS LIKE YOURSELVES ARE PROPERLY VETTED.

IT IS A MYSTERY.

"NO"?

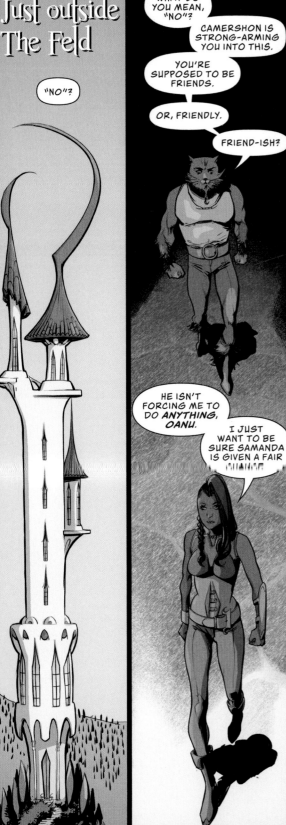

WHAT DO YOU MEAN, "NO"?

CAMERSHON IS STRONG-ARMING YOU INTO THIS.

YOU'RE SUPPOSED TO BE FRIENDS.

OR, FRIENDLY.

FRIEND-ISH?

HE ISN'T FORCING ME TO DO ANYTHING, OANU.

I JUST WANT TO BE SURE SAMANDA IS GIVEN A FAIR

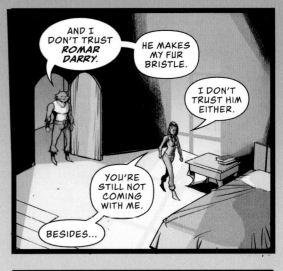

AND I DON'T TRUST ROMAR DARRY.

HE MAKES MY FUR BRISTLE.

I DON'T TRUST HIM EITHER.

YOU'RE STILL NOT COMING WITH ME.

BESIDES...

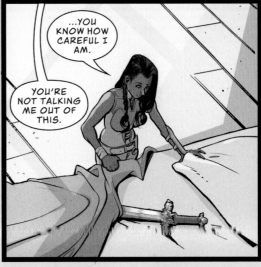

...YOU KNOW HOW CAREFUL I AM.

YOU'RE NOT TALKING ME OUT OF THIS.

FINE.

GO HOME AND GET YOUR THINGS. WE'LL LEAVE AT DAWN.

DON'T WORRY...

"I'D SAY YOUR EGO IS COMPROMISING YOUR JUDGMENT."

"HEAR ME OUT. A FRIGHTENED WOMAN WHO WANTS NOTHING BUT ISOLATION IS PLACED HERE FOR HER OWN SAFETY BY *ME*. THREE PEOPLE ARE MURDERED, INCLUDING A CONSTABLE. YOU GET HIRED. YOU BRING IN CAMERSHON. CAMERSHON BRINGS IN ME."

"A LOGICAL CHAIN OF EVENTS."

"I DON'T KNOW. ONE OF THE OTHER GUESTS? MAYBE ONE OF THE CARETAKERS? THEY NEED SOMEONE TO IMPLICATE, AND THEY PICK HER."

"YOU'RE A GOOD FAIRMAN, ROMAR. YOU WOULD'VE CONSIDERED THAT BEFORE GOING TO CAMERSHON.

"YOU'VE NEVER ONCE HINTED AT ANOTHER SUSPECT.

"THE BODY WAS BRUTALLY DISFIGURED."

THE ASSAILANT USED MORE THAN EVEN A MAGIC BLADE. MUCH MORE.

HE DOESN'T WANT US TO BE ABLE TO IDENTIFY THE CONSTABLE.

"HE"?

WHAT WAS THIS CONSTABLE'S NAME?

IT WAS NEVER KNOWN TO US. IN FACT...

"...NO ONE HAD EVER SEEN HIM BEFORE WE DISCOVERED HIS BODY."

YOUR BROTHER **WAS** A GUEST AT THE VILLAGE, YES?

WE MOVED HERE TO BE CLOSER TO HIM. WE'D VISIT ONCE A WEEK.

CARETAKERS WERE GOOD ENOUGH TO TAKE HIM IN. GUESS THEY DON'T REFUSE ANYBODY S'NEEDS HELP.

BUT YOU DIDN'T HIRE **THE OTHER MAN**? THE FAIRMAN? TO INVESTIGATE HIS DEATH?

NAW. HE CAME HERE AND ASKED SOME QUESTIONS, LIKE I SAID... THEN HE LEFT.

DIDN'T OFFER HIS SERVICES AND WE DIDN'T ASK.

COULDN'T HAVE AFFORDED IT ANYWAY, WHAT WITH THE MOVE AND ALL.

DIDN'T KNOW THEY HAD FAIR*LADIES* NOW.

YOU EVER SEE A CONSTABLE AROUND HERE?

NAW. NEVER.

WISH THERE'D BEEN ONE AROUND **THAT** NIGHT.

I KNOW THINGS NOW.

BUT THERE'S A DIFFERENCE BETWEEN *CLUES* AND *EVIDENCE.*

SOMEONE'S BEEN SLOPPY.

BUT THAT SOMEONE HAS RESOURCES.

SKILLS.

ROMAR SAID SOMETHING BEFORE AS WELL.

HE SAID MY EGO WAS GETTING IN THE WAY OF MY JUDGMENT.

I HAVE TO CONSIDER THAT AS A POSSIBILITY.

ARE THERE PLENTY OF **CLUES** THAT SUGGEST
SOMEONE IS MANIPULATING ME, TESTING ME?

ABSOLUTELY.

AND WE'RE NOT JUST TALKING ABOUT THIS.
THIS IS TERRIBLE. PEOPLE ARE DEAD, AND IF
SAMANDA HAD A HAND IN IT, THEN SO DID I.
I PUT HER HERE. WAS THAT WRONG?

BUT WE'RE NOT JUST TALKING ABOUT THIS.
THERE WAS **KOTHAN. DUNKARR.** SAMANDA WAS
RUNNING FROM SOMEONE BEFORE.
NO, NOT SOMEONE.
SHE WAS WORRIED THAT "THEY" COULD SEE OR
HEAR HER.

PERHAPS "THEY" ARE THE ONES--

COULD IT ALL BE IN MY HEAD?

YEAH. IT COULD.
THAT'D BE A SURPRISING TWIST.

BUT IT'S NOT. I **KNOW** THAT NOW. I KNOW THAT NOW.

"HE'D PLANNED TO KILL HER.

"HE COULD CERTAINLY AFFORD TO HIRE OUT FOR THE JOB, BUT HE WOULDN'T SEND REPTILIANS. NOT AFTER LAST TIME.

"MAYBE HE'D DO IT HIMSELF.

"WITH HIS RESOURCES, IT STANDS TO REASON HE MIGHT EVENTUALLY FIND OUT THAT SHE WAS HERE.

"HE MIGHT EVEN BE ABLE TO ARRIVE UNNOTICED.

"A MAGIC DAGGER WHOSE WOUNDS WON'T HEAL IS DEFINITELY SOMETHING HE COULD ACQUIRE.

"SO'S A CLOAK OR SOME OTHER DINGUS THAT MIGHT MAKE HIM UNRECOGNIZABLE TO ANY WITNESSES.

"WHEN HE DISCOVERS THAT SHE'S GONE...

"...HE'S FORCED TO IMPROVISE.

"HE STAGES HER BREAKOUT.

"HE KILLS TWO OF THE GUESTS.

"THE CONSTABLE IS JUST IN THE WRONG PLACE AT THE WRONG TIME."

NOW WHAT?

NOW WHAT?

SAMANDA MUST HAVE BEEN HIDDEN BY THE CARETAKERS.

THEY MUST HAVE SENSED THAT SOMEONE WAS COMING FOR HER.

OR SOMETHING LIKE THAT.

I DUNNO.

BLEEDING A BIT HERE.

CAMERSHON. HE SAID HE'D SEND HIS CONSTABLES... WHEN?

CAN'T WAIT TO SEE THE LOOK ON HIS FACE.

HEH. A FAKE CONSTABLE. NICE TOUCH, ROMAR.

OANU WILL SHOW UP EVENTUALLY. HE'LL BE ANGRY, BUT...

MAYBE HE'LL FIND ME BEFORE THE END.

Claudia Balboni & Marissa Louise
Issue One Cover A

Tula Lotay
Issue One Cover B

Claudia Balboni & Marissa Louise
Issue Two Cover A

Benjamin Dewey
Issue Two Cover B

B. DEWEY
2019

Claudia Balboni & Marissa Louise
Issue One Cover, 2nd Printing

Claudia Balboni & Shari Chankhamma
Issue Three Cover A

Justin Greenwood & Brad Simpson
Issue Four Cover B

Jeremy Saliba
Issue Five Cover A

From the Case Files of
Jenner Faulds, Fairlady

Client: Garrick Bretch
Case: Renegade Bard
Status: Solved, paid, commemorated in song

~

Only someone as rich and clueless as Garrick Bretch would hire me to chase down a bard. Bretch paid a singer-songwriter named Morden to compose a ballad about one of his awful ancestors, and Morden ran off with the cash. If I have to talk to the pretentious nits at the Bardic Guild over this I'll eat my sword.

~

According to the nits at the Bardic, Morden is the most professional bard in the guild. It's probably why he never got famous; couldn't pull off the "tortured genius" routine. The idea of him running out on a commission seems absurd. His registered compositions are stored in the archive; they very politely offered to have someone sing everything to me. I very politely declined.

~

Looked into Bretch's ancestor to see if that led anywhere. Harron Bretch was a rotten, scum-sucking bastard: he routed a colony of refugees from the Underheel and got some kind of civic medal for it. If I were hired to write a song about him, I'd run for the hills too.

~

Doesn't look like Morden had many friends; his colleagues and clients speak well of him, but no one knows him well enough to tell me much about his habits. By all accounts he kept to himself and wrote songs. Apparently he has a lovely baritone.

~

This is it. I'm down to my last scrap of a lead. Tonight I hire a singer and listen to every damn tune Morden ever put to paper.

~

Morden was in The War. He wasn't just in The War: he was in the Twelfth High Company. He survived the Twelfth High Company. He hid it well, but right in the middle of a very boring oratorio is a tune only a handful of people know, and one I never thought I'd hear again.

When my brigade was trapped in the trench network east of the Plains, they sent in the Twelfth High Company to get us out. For weeks they couldn't get close enough to send in aid, but we could see their garrison from the trenches and if we shouted loud enough they'd shout back. Twenty-two days we were trapped there, saved from going mad by knowing help was just close enough to call to. Towards the end, when we ran out of things to shout, we started singing. Someone on their side had a grand, booming voice, and he made up a tune we'd echo back with dirty lyrics and silly jokes. Sometimes I think that song kept us from laying down our arms and giving up.

The enemy filled siege bellows with Nafthan Flame and burned the Twelfth High Company to ash and melted fat. We sang that song when we swarmed out of the trenches in fury and won a battle we had no right to win. Afterwards, we vowed we'd never sing it again.

~

Oanu's sitting this one out, and I can't blame him. Being back here is hard. Most of the trenches are filled in and what's left of the Twelfth's garrison blew away a long time ago, but there's still something about seeing the hills just so on the horizon that makes me sweat.

Knowing Morden was in the Twelfth helped me understand what to look for. I went back to the Bretch family archives and looked for the histories they don't show to visitors. That's where I found what sent Morden back to this battleground.

Yes, Harran Bretch was a rotten, scum-sucking bastard, but it's the kind of rotten, scum-sucking bastard he was. He burned out the colony in the Underheel with siege bellows and Nafthan Flame — the same hellish weapons that scorched the garrison of the Twelfth High Company. The description in the histories was like being back in that trench, watching the fire rain down from the sky. I can only imagine what it was like for Morden to revisit that memory.

~

Luckily for both of us, the money is mostly unspent, and the song about halfway written. Morden gave me the rest of the cash, which is enough to hire a Guild ghostwriter to finish the job. I'll tell Bretch Morden finished, and that he's gone away for his health. It's the least I can do.

He wrote our old war song down for me. I'll keep it somewhere safe.

J

IMELIA'S
HOME

CONSTABULARY
HEADQUARTERS

KOTHAN'S FARM
(FIVE LEAGUES)

NERRAW
(TWO DAYS' RIDE)

MERCHANT DISTRICT

LIBRARY

THE VILLAGE
(THREE DAYS' RIDE)

HIDDEN ENTRANCE
TO CATACOMBS

THE FELD
POPULATION: 10,191

SAMANDA'S HOME

HUSKER'S

DRAM'S

THE TOWER
(THREE LEAGUES)

BOOKSTORE

FLOPHOUSE
(WHERE DUNKARR'S
BODY WAS FOUND)

CRIME SCENE
"THE DEAD FAIRMAN MYSTERY"
(TWO LEAGUES)

THE FAIRMAN OATH, COVENANTS, & CODE OF ETHICS

IN SERVING AS A FAIRMAN, I AFFIRM AND PLEDGE
TO THE BOARD OF ETHICS COMMITTEE, THE CHARACTER AND FITNESS COMMITTEE,
THE UNAUTHORIZED PRACTICE OF INVESTIGATIONS COMMITTEE,
AND THE PROFESSIONAL CONDUCT BOARD:

TO PERFORM ALL CASE INVESTIGATIONS AND EXAMINATIONS IN A MORAL, ETHICAL,
AND LEGAL MANNER;

TO SEEK OUT THE TRUTH, OBTAIN THE FACTS, AND PRESENT THEM IN A PROFESSIONAL
MANNER;

TO NOT KNOWINGLY MAKE A FALSE STATEMENT OF MATERIAL FACT;

TO NOT ENGAGE IN CONDUCT INVOLVING DISHONESTY, FRAUD, DECEIT OR
MISREPRESENTATION;

TO IMMEDIATELY INFORM THE APPROPRIATE CONSTABULARY MEMBER WHEN
KNOWLEDGE EXISTS OF ANOTHER FAIRMAN THAT HAS COMMITTED A VIOLATION OF
THE STANDARDS OF PROFESSIONAL CONDUCT, AS SET FORTH HEREWITH, THAT RAISES
A SUBSTANTIAL QUESTION AS TO THAT *PERSON'S* ~~MAN'S~~ HONESTY, TRUSTWORTHINESS, OR
FITNESS AS A FAIRMAN IN OTHER RESPECTS;

TO REPRESENT MY CLIENTS TO THE BEST OF MY ABILITY, TO ALWAYS PROTECT THEIR
BEST INTERESTS, AND TO MAINTAIN THE HIGHEST REGARD FOR THEIR CONFIDENTIALITY;

TO NOT BREAK MY OATH, NOT THROUGH PRESSURE, OPPRESSION, OR TYRANNY;

AND TO BE HONEST AND TRUTHFUL, AND TO FULFILL MY DUTIES TO THE HIGHEST
LEVEL OF STANDARDS AND COMPETENCE IN EXECUTING MY ROLE AS A LICENSED
FAIRMAN.